103.88
LdL.90

whistle clean, tight

the
**complete
typographer**

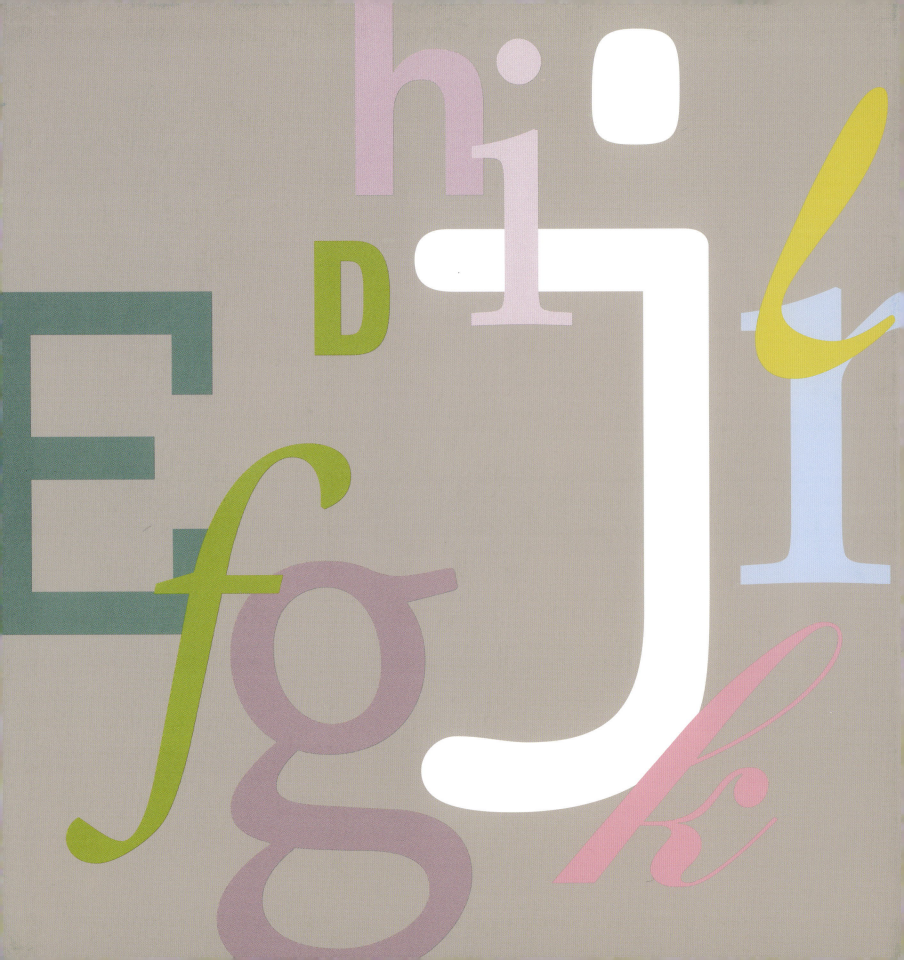

the complete typographer

a manual for designing with type

Will Hill

A QUARTO BOOK

Published by Pearson Prentice Hall
Pearson Education, Inc.
Upper Saddle River
New Jersey 07458

Editor in Chief: Sarah Touborg
Acquisitions Editor: Amber Mackey
Editorial Assistant: Keri Molinari
Manufacturing Buyer: Sherry Lewis
Executive Marketing Manager: Sheryl Adams

Cataloging-in-Publication Data
is available from the Library
of Congress

Pearson Education LTD.
Pearson Education Australia PTY, Limited
Pearson Education Singapore, Pte. Ltd
Pearson Education North Asia Ltd
Pearson Education, Canada, Ltd
Pearson Educación de Mexico, S.A. de C.V.
Pearson Education—Japan
Pearson Education Malaysia, Pte. Ltd

Conceived, designed, and produced by
Quarto Publishing plc
The Old Brewery
6 Blundell Street
London N7 9BH

QUAR.TYB2

Project Editor: Michelle Pickering
Art Editor & Designer: James Lawrence
Editors: Mary Senechal, Julia North,
 Mary Groom
Photographer: Paul Forrester
Picture Researcher: Veneta Bullen
Indexer: Dorothy Frame
Assistant Art Director: Penny Cobb

Art Director: Moira Clinch
Publisher: Piers Spence

Color separation by Modern Age Repro
 House Ltd, Hong Kong
Printed by SNP Leefung Printer Ltd, China

10 9 8 7 6 5 4 3 2 1
ISBN 0-13-134445-5

Contents

introduction

WILL HILL

For 500 years the printed word has been a crucial tool in the development of civilizations and cultures, the dissemination of knowledge, and the expression of human sensibility. A hundred years ago the setting of type was still a specialized craft within the printing industry. Twenty-five ago quality typesetting was only available to professionals within graphic design and related industries. Today, however, typographic software and desktop publishing have permeated all areas of contemporary life, across visual communication, commerce, and recreational use. The capacity to utilize and manipulate a proliferating range of types is now within the reach of the non-specialized user: the aspiring design student or the interested novice.

The development of an individual typographic sensibility requires an understanding of the way in which type works. This book is designed to provide a foundation for this awareness, providing a brief outline of the evolution of type, an introduction to the language and terminology of type and type setting, fundamental rules and conventions of professional practice, and key decisions on type selection and page layout. A directory of typefaces places the major type categories and typefaces into their historical context, introducing some key examples of excellence in contemporary type design as well as identifying the fundamental values that have sustained the continued use of classic typefaces over the last 500 years of print history.

More typefaces are now readily available to a wider public than at any time in the past. This book is designed to give a basis for the confident and informed exploration of a rich and vivid medium that continues to play a fundamental role in human communication.

the history of type

For its first 400 years, the evolution of type design was dominated by the history of print. Most major developments in typography were prompted by developments in print technology, from the mechanization of punchcutting and the invention of the Linotype and Monotype systems in the 19th century to the introduction of phototypesetting in the 20th century.

The development of typographic design as a distinct profession is a 20th-century phenomenon that itself reflects significant changes in reprographic technologies. The arrival of computerized typography revolutionized type design, bringing digital software to the independent user and providing the type designer with the means to design, market, and distribute typographic products. At the same time, the requirements of the Internet have created a major new area of typographic practice. Where digital design initially focused on making screen information resemble the final printed output, today's typographic designers are developing design methods and new typefaces specifically for the screen.

EARLY MOVABLE TYPE

The first European book to be printed from movable type was Johann Gutenberg's 42-line bible, printed at Mainz in Germany in 1455. Gutenberg's achievement was to mechanize the production of what had previously been a uniquely crafted object, and his work marks the inception of book typography and typeface design.

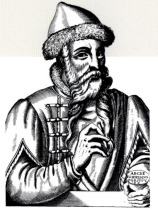

Gutenberg was not the originator of printed type, since there is evidence that printing was already established in China and Korea at this time, both in the form of block books and early forms of movable type. The European alphabet was, however, more easily adapted to the concept of movable type than the more complex Chinese writing system, and the impact of printed type upon the culture was consequently more immediate and far-reaching.

Hand-cut punches

The details of Gutenberg's working methods were closely guarded during his life and remain the subject of speculation and research, but the casting of his type is likely to have followed a process that came to be widely adopted across Europe. The letters would first be cut in relief on the end of a cylinder of steel. This positive reversed form was known as a punch. The punch would then be struck into a softer metal, usually copper, to create an impressed right-reading form, known as a strike. This was then trimmed to appropriate width to form the matrix. The matrix was fitted within the two halves of a mold, into which liquid metal could be poured to create the sort (the name given to the individual piece of type), giving a reversed relief letter that would create a right-reading impression when printed. A separate punch would be made for every letter and punctuation mark in the font, for every size. While this process underwent considerable refinement between the 15th and 20th centuries, it remained at the core of typefounding for some 400 years.

Hand-cut punches show considerable variations of form between the smaller and larger sizes, reflecting adjustments and modifications made by the punchcutter to ensure the optical effectiveness of the type at each size. At smaller sizes, serifs would be strengthened and counters opened up to aid legibility and prevent the risk of ink clogging, or "filling in." The cutting of punches in the larger sizes allowed for the fine details of the letters and particularly the form of serifs to be sharpened and refined.

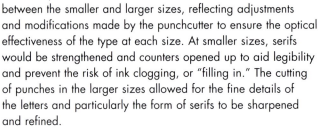

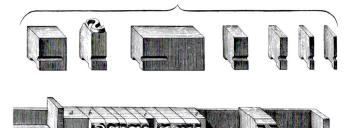

Far left Johann Gutenberg (1397–1468) introduced movable type to Europe and mechanized the printing process. By trade a goldsmith, he was knowledgeable in the casting of metal—essential training for typefounding.

Below left Metal type and spaces were assembled on a composing stick before being positioned in galleys and locked into a chase for printing.

The punchcutter was therefore a key craftsman, and punches and matrices became a crucial component in the development and dissemination of typographic knowledge, passing from hand to hand, and indeed from one country to the next, to be reused by successive generations of printers and typefounders.

Calligraphic letterforms

The letters in Gutenberg's 42-line bible were designed primarily to replicate the calligraphic Textura Blackletter forms used in German illuminated manuscripts of the time. This necessitated the casting of a large number of ligatures and alternate letters to simulate the variations of typographic form used by the scribes whose work Gutenberg set out to replicate. Analysis of the pages shows a font totaling over 300 characters. Neither type nor punches survive, giving rise to differing opinions about the exact number of characters cast. Recent research has questioned the extent to which movable type was used in the printing of the Gutenberg bible. It is, however, clearly established that Gutenberg had instituted the process of printing from movable type at this time.

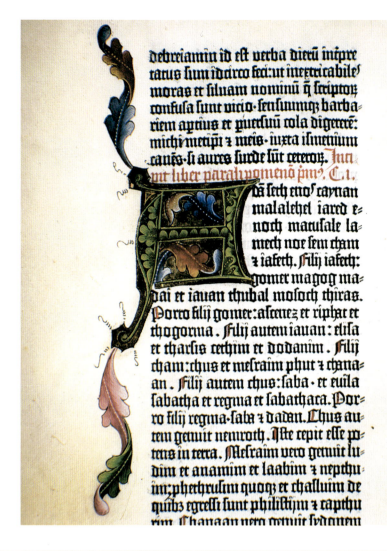

Right A page from Gutenberg's 42-line bible, printed in 1455. The condensed, angular qualities of the Textura Blackletter type create a great impact on the page, but make the text virtually illegible to modern eyes. The hand-colored initial letters and borders, which were added later, provide some visual relief.

WRITING

The history of the printed word is only part of the larger and even more complex history of written language itself. The development of the European alphabet can be traced back to Sumerian cuneiform, a form of incised writing on clay tablets that evolved in southern Mesopotamia around 3150 BC. This marked the emergence of an abstract writing system out of a set of pictographic symbols. The symbols were largely descriptive. A phonetically based alphabetic system, in which the sounds of spoken language are represented by a scheme of abstract marks, was developed by the Phoenicians from 1500 BC. The influence of the Phoenicians as a trading culture introduced the idea of a full, non-representational writing system across the Mediterranean and formed the basis for successive Greek, Etruscan, and Roman alphabets. As writing spread across medieval Europe, the square forms of the Roman alphabet gradually developed into rounder shapes, known as uncials and half uncials. The many variants were standardized

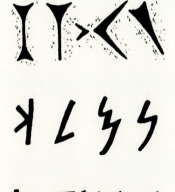

by the Emperor Charlemagne in the Carolingian edict of AD 800 that established a consistent alphabet of 24 letters and gave its name to the Carolingian minuscule hand that is the basis for the lowercase letters in use today.

Left, from top to bottom The first writing system, Sumerian cuneiform (3150 BC), consists of wedge-shaped marks. The Phoenician alphabet (1500 BC) is the first phonetic alphabet; the letters shown here would eventually become k, l, m, and n. The influence of the Phoenician alphabet on the early Greek alphabet can be seen when comparing the same four letters.

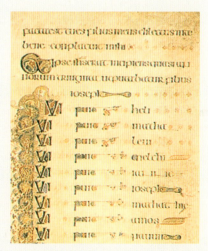

Above Half uncials, a book script, are used in the 8th-century *Book of Kells*. The beginnings of lowercase letters can be seen in the extension of the vertical strokes of letters such as b, d, and p.

THE DEVELOPMENT OF PRINTING

Printing was introduced into Britain by William Caxton in 1476, and as printing spread across Europe, so styles of type developed to reflect regional preferences. The dense angularity of the Textura Blackletter was replaced in much of Europe by the humanistic roman forms, based upon the Carolingian minuscule, preferred in Italy and France.

Above A paragraph from *The Natural History of Pliny the Elder*, printed in Venice in 1476 by French typecutter and printer Nicholas Jenson (1420–80). Jenson's roman letters are widely viewed as a definitive Humanist type.

Right An extract from the first specimen sheet, printed in 1734, showing the types of William Caslon (1692–1766). Before the advent of the point system, type sizes were referred to by names such as Great Primer and Double Pica.

The roman forms influenced the development of the early Humanist typefaces, and mark the emergence of the punchcutter's art, as type design developed beyond the simulation of handwritten forms and emerged as a medium with its own characteristics. However precise the punchcutting and casting, type remained at the mercy of the related technologies of printing and paper production. We can safely assume that the Renaissance punchcutter allowed for the spread of ink in absorbent paper and the mechanical imprecision of the printing process, cutting the punches considerably lighter than the intended letter to compensate for the subsequent coarsening of the printed result. Developments in print and paper technology in the 17th and 18th centuries created the conditions for letterforms of far greater delicacy, sharpness, and contrast.

The type case

The earliest typefaces included a large number of ligatures and alternate versions of letters. However, for practical reasons the typeface was rationalized to comprise 24 to 26 lowercase letters (u and j were later additions to the standard alphabet), along with capitals and numerals. Each font of type was arranged in two cases, giving rise to the terms uppercase to describe capitals, and lowercase to describe the minuscule letters.

Type sizes

The sizes at which type was cast were not subject to a standard measurement until the 18th century. Prior to this, type sizes had been given specific names, including Great Primer, Double Pica, and others related to their intended use. French punchcutter Pierre-Simon Fournier (1712–68) first introduced a unified system of type sizes based upon the division of the inch into units, known as points. This was adopted in mainland Europe, and although different from the point system used in the US and UK, it marked the inception of a consistent language for describing type size.

John Baskerville (1707–75) was responsible for a number of innovative developments within typography and printing. The typeface by which he is known has been successfully adapted to a range of technological changes and remains one of the most attractive and legible of text faces. It also reflects a number of innovations for which Baskerville was responsible, and embodies refinements of form that were to gain full expression in the Didone typefaces of Bodoni and Didot. The clarity and definition of printed type was subject to the spread of inks into the paper surface, resulting in printed letters that were considerably heavier and less sharp than the metal type from which they had been created. Baskerville developed inks of greater density and concentration, and introduced the use of hot-pressed "calendared" paper that had a harder and less absorbent surface. This allowed for finer printing and enabled the greater contrast of stroke widths that characterizes Baskerville's types, prompting the transition toward the highly refined hairlines of the Didone letterforms.

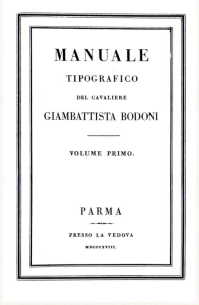

Above A page from John Baskerville's *Virgil* (1754), set in his own types.

Above The title page of *Manuale Tipografico* (1818), the type specimen book of Bodoni.

Presses

Gutenberg's presses were wooden, based upon a principle used in agricultural machinery. They involved placing the paper face down upon the type, after which a screw was tightened to make the impression. The iron hand press was introduced to the UK by Lord Stanhope at the beginning of the 19th century, followed by the Columbian presses in the US, and the Albion presses in the UK. These presses used a lever mechanism, giving greater power of impression in a single movement, and thus allowing greater precision than was possible with wooden presses.

The industrialization of the printing process continued with the development of the cylinder press, invented in London by the German designers Koenig and Bauer. The press carried the paper over the type on a rolling cylinder, a principle that lent itself readily to mechanization. One of the first steam-powered presses was installed at *The Times* newspaper in London in 1814. Mechanization quickly spread to most major newspapers, but book publishing houses continued to make use of hand presses throughout the 19th century.

Hand-set type

Although these developments increased the speed and efficiency of the printing process, the actual setting of type continued to rely upon the exacting and labor-intensive practice of hand composition. The individual sorts would be assembled into lines of text in a composing stick, to be transferred to a tray, known as a galley, and finally locked into a metal frame, known as a chase, that would be positioned in the press for printing.

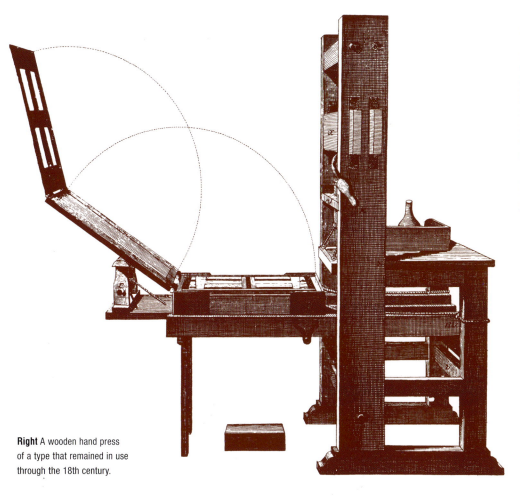

Right A wooden hand press of a type that remained in use through the 18th century.

Linotype and Monotype

In the 1880s, two American engineers independently designed machinery to automate type composition. In both cases, this was achieved by assembling the matrices for casting text ready for printing. The process came to be known as hot metal, because the lines of text are created by fresh casting rather than the manual arrangement of previously cast (cold-metal) type.

The Linotype machine, invented by Ottmar Mergenthaler and installed at the New York *Times* in 1886, was designed to cast type in whole lines. Known as slugs, these solid cast lines were easy to handle but impossible to correct, and the Linotype machine was widely adopted in newspaper production and other areas where speed of production was of greater significance than precision.

The Monotype machine, invented by Tolbert Lanston in 1887, was designed to cast a sequence of separate sorts. Text was set from a keyboard that punched holes in a paper spool, through which compressed air was passed to position the matrix for casting each character in the correct order. The Monotype machine could be used both for setting text for the page and for casting type for hand-setting.

Both Monotype and Linotype systems allowed for the automated justification of lines, expanding the word spaces to fit a predetermined measure.

Above The punchcutting machine was invented in 1884 by Linn Boyd Benton (1844–1932).

Below left The Linotype machine, the first mechanical typesetting machine, was invented in 1886.

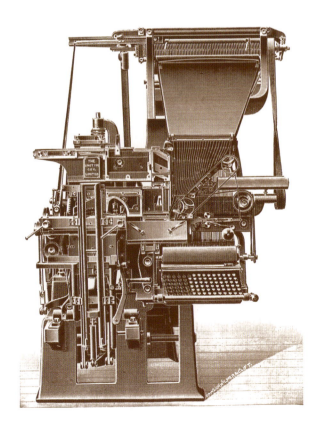

New designs

Initially the new typesetting manufacturers adapted existing foundry typefaces for hot-metal casting, but both Monotype and Linotype went on to commission new designs for the new systems. The format of the Monotype matrix case standardized the body widths upon which letters were cast, and the adaptation of foundry types to the new technology required subtle adjustments to the proportions of certain characters. Machine composition was widely adopted for mass communications, but did not fully replace hand composition for books until after World War I.

The punchcutting machine

One of the most significant developments to affect type design in the 19th century was the invention in 1884 of the punchcutting machine. Designed by Linn Boyd Benton, this traced the form of the letter through a pantographic apparatus to engrave a punch. It therefore allowed a punch to be created as a direct, unmediated transcription of a drawing.

Though printers and designers had in the past made drawings for punchcutters to work from, this process had necessarily been a

WILLIAM MORRIS AND THE PRIVATE PRESS MOVEMENT

The 19th century is generally viewed as a time of declining technical standards in printing as demand for mass publication increased, and it is true that few printing companies in Britain maintained high typographic standards in the face of a broadening but less specialized market. The designer, writer, and polemicist William Morris was concerned with both the decline in aesthetic standards and the erosion of craft skills brought about by the industrialization of printing. Morris commissioned the Chiswick Press, founded by Charles Whittingham, to publish two of his books of poems, and later set up the Kelmscott Press in 1891, with the intention of restoring standards of craft and quality in printing. Morris was responsible for new typefaces based upon a Humanist model, most notably Golden Type, and the Blackletter faces Troy and Chaucer.

Equally significant was the work of Morris's associates Emery Walker and T.J. Cobden-Sanderson, who founded the Doves Press in 1900. The Doves Bible of 1905 used a Humanist face, the Doves Type, recognized as a far more sensitive interpretation of the 1476 Jenson model than Morris's. Other private presses were founded in

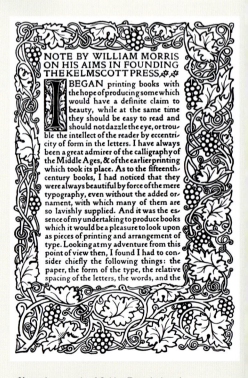

NOTE BY WILLIAM MORRIS ON HIS AIMS IN FOUNDING THE KELMSCOTT PRESS.

I BEGAN printing books with the hope of producing some which would have a definite claim to beauty, while at the same time they should be easy to read and should not dazzle the eye, or trouble the intellect of the reader by eccentricity of form in the letters. I have always been a great admirer of the calligraphy of the Middle Ages, & of the earlier printing which took its place. As to the fifteenth-century books, I had noticed that they were always beautiful by force of the mere typography, even without the added ornament, with which many of them are so lavishly supplied. And it was the essence of my undertaking to produce books which it would be a pleasure to look upon as pieces of printing and arrangement of type. Looking at my adventure from this point of view then, I found I had to consider chiefly the following things: the paper, the form of the type, the relative spacing of the letters, the words, and the

Above An example of Golden Type designed by William Morris (1834–96), reflecting the influence of medieval manuscripts.

collaborative one, reliant upon the skill and sensitivity with which a punchcutter interpreted his client's or master's intentions. Mechanical punchcutting allowed for a range of sizes to be created from a single set of master drawings. This process standardized some of the subtle variations by which hand punchcutters made optical adjustments to letters at different sizes. Although the more exacting type founders introduced variant drawings for different sizes, this practice was not universally adopted, with consequences for the quality of many historic typefaces when mechanically recut.

New design freedom

As new typefaces came to be designed specifically for mechanized punchcutting, however, the need for all sizes to be based upon a limited number of master drawings was absorbed into the designers' working method. The design of new typefaces was no longer an exclusive craft dependent upon the skills of the punchcutter, and consequently became a less specialized practice, embraced by designers, illustrators, and architects. Linn Boyd Benton's son Morris Fuller Benton (1872–1948) became one of the most prolific of this new breed of type designers.

Left A page from the 1905 Doves Bible, printed by T.J. Cobden-Sanderson (1840–1922) and Emery Walker (1851–1933) at the Doves Press. The Humanist-style Doves Type is a revival of Nicholas Jenson's Humanist type of 1476.

the early 20th century, notably the Vale and Ashdene presses in England, and the Roycroft Press in the United States.

Although the phenomenon of the private presses represents a fairly specialized area of practice, its wider impact upon typographic awareness was considerable. The revivals of Humanist typefaces created a focus upon the reform of typographic standards that was continued by Stanley Morison at Monotype and informed the development of type design in the 20th century.

Stanley Morison was one of the most significant influences on the reform of typographic standards in the early part of the 20th century. From 1923 he was typographic advisor to the Lanston Monotype Corporation, and in the same year he founded the typographic journal *The Fleuron* with Oliver Simon. He was appointed typographic advisor to the Cambridge University Press from 1925, and his book *First Principles of Typography* was published in 1928. His achievements at Monotype included commissioning Eric Gill to design Gill Sans (1928) and Perpetua (1932).

Above The first issue of *The Times* newspaper to be set in a specially commissioned typeface, Times New Roman, was published in 1932.

Top Stanley Morison (1889–1967), who directed the highly influential program of type development and design for Monotype in England.

THE FLEURON
A JOURNAL OF TYPOGRAPHY
EDITED BY
STANLEY MORISON

Nº VII

Cambridge Garden City, N.Y.
AT THE UNIVERSITY PRESS DOUBLEDAY DORAN & CO
MCMXXX

Above *The Fleuron*, which appeared between 1923 and 1930, was an influential typographical journal that set out to promote the highest standards of typography.

Above A series of sign letters in Gill Sans Light designed by Eric Gill, based on the sympathetic style and proportions of classical letterforms.

Below English designer Eric Gill (1882–1940), who made a major contribution to typography during the 1920s–30s.

Though Morison collaborated with Victor Lardent on the design of Times New Roman (1932), his significance is less as a designer than as a highly informed commentator upon typographic practice. His position within Monotype and his standing in the worlds of printing and publishing enabled him to implement his concern for typographic quality within an industry whose standards had been undermined by the pressures of mechanization. While his concern for the integrity of typographic form was based largely in the qualities of traditional types, this was not a retrogressive position. In contrast to Morris and the private press movement, Morison did not seek to return printing to an earlier state of manual craftsmanship, but rather to ensure that the printing industry developed according to appropriate aesthetic standards.

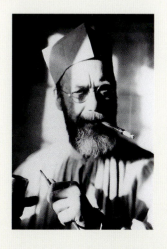

OFFSET LITHOGRAPHY AND PHOTOSETTING

During the 20th century, two closely linked developments in printing and print origination radically altered working methods in type design and type use. For 400 years, the printed word had been reproduced primarily through relief printing, a three-dimensional mechanical process in which the raised areas of type or image are inked and then impressed onto the paper. During the course of the 20th century this was superseded by the chemical process of lithography, in which the ink-retaining areas are determined through the action of a light-sensitive emulsion upon a flat metal plate.

Offset lithography

Originally used for the multiple transfer of drawings made onto lithographic stone, this process was developed for mass commercial applications through the use of flexible zinc plates that could be cylinder-mounted for printing via an inking roller. This process became known as offset lithography. In addition to streamlining the printing process, it allowed for continuous printing onto a continuous roll of paper, or web: a process known as web offset.

One of the major advantages of the lithographic process is that it does not require a raised print surface, but until the 1930s text type was only available in metal form. Pages of text to be printed lithographically had first to be typeset in metal, from which a proof copy was taken. This was then used to create the photographic negative from which the litho plate was made.

Phototypesetting

The obvious inefficiencies of the lithographic process prompted the development of two-dimensional page composition and the emergence of phototypesetting. In 1930 Edmund Uher designed a prototype photocomposition system. This used a master disk containing all of the characters of a typeface in the form of a photographic negative. A keyboard rotated this negative disk to select characters that were then exposed, in turn, through a lens onto photographic paper. The first commercial phototypesetters came into use in the 1950s. The Linotype Corporation's Linofilm machine and Monotype's Monophoto machine were followed by many others, in most cases developed by major foundries.

Photosetting or photocomposition are the terms used to describe the typesetting process in which letters are successively exposed upon photographic paper or film. The resulting image is then used to create the negatives to which the lithographic plates are exposed. Sometimes described as cold composition, this process revolutionized not only the printing industry and the design of type but also the practice of graphic design. The increasing dominance of offset lithography and photosetting in the latter part of the 20th century radically changed working practices, moving the processes of typographic decision-making from the industrial environment of the printing floor to the design studio. Photosetting completed the change in type design methods started by mechanical punchcutting, since the design of typefaces for photosetting required no knowledge of relief print or punchcutting processes.

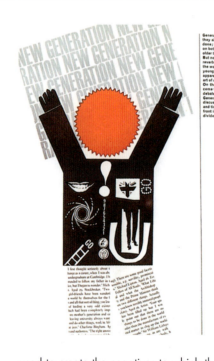

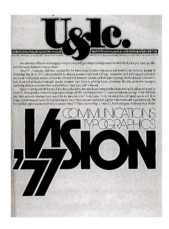

Above left & right Photosetting gave graphic designers greater opportunities for experimentation, such as this page from a 1964 edition of *Viewpoint* (left), a short-lived youth culture magazine that featured layouts of great inventiveness, and the International Typeface Corporation's *U&lc* (right). ITC was a key player in the development of faces for photosetting, one of which is featured on this cover.

JAN TSCHICHOLD AND NEW TYPOGRAPHY

Jan Tschichold (1902–74) formulated the principles of a new typography in his books *Die Neue Typographie* (1928) and *Typographische Gestaltung* (1935). The influence of the Bauhaus informs his early work, in which the largely abstract modernist principles are applied to the practical problems of graphic design. The new typography was characterized by the use of sans serif types, flush text, and asymmetrical layout, a dynamic and explicitly modern idiom that was enthusiastically developed into a typographic ideology in Tschichold's early writings. His later career in Switzerland and the UK is marked by his development from a somewhat doctrinaire modernist position to one that encompassed a much broader frame of reference, through distinguished work as a book designer and designer of typefaces, notably Sabon in 1967.

Above The title page of Jan Tschichold's first book, *Die Neue Typographie* (1928).

Above The title page of Tschichold's *Typographische Gestaltung* (1935).

Above Tschichold designed over 500 Penguin books in the 1940s.

New faces

Type designed for photosetting was drawn at large scale, and customarily cut from a form of film before being photographed to create the master negatives of the font. In most instances, a single set of master drawings served for the setting of a wide range of sizes. The demand for typefaces for the new photosetting systems, and the relative ease with which such typefaces could be created, led to a proliferation of new faces of widely varying quality, and some questionable adaptations of faces from metal originals. It also prompted the widespread pirating of typefaces, adapted for new systems under different names and often inferior in form and detailing.

Photosetting uses the action of light upon photosensitive surfaces, which created particular problems for type designers, because the concentration of light at areas such as the junctions of letters led to overexposure and a loss of definition. Several photosetting typefaces were designed with adjustments to the junctions to compensate for this.

The earlier and less sophisticated photosetting systems set single columns of type that were printed out as galley proofs and manually assembled into the required layout (pasted up), before being photographed to create the negative from which a lithographic plate could be made. The second phase of photosetting machines made increasing use of computerized information, allowing a page of set type to be viewed on a monitor screen. This enabled more of the page assembly to take place within the setting process, and meant that multiple columns and elements such as running heads, folio numbers, and subheads could be set to page. In this, photocomposition anticipates some of the key characteristics of present-day digital systems.

SWISS TYPOGRAPHY

A rigorous modernist aesthetic informed the postwar movement broadly described as Swiss typography. This represented the postwar development of ideas first formulated by Jan Tschichold and Paul Renner (1878–1956). Characterized by strong asymmetrical grids, a severely limited use of Grotesque or Neo-Grotesque sans serif type focused attention upon the underlying dynamics of composition. The deliberate choice of mechanical, undemonstrative typefaces, and the consequent lack of reference or associative values, allowed this idiom to transcend national boundaries to become an effective international style.

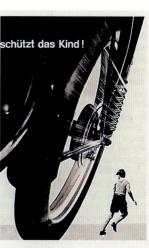

Above One of the leading exponents of the Swiss typographic style was Josef Muller-Brockmann. His poster design from 1955 features the use of sans serif type and a photographic image taken from an unusual ground-level viewpoint to increase the dramatic effect of the "Mind that child!" message.

Left This late 20th-century publication designed by Intégral Concept, with its use of all lowercase letters for headings and the small Helvetica type, harks back to the Swiss typographic style.

THE DIGITAL AGE

The story of typography from 1970 to the present day is the story of the explosion of computer power throughout the type industry. During this period there has been an unprecedented growth in type technology that has profoundly affected everyone who works with type—designers, typographers, typesetters, and manufacturers alike.

Below The same character generated using different facilities. From top to bottom: an outline font; a screen font created from a font installed at the same size; a screen font created from the nearest available size; the same character improved using anti-aliasing.

Left During the 1980s, the Netherlands was a focal point for the development of the avant-garde style, characterized by multiple layered images such as this design by Studio Dubar. This was a reaction to the minimalist design of the Swiss movement of the 1960s and 1970s.

Right This logotype for Cabaret Voltaire by Neville Brody is a good example of the outbreak of modified letterforms that occurred in the 1980s.

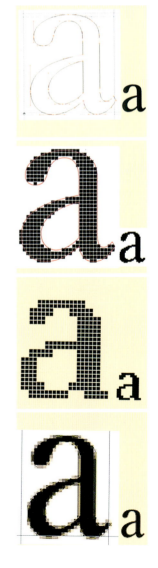

Desktop publishing

While professional typesetting systems had incorporated digital processes to become largely computerized by the 1980s, typesetting remained a specialized service within the printing and reprographic industries. Compugraphic's use of the Apple Lisa personal computer to drive their MCS photosetters signaled the potential for typesetting to be incorporated within the designer's personal computer, and prompted the emergence of desktop publishing.

The integration of detailed typesetting within an on-screen design process radically altered the working relationship between designer, typesetter, and printer. It also opened up the previously specialized world of typography and type design to a mass market of personal computer users. While it is now possible to see photosetting as having anticipated the development of digital typefaces, early desktop systems served to emphasize the apparent shortcomings of the emerging technology by comparison with the extremely high standards that had been

achieved in photosetting by the 1980s. Although this is partly attributable to the standards of resolution and definition (resolution of early digital print and screen display compared very unfavorably with the clarity of analog photosetting), it is also a consequence of the early attempts to translate traditional typefaces into digital form.

Bitmapping

As with previous developments in type history, a period of experimentation determined the particular demands of the new technology before it could be assimilated into the working methods of type designers. Digital type on screen is formed from a grid of pixels, with all of the pixels that fall within the letterform appearing as positive. The resulting form is known as a bitmap. Type can also be recorded and stored in vector form. This maps the outline of the letter as a sequence of straight and curved lines, the mathematical formulae for which are then stored digitally. Both the screen information and the eventual printed output are bitmapped.

AaBbCcDdEeFfGgHhIiJjKkLlMmNnOoPpQqRrSsTtUuVvWwXxYyZz
1234567890

Pixelated surfaces

The perceived problems of digital type design were addressed with particularly incisive vision in the work of Zuzana Licko. Licko's early designs for Emigré incorporate the pixelated surface into the working method, rather than treating it as a visual interference. Designed to maintain their integrity of form under variable levels of resolution, Licko's early faces anticipate questions that later became fundamental to web typography and new media applications.

Above The lowercase n from a screen (bitmap) font without hinting.

Above When hinting is applied, the stems become even and the shape more refined.

During the late 1980s and early 1990s, digital technology broadened access to both graphic production and typeface design, providing unprecedented scope for radical graphic initiatives that questioned established views on the values, purpose, and nature of graphic design. Borrowing theoretical positions from post-modernism and critical theories of deconstruction, as well as the reappraisal of vernacular sources and "bad" design, innovative designers and design educators promoted confrontational work that questioned not only accepted aesthetic norms but also the social and commercial role of the designer. The grid-free and intuitive working methods of designers such as David Carson explored an integrated graphic language of type and image, developing an expressionistic idiom that permeated popular culture.

Above A complex multilayered design by April Greiman, combining formal grids with a loose asymetrical arrangement of rules and titles, together with variations of weight, size, and color.

Left A page from the typographic journal *Emigré*. The publication has featured many new typefaces specifically designed to withstand low-resolution output on desktop-publishing systems.

While photocomposition made use of early digital technology for the storage and management of data, the actual form of output was a physical, analog process in which the photographic profiles of letters were mechanically exposed and printed to film or paper. Digital type, by comparison, is created without mechanical processes, and each typeface is stored in the form of binary information. The shape of each character is composed upon a fine grid of pixels, and this character shape, along with coded information on the side bearings, kerning, and hinting (a facility to improve the quality of type at low resolutions), is stored as digital information in the font software. New bitmaps are created for each type size.

Digital description systems

A major development in computer-based type was the introduction of PostScript by Adobe Systems in the mid-1980s. This is a computer language that encodes descriptive information about the design and layout of a page of text, irrespective of the resolution quality of the device to which the text is being sent.

Some of the most important developments in type technology concern the evolution of description languages: the means by which information is managed between digital file, screen, and printer. Early digital design programs allowed for only very approximate on-screen display, limited by the relatively crude pixel grid that is fixed at 72 dpi (dots per inch) on the Apple Mac and 96 dpi on PCs. Compared with the resolution of the output of even domestic digital printers, at between 300 and 600 dpi, and professional imagesetters at up to 3000 dpi, this created noticeable disparities between screen information and printed output. This problem was addressed through two different

description systems: TrueType, developed by Apple; and PostScript, developed by Adobe. Both translate the character information from bitmap into vector form for display.

PostScript fonts

The information required for the digital output of type is stored in bitmap form. Since bitmaps cannot be scaled, this requires a separate set of bitmaps for each size. The image produced on screen is, however, marred by the irregularities of the pixel grid, and does not give a clear representation of the letter's profile or of the printed outcome. In order to address this problem and provide better screen information, Adobe developed fonts using the PostScript description language. These are known as PostScript fonts or Type 1 fonts.

Below PostScript fonts consist of bitmap files and PostScript files. The PostScript files use information from the bitmap files to render characters on screen.

Bodoni, Bauer			
16 items, 269.60 GB available			
Name	Date Modified	Size	Kind
BauerBodni BdCn BT	Mon, Jun 16, 1997, 10:58 am	8 K	font suitcase
BauerBodni Blk BT	Mon, Jun 16, 1997, 10:58 am	20 K	font suitcase
BauerBodni BlkCn BT	Mon, Jun 16, 1997, 10:59 am	8 K	font suitcase
BauerBodni Rm/Bd BT	Mon, Jun 16, 1997, 10:59 am	40 K	font suitcase
BauerBodni Titl BT	Mon, Jun 16, 1997, 10:59 am	8 K	font suitcase
BauerBodni Titl2 BT	Mon, Jun 16, 1997, 11:00 am	8 K	font suitcase
BauerBodBTBla	Thu, Nov 29, 1990, 11:47 am	40 K	PostScript™ font
BauerBodBTBlaCon	Fri, Nov 9, 1990, 9:15 pm	40 K	PostScript™ font
BauerBodBTBlaIta	Wed, Nov 14, 1990, 8:46 am	40 K	PostScript™ font
BauerBodBTBol	Fri, Nov 9, 1990, 9:14 pm	40 K	PostScript™ font
BauerBodBTBolCon	Fri, Nov 9, 1990, 9:15 pm	40 K	PostScript™ font
BauerBodBTBolIta	Fri, Nov 9, 1990, 9:15 pm	40 K	PostScript™ font
BauerBodBTIta	Fri, Nov 9, 1990, 9:14 pm	40 K	PostScript™ font
BauerBodBTRom	Fri, Nov 9, 1990, 9:14 pm	40 K	PostScript™ font
BauerBodBTTit	Mon, Nov 26, 1990, 6:24 pm	60 K	PostScript™ font
BauerBodBTTitNo2	Tue, Jun 22, 1993, 10:40 am	40 K	PostScript™ font

The PostScript font consists of two parts: bitmap files and PostScript files. PostScript files use the fixed-size bitmap file information for drawing the characters on screen. This vector information can then be sent to the printer, which fills in the vector shape with pixels—a process known as rasterization. Adobe Type Manager scales information from the PostScript outline font to create appropriately sized bitmap letterforms on screen at any size.

TrueType

TrueType fonts, originally designed by Apple, are outline fonts in vector format, and are infinitely scalable. Both Mac and Windows operating systems include a TrueType rasterizer that converts the vector information into bitmap form for both screen drawing and print output. TrueType fonts are contained within a single file, which makes them more manageable than PostScript fonts.

Right top An example of the multiple master face Myriad, demonstrating the typeface's sliding scale of weight and width.

Right center Penumbra features a sliding scale from sans serif through flare and half-serif to full serif at different weights.

Right bottom Ex Ponto was designed to allow the user to determine the thickness of the stroke width, and features a range of variants, including special beginner and end letters and old-style figures.

Multiple mastering

Multiple master fonts were introduced by Adobe in the mid-1990s to allow the user to adjust attributes of weight, width, or other variant characteristics on a sliding scale between two versions of the face. Multiple master faces may involve more than one axis, allowing both weight and width to be independently modified. They are also designed to adjust optical sizing, and in at least one case, the extent of serif between serif and sans versions.

Multiple master faces
Multiple master faces
Multiple master faces
Multiple master faces
Multiple master faces
Multiple master faces

MULTIPLE MASTER FACES
MULTIPLE MASTER FACES
MULTIPLE MASTER FACES
MULTIPLE MASTER FACES
MULTIPLE MASTER FACES
MULTIPLE MASTER FACES
MULTIPLE MASTER FACES
MULTIPLE MASTER FACES

Multiple master faces
Multiple master faces
Multiple master faces

Unicode

Unicode, a system for describing a character set developed in the 1990s, allows for up to 65,000 characters or glyphs, instead of the 200 used in most western computers. This prompted the development of a new generation of font encryption formats that is expected to supersede PostScript and TrueType.

The OpenType format was developed jointly by Microsoft and Adobe and is designed to the Unicode standard. OpenType fonts consist of a single file that can accommodate the extended number of characters/glyphs that the Unicode system defines. This allows for the font file to include not only all the alternate glyph sets required by different languages using the western alphabet, but also to include alphabets such as Greek, Russian, Hebrew, and Devangari. Where, in the past, the development of non-European versions was an inconsistent and selective process, limited to the more widely used faces and often carried out at a later date or independent of the original design, it is likely that, in future, many typefaces will be initially conceived for a number of alphabets. Several new OpenType faces currently offer extended multilingual character sets to support a wide range of languages through the inclusion of special diacritics and non-Latin alphabets. Agfa Monotype have developed the WorldType format, also based upon the Unicode standard and providing similar capability.

Font design software

Digital media broadened the availability of font design technology. Many early digital fonts were designed using the relatively specialized professional industry program Ikarus. More accessible and economical programs, such as the now largely defunct Font Studio, brought font design software within the reach of the individual user. Macromedia's Fontographer became a dominant type design tool through the 1990s, and Fontlab continues the development in relatively inexpensive, industry-standard software, now providing for the design of installable typefaces in OpenType format as well as TrueType or PostScript.

The accessibility of type design software to the less specialized independent user resulted in a proliferation of new faces of variable quality. More significant in the longer term, however, is the effect upon the economics of typeface production and distribution. As type developed from cost-intensive industrial hardware to digital software, a product that had previously required a major corporate infrastructure could be produced, marketed, and commercially distributed by its designer. Since the 1990s there has been a growth of independent, designer-led foundries, in addition to companies that manage the licensing and distribution of typefaces for individual designers. The Internet

Above An example of a letter being designed using font design software. The outline of the whole letter is plotted first, then specific points are manipulated to achieve a satisfactory result. Finally, side bearings are added to determine the letter spacing.

has been a key component in this development, providing designers with both a source of type information and a means through which fonts can be purchased and downloaded. The major foundries have developed comprehensive libraries of digital typefaces, investing in both the digitization of historic types in which they already hold an interest and the commissioning of new faces.

Type and the Internet

The development of Internet communications from the late 1990s created a major new area of typographic practice, and set new challenges for both the website designer and the designer of typefaces. Earlier phases of digital design identified the need for screen information to resemble more closely the quality of final printed output, but with the growth of the Internet, it became necessary to view screen graphics not as an intermediate monitoring stage but as a final product. The visual quality of type on the screen therefore became increasingly significant.

This prompted the development of typefaces specifically designed for the screen. The process takes as its starting point the appearance of the type on the monitor, rather than in an intended printed form, and led to the design of faces in which there were no print-based subtleties to be obscured or diminished when viewed on screen. Serifs were specifically designed for integration with the pixel grid, and detailed hinting ensured that letters were consistently aligned to pixels.

Although such a rationalization might be expected to result in crude, reductive letterforms, it has in fact informed the design of some distinguished typefaces, in which fitness for purpose is matched by exceptional aesthetic coherence. The work of Matthew Carter is particularly notable in this area, and his faces Tahoma (1995), Verdana (1996), and Georgia (1996), commissioned by Microsoft, were widely adopted for on-screen use.

Contemporary typographic design

The late 20th century may well have seen the most significant changes in communication technology since Gutenberg. More recently the development of Unicode and OpenType, and the spread of Internet communications, signal a major cultural shift in type design. The fact that an OpenType font can contain a number of different scripts, as well as all the diacritics necessary for a wide range of European languages, marks a move away from the dominance of western Europe and the US, and the emergence of a more inclusive global awareness. Typeface designers are increasingly producing fonts to meet the needs of a number of different cultures, while the relative ease of distribution allowed by digital font software means that the availability of type is no longer limited to the industrialized world, or dependent upon the infrastructure of a western printing industry.

CHAPTER

two

2

In talking about typography, we are talking about the arrangement of positive shapes from which we construct readable meanings. Within these shapes, there is information about the internal workings of language, about texts and subtexts, about histories, systems, and cultures.

This discipline is an amalgam of several kinds of knowledge. Effective typography depends as much upon our awareness of design history as a mastery of technology, as much upon our understanding of language as our sense of visual aesthetics, and as much upon problem analysis as upon creativity.

This chapter introduces the terminology of typeface design, the fundamentals of page layout, the linguistic and grammatical conventions of typographic usage, and aspects of display, new media, and environmental typography.

THE TYPEFACE

The term typeface traditionally refers to any full set of standardized letterforms designed for reproduction through print. In recent years, this has also encompassed faces designed specifically for digital screen use. Although the terms typeface and font have increasingly been used as though they were interchangeable, a font is in fact a single character set comprising all uppercase and lowercase letters, numerals, and standard punctuation marks.

ABCDEFGHIJKLMNOPQRSTUVWXYZ &!?(),:;'
abcdefghijklmnopqrstuvwxyz 1234567890

ABCDEFGHIJKLMNOPQRSTUVWXYZ &!?(),:;'
abcdefghijklmnopqrstuvwxyz 1234567890

ABCDEFGHIJKLMNOPQRSTUVWXYZ &!?(),:;'
abcdefghijklmnopqrstuvwxyz 1234567890

Futura typeface comprising roman, italic, and bold fonts

Type families

A typeface normally includes a number of separate fonts, including roman, italic, and at least one variant weight, normally described as bold. The typeface may, in turn, belong to a larger type family, including condensed and extended versions and display faces. These are commonly seen as distinct but related. As a general but not universal rule, those variants that share a common width and proportion are seen as part of the same face, whereas related forms of differing width are more likely to be described as different faces within the same type family.

Some typefaces, such as Adrian Frutiger's Univers, were originally conceived as a system working across an extended range of weights and widths. In other instances, additional weights were introduced after the publication of the original face, sometimes drawn by other designers, as in the later weights of Paul Renner's Futura. The extreme display weights of Gill Sans were produced reluctantly in response to commercial demand, and, as a consequence, lack the integrity of form that characterizes the two original weights.

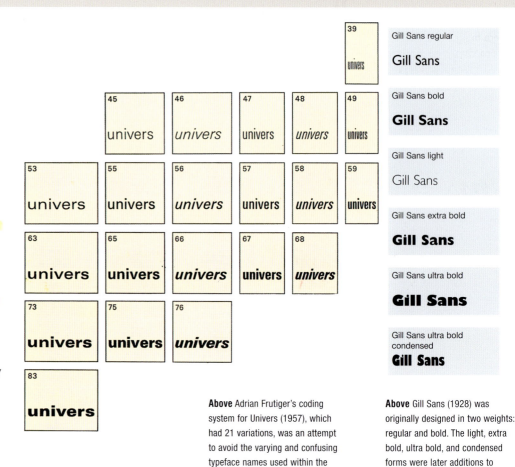

Above Adrian Frutiger's coding system for Univers (1957), which had 21 variations, was an attempt to avoid the varying and confusing typeface names used within the industry, such as light, medium, bold, extra bold, heavy, and so on.

Above Gill Sans (1928) was originally designed in two weights: regular and bold. The light, extra bold, ultra bold, and condensed forms were later additions to the family. The ultra bold and condensed forms in particular compromise the proportion and integrity of Gill's original letters.

What does a typeface contain?

All text typefaces can be expected to include a regular or roman form, a bold, italic, and a bold italic. It should be noted that the last, in particular, is a fairly recent convention. As a consequence, the design of bold italic forms for historic typefaces has often taken place at a much later date and been achieved with varying degrees of sensitivity.

The relationships between the italic and the roman, or upright, form vary considerably between one typeface and another. The italic forms of classic Humanist and Garalde faces are essentially distinct alphabets, revealing a greater influence from handwritten script than is evident in the roman form, and often a narrower set width. The convention that every typeface should be designed with an italic version is a slightly later development in type history, and many 19th- and 20th-century typefaces in these idioms actually draw upon different but contemporaneous sources for their italics.

By comparison, many sans serif typefaces have an italic that is little more than an inclined version of the upright form. Notable exceptions can be found in the italic forms of Goudy Sans or the understated elegance of the Gill Sans italics.

Tennis
Tennis

Bembo roman and italic

Tennis
Tennis

Gill Sans roman and italic

Tennis
Tennis

Goudy Sans roman and italic

Tennis
Tennis

Rockwell roman and italic

Above The original medieval roman type of Francesco Griffo, upon which Bembo is based, had no italic form. Bembo pairs these letters with an italic based upon a face designed by Ludovico degli Arrighi in the 1520s and later known as Blado. Frederic Goudy's Goudy Sans takes on a distinctive decorative fluidity in its italic form.

Above Gill Sans italic is a subtle and gracefully adapted form of the roman. Rockwell italic is a largely mechanical oblique variant—a sloped version of the upright letter.

In order to make informed decisions in the observation, analysis, selection, and use of type, we need to understand something of the vocabulary used to describe it. This vocabulary reflects some 500 years of typographic history, and remains essential if we are to communicate observations, identify preferences, and provide accurate instructions in the use of type.

The parts of the letter

An understanding of the basic anatomy of the letterform allows us to describe its characteristics in detail and to identify the defining features that distinguish one typeface from another. This provides the means for the recognition of typefaces and the vocabulary for describing their particular qualities.

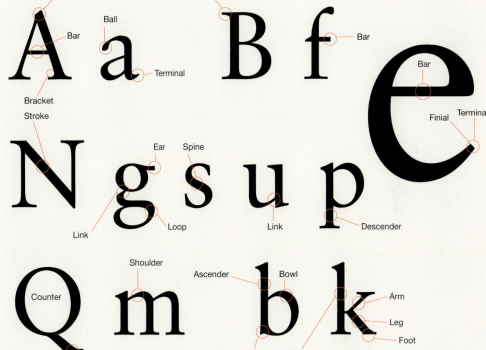

Stress

The term stress is used to describe the angle of variation between thick and thin stroke width. It could be seen as equivalent to the angle at which the letterer or calligrapher holds a broad-edged pen or brush. Vertical or angled stresses are characteristic of certain categories of type. The move from an inclined to a vertical stress follows a steady historical progression from the Humanist types of the late 15th century, in which there is a pronounced inclined stress, to the Didones of the late 18th century, in which the stress is vertical.

Color

The term color is used to describe both the tonal density and texture created by type when set as continuous running text upon the page (qualities also sometimes described in terms of gray value), and more specifically to describe the degree of variation or contrast in weight between its thick and thin strokes. This variation ranges from monoline designs that have a consistent weight of line at all points, and therefore minimal color, to the pronounced color resulting from the extremes of contrasting stroke width in the Didone faces of the late 18th century.

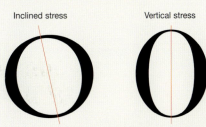

Inclined stress — Bembo

Vertical stress — Bauer Bodoni

Monoline stroke width — Bell Gothic

Contrasting stroke widths — DeVinne

THE POINT SYSTEM

The size of type is measured in points. While there have in the past been national variations in the exact size of a point, the historic differences between the European Didot system and the Anglo-American point system were effectively resolved in the decision by Adobe and Apple in 1985 to establish a point of exactly 1/72 of an inch for the Adobe page description language PostScript. This corresponds to the Mac screen, which has a resolution of 72 pixels to the inch.

Body height

Like most type terminology, the point system is based in the traditions of hand-set metal type, and the point size originally referred to the size of the "body" upon which the letterform was cast. This body was of a height to accommodate both the highest ascender and the deepest descender in the alphabet, and to leave some additional body clearance necessary to prevent ascenders and descenders from touching. For this reason, a 12-point (12pt) capital letter is not 12 points in height, and 12pt letters in some typefaces may appear considerably larger than in others, despite being the same point size. This variation is due to differences in body clearance and, primarily, to differences in x-height.

Below left The point size describes the size of the body upon which the type was cast—a height incorporating the tallest and deepest elements of letters in the font. Within this overall height a typeface will have a consistent baseline, x-height, and cap height.

Below right Adjustments to leading will increase or reduce the amount of interlinear white space.

X-height

The x-height is the median line that defines the top of the lowercase letters—specifically, the height of the lowercase x. A typeface with shorter ascenders, and therefore a higher x-height, allows for a larger lowercase letter relative to the body size. Some typefaces are traditionally set on a generous body, giving larger body clearance space and a correspondingly smaller character size.

Baseline and cap height

The baseline is the line upon which the base of the letter sits. The cap height refers to the height of the uppercase letters, frequently a little lower than the full extent of the ascender.

Leading

As well as describing the size of type, the point system is used to specify the depth of space between lines (sometimes known as the pitch or line feed). Originally referring to the strips of lead inserted between lines of type, leading is the measurement in

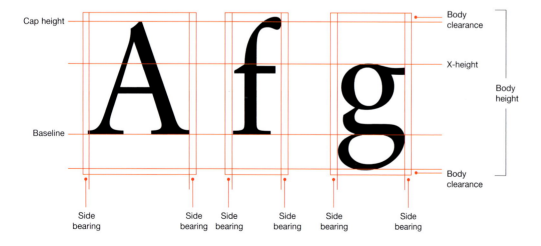

This text is set 18/28pt. There is plenty of space between each line of type.

This text is set 18/18pt, known as set solid. There is little space between each line of type.

points from one baseline to the next. This allows for both size and leading to be combined within a concise specification—for instance, 12pt type on 18pt leading, sometimes abbreviated to 12/18. Type set with no additional leading is described as set solid.

Digital and photoset type may be set with the space between lines reduced to less than would be created by the body height of the letters; this is described as minus leading. When type is minus leaded, ascenders and descenders may overlap one another or even cross the baseline or x-height of adjacent lines. Minus leading is specified in the same way as the size/leading, but in these cases the leading will be less than the type size—12/10 or 12/8, for example.

When your type is minus leaded, in this case 30/24pt, the ascenders and descenders of the letters may overlap one another.

Line measure

The point system can be used to specify line measure, the column width, or maximum line length of type. This length is commonly expressed using the pica, a measurement of 12 points, giving 6 picas to the inch. This is also sometimes referred to as a pica em, or simply an em. While it is now increasingly common for column widths to be expressed in millimeters, pica ems remain in use as a system of line measure and the example below might be described as being set 9/12 to a column width of 21 pica ems (3$\frac{1}{2}$ inches/85mm).

There are 6 picas to the inch. This is also sometimes	12pt
referred to as a pica em, or simply an em. While it is now	12pt
increasingly common for column widths to be expressed	12pt
in millimeters, pica ems remain in use as a system of line	12pt
measure and this example might be described as being	12pt
set 9/12 to a column width of 21 ems (3$\frac{1}{2}$ inches/85mm).	12pt

1 2 3 4 5 6 7 8 9 10 11 12 13 14 15 16 17 18 19 20 21 ems

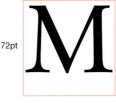

Em-square
72pt
72pt
72pt

Em-square
12pt
12pt

64 units
72pt
72pt

The em

In the context of line measurement, the term em refers to a 12pt em (a pica), but the expression is more broadly used to describe a measure equal to the body height of the type at any size (based upon the square proportions of a classical capital M). A 30pt em is therefore 30 points in width. Both the em (a measure equal to the body height) and the en (a measure that is half the body height) are used to describe the width of dashes and spaces.

The unit

The em is subdivided into units. This is a term used for specifying in detail the individual widths of letters and the spaces between them, based upon the division of the em into fractions. Until relatively recently, it was common for this to be expressed through division of the em into anything between 18 and 64 units. However, depending on the software used, current PostScript technology uses a division of 1,000, giving 1,000 units to the em.

Set width

The resulting measurement allows for the description of the set width of each letter—that is, the individual measurement of each letter's width. It also provides a means of describing the space between letters, which can be increased or decreased unilaterally (letter spacing) or adjusted between individual letters (kerning).

Unlike the point, the unit is not a fixed measure, but a proportional measurement based upon the size of the type used: 10pt type is measured in units of 1,000th of 10 points; 36pt type in units of 1,000th of 36 points. Any adjustment to unit values can therefore be applied consistently across a range of type sizes. Letter spacing adjustments are specified in different ways by different typesetting systems, but the 1,000-unit em has allowed for unprecedented precision in the adjustment of letter and word space.

Many current software programs also allow for adjustments to set width—extending or condensing the proportions of the character itself. This should be used sparingly, because any change to the proportions of the letter is in effect a redesign of the font.

Above left & center The em is a variable square measurement equal in width to the body size of the type. A 72pt em is 72 points in width; a 12pt em is 12 points in width.

Above Detailed calculations of character width and spacing are specified in units. These are subdivisions of the em, which used to be divided into 18 to 64 units, but is now divided into 1,000 units using current PostScript technology.

Below The vertical proportion or set width of letters can be modified digitally. This creates extended or condensed versions of the original, and should be used sparingly and with care.

Set width: 100%

Set width: 120%

Set width: 80%

SPACING

Professional typesetting programs allow the designer to make detailed adjustments to the space between letters. The term letter spacing refers to modification of intercharacter space applied over an entire text, whereas the term kerning refers to separate adjustments in the spaces between individual pairs of letters.

Below The pairing of certain letters creates disproportionate amounts of white space between them, requiring the use of kerning pairs in the design of the typeface. This process automatically introduces special adjustments to the side bearings each time the pairing of these letters occurs.

Ta Ta VA VA

Unkerned Kerned Unkerned Kerned

Letter spacing

Adjustments to letter spacing may be made necessary by a number of factors. Some typefaces tend to lose clarity of intercharacter space at smaller sizes, and an increase in the space around letters may make their form more easily readable. At larger sizes, the intervals between letters may be made more harmonious by a reduction in the spaces between them. Where whole words or sentences have been set in capitals, additional letter spacing is often necessary for optical balance and readability. Adjustments to letter spacing can radically alter the appearance of a body of text and the performance of a typeface, so they should be applied consistently throughout a document.

Manual kerning

Manual kerning is the adjustment of individual intercharacter spaces to achieve a more consistently balanced spacing. Display type and titling, in particular, often benefit from manual kerning. However, it would be impractical to apply this process to continuous text.

Kerning

The design of text faces incorporates inbuilt automatic adjustments to the spacing of particular letter pairs that would otherwise create disproportionate spaces: VA and Ta, for example. These are known as kerning pairs. The quality and extent of kerning pairs within a font illustrate the attention to detail that characterizes high-quality typefaces that may, in many cases, include thousands of kerning pairs. The necessity for this degree of detailed kerning varies widely according to the stylistic qualities of the typeface. A monospace typeface, in which every letter is designed to sit upon a consistent body width, involves no kerning at all, whereas the digitization or adaptation of classic serif typefaces may require a great deal of kern adjustment and therefore a large number of kern pairs. Effective kerning ensures a consistent rhythm of intercharacter space, which enhances legibility and readability.

Word spacing

The space between words has traditionally been based upon a space equivalent to the body width of a lowercase i. This space can be adjusted manually for display and title setting. In text setting, it can be specified either as a constant—in the case of flush, or ranged, type—or as a maximum and minimum—in the case of justified type (see pages 36–39). The majority of digital type media give a generous space between words, and the appearance and readability of text can in many cases be improved by reducing the word spacing, giving greater continuity and less interruption to the flow of the sentence.

Space between words makes a noticeable difference to the readability of the text.

Space between words makes a noticeable difference to the readability of the text.

Space between words makes a noticeable difference to the readability of the text.

Above The word spacing in the top example has been reduced to the point at which differentiation becomes difficult but is still distinct. The middle example is ideal for the width and openness of the type, while the lower is too wide, and interrupts the continuity of the text.

Left Increasing the letter spacing serves to balance the irregularities of a geometric face and the otherwise intrusive effect of the large counter of the circular O.

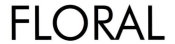

Auto letter spacing

Adjusted close letter spacing

FLORAL

Adjusted wide letter spacing

A ligature is a single form incorporating two or more letters, parts of which might otherwise touch or overlap—for instance, fi or fl. This typographic refinement can be seen in the earliest printed books, and continues to be incorporated within professional-quality typefaces. Digital type design has allowed for unprecedented development in the range of ligatures available within certain typefaces. Some typefaces do not require ligatures at all, because their letterforms have been designed to minimize those problems that make ligatures necessary.

Standard ligatures

Many typefaces incorporate a small number of standard ligatures. Most common among these are the f ligatures. These address the problems caused by the overhanging drop of the lowercase f when followed by i, l, or f—fi, fl, ffi, or ffl (sometimes also including the less common fj). These ligatures are included in many serif faces and also in those sans serifs that feature significant overhang to the f.

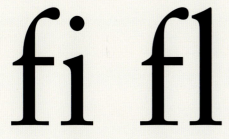

Set without standard ligatures (Sabon)

Set with standard ligatures (Sabon)

Archaic ligatures

Some specialist revival typefaces include a number of additional ligatures joining consonants, such as ct and st. These were in common use in printing up to the 18th century and would now normally only be used in instances where reference is being made to an appropriate historical period.

fb tt cti fh ffh tfr fi fk fj ffj ttfr ffk stfr te sfr stfl sty tf ta sp stfi stfj tti ttr ctr str sfi sfy sh sk sp sf sta ste ch ffb ttf tte tta cty stf sti cta ctf ctfi cte fr fk fti ftr fty fflffy fta

Special ligatures

Some typefaces include a large range of ligatures, in a few instances dedicating entire fonts to them, as in Hoefler Requiem. Where a typeface contains an extended family of ligatures, they may be used selectively for variation and visual effect. In particular, typefaces based upon script or calligraphic form may include a wide range of different ligatures and alternate letters, allowing the designer an extended palette of visual variations. A dramatic example of this can be found in Herman Zapf's Zapfino.

Diphthongs

A diphthong is a single form incorporating two vowel letters for specific phonetic reasons—such as ae and oe—rather than for the optical/aesthetic reasons that govern the design of ligatures.

Œ œ Æ æ ß

Above Diphthongs have a specific phonetic function, used largely in words derived from classical Latin (Hoefler Requiem).

Left A typeface with an exceptionally extensive font of ligatures, incorporating up to four letters and using the archaic linking strokes on the s and c forms (Hoefler Requiem).

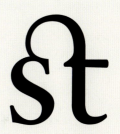

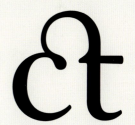

Above Archaic ligatures, reviving a typographic device originally found in historic metal types (Hoefler Text).

ALTERNATE FONTS

Many special characters that are not supplied with the basic font can be obtained as a separate package called an expert set. These may include alternate versions of certain letters. For example, several type designs offer variants of the capitals R, K, and Q, allowing the designer to select either a descending stroke that sits on the baseline or one that descends below it. Similarly, some typeface families include alternate "beginner" and "ender" letters, to be used at the beginning and end of words. These may also be included within swash fonts.

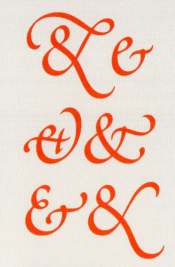

Above A selection from the extended range of 58 ampersands available in Robert Slimbach's Poetica.

Swash characters

Some typefaces include fonts of swash characters. These are letters of greater decorative extravagance than those of the main face, and are designed for selective use. They may be used in titling and display, or as initial capitals to identify the beginning of a section of text. A swash font may also incorporate alternate lowercase letters and other decorative variant forms, such as ornaments and fleurons.

Below Typefaces that are derived from calligraphic forms, such as Poetica, offer particular scope for the design of swash alternates, adding color and variety and offering the designer an extended range of choices.

Small caps

Many high-quality typefaces include a small-cap font, for use in those instances where capital letterforms are used to set whole words and sequences of words. The substitution of a smaller size of capital letterform in place of lowercase letters is an established typographic tradition, perhaps most commonly associated with chapter openings.

The irregular shapes created by ascenders and descenders can be replaced

by Small-Cap Letters designed to create clean horizontals.

Typesetting Software can be used to create an inferior small-cap setting.

Above Comparison between the two small-cap examples reveals the shortcomings of false small caps. The lower example shows less harmonious character spacing and an unacceptable variation in stroke width between the two sizes of capital.

Small-capital letters may be used for emphasis, differentiation, or in subtitles and running heads, where clean horizontals may be preferable to the irregular shapes created by ascenders and descenders. The small-cap letters are designed specifically for this purpose. Their weight, color, and stroke width all correspond to that of the full caps in their size, while their proportions are usually wider, corresponding more closely to those of the lowercase letter. The side bearings are more generous, and are designed to give balanced character spacing between capital forms. By comparison, words and phrases set using ordinary capital forms generally require both general and specific adjustment to spacing.

Professional typesetting software allows the designer automatically to create an inferior version of small-cap setting, through the crude substitution of capitals of a smaller point size. The visual shortcomings of this process serve to demonstrate the importance of a well-designed small-cap font, because the false small caps substituted in this way will be lighter in weight and stroke width, and will lack the considerations of set width, letter spacing, and kerning that characterize the well-designed small-cap font.

Old-style numerals
The small-cap font or expert set usually also contains old-style numerals. These are also known as non-lining or proportional numerals. They might usefully be described as lowercase numerals, because the forms align to the x-height rather than the cap height of the face, and have ascending and descending strokes. They are particularly valuable in those instances where there is a large amount of numerical information within the running text.

Standard lining or tabular numerals that correspond to the cap height may create an unintended visual emphasis, equivalent to that which occurs when a word is set in capitals. This interrupts the visual consistency of the text and the ease of reading. By comparison, old-style numerals correspond to the profiles and proportions of lowercase letters, and are therefore better integrated within running text.

Ornaments and other non-alphabet forms
In addition to the letters of the alphabet, punctuation marks, and other standard glyphs, digital fonts include a variety of non-alphabetical forms. These include ornaments, symbols, and other graphic icons. Historical forms, such as the dagger and double dagger, are included within the main font for most traditional typefaces. Other sets of non-alphabetical forms are associated with specific typefaces but occupy whole fonts. Many of these are adaptations of historical decorative forms, referred to as fleurons or printers' flowers. These may be used as paragraph markers and text endings, or may also be used to form continuous decorative borders or fields of repeated pattern. There are also fonts designed specifically to create borders and frames.

Right Tabular numerals (Sabon) and non-lining numerals (Sabon Old Style).

Right Ornaments and fleurons (Hoefler Text Ornament).

Hoefler Text typeface © The Hoefler Type Foundry, 1991–1994. http://www.typography.com

Right An informal miscellany of abstract and figurative symbols (Zapf Dingbats).

Right In Gill Sans Dual Greek, the outward characteristics of Gill's classic sans serif forms are applied to the different requirements of the Greek alphabet.

ΤΨΔΩΓΛΠΞαβγδεζηθικλ
μνξοπρστυφχψως

Some non-alphabetic fonts are not specific to any typeface or typographic genre, but are freestanding miscellanies including both functional and ornamental elements. These are commonly known as dingbats, wingdings, or sorts. Some fonts include graphic informational symbols. These are designed for more specific uses, including cartographic, mathematical, and scientific functions.

Other alphabets
Digital technology has led to major improvements in the availability of compatible Cyrillic and Hellenic alphabets. In the past, the coordinated design of typefaces across more than one alphabet was a relative rarity, limited to a few widely used faces, such as Times or Gill Sans, while the process of adapting the characteristics of existing Western faces and styles into different alphabets was achieved with only limited success. The development of Unicode and OpenType offers the prospect of far more effective typographic integration, allowing the incorporation of multiple alphabets or scripts within a single font.

SELECTING TYPE

In choosing a typeface for the setting of text, our first impulse is, understandably, to look at the letterforms themselves. Do they attract us visually? What associations do they possess? What values do they suggest? What responses do they evoke? However, this impulse is, if not misguided, an incomplete basis for choice.

Assessing type

Viewing an alphabet does not tell us how a typeface functions. It tells us how the letters look, but not how they work. Typeface design is the design not only of forms but also of capabilities, and informed typeface choice depends not simply upon how type looks but also how it can serve the designer's purpose. This is a different methodology and involves a distinct aesthetic — as different as architecture is from painting.

Another analogy might be the way we look at a piece of textile. We look not only at the pattern printed upon it, but also at its texture, its construction, the way in which it is woven or knitted. We look at the way that it falls when tailored; whether it lets the light through, or keeps the rain out.

Left Brochures and leaflets produced by type foundries to promote their products are useful tools for assessing type.

The questions we might ask of a typeface will depend upon the job we wish it to do. The quality of our decisions will depend upon the intelligence we bring to this question. Relevant questions might include:

• How extensive is the range of fonts available as part of this face or family? For instance, what range of weights is available, and is the design equally satisfactory across the range of weights?

Weight *Weight*
Weight **Weight**
Weight **Weight**

• Are its historical references and antecedents appropriate to the context and structure of the product?

Context *Context*
Context **Context**
Context **CONTEXT**

• Does it include fractions and non-lining numerals, which may be an important consideration if the job involves the use of numerals such as dates within the running text?

123456 *123456*
123456 *123456*
½ ⅛ ⅜ *½ ⅛ ⅜*

• Does it have related variants for display use? Does it include small caps and other expert set features?

Variants *Variants*
Variants *Variants*
VARIANTS *VARIANTS*
VARIANTS VARIANTS
VARIANTS VARIANTS

• Does it form part of a family of related faces? This might include condensed or extended versions and display variants, allowing the same typeface or family to be maintained across text and display uses.

Roman Text Face
Black Text Face
Swash Titling Face
ENGRAVED FACE
LIGHT SMALL-CAPS
ITALIC SWASH SMALL-CAPS

Final bullet point examples: Hoefler Text typeface © The Hoefler Type Foundry, 1991–1994.
Hoefler Titling © The Hoefler Type Foundry, 1994. http://www.typography.com

Legibility is probably best viewed as a body of knowledge, research, and opinion to which designers refer selectively, rather than a subject governed by any single unified theory or categorical law. There is a range of provisional truths, but the designer's own response to the text may still be the best point of reference. It is useful, however, to keep the following points in mind:

- The eye registers the shapes of words, reading as a whole the profiles of all words with which the reader is familiar. It is only when encountering a word that is new to us that we trace it letter by letter.
- Ascenders and descenders aid differentiation (distinguishing j from i, a from d). Lowercase forms are therefore more legible than capitals of equivalent size.
- Lower and more clearly defined junctions, as in the join of the stem to the curve of a lowercase n, will aid legibility. Open and well-defined counters are also a characteristic of the most legible typefaces.

Legibility

The analysis of legibility involves a range of factors, perspectives, and methodologies. While any of these may be relevant and illuminating in a particular context, it remains a study that resists absolute rules or categorical statements. For the experienced designer, legibility is largely addressed intuitively or, more accurately, through accumulated knowledge and experience. It may vary radically with the context of the work, with the use of negative space, leading, and line measure, and cannot be identified solely with the typeface itself.

Legibility depends upon the ease with which the eye can identify letters, and distinguish them from one another. It therefore depends as much upon the relationship of letters in the font as upon the design of the individual letters. An i that might appear perfectly legible when viewed in isolation will be compromised if the j is insufficiently differentiated from it. A geometric lowercase d appears highly legible until one considers how easily it may be mistaken for an o tight-spaced to an l. One might mistakenly assume that the relatively unadorned forms of geometric sans serifs, with their clear, or "clean," lines, would make such typefaces supremely legible. However, this clarity of form results in a lack of differentiation between letters.

We should also recognize that legibility is determined not only by formal and physiological influences, but also by the cultural norms and expectations of the time. John Baskerville's typefaces, models of legibility by present-day standards, were criticized in their time as unreadable due to the brilliance of their contrast. Blackletter type, which remained the norm for long text setting and book work in Germany until the 1940s, is now regarded as difficult to read. Certain typefaces can be identified as giving exceptional "page economy," providing a greater number of legible words per column inch than their competitors, but this is a partial and rather reductive measure of legibility.

Letter spacing that is too tight impairs legibility.

The correct amount of letter spacing enhances legibility.

Letter spacing that is too loose impairs legibility.

Above If letter spacing is too tight or too loose, it will impair legibility. The correct amount of letter spacing depends upon the characteristics of the typeface being used.

Above A formal type design is more legible than a decorative one.

Legibility Legibility

Above Serif type is more legible than monoline sans serif.

Legibility LEGIBILITY

Above Lowercase letterforms are more legible than capitals.

Legibility Legibility Legibility

Legib

Above Very small or large type tires the reader and reduces legibility.

Legibility

Legibility

Legibility

Left A medium-weight type is more legible than a light or bold face.

Above Black on white is generally more legible than other color combinations.

Readability

Readability and legibility are interdependent but distinct. Legibility concerns the recognition and differentiation of letters and the resulting word shapes that they form. Readability concerns the manner and ease with which the reading eye traces, connects, and absorbs these words as coherent and continuous sentences and paragraphs.

Line length, word spacing, and leading all crucially affect the readability of text. Short lines create repeated interruptions in the reading process, breaking sentences into dislocated fragments. Unduly long lines require the reader to scan more widely, and make it difficult for the eye to track accurately back to the succeeding line. A character count of 60–66 characters per line is widely held to be an optimum. In those circumstances where longer lines are unavoidable, their effect upon readability can be compensated by increases in leading.

Word spacing is also a key factor in readability. While too little space between words may make it difficult to distinguish one word from the next, the majority of digital type suffers from the other extreme, because the default settings insert excessive space between words. This causes unnecessary interruption to the readability of the text as well as introducing excessive white space into the overall texture of the column.

TEXTURE AND COLOR

The choice of typeface, type size, leading, word spacing, and line measure affects the texture and color (tonal value) of text setting. In these examples, the Clarendon creates a strong horizontal emphasis, while Bauer Bodoni has a pronounced vertical stress. The abrupt contrast of stroke widths in Bodoni produces a much richer texture than the monotone appearance of Helvetica. Text set in Baskerville italic has a more close-knit texture than text set in Baskerville roman. Note also the changes in color and texture achieved by increasing the leading.

9/11½pt Clarendon light
The purpose of typographic design is to arrange all the component parts of a piece of text into a harmonious and cohesive whole. This can be achieved either through the unity of similar design elements or by contrasting values.

10/11½pt Bauer Bodoni
The purpose of typographic design is to arrange all the component parts of a piece of text into a harmonious and cohesive whole. This can be achieved either through the unity of similar design elements or by contrasting values.

9/11½pt Baskerville
The purpose of typographic design is to arrange all the component parts of a piece of text into a harmonious and cohesive whole. This can be achieved either through the unity of similar design elements or by contrasting values.

9/11½pt Baskerville italic
The purpose of typographic design is to arrange all the component parts of a piece of text into a harmonious and cohesive whole. This can be achieved either through the unity of similar design elements or by contrasting values.

9/9pt Helvetica
The purpose of typographic design is to arrange all the component parts of a piece of text into a harmonious and cohesive whole. This can be achieved either through the unity of similar design elements or by contrasting values.

9/9pt Helvetica italic
The purpose of typographic design is to arrange all the component parts of a piece of text into a harmonious and cohesive whole. This can be achieved either through the unity of similar design elements or by contrasting values.

9/9pt Helvetica
The purpose of typographic design is to arrange all the component parts of a piece of text into a harmonious and cohesive whole. This can be achieved either through the unity of similar design elements or by a more dynamic composition of contrasting values.

9/14pt Helvetica
The purpose of typographic design is to arrange all the component parts of a piece of text into a harmonious and cohesive whole. This can be achieved either through the unity of similar design elements or by contrasting values.

9/14pt Helvetica italic
The purpose of typographic design is to arrange all the component parts of a piece of text into a harmonious and cohesive whole. This can be achieved either through the unity of similar design elements or by contrasting values.

9/14pt Helvetica
The purpose of typographic design is to arrange all the component parts of a piece of text into a harmonious and cohesive whole. This can be achieved either through the unity of similar design elements or by contrasting values.

9/14pt Helvetica italic
The purpose of typographic design is to arrange all the component parts of a piece of text into a harmonious and cohesive whole. This can be achieved either through the unity of similar design elements or by contrasting values.

ALIGNMENT

Lines of continuous text—also referred to as running text or long text—may be arranged upon the page according to any one of four main forms of alignment. While some are suitable for a wider range of purposes than others, it is important to recognize that no form of alignment is intrinsically better than another; their suitability is determined by the context in which they are to be used.

Using flush, or ranged, text

Flush type is seen as informal and its asymmetry may be used as a positive element in the design of a page. It may be set in narrow columns of as few as four or five words per line, and the consistent word spaces make flush type more readable and visually harmonious than the variable word spacing of justified type. Hyphenation can be kept to a minimum, or in some cases eliminated altogether. Frequently used in page layouts utilizing two or more columns, and in smaller documents, it is rarely used for single-column book pages, though arguments have been made, notably by Eric Gill, for the adoption of flush text in this context.

Hyphenation and word spacing: flush type

Flush type should be the preferred option when using basic programs that do not allow for detailed modifications of setting, but it can nevertheless benefit from the adjustments to hyphenation and word spacing provided by professional typographic software.

FLUSH-LEFT TEXT—PROS AND CONS

Each form of alignment has its characteristic qualities, advantages, and disadvantages. Decisions on the alignment of continuous text are ultimately governed by considerations of type size and column width. It is the relationship of these three interdependent factors that ultimately determines the appearance of printed text.

What is it?
Type set to an even left margin, giving an uneven or ragged right margin.

Other names
Also called ranged left or ragged right.

Key characteristic
Asymmetry.

Right Flush-left type, creating an irregular right-hand margin.

The typographer's first duty is to the text itself. An intelligent interpretation of the text will not only ensure readability, but will also reflect its tone, its structure, and its cultural context. The typographer's analysis illuminates the text, like the musician's reading of a score.

> The typographer's first duty is to the text itself. An intelligent interpretation of the text will not only ensure readability, but will also reflect its tone, its structure, and its cultural context. The typographer's analysis illuminates the text, like the musician's reading of a score.

Above Type flush left to standard spacing defaults, showing unneccessarily wide word spacing.

12pt Classical Garamond
14pt leading
Word spacing—standard default: opt 110%
Hyphenation—none

> The typographer's first duty is to the text itself. An intelligent interpretation of the text will not only ensure readability, but will also reflect its tone, its structure, and its cultural context. The typographer's analysis illuminates the text, like the musician's reading of a score.

Above Type flush left with word spacing reduced, to give a tighter line and improved readability.

12pt Classical Garamond
14pt leading
Word spacing—adjusted: opt 85%
Hyphenation—none

Since one of the main virtues of flush setting is that it minimizes the need for hyphenation, it is logical to hyphenate only where absolutely necessary. It may also be argued that the more pronounced raggedness of the resulting right-hand column makes a positive feature of its asymmetry, where a flush text that has been extensively hyphenated may result in nearly even lines.

The majority of typefaces and default settings allow more space than is strictly necessary between words, and the appearance of flush text setting can often be improved by fine-tuning the word spacing. While word spacing is traditionally equivalent to the body width of a lowercase i, in practice the designer's eye is the best guide in optimizing word space for ease of reading.

Advantages
- The space between words remains consistent. This is important to the readability of the text—the ease with which the reader's eye traces the progression from one word to the next. It also ensures an even texture to a column of type, maintaining an even "gray value" from line to line.
- It is not necessary to hyphenate words. Strictly speaking, it need not be necessary to hyphenate any words at all within flush text; in practice, it may be useful to specify hyphenation of extremely long words to avoid an excessively ragged right margin.
- It can be set across narrow columns.

Disadvantages and limitations
- Asymmetry—the ragged right margin may disturb the balance of an otherwise symmetrical page layout. However, this might equally be listed as an advantage, since asymmetry can be the basis for dynamic typographic compositions.

CENTERED TEXT—PROS AND CONS

What is it?
Type set on a central axis, with even word spacing and ragged left and right margins.

Other names
Also called ragged left and right.

Key characteristic
Symmetry.

Advantages
- Although seldom used for the setting of large quantities of continuous text, centered type can be extremely effective in the design of single pages in formal contexts (such as title pages).

Disadvantages and limitations
- Reduced readability—the absence of an even left margin makes it more difficult for the reader's eye to identify the beginning of the next line. This may be addressed by increasing the leading.

> The typographer's first duty is to the text itself. An intelligent interpretation of the text will not only ensure readability, but will also reflect its tone, its structure, and its cultural context. The typographer's analysis illuminates the text, like the musician's reading of a score.

FLUSH-RIGHT TEXT—PROS AND CONS

What is it?
Type set to an even right margin, giving an uneven or ragged left margin.

Other names
Also called ranged right or ragged left.

Key characteristic
Asymmetry

Advantages
- Flush-right text is rarely used for text of any length. It can, however, be extremely effective for setting small bodies of text, captions, and so on within asymmetrical layouts, where a ragged left column may create or resolve dynamic tension within the composition of the page.

Disadvantages and limitations
- Reduced readability—the absence of an even left margin makes it more difficult for the reader's eye to identify the beginning of the next line. This may be addressed by increasing the leading.

> The typographer's first duty is to the text itself. An intelligent interpretation of the text will not only ensure readability, but will also reflect its tone, its structure, and its cultural context. The typographer's analysis illuminates the text, like the musician's reading of a score.

What is it?
The space between the words is adjusted in each line, giving even margins both left and right.

Other names
Also called flush left and right.

Key characteristic
Symmetry.

Advantages
- Even margins left and right, giving a neat rectangular text area.

Disadvantages and limitations
- The space between words will necessarily vary from one line to the next, because each is adjusted to fill the same column width. This requires detailed adjustments to specification in order to avoid excessive spaces between words.
- Requires hyphenation.
- Requires wide columns/larger number of characters per line.

The typographer's first duty is to the text itself. An intelligent interpretation of the text will not only ensure readability, but will also reflect its tone, its structure, and its cultural context.

Above Justification involves automatic variations in word spacing to create a clean right-hand margin.

WORKING WITH TYPE

Using justified text

Justification creates balanced formal columns of text, providing visual symmetry and clean margins. It remains the accepted form of alignment for traditional single-column book pages, providing clean inner and outer margins. The feasibility of justified setting will depend upon the number of words per line. This is determined by two factors: the size of the type and the width of the column.

If type has to be fitted into a narrow, predetermined column width, at optimum size, this may result in a character count too small for justification to be feasible. If the nature of the job gives some measure of control over the column width, the designer may determine an optimum column width based on considerations of readability.

The optimum type size will be determined by the nature of the document, and may be affected by questions of economy and the need to achieve a given number of words per page. The smaller the character count, the fewer words per line, resulting in an increasingly noticeable variation of word spacing when justified. A column width giving an average of four or five words per line will show marked and intrusive variations of space that will not occur in a column of ten to twelve words per line.

Hyphenation and word spacing: justified type

Justification should not be attempted unless using a program or setting system that allows for detailed adjustments to hyphenation and justification (H&Js). Some degree of hyphenation is essential to justified setting. It is the designer's role to specify how far hyphenation is applied. This is expressed in terms of: the smallest word to be hyphenated, the minimum number of words before a hyphen, and the minimum number of words after a hyphen. While some clients may have a predetermined house style covering such questions, it is frequently left to the designer. The fine-tuning of H&Js can reflect a general aesthetic preference or be used to address specific justification problems.

Justification settings allow the designer to specify the minimum, optimum, and maximum spaces between words. The majority of typefaces and default settings allow more space than is strictly necessary between words, and the appearance of text setting can often be improved by fine-tuning the word spacing. Justification settings also allow for additional spacing to be introduced between letters where necessary. This last capability should be used sparingly, if at all, because even minimal increases in letter spacing can create lines that appear inconsistent with the rest of the text.

12pt Classical Garamond	
14pt leading	
Word spacing—standard default:	
min 85%, opt 110%, max 250%	
Hyphenation—standard default:	
Shortest word	6
Minimum before	3
Minimum after	2

The typographer's first duty is to the text itself. An intelligent interpretation of the text will not only ensure readability, but will also reflect its tone, its structure, and its

The typographer's first duty is to the text itself. An intelligent interpretation of the text will not only ensure readability, but will also reflect its tone, its structure, and its cultural context. The typographer's analysis illuminates the text, like the musician's reading of a score.

Left Without adjustment to settings, there are very noticeable rivers in the text.

12pt Classical Garamond	
14pt leading	
Word spacing—adjusted	
min 50%, opt 70%, max 90%	
Hyphenation—standard default:	
Shortest word	6
Minimum before	3
Minimum after	2

The typographer's first duty is to the text itself. An intelligent interpretation of the text will not only ensure readability, but will also reflect its tone, its

The typographer's first duty is to the text itself. An intelligent interpretation of the text will not only ensure readability, but will also reflect its tone, its structure, and its cultural context. The typographer's analysis illuminates the text, like the musician's reading of a score.

Left Reduced minimum and optimum settings improve the readability and the density of the type.

12pt Classical Garamond	
14pt leading	
Word spacing—adjusted	
min 50%, opt 70%, max 70%	
Hyphenation—standard default:	
Shortest word	6
Minimum before	3
Minimum after	2

The typographer's first duty is to the text itself. An intelligent interpretation of the text will not only ensure readability, but will also reflect its tone, its structure, and its cultural context. The typographer's analysis illuminates the text, like the musician's reading of a score.

Left Where type is justified across a longer measure, the irregularities of word spacing are reduced.

RESOLVING JUSTIFICATION PROBLEMS

The most common problem of justification is the appearance of excessive spaces between words, creating what are called "rivers" within a column or page of type. This may be resolved by any of the following measurements:

- Adjusting the H&Js—to reduce the maximum word space and increase the incidence of hyphenation.
- Reducing type size—this will give a greater character count per line.
- Increasing leading—greater space between lines will compensate visually for pronounced word spaces; tighter leading will make the rivers more apparent.

The typographer's first duty is to the text itself. An intelligent interpretation of the text will not only ensure readability, but will also reflect its tone, its structure, and its cultural context. The typographer's analysis illuminates the text, like the musician's reading of a score.

Above Rivers in justified type.

DIFFERENTIATION

Any piece of typographic design is likely to contain several different kinds of information. It is an important part of the designer's role to ensure that these are prioritized and clearly differentiated visually. Differentiation may be achieved through: position, scale, weight, italicization, case, and mixing typefaces.

Position

Different types of information may be identified visually by their position on the page. Designated spaces within the page layout may, for instance, be allocated to running footnotes, captions, or timelines, as well as to recurring elements such as page numbers and running heads.

Scale

Content may be differentiated through the scale of type, by increases in point size. A title or subtitle, an introductory paragraph, or pull-quote may be differentiated from the main text by being set in a larger size. In some cases, specific words or phrases within continuous text may be set in larger sizes for emphasis. As a general rule, any such increase should be of at least 2 points; a single point difference is likely to look like an error rather than a deliberate decision.

Weight

Typefaces customarily include a choice of weights, from the single bold variant common to most text faces to intermediate weights, such as book, medium, and demi; or extremes, such as black or ultra bold. Among those typefaces that have only two weights, the interval between weights varies widely from one face to the next. As a consequence, the mixing of weights in one typeface may constitute a more "colorful" variation than in others. Because a typeface is designed in a different weight or width, a number of considerations inform the new design. An increase in stroke width will necessitate modifications of form, requiring particular attention to the junctions of strokes and in some cases significant changes to the design of letters.

Some type categories lend themselves naturally to variations of weight and width. In particular, the characteristic qualities

MULTIPLE MASTER TECHNOLOGY

Since the late 20th century, several typefaces have been designed in an extended range of weights using multiple master technology. The resulting range of options should nevertheless be used sparingly. A limited number of weights should be selected and careful consideration given to the amount of difference between them.

Bliss Light	Bliss Caps Light
Bliss Light Italic	*Bliss Caps Light Italic*
Bliss Regular	Bliss Caps Regular
Bliss Italic	*Bliss Caps Italic*
Bliss Medium	Bliss Caps Medium
Bliss Medium Italic	*Bliss Caps Medium Italic*
Bliss Bold	**Bliss Caps Bold**
Bliss Bold Italic	***Bliss Caps Bold Italic***
Bliss Extra Bold	**Bliss Caps Extra Bold**
Bliss Extra Bold Italic	***Bliss Caps Extra Bold Italic***
Bliss Heavy	**Bliss Caps Heavy**
Bliss Heavy Italic	***Bliss Caps Heavy Italic***

Left Multiple master fonts are available in an extended range of weights—24 of the 160 versions of Bliss are shown here.

of Didone types, in which there is pronounced contrast between horizontal hairlines and vertical strokes, can be maintained across a wide range of weights and dramatically condensed or extended variants.

Care should be observed when introducing bold type in digital setting. Some typesetting and word-processing software will respond to a "bold" command by introducing an automatically emboldened version of the face, rather than accessing the correct bold font. This false bold will invariably be inferior in form and detailing. For this reason, it is good practice always to specify the bold through making a specific font selection.

Italicization

Italic forms may be used to create emphasis or differentiation within continuous text. Their use can denote the stresses in speech, and indicate the introduction of words from other languages or idioms. Italic form also has a more general association with the spoken word, and may therefore be used for the setting of extended sections of quotation or reported speech. Italics may be adopted as the main text font for continuous setting, but it should be remembered that this will in turn create the need for some alternative form of differentiation where words within the text would otherwise have been italicized.

Case

Capital forms may be used within continuous text for visual differentiation or, sparingly, for emphasis. Where capital letters are to be set as "strings" to create whole words or sentences, the designer should consider the use of a small-cap font if one is available. If using the standard capitals from the main text font, particular attention must be given to letter spacing. Strings of capitals almost invariably benefit from general adjustments to letter spacing, and may also require the individual manual kerning of letter pairs at larger sizes.

Mixing typefaces

Many typefaces or typeface families contain within them a wealth of inbuilt variation, offering a range of weights and widths, display variants, small-cap fonts, and other characteristics, allowing the designer many forms of differentiation while using only one face. There will, however, be instances where the use of more than one type family is appropriate. Care should be taken to ensure both a well-defined contrast and an underlying affinity between the faces used.

It may be preferable to make positive use of the contrasts between serif and sans serif, rather than using two serif or two sans serif faces. (It is particularly difficult to combine different categories of sans serif successfully.) If contrasting typefaces are to be used in such a way that they occur within the same line, care should be taken to ensure that the two faces have a consistent x-height. Sans serif and serif faces can work together

Typographic variation, whether in the use of differing typefaces, weights, and sizes, the introduction of bold, italic, or small-cap fonts, should serve to clarify visually for the reader specific kinds of emphasis and prioritization, and to establish consistent distinctions between different kinds of content. It separates the design of the page into levels or layers, simultaneously visible but distinct, clarifying for the reader the relationships between several related kinds of information. While this has the effect of visually enlivening the page, this is a consequence of the designer's analysis of the copy and the brief, rather than an outcome in itself.

Below A wide variety of weights and sizes has been used in this spread from *Fitréttir*, a newsletter for the Icelandic Association of Graphic Designers, by Einar Gylfason.

particularly well if there is a similarity in the underlying proportions of the letterforms. For this reason, Humanist Sans typefaces combine particularly happily with Romanesque serif letters, because they share a common model of proportion, both being modeled upon the classic Roman capital.

By comparison, Geometric and Neo-Grotesque faces are less suitable for combining with faces from other categories, because their forms and proportions reflect specific phases in the development of type. The historical and stylistic associations of such typefaces may render them unsuitable for combining with others.

PAGE LAYOUT

The design of the page involves both the composition of the columns and margins that form the page grid, and decisions governing the size, weight, and leading of text, subheads, and titling. Page design is likely to involve both practical considerations, such as the amount of text on the page, its legibility and ease of use, and aesthetic or expressive factors, such as impact, differentiation, and visual appeal.

The choice of typeface and the structure of the page are closely linked and interdependent decisions, each of which may influence or determine the other. For example, an initial decision to compose a page along asymmetrical principles, using short columns of flush, or ranged, type, will in turn suggest certain typefaces as appropriate to this strategy, and rule out others as being either historically or visually unsuitable. Conversely, the page design may be driven by the choice of a particular typeface that then suggests certain characteristics of layout. These will be determined by both the functionality of that typeface and its associations within typographic history.

Many 20th-century sans serif faces have strong associations with the prevailing design philosophies of their time. For example, 20th-century Neo-Grotesques of the Swiss school belong to a tradition of typographic minimalism in which variation and differentiation is achieved primarily through scale and composition rather than variations of typographic form.

Text setting
The appearance of a column of type is determined by several distinct but closely interrelated factors. As well as the choice of typeface and alignment already discussed, the size of the type, the width at which it is set, and its leading must all be considered in relation to one another.

Type size
Text for the printed page is generally set at between 9 and 12 points. Variation in the x-heights of text faces means that it may be feasible to set in smaller sizes when using typefaces of exceptionally generous x-height, while typefaces with unusually pronounced ascenders may need to be set larger to achieve the optimum legibility.

Line length/column width
The width of a column may be determined by the amount of space available within a predetermined page, but wherever possible attention should be given to achieving an appropriate number of words per line. Lines that are too short impair readability by constantly interrupting the text; lines that are too long make it difficult for the reader's eye to return to the margin and identify successive lines. A character count of around 60–66 characters is generally accepted as providing an optimum point between these extremes. In some cases, longer lines may be unavoidable, in which case the effect upon readability can be compensated by an increase in leading.

Leading
The amount of leading necessary for a balanced and legible column of type will depend upon the typeface, and, in particular, the body clearance and x-height. Typefaces with long ascenders and descenders will, as a rule, require less additional leading than those with a greater x-height.

Below The long ascenders of Bauer Bodoni (left) create a greater volume of white space between the lines of lowercase letters than the high x-height of Swiss 721 (right), a Helvetica derivative.

Typefaces with long ascenders and descenders will as a rule require less additional leading than typefaces with a generous x-height.

Typefaces with generous x-height will as a rule require more additional leading than typefaces with long ascenders and descenders.

Text-setting styles

Many documents require a number of text-setting styles for the differentiation of distinct types of information or, in some cases, simply for visual variety, such as between different features in a magazine. This may introduce variations in type color, column width, and the size, weight, or typeface. Distinct and consistent styles also need to be established for the setting of captions, footnotes, and any other content that is not included within the running text.

Introduction styles

The point at which a text begins on the opening page of a chapter or the introduction to a magazine feature may be signposted visually in a number of ways. It may be necessary to make clear to the reader that the text is not a continuation from a previous page, or to bridge the otherwise abrupt transition from a space that may involve images and display typography into the continuum of running text.

This transition may be achieved by the use of a drop-cap: an initial letter set at a larger size than that used in the main text, either positioned on the first line or recessed into the text by being set to align with the second, third, or fourth line, depending upon its size. This may in turn be followed by additional words of the first sentence set in small caps at a size corresponding to the text, before moving into the established text style for the book. Introductory paragraphs may be identified by being set in a larger size, a heavier weight, or even a different typeface from the subsequent text.

Right Four different approaches to signaling paragraphs: moderate and deep indents, hanging exdents, and ornamental paragraph marks.

Below The use of an initial drop capital signals the beginning of a chapter and provides a visual transition to the running text.

footprints on the sand | GARETH WATKINS

The SNAIL
and the GRAIN OF SALT

SINCE BEING BROUGHT TOGETHER mysteriously after a particularly heavy rainstorm, the snail and the granule of salt had become friends. The granule had ridden on the snail's back for some time now and they had become accustomed to each other's company. It was the month of April, rainstorms were frequent, and the poor granule, being a soluble salt, dwindled in size after every shower. "Please remove your shell for the moment so that I can get inside and shelter from the rain" called the grains to the snail, now fearful for their safety. Being an easygoing sort, the snail obliged and the grateful grains nestled down in the snail's soft skin. No sooner had he done so than the snail withered away and died.

The designer has a number of typographic options for indicating the beginnings and ends of paragraphs. This is both an aid to readability and a means to introducing some visual variation into large sections of continuous text.

The first line of a new paragraph may be indented—that is, set in from the margin by a fixed measure.

The designer has a number of typographic options for indicating the beginnings and ends of paragraphs. This is both an aid to readability and a means to introducing some visual variation into large sections of continuous text. Very occasionally, there are instances where the opening of the paragraph is set outside the column margin.

The designer has a number of typographic options for indicating the beginnings and ends of paragraphs. This is both an aid to readability and a means to introducing some visual variation into large sections of continuous text.

The first line of a new paragraph may be indented—that is, set in from the margin by a fixed measure.

❂ The designer has a number of typographic options for indicating the beginnings and ends of paragraphs. This is both an aid to readability and a means to introducing some visual variation into large sections of continuous text. ❂ Paragraphs may be indicated by graphic devices, removing the need to begin a paragraph on a new line.

Paragraph and indent styles

The designer has a number of typographic options for indicating the beginnings and ends of paragraphs. This is both an aid to readability and a means to introducing some visual variation into large sections of continuous text.

The first line of a new paragraph may be indented—that is, set in from the margin by a fixed measure. While traditional convention sets the optimum indent as one em (giving an indent equivalent to the point size of the type), there are many instances where a deeper indent may be appropriate, particularly if the column itself has an unusually long measure and word count. There are few instances where one would wish to indent by less than an em, since a poorly defined indent can appear as an error or inconsistency rather than a deliberate aspect of the design.

Very occasionally, there are instances where the opening of the paragraph is set outside the column margin. Sometimes rather clumsily termed an outdent, exdent, or hanging indent, this device is effective for highlighting paragraph openings within smaller documents, but creates an exaggerated differentiation between paragraphs and would seldom be used throughout a book.

The end of paragraphs may, in some cases, be indicated by additional line spacing. This is more common within smaller printed documents than in books, where considerations of page

economy and the effect on readability are likely to make this approach inappropriate. If an additional space is to be inserted, the space should be related to the leading of the text, as a line space or half-line space.

Paragraphs may be indicated by other graphic devices, removing the need to begin a paragraph on a new line. The book designs of William Morris for the Kelmscott Press draw upon medieval examples in using a fleuron for paragraphing, giving an unbroken right margin to the justified page.

Subheads

Many documents involve the use of subheads—secondary titles that may occur within the column of running text. The weight given to these headings depends both upon editorial and aesthetic considerations.

Subheads

Many documents involve the use of subheads—secondary titles that may occur within the column of running text. The weight given to these headings depends both upon editorial and aesthetic considerations.

SUBHEADS

Many documents involve the use of subheads—secondary titles that may occur within the column of running text. The weight given to these headings depends both upon editorial and aesthetic considerations.

Subheads

Many documents involve the use of subheads—secondary titles that may occur within the column of running text. The weight given to these headings depends both upon editorial and aesthetic considerations.

Subheads

Many documents involve the use of subheads—secondary titles that may occur within the column of running text. The weight given to these headings depends both upon editorial and aesthetic considerations.

Above, from top left The subheads in the first three examples are the same point size as the main text. The first uses a bold version of the same font (Futura), the second a serif bold font of similar x-height (Walbaum), and the third the same roman font as the main text but all caps. The final two examples use Futura bold and Walbaum bold italic, but at a larger size than the main text and with leading adjusted.

Subheads

Many documents involve the use of subheads—secondary titles that may occur within the column of running text. The weight given to these headings depends both upon editorial and aesthetic considerations. The content of the text itself and the preferences of the author or editor may indicate how much emphasis is appropriate, while the designer's own visual judgment will determine how far the subhead visually interrupts the continuity of the column. It may be that the subhead can be indicated without any change to type size or leading, by using a heavier weight or capital form of the typeface used in the text, or another typeface of equivalent size.

However, a subhead may involve the use of one or more different sizes of type, necessitating increased space both before and after the subhead. Care must be taken over the size and leading of subheads, to ensure that the total depth around the subhead relates to the leading of the running text, typically occupying a depth equal to one, two, or three lines of text. This ensures that the text following the subhead continues to align with text on adjacent columns.

In some instances, a page involves two different sizes of text. A consistent visual relationship can be maintained by basing the leading of larger type upon common multiples of the text leading.
10/12pt

A consistent relationship can be maintained by basing the leading of larger type upon common multiples of the text leading.
11/15pt

A consistent relationship can be maintained by basing the leading of larger type upon common multiples of the text leading.
12/18pt

Care should be taken to ensure that the lines of type on adjacent pages or columns align properly to one another. Where both columns are uninterrupted by subheads or the intrusion of any other form of additional space, this should occur automatically. The consistent leading of all the text will ensure that, as long as the top lines are correctly aligned, all subsequent lines will also align and each column will end at the same baseline across the double-page spread. If, however, any additional space is to be introduced between lines, this space should be designed so that the position of the following line of text returns to alignment with the lines on the adjacent column. The total leading of the subhead should therefore always be a multiple of the leading of the text.

In some instances, a page involves two different sizes of text; introductions or standfirsts may typically be several points larger than the main running text. In such cases, it may not be possible to maintain the same leading as the text. A consistent visual relationship, however, can still be maintained by basing the leading of the larger type upon common multiples of the text leading. If the text is set on 12pt leading, a larger introductory text may be set upon a leading of 18pt, allowing alignment of every fourth line of text (three lines to four), or 15pt, allowing alignment of every fifth line (four lines to five).

Even in layouts where the strict alignment of text may not be a consideration, recurrent mathematical relationships of this kind serve to reinforce the underlying coherence of the design and the sense that each of the elements belongs to a common scheme.

Although there are variations, the majority of books are structured according to the following conventions.

The prelims

Within the traditionally structured book, there are a number of preliminary pages that precede the main text:

Half-title

This is an initial title page that faces the endpapers (the inside of the front cover). It customarily gives the book title only.

Frontispiece/title page

The full-title page, including title, subtitles, author, and publisher, may fall on the right (recto) page, facing a frontispiece illustration on the left (verso). It may, alternatively, run across the whole double-page spread.

Imprint or biblio page

The verso page following the title normally contains the publishing details of the book: publisher, printer, edition, typeface/foundry, copyright dates, and so on. Alternatively, this information may appear on the verso page preceding the frontispiece or on the last page of the book.

Dedication

If the book is to have a dedication, it customarily falls on the recto, facing the biblio page.

Contents

This customarily falls on the next recto page, though in some circumstances there may be reason to run it across the whole spread.

List of illustrations, acknowledgments, preface, introduction

The book may require any or all of these, which commonly fall in the order shown above, although the first two items frequently also appear at the end of the book.

Part-titles

Where a book divides into several parts, with chapters within them, each part may be preceded by a part-title page. This is a form of page divider between the parts and commonly occurs on the recto page. The preceding verso page may also be incorporated into the design of the part-title.

Chapter titles

If the parts of the book are subdivided into chapters, the chapter title may occur on the same page as the opening text of the chapter or on the previous page. It may be designed as a single- or double-page spread, referred to as a chapter opener.

Footnotes, appendices, index

These are usually listed at the end of the book. Footnotes may also appear at the base of the page to which they refer.

Left Half-title page, featuring the title of the book.

Left Title spread, featuring the title, subtitle, author, and publisher.

Left Imprint and contents spread.

Left Chapter opener spread, featuring the chapter number and title with some introductory text.

Left Index.

The grid

The positioning of the columns of text upon the page spread is determined by the grid—a way of describing a fixed relationship of measurements applied throughout the document. The simplest page grid comprises the four lines used to define the left and right margins, the top line, and the baseline of the text area of each page. This is then repeated on the facing page, allowing for the design of the page spread as a whole. The grid also determines and defines the positioning of page numbers, running heads, and any other elements outside the text area that are to recur throughout the document (titling, section headings, and so on).

Magazines, newspapers, and large-format books use grids of far greater complexity, designed to allow flexibility and variation of page layout while maintaining an underlying consistency of structure. Within a multiple-column grid, the type may be set across two or more columns, giving the designer a range of column-width options. A six-column grid, for example, allows for a wide range of permutations: two columns of three-columns width; three columns of two-columns width; one column of four, and one of two. This flexibility of structure also allows for variation in the scale and positioning of illustrations and photographs, which may be set across any width from a single column to the entire text area, while still conforming to the grid structure.

Fielded grids

Some grids involve the horizontal division of the text area, creating a grid of smaller rectangular "fields" of consistent proportion. While this may be useful or aesthetically satisfying in some cases, it is not necessary in itself as long as the grid clearly establishes all the recurring horizontal elements within the design.

Asymmetrical grids

Some pages may use a grid based around two differing widths of column. This asymmetry may then either be reflected, keeping the narrower column at the outside or in the gutter of the spread, or duplicated, placing the narrower column at the same side of both recto and verso pages.

Above The basis of the grid: four lines that define the position of the text area upon the page.

Above A double-page grid, showing the text area and the "gutter" where pages join at the spine of the book.

Above A six-column grid divided into two columns.

Above A six-column grid divided into three columns.

Right A six-column grid using regular horizontal intervals to create fields.

Far right An asymmetrical grid using one wide and one narrow column.

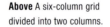

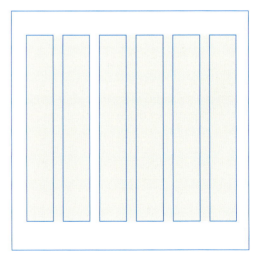

Restless giants

>>> The legacy of the Toba super-eruption is a spectacular lake-filled caldera over 62 miles (100km) long, which is almost matched in size—at 50 miles (80km)—by the largest of the three, giant Yellowstone calderas.

ABOVE Toba ash has been discovered in deep sea cores across southeast Asia.

ABOVE The island and much of the Toba lake margin has been uplifted by up to 1,300 feet (400m) indicating that fresh magma is still pushing up from below.
LEFT The 60-mile (100-km) long Toba caldera is now filled with a lake and has become a well-known tourist resort.

> Other great volcanic blasts have also excavated calderas at Long Valley in California, Campi Flegrei in the Italian Bay of Naples, Rabaul in Papua New Guinea, and Taupo in New Zealand.

Although each of these volcanoes has destroyed itself in a past eruption, it would be wrong and dangerous to conclude that they are now extinct. Far from it, all of these calderas are described by volcanologists as restless and merit careful watching. At each of them magma stirs not far beneath the surface generating ground tremors and causing the ground to rise and fall almost as if a sleeping giant snored serenely beneath waiting a wake-up call. At Campi Flegrei near Naples, the ground swelled over a huge area by almost seven feet (2m) during the 1970s and 1980s, causing consternation among the millions of people who live close by and desperately increasing fears of an imminent eruption. The situation has now returned to normal but, with the last eruption occurring just over 400 years ago, nobody can afford to relax. The residents of Naples are only too aware that similar restlessness at Rabaul caldera in Papua New Guinea during the 1980s was followed by a devastating eruption in 1994.

In the United States, there is increasing concern over signs of life at the huge Long Valley caldera in California. Numerous earthquakes, swelling of the ground surface, and the release of carbon dioxide gas since 1980 seem to point to new magma approaching the surface. Activity is focused beneath the famous Mammoth Mountain ski resort, and both scientists and locals are wondering what the future will hold.

Further north in Wyoming, the Yellowstone caldera is also far from dead. As at other restless calderas, the ground rises and subsides periodically while earthquakes—some large enough to damage property and take lives—regularly shake the region. Most significantly, hot magma not far beneath the surface makes itself known by heating up rainwater percolating into the ground, and sending it back again in the form of bubbling mud pots, steaming pools, and spectacular geysers.

Certain obliteration

If one of these restless giants awakens—as some day it surely must—what can we expect? In one word—obliteration! The last Yellowstone super-eruption, which occurred around 630,000 years ago, sent blistering pyroclastic flows across what is now Wyoming and neighboring states, sufficient to bury the entire country in a deposit three inches (8cm) deep. Ash poured down from the skies over more than half of the country, falling as far as El Paso in Texas, and Los Angeles in California. A similar blast today would paralyze the United States and bring the economy to its knees. The climatic impact of the eruption, together with the resulting economic effects, would plunge the entire planet into years of mayhem and anarchy that would see our sophisticated global society fighting to survive.

What volcanologists fear most, however, is a future eruption on the scale of the cataclysmic Toba blast. Ash from the last Toba eruption is found in deep sea sediments all over south and Southeast Asia and recent estimates suggest that the volume of material ejected might have been as much 212 million cubic feet (6000 cubic km)—six times greater than Yellowstone. Like its U.S. counterpart, the Toba caldera continues to swell and shiver, revealing that magma is still churning beneath the surface. Lake sediments deposited after the eruption have been thrust

RIGHT Super-eruptions in Yellowstone National Park have excavated three huge calderas over the past 2 million years.
BELOW Calderas form when magma is explosively evacuated from circular fractures and the central block susides into the resulting cavity.

Top A complex grid allows the designer to create considerable compositional variation and to introduce a range of image formats into the spread, while maintaining a consistent underlying structure.

Above The superimposed grid shows the underlying structure to which the page layout conforms.

Rules, frames, and borders may be used for purposes of differentiation and decoration. They are particularly effective where it is necessary to make clear the distinction between two different texts on the same page. Professional typographic programs offer a range of styles of rule, the width of which is specified in point sizes. Forms of rule include the traditional Oxford rule, composed of a thick and thin line, along with more elaborate variations.

Constructing the grid

While the term grid may suggest restriction, and grid-free design has at times been thought to allow greater scope for creative expression, the intelligent use of a well-designed grid can allow for wide and colorful variation of page content while retaining an underlying visual continuity. In this sense, the most effective grid is the one that renders its presence imperceptible.

Relationship of text area to page

Most digital programs encourage the designer to define the dimensions of the margins and columns at the outset. It is, however, advisable to explore this through experimentation first, either through layout drawings on paper or by moving the position of the text columns on screen. This enables the designer to determine the relationship of the text area to the page spread visually, rather than letting this occur as the result of a series of decisions on margin width.

The page of a bound document is unlikely to require equal margins to left and right of each page. The outer margin should allow comfortable space for the reader to hold the pages open without obscuring the text. The space required for the inner or gutter margin will, to some extent, be determined by the size and binding of the document, because extra provision may need to be made at the gutter for the curve of the page toward the spine of the book. After any such factors have been taken into consideration, the designer should consider the relationship between the outer margins and the total inner margin space between the text areas of the two pages. To give each page an equal left and right page margin would result in a central margin area twice the width of the outer margins—a disproportionate white space that isolates the two page layouts from one another, rather than creating a unified spread.

A harmonious relationship between the inner rectangles of type areas and the outer rectangle of the page spread may be established by the use of diagonals. Studies of historic manuscripts and early printed books reveal the long history of this method, and it remains an effective way of determining the position and proportions of the text area. Diagonal lines drawn from corner to corner of the page and of the spread are used to determine the points at which margins intersect with baseline and topline.

Intercolumn space

The space necessary between adjacent columns depends upon a number of factors: the length of the lines, the size of the type, and particularly, the amount of leading. It may be necessary to allow for vertical rules to be inserted between columns, either as a general pattern or to distinguish one feature or section from another.

Above A double-page spread requires greater space at the outer margins than the inner. When the effect of the gutter has been taken into consideration, the spread should show a space between the two text areas roughly equal to the outer margins.

Below The proportions of the type area and its relationship to the page margins may be established by the use of diagonal lines.

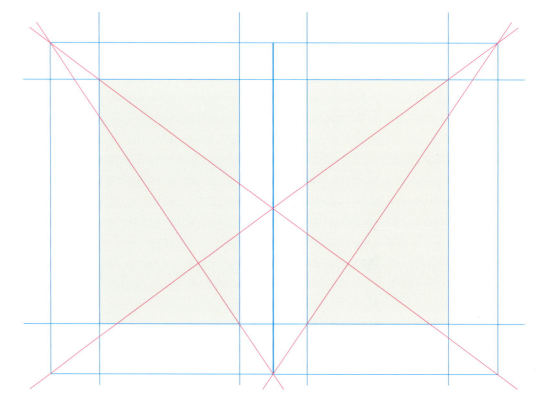

In addition to the main running text, most pages include the following recurrent elements.

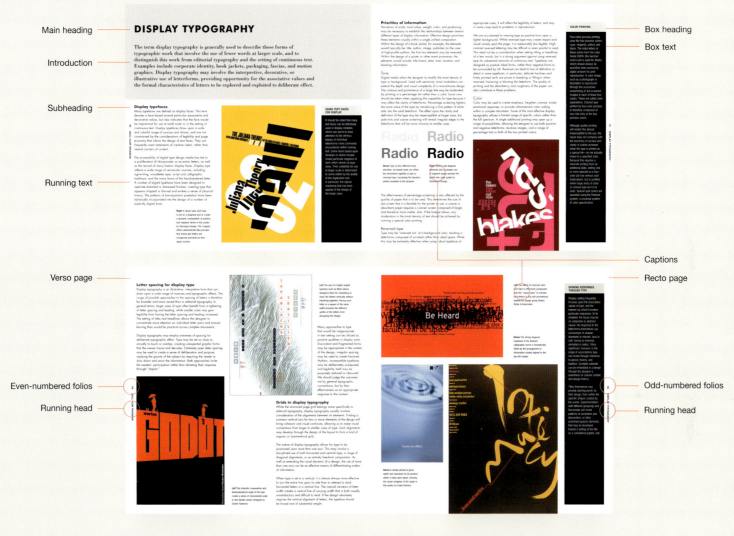

Main heading

Introduction

Subheading

Running text

Verso page

Even-numbered folios

Running head

Box heading

Box text

Captions

Recto page

Odd-numbered folios

Running head

Folios

Page numbers are referred to as folios. Odd numbers are traditionally the recto or right-hand page, and even numbers the verso or left-hand page. Folios may be aligned to the main text in a number of ways: at the top or the base of the page or partway up. They may range to the same column margin as the text, or be set outside the column, aligned to the baseline of the first or last line. Traditionally, the introductory pages of a book (prelims) were numbered in Roman numerals (i, ii, iii, iv, v, vi, and so on) so that the numerals 1, 2, 3 began with the first chapter of the book itself, although this convention has fallen out of use in many areas of publishing.

Running heads

Running heads are the small headings repeated on each page. They may be used in a number of ways, according to the nature and requirements of the book. Examples include:

Verso	Recto
Book title	Chapter title
Part-title	Part of book (as in introduction, notes)

Other elements

The page may also include images for which a consistent caption style must be established, and other items of text such as pull-quotes, footnotes, attributions, and box items.

DISPLAY TYPOGRAPHY

The term display typography is generally used to describe those forms of typographic work that involve the use of fewer words at larger scale, and to distinguish this work from editorial typography and the setting of continuous text. Examples include corporate identity, book jackets, packaging, fascias, and motion graphics. Display typography may involve the interpretive, decorative, or illustrative use of letterforms, providing opportunity for the associative values and the formal characteristics of letters to be explored and exploited to deliberate effect.

Display typefaces

Many typefaces are defined as display faces. This term denotes a face based around particular associative and decorative values, but also indicates that the face would be impractical for use at small scale or in the setting of continuous text. Display typefaces draw upon a wide and colorful range of sources and idioms, and are not constrained by the considerations of legibility and page economy that inform the design of text faces. They are frequently overt statements of creative intent, rather than neutral carriers of content.

The accessibility of digital type design media has led to a proliferation of idiosyncratic or eccentric letters, as well as the revival of many historic display faces. Display type reflects a wide range of vernacular sources, including signwriting, woodletter type, script and calligraphic traditions, and the many forms of the hand-rendered letter. A number of digital typefaces have been designed to replicate distorted or distressed finishes, creating type that appears chipped or blurred and evokes a sense of physical history. The patterns of low-resolution pixelation have been stylistically incorporated into the design of a number of explicitly digital fonts.

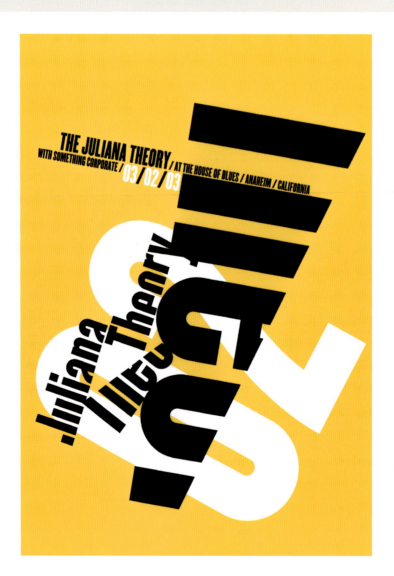

Right A robust sans serif type is set on a diagonal axis to create a dynamic composition of positive and negative forms in this poster by Sterotype Design. The cropped letters demonstrate the principle that lowercase letters are recognized primarily by their upper section.

THE JULIANA THEORY / WITH SOMETHING CORPORATE / AT THE HOUSE OF BLUES / ANAHEIM / CALIFORNIA / 03 / 02 / 03

USING TEXT FACES FOR DISPLAY

It should be noted that many text faces can be effectively used in display contexts, which can serve to draw attention to the intrinsic beauty of individual letterforms more commonly encountered within running text. Some faces based upon Venetian or Aldine models reveal particular elegance of form when viewed at large sizes. Their suitability for use at larger scale is determined to some extent by the quality of the digitization and, in particular, the optical mastering that has been applied in the design of the larger sizes.

Priorities of information

Variations of scale, tonal value, weight, color, and positioning may be necessary to establish the relationships between several different types of display information. Effective design prioritizes these elements visually within a single unified composition. Within the design of a book jacket, for example, the elements would typically be: title, author, image, publisher (in the case of high-profile authors, the first two elements may be reversed). Within the design of a poster or other event promotion, the elements would include: title/event, date, time, location, and booking information.

Tone

Digital media allow the designer to modify the tonal density of type or background. Used with sensitivity, tonal modulation can extend the depth and visual complexity of a monochrome design. The contrast and prominence of a large title may be moderated by printing in a percentage tint rather than a solid. Some care should be taken when applying this capability for type because it may affect the clarity of letterforms. Percentage screening lightens the tonal value of the type by introducing a fine pattern of white dots into the solid letterform. The effect upon the clarity and definition of the type may be imperceptible at larger sizes, but pale tints and coarse screening will reveal irregular edges to the letterforms that will be more intrusive at smaller sizes.

Radio **Radio**

Radio **Radio**

Above Type at four different tonal densities. Increased scale can offset the diminished legibility of pale or reversed type, increasing the dynamic palette available to the designer.

Right Vertical and diagonal elements and a complex use of negative space animate this subtle two-color poster by Stereotype Design.

The effectiveness of percentage screening is also affected by the quality of paper that is to be used. This determines the size of dot screen that it is feasible for the printer to use; a coarse or absorbent paper requires a coarser screen composed of larger, and therefore more visible, dots. If the budget allows, any moderation in the tonal density of text should be achieved by running a special color printing.

Reversed type

Type may be "reversed out" of a background color, resulting in letterforms composed of un-inked rather than inked space. While this may be extremely effective when using robust typefaces at

appropriate sizes, it will affect the legibility of letters, and may in some cases lead to problems in reproduction.

We are accustomed to viewing type as positive form upon a lighter background. While reversed type may create impact and visual variety upon the page, it is measurably less legible. High-contrast reversed lettering may be difficult or even painful to read. This need not be a consideration when setting titling or headlines of a few words, but is a strong argument against using reversed type for substantial amounts of continuous text. Typefaces are designed as positive inked forms, rather than negative forms to be surrounded by ink. Reversal can lead to loss of definition or detail in some typefaces; in particular, delicate hairlines and finely pointed serifs are prone to breaking or filling-in when reversed, fracturing or blunting the letterform. The quality of printing and the absorbency and roughness of the paper can also contribute to these problems.

Color

Color may be used to create emphasis, heighten contrast, evoke emotional responses, or provide informational color coding within a complex document. Some of the most effective display typography utilizes a limited range of specific colors rather than the full spectrum. A single additional printing may open up a range of possibilities, allowing the designer to use both positive and negative letterforms, duotone images, and a range of percentage tints in both of the two printed colors.

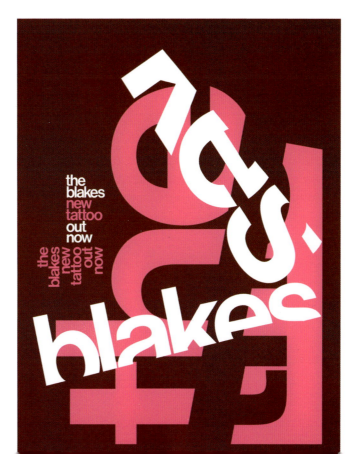

COLOR PRINTING

Four-color process printing uses the four process colors: cyan, magenta, yellow, and black. The initial letters of these colors form the color mode CMYK (the German word *kohl* is used for black), which should always be specified when producing digital artwork for print reproduction. A color image such as a photograph or illustration is reproduced through the successive overprinting of dot-screened images in each of these four colors. These are called color separations. Colored type printed by four-color process is therefore composed of very fine dots of the four process colors.

Although quality printing will render this almost imperceptible to the eye, the result does not compare with the evenness of surface and clarity of outline achieved when the type is printed as a special ink—an ink actually mixed to a specified color. Because this requires a separate printing from an additional plate, adding one or more specials to a four-color job has serious cost implications, but is justified where large areas of color or colored type are to be used. Special spot colors are specified using the Pantone system, a universal system of color specification.

Type and image

Digital media have given designers increased control over the introduction of type into an image space, to the extent that this has become an accepted norm within many design contexts. The ease with which type can be laid over or reversed out of a photographic image or illustration in turn raises a number of potential problems.

To place type upon any tonally varied background either impairs its legibility overall or creates variations of legibility and contrast, making some letters or words more prominent than others and, at worst, rendering some parts illegible. The widespread practice of attempting to correct this by the introduction of drop-shadow is at best a crude solution to problems that should have been avoided at their source. The loss of legibility associated with variations of background tone may in turn necessitate the use of larger or bolder type than would otherwise be necessary, sacrificing subtlety and flexibility in the design.

Some programs allow the designer to fill the type from an image source. Provided that the typeface is appropriately robust and has sufficient weight, this can be an extremely effective graphic device.

Right A range of basic digital effects applied to type. These digitally mimic the effects of different physical processes and phenomena.

Below Type is positioned at the center of the image, and composed of graduated tints from the same color range.

Bottom An image is used to fill the positive space of the type.

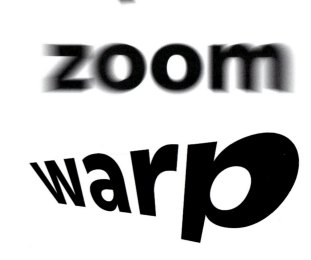

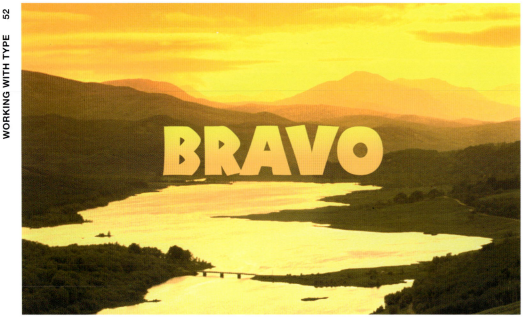

Effects

Digital programs offer a wide range of effects that can be applied to type. Many of these are essentially illusionistic, designed to replicate the effects of light. This may involve casting shadow as though the type were raised (drop-shadow), or creating the effect of three-dimensional embossed or recessed letterforms. Effects can replicate reflective surfaces such as chrome or glass, or luminous media, such as neon.

These effects are of varying use to the serious designer and should be used sparingly and with caution; a novelty effect may be as likely to distract the viewer from the message as it is to enhance it. Any effect should be integrated into the overall composition of the design. Illusions of three-dimensionality can be extremely effective in establishing a sense of depth, allowing the designer to organize multiple levels of information.

Designers have at their disposal a range of specialized processes and treatments that can enhance and enliven typographic products. Many of the following processes are not handled in-house by commercial printers but put out to more specialized finishers.

Spot UV varnishes

Varnishes and laminations may be used simply to protect the inked surface, to heighten the richness of color, or to provide a uniformity of gloss or matte texture. Varnish may, however, be more imaginatively used as a graphic medium in itself. Most varnishes are printed using essentially the same press technology as that used for color printing, and can be viewed as a special print run, much as one might view a special or spot color. The varnish may be printed onto the type alone or onto illustrations, or used as a visually independent level of artwork in which some elements are printed in varnish only. Varnishes are available in a wide range of finishes from high gloss to matte, and include colored and metallic variants.

Metallic inks

Wide ranges of metallic inks are available. While the quality of metallic print technology has improved considerably in recent years, it should be kept in mind that metallic inks normally have a fairly flat and granular finish.

Foil blocking

Reflective metallic finishes are best achieved through foil blocking—a relief printing process whereby a very fine layer of pressed metal is fused to the paper surface. Foil blocking can be carried out in a wide range of colored metallic finishes and matte colors, and is frequently combined with an embossing process.

Embossing

Type may be embossed in a number of different ways. Relief processes using both a positive and negative block can be used to create raised type; cushion embossing creates a gently curved relief surface over larger areas. Type can be impressed into a surface using relief-printing processes in combination with either metal foil or inks. Type may be embossed using no color at all—a process described as blind embossing. Relief-printing methods are particularly valuable when printing onto rough-textured materials, because the pressure of the press impresses the type, flattening the paper surface.

Above Silver foil blocking animates a gestural, calligraphic title on this book jacket.

Left Matte laminate, spot varnish, and embossing create a complex interplay of layers and textures on this publishing company's catalog.

Die cutting

Letterforms and other graphic shapes may be cut out of paper or cardboard. In the past, this required the use of complex metal dies; recently, laser technology has allowed for more complex and versatile use of cutout forms.

Screen printing

Designs involving pale opaque printings upon darker paper stocks require special printing processes, because commercial lithographic inks are relatively transparent. Letterpress foil blocking may be used, but, for short print runs, it can be more economical to use screen printing. Screen-printing inks range from extreme transparency to colors with enough body to print vivid, densely opaque colors onto darker backgrounds.

Letter spacing for display type

Display typography is an illustrative, interpretive form that can draw upon a wide range of nuances and typographic effects. The range of possible approaches to the spacing of letters is therefore far broader and more varied than in editorial typography. In general terms, larger sizes of type often benefit from a tightening of letter spacing and leading, while smaller sizes may gain legibility from having the letter spacing and leading increased. The setting of titles and headlines allows the designer to concentrate more attention on individual letter pairs and manual kerning than would be practical across complex documents.

Display typography may employ extremes of spacing for deliberate typographic effect. Type may be set so close as actually to touch or overlap, creating unexpected graphic forms that the viewer traces and decodes. Extremely open letter spacing may be used to create a sense of deliberation and purpose, implying the gravity of the subject by requiring the reader to slow down and savor the information. Both approaches invite the readers' participation rather than dictating their response through "impact."

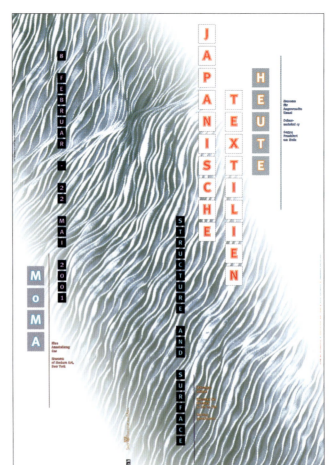

Left The use of a highly legible typeface such as Meta allows designers Büro für Gestaltung to stack the letters vertically without impairing legibility. Placing each letter in a square of the same width prevents the different widths of the letters from disrupting the design.

Many approaches to type that would be inappropriate in text setting can be utilized as positive qualities in display work. Discordant and fragmented forms may be appropriate in the context of the design; irregular spacing may be used to create fractured rhythms, incompatible typefaces may be deliberately juxtaposed, and legibility itself may be purposely reduced or obscured. We should judge the outcomes not by general typographic conventions, but by their effectiveness as an appropriate response to the content.

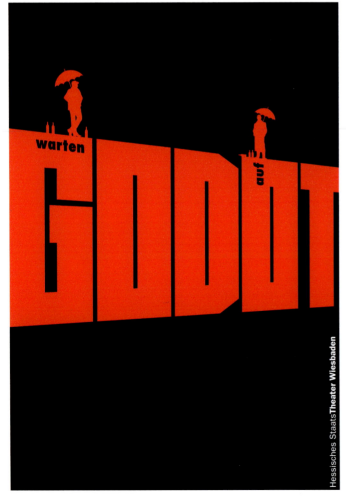

Left The dramatic composition and dimensionalized angle of the type create a sense of monumental scale in this theater poster designed by Günter Rambow.

Grids in display typography

While the structured page grid belongs more specifically to editorial typography, display typography usually involves consideration of the alignments between its elements. Finding a common vertical axis for two or more elements of the design will bring cohesion and visual continuity, allowing us to make visual connections from larger to smaller sizes of type. Such alignments may develop through the design of the layout to form a kind of organic or asymmetrical grid.

The nature of display typography allows for type to be positioned upon more than one axis. This may involve a disciplined use of both horizontal and vertical type, a range of diagonal alignments, or an entirely free-form composition. As well as extending the visual dynamic of a design, the use of more than one axis can be an effective means of differentiating orders of information.

When type is set to a vertical, it is almost always more effective to turn the entire line upon its side than to attempt to stack horizontal letters in a vertical line. The natural variation of letter width creates a vertical line of varying width that is both visually unsatisfactory and difficult to read. If the design absolutely requires the vertical alignment of letters, the typeface should be broad and of substantial weight.

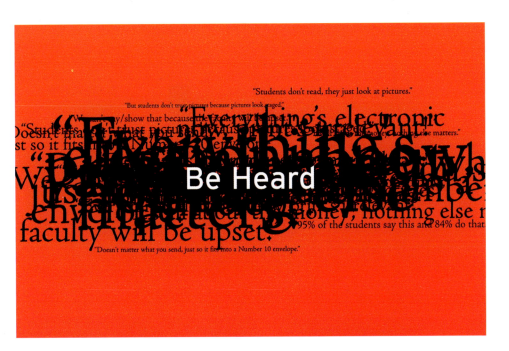

Be Heard

Left The clarity of reversed sans serif type is effectively juxtaposed with the "visual noise" of overlaid serif letters in this self-promotional booklet for design group Robert Rytter & Associates.

Below The strong diagonal emphasis of the abstract calligraphic forms is dramatically offset by the arrangement of information closely aligned to the top-left margin.

EVOKING RESPONSES THROUGH TYPE

Display setting frequently focuses upon the associative values of type, and the manner by which it evokes particular responses. At its simplest, the focus may be on subjective or abstract values: the response to the letterforms themselves (as curvaceous or angular, dominant or reticent, loud or soft, formal or informal, animated or static). More significant, however, is the range of associations type can evoke through reference to period, history, and tradition. Complex subtexts can be embedded in a design through the designer's awareness of cultural context and design history.

Titles themselves may provide starting points for their design, from within the specific shapes created by the words. Experimentation with different groupings and line-breaks will reveal patterns of ascenders and descenders, or other prominent graphic elements, that may be developed toward a setting of the title as a considered graphic unit.

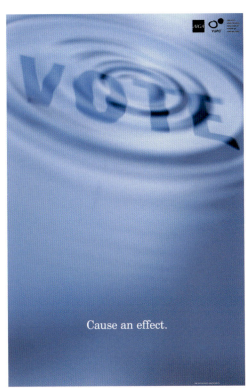

Cause an effect.

Above A simple phrase is given depth and resonance by its position within a large open space, echoing the visual metaphor of the ripple in this poster by Doyle Partners.

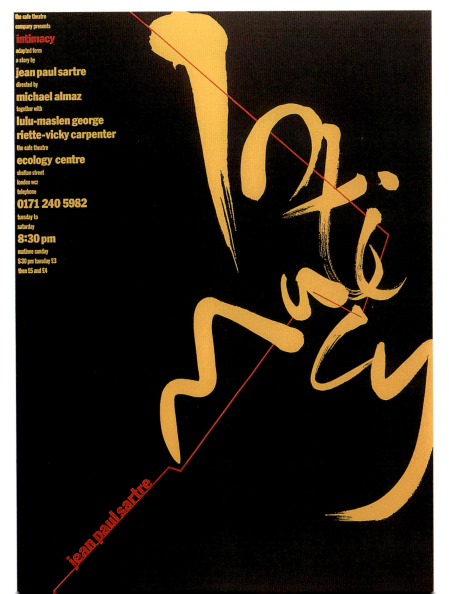

NEW MEDIA TYPOGRAPHY

Applications such as web design, interactive CD-ROM, and any other outcomes designed to be viewed on screen involve certain considerations that are particular to new media. This does not, however, place them outside the broad principles of typographic practice and information design. Issues of legibility, readability, and a logical navigational structure are equally crucial to the screen and the printed page.

The layout may create variations in the alignment between the letterform and the grid of pixels that make up the screen. The process of anti-aliasing is designed to compensate for this loss of clarity, smoothing the contours of the letterform by introducing intermediate tones to selected pixels.

CD-ROM, screen, and broadcast graphics may use any digital typeface, but their clarity upon the screen can vary widely. Certain typefaces have been specifically designed for screen use, and it is best to use these wherever possible, particularly when working at smaller sizes, in order to ensure optimum legibility.

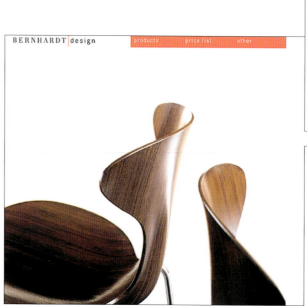

Above Digital effects such as embossing and drop-shadow can be incorporated into type when it is saved as a graphic. This transforms the type into an image that cannot then be edited.

Web design

The design of text for the web raises particular problems for the typographer, and offers less control over the appearance of the final outcome than any other area of graphic reproduction. It remains the case that the text in a web page will appear in the fonts available on the end user's machine, rather than necessarily remaining consistent to the face in which it was designed. This presents the designer with a range of options. The simplest is to use the most widely available fonts for all running text, or to use a preferred font in which the body sizes and proportions correspond reasonably closely to a commonly used default. While it should be possible to embed fonts within the web page,

Above & right Intelligent use of negative space focuses the viewer's attention upon key navigation categories, making the use of the site clear and unambiguous (www.bernhardtdesign. com by Piscatello Design Center).

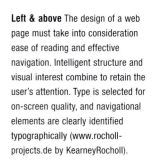

I01I02I03I NEWS

WIE KAMEN SIE ZUM DESIGN?
Ich hatte mit 20 eine Ausgabe der italieni-
schen Vogue in der Hand, doppelt so dick
wie die deutsche Ausgabe und voller inte-
ressanter Bilder. Das hat einen verborge-
nen Code in mir aktiviert und mir war
sofort klar, ich wollte auch so etwas
machen: Images kreieren.

INTRO | 01 | 02 | 03 | 04 | 05

SITEMAP | SOUND OFF

Left & above The design of a web
page must take into consideration
ease of reading and effective
navigation. Intelligent structure and
visual interest combine to retain the
user's attention. Type is selected for
on-screen quality, and navigational
elements are clearly identified
typographically (www.rocholl-
projects.de by KearneyRocholl).

this will have an adverse effect upon download times, and also
contravenes copyright. As with other screen-based applications,
particular care should be taken at small sizes to ensure that the
alignment of the letters with the pixel screen does not compromise
or obscure their form. Wherever possible, the designer should use
a typeface specifically designed for screen use.

In the design of display graphics for web, the designer can
ensure that typographic material retains its intended form by
saving headings, titles, and so on as graphics. This allows them
to open without significant delay, but they will not be editable.
Web type will be viewed upon monitors of varying size and
quality, and should always be designed to function effectively at
the lowest resolution at which it is likely to be seen. While this
may seem to present an unacceptable set of limitations on the
designer, and to diminish control over the quality of the final
outcome, the best strategy will incorporate these constraints into
the overall design rather than working in spite of them.

Below Color-coded pages identify different aspects of a photographer's
portfolio, designed on a simple but effective three-column grid
(www.dixonphotography.com by Paone Design Associates).

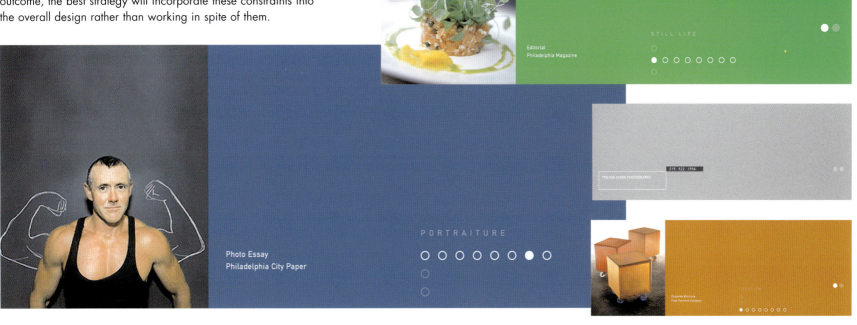

ENVIRONMENTAL TYPOGRAPHY

The design of lettering for the built environment has historically drawn upon different traditions, skills, and media than the design of type for print. Though these histories frequently overlapped or informed one another, the application of lettering to traditional building materials was seen as part of the craft of the stonemason or the signwriter, much as the layout of type was, until relatively recently, seen as the craft of the printer. Digital technology has to some extent brought about convergence of these areas of practice.

Architectural typography

Architectural typography needs to function effectively at scale, to be readable from a range of angles and distances. It must communicate to the moving viewpoint of the pedestrian or motorist, harmonize with the materials and proportions of the building, and reflect the values of both the architect and the institution or organization it houses. Faces designed for print may appear both ill-proportioned and visually crude if they are simply enlarged to the scale necessary for a building or monument. The designer needs to consider the action of light, and the manner in which the letters interact with the building materials. This may include the possibility of three-dimensionality: type that is raised, incised, or recessed. The conditions may require illuminated signage, presenting a wide range of options for type to be lit from within, behind, above, or below.

Opposite left, above & below Three-dimensional relief lettering used in a public art project based upon oral histories, designed by Bettina Furnee.

Left Sans serif type set on a raised circular frame uses the effect of light to provide dimensional depth and integrate the type within the architecture.

Below Lettering by Richard Kindersley carved directly into a brick fascia reflects the particular sensitivity involved in the design of letterforms for architectural scale.

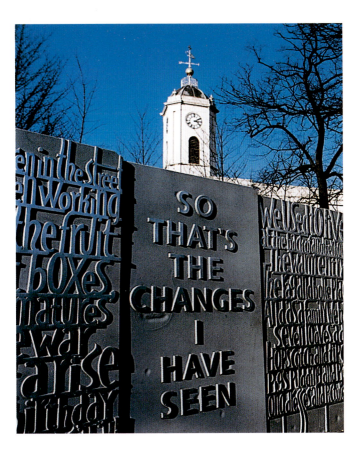

Informational signage

In the context of informational signage, legibility may be not only a matter of design aesthetics but also of life and death. It is therefore in this area that some of the most sustained and objective studies of legibility have taken place. Information on highways, hospitals, and airports may be crucial to safety, and the legibility of the type is therefore paramount.

In particular, the differentiation of letters within the typeface must be explicit, ensuring that no letter or numeral can be confused with any other. The legibility of letters for use in these contexts depends, in particular, upon well-defined counters and junctions.

Words that may be viewed from an angle or while in motion require greater space between characters than words designed to be viewed at a fixed reading distance. Sufficient space must be allowed between the words and any additional graphic forms, such as directional arrows, symbols, or schematic mapping.

Below center A contemporary sans serif type, Parisine, was designed by Jean-François Porchez specifically for the French RATP transit system. It improves significantly upon the Helvetica type previously used in their informational signage.

Below & bottom right Poulin + Morris's environmental graphic and wayfinding sign program for the newly renovated interior space at the New York Public Library for the Performing Arts at the Lincoln Center, consisting of public reading rooms, galleries, auditorium, and preservation lab.

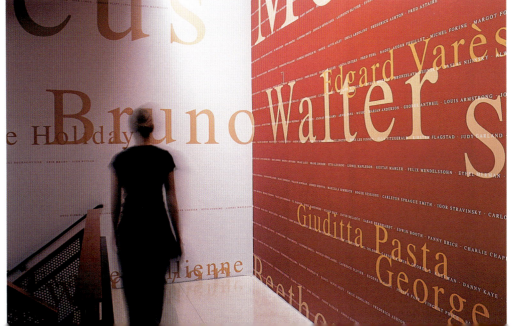

three

3

Almost all typefaces belong to a recognized tradition, and in order to make informed decisions about their use, we need to locate them within their wider historical context. The classification of typefaces is, however, a complex subject and continues to be a matter of debate among typographers and type historians.

Although widely recognized terms are used to describe the main categories of type, no entirely comprehensive classificatory system has yet been devised. The classification that has attracted the broadest consensus, despite its inevitable imprecisions, is the Vox system, devised in 1954. The following directory of typefaces is based primarily on that system, introducing additional subgenres where appropriate, and extending the 9 main Vox categories to a total of 14.

TYPEFACE CATEGORIES

Some typographic historians devise personal modes of categorization that seek to give new insights into typefaces and their uses. Others assemble classifications from elements of existing systems, retaining some categories and revising others. Traditional terminology often proves imprecise, or unequal to the complexities of present-day type design.

In many instances, the names of specific typefaces or their designers have come to be used as generic terms for typefaces sharing broadly similar characteristics. Bodoni has been used as a term to encompass Didone forms (which are also known as Modern forms), Clarendon to describe bracketed slab serifs. Sans serifs have at various times been generically described as Gothics in the US and Grotesques in the UK. Gothic is, however, also used as a descriptive term for Blackletter. The word Humanist has two distinct meanings: as a category of serif typefaces based on the Venetian model, and as a term for describing classically proportioned sans serifs.

Historical classification
A typographic genre can be identified by the historical period when the type originated, but this is less workable than it sounds. The history of type is characterized by revivals and reinterpretations. Changes in print technology, design theory, and prevailing fashion over the last hundred years continually prompted the design of "new" typefaces inspired by historic examples. Some of these are faithful reconstructions of historic forms; others reflect the general characteristics of a particular tradition while applying them to a new typographic vision. In addition, major changes in the technology of typesetting and printing necessitated the modification of established type styles.

Characteristics and uses
Typefaces can alternatively be grouped according to formal characteristics: their overall shape, the form or absence of serifs, the proportion of the letters, or other visual features. Categories may be defined by the tools used to design the letters—the pen, the chisel, the ruler and compasses, or the pixels and the mouse—which are, in turn, reflected in the letterforms themselves.

Some groups are defined by their uses—notably in the application of the term display type. This classification is flawed, however, in that many typeface families include a display variant, and many faces function equally well across both text and display applications. Some typographic historians link typeface design with broader cultural history, through classifications such as Baroque or Romantic. These have the scholarly virtue of relating developments in type design to concurrent developments in art, architecture, and the history of ideas. Any of these approaches to classification may be appropriate to particular circumstances, and may help us better understand a typeface and its fitness for an intended purpose.

The Vox system
It is, however, equally important that any classificatory system should be widely recognized and thus form a basis for shared

1 Typeface leaflet This leaflet produced by the Monotype corporation in the mid-20th century is designed to assist in the identification of types by category. Its promotional function is indicated by the reference on the cover to several Monotype faces and "other faces of outstanding merit."

The directory is divided into 14 categories. Each category starts with an exploration of the historical origins and stylistic features of the category, followed by an in-depth analysis of key typefaces within it, plus a brief look at a representative selection of other typefaces in the category.

Category overview

1 Category name.

2 Brief introduction.

3 Analysis of the historical origins and stylistic features of the category.

4 Characteristic features of the typefaces within it.

5 Professional examples of the typefaces in use.

6 Captions.

In-depth typeface analysis

7 Typeface name.

8 Designer and date of origination.

9 Discussion of the typeface's attributes and applications.

10 Selected alphabets from the typeface. Unless indicated otherwise, the alphabets are 17pt and the text sample 7/9pt.

11 Fonts within the typeface shown in context with each other. Unless indicated otherwise, the text is 9/13pt.

12 Key features of the typeface.

Typeface selection

13 Typeface name.

14 Alphabet and sample text setting. All the alphabets are shown at 22pt; the text setting is 9/12pt, unless indicated otherwise.

15 Designer, date of origin, and brief description of typeface.

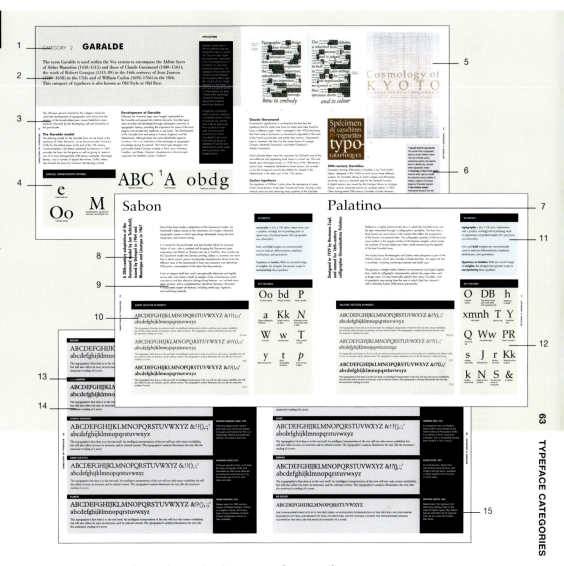

understanding among professionals. The closest to a broad consensus on type classification is the Vox system, devised by Maximillien Vox in 1954 and adopted by the Association Typographique Internationale (ATypI). It comprises nine main categories, incorporating some traditionally established terms and inventing some new categories. These encompass both the historical criteria that determine categories such as Humanist or Transitional, and those formal criteria that give us categories such as Slab Serif or Lineale.

The first four Vox categories are historically defined, mapping the development of type forms from the Venetian Humanist letter through the Garalde and Transitional forms to the Didones. Subsequent categories are based upon characteristics of appearance: slab serif and sans serif types (termed Slab Serif and Lineale respectively), with some recognition of subgenres within these categories. Finally, the terms Glyphic, Script, and Graphic are used to categorize a range of faces outside the typographic mainstream, according to the processes and tools that inform their design.

Adapting the Vox system

Like any attempt at all-inclusive classification, the Vox system is frequently imprecise. The invention of the term Garalde to encompass typefaces such as Aldine and Garamond, while more specific than the ambiguous term Old Style, has no basis in usage or typographic tradition. The description of sans serif as Lineale carries the misleading suggestion that sans serif faces are necessarily monoline. Each of these categories encompasses many significant faces that might usefully be divided into subgenres, while categories such as Slab Serif define a far smaller area of typeface design and type history.

The organization of typefaces in this chapter is based on the Vox classification system, with the addition of some subgenres to create 14 categories. The complex history of Blackletter type deserves a dedicated category, and sans serifs contain at least three identifiable subgenres. Decorated and display types are addressed as a defined category, and I adopted from Lewis Blackwell the pragmatic term Beyond Classification to encompass not only the more eccentric products of digital type design, but also those typefaces that combine key characteristics of several genres.

HUMANIST

Humanist types, dating from the 1470s, represent the first major stylistic development in type design, and the emergence of print-based typographic forms distinct from handwritten letters.

Whereas Gutenberg's type was designed primarily to replicate the formal Textura Blackletter of manuscripts, Humanist types drew upon the Romanesque book hand of their time, giving a greater openness of form. Humanist typefaces were characterized by a calligraphic quality, the inclined stresses and inflection of the strokes echoing the forms created by a broad-nibbed pen.

Jenson and Venetians

The most influential exponent of the Humanist typeface was the French printer Nicholas Jenson, who worked in Venice in the 1470s. Venetian and Jenson were used as generic terms to describe revivals of Humanist type in the late 19th and early 20th centuries. The Humanist idiom informed the design of William Morris's Golden Type, Morris Fuller Benton's Cloister Old Style, Frederic Goudy's Kennerley, and Bruce Rogers' Centaur.

Modern interpretations

Although they mark a significant development in typographic form, Humanist types represent a short period of type history (1470s–90s); they did not inspire an ongoing tradition or any real stylistic continuity, and their revival took place after some 500 years of relative neglect. As a consequence, many late 19th- and early 20th-century revivals were at best imaginative reconstructions, at worst rather questionable interpretations of an idealized antique form. Some Venetian revivals, such as Morris Fuller Benton's Cloister Old Style, appear to mimic the ink-spread and print quality of the originals, in the bluntness of their serifs and the lack of contrast in their stroke widths. Morris based his Golden Type upon tracings of printed examples rather than the first-hand evidence of type or matrices, thus incorporating the degeneration of print quality into a new generation of punches.

APPLICATIONS

Humanist typefaces have considerable character but limited practical use. They are served better by the physical imprint of letterpress than the flat inking of lithographic printing. Some types can perform well under conditions of low resolution, and there are advantages in using a typeface specifically designed in digital form such as Robert Slimbach's Adobe Jenson, over the digitized forms of metal types such as Cloister or Centaur.

Humanist types are characterized by deep descenders, high ascenders, and consequently low x-height, and generally require little additional leading. The relatively small size on the body, irregularity of outline, and small counters mean that they are not particularly legible at smaller sizes. They can be highly evocative in fine book work, display type, and for small bodies of running text within contexts associated with their historical period.

HUMANIST: CHARACTERISTIC FEATURES

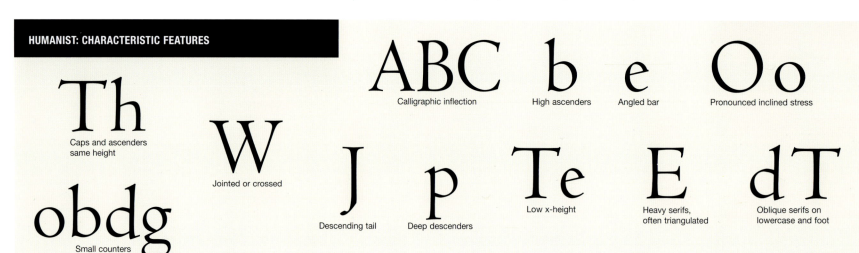

Th — Caps and ascenders same height

obdg — Small counters

W — Jointed or crossed

J — Descending tail

p — Deep descenders

ABC — Calligraphic inflection

b — High ascenders

e — Angled bar

Te — Low x-height

E — Heavy serifs, often triangulated

Oo — Pronounced inclined stress

dT — Oblique serifs on lowercase and foot

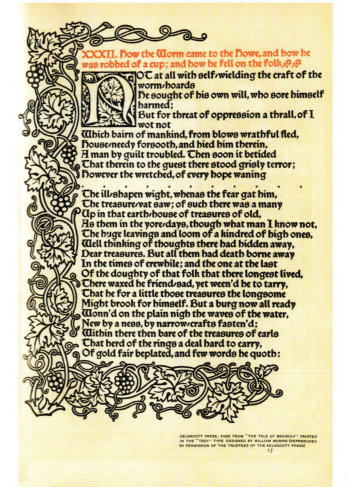

The enthusiasm with which Morris embraced the Venetian form was further developed in the work of T.J. Cobden-Sanderson and Emery Walker at the Doves Press in London in the early years of the 20th century. The adoption of the Humanist types by the private press movement, exemplified by the work of Morris and of the Doves Press, represents a conscious reaction against the aesthetically chaotic state of 19th-century printing, and the belief that earlier examples would provide a greater integrity of typographic form.

Italics

Renaissance types did not have italic equivalents in the modern sense of the term. While the Renaissance marks the emergence of classic italic typefaces, these were conceived as self-contained alphabets (usually with a roman uppercase). They were not paired with the upright, or roman, lowercase letters in the manner to which we have become accustomed. As a consequence, contemporary interpretations of Renaissance and Aldine types frequently combine roman and italic letters originating from separate but broadly contemporaneous sources. Renaissance italics were designed for setting as continuous text, and can be effectively used for this purpose.

1 *Mason & Dixon* book jacket
This book jacket design by Raquel Jamarillo utilizes the low x-height and robust forms of the Humanist letter. Blurring suggests the effects of ink-spread, exaggerating the irregularities in the type.

2 *Be Heard* promotional booklet
A promotional booklet for the design company Robert Rytter & Associates makes effective use of the distinctive forms of Humanist letters at display sizes.

3 Page from *The Tale of Beowolf*
Produced by William Morris's Kelmscott Press, this decorated page shows the rich contrasts and consistent texture of Morris's Golden Type.

Centaur

Designed by Bruce Rogers in 1912–14, based on Nicholas Jenson's roman Eusebius type of 1470

The capital forms of Centaur allude to the Roman inscriptional letter, whereas the lowercase draws upon the 15th-century book hand, based on the Carolingian minuscule. It was issued by Monotype in 1929. Centaur is paired with a companion italic face, Arrighi, originally drawn by Frederic Warde in 1923–25 and based upon a chancery hand of the calligrapher Ludovico degli Arrighi in 1524. The bold weights impose the 20th-century convention of a companion bold upon a Renaissance typeface.

The calligraphic inflections and relatively light weight of Centaur can appear unassertive when printed lithographically from digital sources. Its low x-height means that it is only moderately legible at smaller sizes. Centaur is therefore not an economical face for extended text setting, but it is an excellent luxury typeface for fine book work at a larger scale. Its calligraphic accenting and more unusual features can create graphic interest at display sizes, where the light weight of the roman will be less evident.

KEY FEATURES

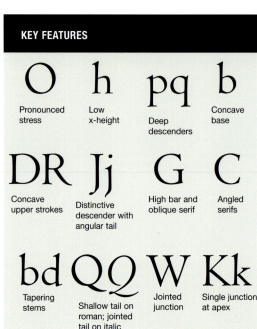

O — Pronounced stress

h — Low x-height

pq — Deep descenders

b — Concave base

DR — Concave upper strokes

Jj — Distinctive descender with angular tail

G — High bar and oblique serif

C — Angled serifs

bd — Tapering stems

QQ — Shallow tail on roman; jointed tail on italic

W — Jointed junction

Kk — Single junction at apex

R — Extended leg

r — Angular ear

hbl — Oblique serifs on ascenders

mn — Oblique serifs on stems

e — Angled bar

t — Oblique serif parallel to terminal

w — Serifed apex

f — Extended loop

a — Small bowl

CENTAUR: SELECTED ALPHABETS

ABCDEFGHIJKLMNOPQRSTUVWXYZ &!?();:;'
abcdefghijklmnopqrstuvwxyz

The typographer's first duty is to the text itself. An intelligent interpretation of the text will not only ensure readability, but will also reflect its tone, its structure, and its cultural context. The typographer's analysis illuminates the text, like the musician's reading of a score.

Regular

ABCDEFGHIJKLMNOPQRSTUVWXYZ &!?();:;'
abcdefghijklmnopqrstuvwxyz

The typographer's first duty is to the text itself. An intelligent interpretation of the text will not only ensure readability, but will also reflect its tone, its structure, and its cultural context. The typographer's analysis illuminates the text, like the musician's reading of a score.

Italic

ABCDEFGHIJKLMNOPQRSTUVWXYZ &!?();:;'
abcdefghijklmnopqrstuvwxyz

The typographer's first duty is to the text itself. An intelligent interpretation of the text will not only ensure readability, but will also reflect its tone, its structure, and its cultural context. The typographer's analysis illuminates the text, like the musician's reading of a score.

Bold

Kennerley

Designed by Frederic Goudy for publisher Mitchell Kennerley in 1911 and released by Lanston Monotype in 1920

Kennerley was the first of Goudy's typefaces to be commercially distributed. Though primarily a Humanist face, it incorporates some very personal and occasionally eccentric details. The sloping bar of the e is fundamentally Humanist; the high bars of the A and H, terminal serifs on the lowercase z and 7, and the bizarre skewed 5 owe more to Goudy's own sometimes fanciful interpretation of the genre.

The italic form was drawn seven years after the roman and is interesting in the relative restraint of its lowercase (in some senses closer to a Transitional italic), and an uppercase in which swash characteristics are introduced to selected letters: the Q, splayed Y, N, and Z show bravura qualities absent from the other italic caps, which are in the main a gently inclined version of the roman.

Kennerley is historically important as a model for the absorption of Humanist characteristics refracted through Goudy's personal sensibility. Though ostensibly a text face, it shares with most Humanist revivals a low x-height and a lightweight appearance when printed lithographically from digital sources, so its best application may be in display or semi-display contexts.

IN CONTEXT

TYPOGRAPHY n. 〖ML f. Gk typos, impression, cast + graphia, writing〗 Art of printing; style or appearance of printed matter (the typography was admirable).

Italic and BOLD weights are conventionally used to indicate differentiation, emphasis, attributions, and quotations.

TYPEFACES OR FAMILIES With an extended range of WEIGHTS, the designer has greater scope in MANIPULATING these qualities.

KEY FEATURES

Te	A	TC
Low x-height	Lightweight high bar	Opposing angled serifs
S	e	w
Oblique serif at base	Angled bar	Low stepped joint
K	k	hn
Single junction at apex	Slightly stepped junction at apex	Deep curves
vwa	z	5
Curved strokes	Double serifs	Sloping bar
QT	Y	S
Selective swash italics	Splayed	Drop and serif terminals in italic

KENNERLEY: SELECTED ALPHABETS

ABCDEFGHIJKLMNOPQRSTUVWXYZ &!?(),:;'
abcdefghijklmnopqrstuvwxyz

The typographer's first duty is to the text itself. An intelligent interpretation of the text will not only ensure readability, but will also reflect its tone, its structure, and its cultural context. The typographer's analysis illuminates the text, like the musician's reading of a score.

Normal

ABCDEFGHIJKLMNOPQRSTUVWXYZ &!?(),:;'
abcdefghijklmnopqrstuvwxyz

The typographer's first duty is to the text itself. An intelligent interpretation of the text will not only ensure readability, but will also reflect its tone, its structure, and its cultural context. The typographer's analysis illuminates the text, like the musician's reading of a score.

Italic

ABCDEFGHIJKLMNOPQRSTUVWXYZ &!?(),:;'
ABCDEFGHIJKLMNOPQRSTUVWXYZ

THE TYPOGRAPHER'S FIRST DUTY IS TO THE TEXT ITSELF. AN INTELLIGENT INTERPRETATION OF THE TEXT WILL NOT ONLY ENSURE READABILITY, BUT WILL ALSO REFLECT ITS TONE, ITS STRUCTURE, AND ITS CULTURAL CONTEXT. THE TYPOGRAPHER'S ANALYSIS ILLUMINATES THE TEXT, LIKE THE MUSICIAN'S READING OF A SCORE.

Small caps

Brioso Pro

Designed by Robert Slimbach for Adobe in 2001

Brioso Pro is a strongly calligraphic, contemporary interpretation of the Humanist form. Its design exemplifies the extended character range afforded by digital media, offering the user a comprehensive selection of options and variants. These include small caps, swashes, alternates, a full set of accented characters, and a set of ornaments. The typeface has four weights: light, medium, semi-bold, and bold; in addition to which it is available in four optical weights, for caption, regular, subhead, and display use. An additional display weight, Brioso Pro poster, is available for use at larger scale.

This range of options allows for practical use across a wide range of contexts. It is, as a consequence, far more versatile than most faces based upon the Humanist model, making its choice more a matter of aesthetic and historic appropriateness. The high contrast and calligraphic sharpness of the forms may limit their suitability for extended text setting, and it is best used in contexts where the historical and autographic qualities of the typeface enhance and complement the content of the text.

IN CONTEXT

typography *n.* [ML f. Gk *typos*, impression, cast + *graphia*, writing] Art of printing; style or appearance of printed matter (*the typography was admirable*).

Italic and **bold** weights are conventionally used to indicate differentiation, emphasis, attributions, and quotations.

Typefaces or families With an *extended* range of **weights**, the designer has greater scope in *manipulating* these qualities.

KEY FEATURES

g — High contrast

f — Calligraphic modulation

o — Strongly inclined stress

jh — Calligraphic finials

l — Calligraphic serifs and curved stems

h — Broad serifs

nm — Low junctions

b — Spur foot

Tz — Double serifs on horizontal strokes

pq — Full serif at foot

f — Full-serif base

eaf — Wide bar

Lez — Flexed stroke at base

ef — Angled full-serif bars

BRIOSO PRO: SELECTED ALPHABETS

ABCDEFGHIJKLMNOPQRSTUVWXYZ &!?(),.:;'
abcdefghijklmnopqrstuvwxyz

The typographer's first duty is to the text itself. An intelligent interpretation of the text will not only ensure readability, but will also reflect its tone, its structure, and its cultural context. The typographer's analysis illuminates the text, like the musician's reading of a score.

Regular

ABCDEFGHIJKLMNOPQRSTUVWXYZ &!?(),.:;'
abcdefghijklmnopqrstuvwxyz

The typographer's first duty is to the text itself. An intelligent interpretation of the text will not only ensure readability, but will also reflect its tone, its structure, and its cultural context. The typographer's analysis illuminates the text, like the musician's reading of a score.

Italic

ABCDEFGHIJKLMNOPQRSTUVWXYZ &!?(),.:;'
abcdefghijklmnopqrstuvwxyz

The typographer's first duty is to the text itself. An intelligent interpretation of the text will not only ensure readability, but will also reflect its tone, its structure, and its cultural context. The typographer's analysis illuminates the text, like the musician's reading of a score.

Bold

Adobe Jenson

A delicate angular face in four weights, Adobe Jenson reflects the influence of earlier interpretations of the form, notably Bruce Rogers' Centaur, which it closely resembles. It has the advantage, however, of being better adapted to current print technologies. The italic is based upon the same sources as Frederic Warde's Arrighi italic, and is broader and more contrasted than the italic used in Centaur.

Adobe Jenson was designed as a multiple master face to be scalable in both weight and optical sizing. Adobe Jenson Pro includes a full range of small caps, alternates, swashes, ligatures, and ornaments.

IN CONTEXT

typography *n.* [ML f. Gk *typos*, impression, cast + *graphia*, writing] Art of printing; style or appearance of printed matter (*the typography was admirable*).

Italic and **bold** weights are conventionally used to indicate differentiation, emphasis, attributions, and quotations.

Typefaces or families With an *extended* range of **weights**, the designer has greater scope in *manipulating* these qualities.

ADOBE JENSON: SELECTED ALPHABETS

ABCDEFGHIJKLMNOPQRSTUVWXYZ &!?(),.;'
abcdefghijklmnopqrstuvwxyz

The typographer's first duty is to the text itself. An intelligent interpretation of the text will not only ensure readability, but will also reflect its tone, its structure, and its cultural context. The typographer's analysis illuminates the text, like the musician's reading of a score.

Regular

ABCDEFGHIJKLMNOPQRSTUVWXYZ &!?(),.;'
abcdefghijklmnopqrstuvwxyz

The typographer's first duty is to the text itself. An intelligent interpretation of the text will not only ensure readability, but will also reflect its tone, its structure, and its cultural context. The typographer's analysis illuminates the text, like the musician's reading of a score.

Italic

ABCDEFGHIJKLMNOPQRSTUVWXYZ &!?(),.;'
abcdefghijklmnopqrstuvwxyz

The typographer's first duty is to the text itself. An intelligent interpretation of the text will not only ensure readability, but will also reflect its tone, its structure, and its cultural context. The typographer's analysis illuminates the text, like the musician's reading of a score.

Bold

KEY FEATURES

O — Inclined stress

h — High contrast

p — Calligraphic inflection

Te — Low x-height

a — Low bowl

hnp — Triangulated heads

at — Open-curved foot

A — Pointed apex

Q — Descending tail

Kk — Slightly jointed leg

e — Angled bar

Ww — Jointed junction and apex serif

ACZ — Swash capitals

T — Double serifs at bar ends

ct st — Archaic ligatures

HORLEY OLD STYLE

ABCDEFGHIJKLMNOPQRSTUVWXYZ &!?(),:;'
abcdefghijklmnopqrstuvwxyz

The typographer's first duty is to the text itself. An intelligent interpretation of the text will not only ensure readability, but will also reflect its tone, its structure, and its cultural context. The typographer's analysis illuminates the text, like the musician's reading of a score.

FRANK PIERPONT, 1925; ROBERT NORTON, 1977

The rounded form and well-defined counters make this a highly legible, open typeface with fewer calligraphic characteristics than many Humanist faces.

CLOISTER

ABCDEFGHIJKLMNOPQRSTUVWXYZ &!?(),:;'
abcdefghijklmnopqrstuvwxyz

The typographer's first duty is to the text itself. An intelligent interpretation of the text will not only ensure readability, but will also reflect its tone, its structure, and its cultural context. The typographer's analysis illuminates the text, like the musician's reading of a score.

MORRIS FULLER BENTON, 1913

A solid, broad Venetian with a very low x-height. Its low contrast and weight make it a substantial text face with a variation of stem width that retains much of the print quality of foundry type.

DEEPDENE

ABCDEFGHIJKLMNOPQRSTUVWXYZ &!?(),:;'
abcdefghijklmnopqrstuvwxyz

The typographer's first duty is to the text itself. An intelligent interpretation of the text will not only ensure readability, but will also reflect its tone, its structure, and its cultural context. The typographer's analysis illuminates the text, like the musician's reading of a score.

FREDERIC GOUDY, 1927

A noticeably perpendicular and geometric interpretation of the Venetian model. With sharply defined horizontal serifs and a low x-height, this is a lyrical and quietly distinctive book face.

ITC BERKELEY OLD STYLE

ABCDEFGHIJKLMNOPQRSTUVWXYZ &!?(),:;'
abcdefghijklmnopqrstuvwxyz

The typographer's first duty is to the text itself. An intelligent interpretation of the text will not only ensure readability, but will also reflect its tone, its structure, and its cultural context. The typographer's analysis illuminates the text, like the musician's reading of a score.

TONY STAN, 1983

A clear and functional typeface based upon Goudy's 1938 face, in which the Humanist characteristics are moderated by a number of 20th-century features and a generous x-height.

ITC GOLDEN TYPE

ABCDEFGHIJKLMNOPQRSTUVWXYZ &!?(),:;'
abcdefghijklmnopqrstuvwxyz

The typographer's first duty is to the text itself. An intelligent interpretation of the text will not only ensure readability, but will also reflect its tone, its structure, and its cultural context. The typographer's analysis illuminates the text, like the musician's reading of a score.

WILLIAM MORRIS, 1891

Based upon tracings from printed examples, Morris's type has, as a result, an exaggerated weight, slab-like serifs, and a crudeness of form offset by elegant broad proportions. It requires generous character spacing.

ERASMUS

ABCDEFGHIJKLMNOPQRSTUVWXYZ &!?(),.:;'
abcdefghijklmnopqrstuvwxyz

The typographer's first duty is to the text itself. An intelligent interpretation of the text will not only ensure readability, but will also reflect its tone, its structure, and its cultural context. The typographer's analysis illuminates the text, like the musician's reading of a score.

S.H. DE ROOS, 1923

A very colorful face, with high contrast, a pronounced calligraphic inflection, and very fine serifs. The high bars are more characteristic of American revivals than the original 15th-century sources.

HOLLANDSE MEDIEVAL

ABCDEFGHIJKLMNOPQRSTUVWXYZ &!?(),.:;'
abcdefghijklmnopqrstuvwxyz

The typographer's first duty is to the text itself. An intelligent interpretation of the text will not only ensure readability, but will also reflect its tone, its structure, and its cultural context. The typographer's analysis illuminates the text, like the musician's reading of a score.

S.H. DE ROOS, 1912

A heavy and somewhat romantic interpretation of the Humanist form, with some intrusive features in the oblique serifs of the p and q, and the undersized descender of the g.

ITC LEGACY SERIF

ABCDEFGHIJKLMNOPQRSTUVWXYZ &!?(),.:;'
abcdefghijklmnopqrstuvwxyz

The typographer's first duty is to the text itself. An intelligent interpretation of the text will not only ensure readability, but will also reflect its tone, its structure, and its cultural context. The typographer's analysis illuminates the text, like the musician's reading of a score.

RONALD ARNHOLM, 1992

An undemonstrative but sensitive redrawing of Jenson's type, with italics drawn from the later italics of Garamond. It is unusual in having a companion sans serif version.

HADRIANO

ÁBCDEFGHIJKLMNOPQRSTUVWXYZ &!?(),.:;'
abcdefghijklmnopqrstuvwxyz

The typographer's first duty is to the text itself. An intelligent interpretation of the text will not only ensure readability, but will also reflect its tone, its structure, and its cultural context. The typographer's analysis illuminates the text, like the musician's reading of a score.

FREDERIC GOUDY, 1918

A broad, angular, and colorful face, reflecting the force of personality that characterizes all of Goudy's faces. It requires generous letter spacing and can be an effective if limited text face.

TRAJANUS

ABCDEFGHIJKLMNOPQRSTUVWXYZ &!?(),.:;'
abcdefghijklmnopqrstuvwxyz

The typographer's first duty is to the text itself. An intelligent interpretation of the text will not only ensure readability, but will also reflect its tone, its structure, and its cultural context. The typographer's analysis illuminates the text, like the musician's reading of a score.

WARREN CHAPPELL, 1937

An angular face with a pronounced calligraphic quality, Trajanus evokes the roundhand upon which the Humanist types were based.

GARALDE

The term Garalde is used within the Vox system to encompass the Aldine faces of Aldus Manutius (1450–1515) and those of Claude Garamond (1480–1561); the work of Robert Granjon (1513–89) in the 16th century; of Jean Jannon (1580–1658) in the 17th; and of William Caslon (1692–1766) in the 18th. This category of typefaces is also known as Old Style or Old Face.

The 200-year period covered by this category marks the continued development of typographic form away from the mimicry of the broad-nibbed pen, toward letterforms more explicitly informed by the developing craft and sensibility of the punchcutter.

The Garalde model

The defining model for the Garalde form can be found in the typefaces of Aldus Manutius, cut by the punchcutter Francesco Griffo for the Aldine press at the end of the 15th century. Cardinal Bembo's *De Aetna*, published by Manutius in 1495, provides the basis for the genre as well as giving its name to one of its most distinguished 20th-century examples, Monotype Bembo, and a number of digital derivatives. Griffo's letters also formed the basis for Giovanni Mardersteig's Dante.

Development of Garalde

Whereas the Humanist types were largely superseded by the Garalde and passed into relative obscurity, Garalde types were revisited and developed through subsequent centuries of typographic history, providing the inspiration for some of the most elegant and durable text typefaces in use today. The development of the Garalde form took place in France, England, and the Netherlands. Although there are some identifiable regional variations, this is an indication of the exchange of typographic knowledge during this period. The French type designer and punchcutter Robert Granjon worked in Paris, Lyon, Antwerp, Frankfurt, and Rome. Granjon's Ascendonica is the principal inspiration for Matthew Carter's Galliard.

APPLICATIONS

Garaldes include some of the most attractive and well-designed text faces in current use. They are highly legible but visually lively, particularly in the crisp angular forms of the Aldines. As with most historically based faces, the adaptation of these letters for changing print technologies has had varying effects upon their integrity of form. Digital adaptations of the Aldines, in particular, can appear anemic or underweighted; too great a fidelity to the original type can lead to diminished impact when printed to present-day tolerances.

All typefaces originating in hand-cut punches showed a considerable variation of form according to size, with the serifs relatively heavier and the modulation of stroke width less pronounced at smaller sizes. These considerations are crucial to the effective design or adaptation of Garalde faces, and distinguish quality recuts and original faces in the Garalde tradition.

GARALDE: CHARACTERISTIC FEATURES

ABC

A — Medium contrast

Inclined apex

obdg — Generous counters

e — Horizontal bar

Oo — Inclined stress

M — Inclined stems, squared-off terminals, and angular form

T — Flattened serifs, often with squared ends

Q — Jointed tail

Te — Medium x-height

K — Arm and leg meet at stem

Claude Garamond

Garamond's significance is confused by the fact that the typefaces that for some time bore his name were later found to have a different origin, when it emerged in the 1920s that faces that had come to be known as Garamond originated in the work of the French punchcutter and printer Jean Jannon. Garamond's type is, however, the basis for the roman forms of Linotype Granjon, Berthold Garamond, and Robert Slimbach's Adobe Garamond.

Dutch old-style letters were the inspiration for Ehrhardt, one of the most effective and appealing book faces in current use. This was based upon Monotype Janson, a 1938 recut of the 18th-century Janson face, mistakenly attributed to Anton Janson, but actually cut by the Hungarian punchcutter Miklós Kis, based in the Netherlands in the latter part of the 17th century.

Caslon typefaces

The typefaces of William Caslon show the emergence of some of the characteristics of the later Transitional forms, having a near vertical stress but also retaining many qualities of the Garalde. It has been noted that the strength and attractiveness of Caslon lies less in the inherent form of the individual letters than in the harmony and consistency with which those letters work together on the page. Caslon has been both freely and faithfully reinterpreted for Monotype, photosetting, and digital form, with the consequence that a number of diverse typefaces carry the Caslon name. Distinguished examples in current use include ATF Caslon 540, Adobe Caslon, Founders Caslon, and Matthew Carter's Big Caslon, a display face specifically based upon the larger sizes of the original types.

20th-century Garaldes

Exemplary among 20th-century Garaldes is Jan Tschichold's Sabon, designed in the 1960s to work across three different systems: for hot-metal setting on both Linotype and Monotype machines, and as a hand-set type for the Stempel Foundry. A digital version was issued by the Linotype library as Linotype Sabon, and an improved version as Linotype Sabon in 2002. Other distinguished 20th-century Garaldes include Hermann Zapf's Palatino and Jonathan Hoefler's Hoefler Text.

1 Spread from *Re Approaches*
This spread from a typographic book by Jeremy Tankard makes vivid use of Adobe Caslon, juxtaposing positive and negative forms to identify key concepts within typographic design.

2 *Cosmology of Kyoto* book jacket
Dramatic letter spacing reveals the distinctive formal qualities of Palatino capitals in this jacket design by Shinnoske Sugisaki.

3 Type foundry sample
Promotional literature from the Porchez Typofonderie demonstrates a range of distinctive features: alternates, discretionary ligatures, and small caps.

Galliard

Designed by Matthew Carter in 1972, based upon the types of Robert Granjon

ITC Galliard is not based upon a single Granjon face, but is a synthesis of the exuberant characteristics of his work.

It is designed in four weights, and is characterized by a pronounced incline to the stress. It is exceptional among 20th-century Garaldes for the coherence and integrity of its italic and roman forms across a range of weights—characteristics that do not feature in historic Garaldes, but are achieved through a sensitive contemporary interpretation of the tradition.

Its forms are crisp yet fluid, and the face includes some elegant terminal letters. The serifs are noticeably deeply bracketed. The face is both colorful and legible, ideally suited to text setting.

The accompanying Poster Galliard adapts the forms for display use, but the face may also be paired with Carter's own later display face, Mantinia.

IN CONTEXT

typography *n.* [ML f. Gk *typos*, impression, cast + *graphia*, writing] Art of printing; style or appearance of printed matter (*the typography was admirable*).

Italic and **bold** weights are conventionally used to indicate differentiation, emphasis, attributions, and quotations.

Typefaces or families With an *extended* range of **weights**, the designer has greater scope in *manipulating* these qualities.

GALLIARD: SELECTED ALPHABETS

ABCDEFGHIJKLMNOPQRSTUVWXYZ &!?(),.:;'
abcdefghijklmnopqrstuvwxyz

The typographer's first duty is to the text itself. An intelligent interpretation of the text will not only ensure readability, but will also reflect its tone, its structure, and its cultural context. The typographer's analysis illuminates the text, like the musician's reading of a score.

Roman

ABCDEFGHIJKLMNOPQRSTUVWXYZ &!?(),.:;'
abcdefghijklmnopqrstuvwxyz

The typographer's first duty is to the text itself. An intelligent interpretation of the text will not only ensure readability, but will also reflect its tone, its structure, and its cultural context. The typographer's analysis illuminates the text, like the musician's reading of a score.

Italic

ABCDEFGHIJKLMNOPQRSTUVWXYZ &!?(),.:;'
abcdefghijklmnopqrstuvwxyz

The typographer's first duty is to the text itself. An intelligent interpretation of the text will not only ensure readability, but will also reflect its tone, its structure, and its cultural context. The typographer's analysis illuminates the text, like the musician's reading of a score.

Bold

KEY FEATURES

M
High contrast

o
Inclined stress

r
Distinctive ear

E
Large tapering serif

bd
Full counters

e
High bar

a
Straight diagonal bowl stroke

ljp
Triangulated terminals

pq
Deep descenders and broad serifs

Υ
Splayed italic

J
Descending tail

M
Variant angled strokes

Kk
Single junction at stem

QQ
Angled tail in roman; jointed tail in italic

&&
Alternate ampersand and swashes

Bembo

Griffo's letters were used by Aldus Manutius to print the *De Aetna* of Cardinal Pietro Bembo, after whom this classic Aldine face is named. As its source predates the italic version, two different approaches were adopted in pairing Griffo's forms with an appropriate companion italic.

The Monotype Bembo italic is based upon Blado, the italic cut of Poliphilus. This was a fairly faithful transcription of one of the italic typefaces designed by Ludovico degli Arrighi in 1526 and acquired for use by Antonio Blado of Rome.

Despite a relatively low x-height, Bembo is an exceptionally legible face that also reveals its complexity of form when used at larger sizes. The bold and extra bold fonts are a later development without a basis in the original sources. Expert sets are available, including a small-cap font.

Its characteristics include an inclined stress, straight bar to the e, and a very low bowl to the a. The ear of the lowercase r and a slight angle to the initial stroke of the m and n are among the subtle details that serve to animate this classic face.

IN CONTEXT

typography *n.* [ML f. Gk *typos*, impression, cast + *graphia*, writing] Art of printing; style or appearance of printed matter (*the typography was admirable*).

Italic and **bold** weights are conventionally used to indicate differentiation, emphasis, attributions, and quotations.

Typefaces or families With an *extended* range of **weights**, the designer has greater scope in *manipulating* these qualities.

BEMBO: SELECTED ALPHABETS

ABCDEFGHIJKLMNOPQRSTUVWXYZ &!?(),.:;'
abcdefghijklmnopqrstuvwxyz

The typographer's first duty is to the text itself. An intelligent interpretation of the text will not only ensure readability, but will also reflect its tone, its structure, and its cultural context. The typographer's analysis illuminates the text, like the musician's reading of a score.

Regular

ABCDEFGHIJKLMNOPQRSTUVWXYZ &!?(),.:;'
abcdefghijklmnopqrstuvwxyz

The typographer's first duty is to the text itself. An intelligent interpretation of the text will not only ensure readability, but will also reflect its tone, its structure, and its cultural context. The typographer's analysis illuminates the text, like the musician's reading of a score.

Italic

ABCDEFGHIJKLMNOPQRSTUVWXYZ &!?(),.:;'
abcdefghijklmnopqrstuvwxyz

The typographer's first duty is to the text itself. An intelligent interpretation of the text will not only ensure readability, but will also reflect its tone, its structure, and its cultural context. The typographer's analysis illuminates the text, like the musician's reading of a score.

Bold

KEY FEATURES

h — Medium to low x-height

Oo — Inclined stress

a — Extended stroke at apex and very low bowl

g — Tapered ear

l — Deep oblique serif

M — Inclined stems

n — Slightly inclined stem

R — Offset, deep leg junction, with long sweeping leg

r — Flag ear

k — Arm and leg joined at stem

e — Straight bar

b — Oblique base

MN — Angled initial stroke

W — Crossed strokes and linked serifs

G — No spur

Sabon

A 20th-century adaptation of the Garamond model by Jan Tschichold, issued by Stempel in 1964 and Monotype and Linotype in 1967

One of the finest modern adaptations of the Garamond model, Jan Tschichold's Sabon stands as the culmination of a hugely influential typographic career in which type design developed alongside book typography and critical writing.

It is named for the punchcutter and type founder Jakob (or Jacques) Sabon of Lyon, who is credited with bringing the Garamond types originating with Plantin or Granjon into use in Frankfurt, thus introducing the Garamond model into German printing. Sabon is, however, far more than a literal revival, since it incorporates characteristics drawn from the different sizes of the Garamonds to form one consistent and definitively 20th-century interpretation of the ideas that they embody.

It has an elegant bold font, and is exceptionally balanced and legible across italic and roman in both its weights. It has a harmonious visual consistency and few obtrusive distinguishing features—an inclined stress, open counters, and a complementary interaction between characters. It incorporates expert set features, including small caps, ligatures, and non-lining numerals.

IN CONTEXT

typography *n.* [ML f. Gk *typos*, impression, cast + *graphia*, writing] Art of printing; style or appearance of printed matter (*the typography was admirable*).

Italic and **bold** weights are conventionally used to indicate differentiation, emphasis, attributions, and quotations.

Typefaces or families With an *extended* range of **weights**, the designer has greater scope in *manipulating* these qualities.

SABON: SELECTED ALPHABETS

ABCDEFGHIJKLMNOPQRSTUVWXYZ &!?(),.:;'
abcdefghijklmnopqrstuvwxyz

The typographer's first duty is to the text itself. An intelligent interpretation of the text will not only ensure readability, but will also reflect its tone, its structure, and its cultural context. The typographer's analysis illuminates the text, like the musician's reading of a score.

Roman

ABCDEFGHIJKLMNOPQRSTUVWXYZ &!?(),.:;'
abcdefghijklmnopqrstuvwxyz

The typographer's first duty is to the text itself. An intelligent interpretation of the text will not only ensure readability, but will also reflect its tone, its structure, and its cultural context. The typographer's analysis illuminates the text, like the musician's reading of a score.

Italic

ABCDEFGHIJKLMNOPQRSTUVWXYZ &!?(),.:;'
abcdefghijklmnopqrstuvwxyz

The typographer's first duty is to the text itself. An intelligent interpretation of the text will not only ensure readability, but will also reflect its tone, its structure, and its cultural context. The typographer's analysis illuminates the text, like the musician's reading of a score.

Bold

KEY FEATURES

Oo Inclined stress

bd Broad counters

P Open counter

a Slight calligraphic inflection

Kk Single junction at apex

N Extended stroke and jointed stem in italic

W Crossed

w Serifed apex

T Rising serifs on bar

y Ball terminal tail

t Short triangulated ascender

þ Cross stroke in italic

Palatino

Designed in 1922 by Hermann Zapf, and named for 16th-century calligrapher Giovanbattista Palatino

Palatino is a highly functional text face in which the Garalde forms can be seen interpreted through a calligrapher's sensibility. The face has a fairly broad set, particularly in the capitals that reflect the proportions of the Roman inscriptional letter. The calligraphic qualities of the face are more evident in the angular strokes of the heavier weights, which evoke the qualities of broad-nibbed pen letters while maintaining the legibility of the best Garalde faces.

The display faces Michelangelo and Sistina were designed as part of the Palatino family, which also includes a Greek text face. An expert set font is available, including non-lining numerals and small caps.

The generous x-height makes Palatino an economical and highly legible face, while its calligraphic characteristics enliven the page when used at larger sizes. It is less historically specific than many Garaldes, and its popularity may spring from the way in which Zapf has imbued it with a distinctly human 20th-century personality.

IN CONTEXT

typography *n.* [ML f. Gk *typos*, impression, cast + *graphia*, writing] Art of printing; style or appearance of printed matter (*the typography was admirable*).

Italic and **bold** weights are conventionally used to indicate differentiation, emphasis, attributions, and quotations.

Typefaces or families With an *extended* range of **weights**, the designer has greater scope in *manipulating* these qualities.

PALATINO: SELECTED ALPHABETS

ABCDEFGHIJKLMNOPQRSTUVWXYZ &!?(),.:;'
abcdefghijklmnopqrstuvwxyz

The typographer's first duty is to the text itself. An intelligent interpretation of the text will not only ensure readability, but will also reflect its tone, its structure, and its cultural context. The typographer's analysis illuminates the text, like the musician's reading of a score.

Regular

ABCDEFGHIJKLMNOPQRSTUVWXYZ &!?(),.:;'
abcdefghijklmnopqrstuvwxyz

The typographer's first duty is to the text itself. An intelligent interpretation of the text will not only ensure readability, but will also reflect its tone, its structure, and its cultural context. The typographer's analysis illuminates the text, like the musician's reading of a score.

Italic

ABCDEFGHIJKLMNOPQRSTUVWXYZ &!?(),.:;'
abcdefghijklmnopqrstuvwxyz

The typographer's first duty is to the text itself. An intelligent interpretation of the text will not only ensure readability, but will also reflect its tone, its structure, and its cultural context. The typographer's analysis illuminates the text, like the musician's reading of a score.

Bold

KEY FEATURES

O — Inclined stress

DB — Top-heavy bowls and small serifs with squared ends

h — Generous x-height

xmnh — Half serifs

T — Narrow bar

Y — Unserifed arm

Q — Touching tail

Ww — Unserifed apex

PR — Open counters

s — Angled half serifs

J — Vertical finial

r — Vertical ear finial

Kk — Single junction at apex

k — Angled lower finial

N — Angle at foot junction

S — Pronounced curve to horizontal

& — Crossbar

Hoefler Text

Commissioned by Apple (1991–93) and based on the types of Jean Jannon and Miklós Kis

Originally commissioned by Apple to demonstrate QuickDraw GX, which allowed for extended character sets, Hoefler Text was inspired by Linotype Garamond No.3 (based upon type designed by Jean Jannon) and Linotype Janson Text 55 (designed by Miklós Kis). In a gentle reaction against the geometric regularity of many digital text faces, it has subtly curved lines that allude to the warmth and print quality of metal foundry types. There is a slight concavity to the serif terminals, and the face has few parallel lines or sharp corners.

Where Hoefler's face transcends its inspiration is in the scope of its styles and weights, and the coherence with which these interrelate. It comprises a total of 27 fonts, including small caps, swash small caps, and swash italics in all of its three weights, as well as two weights of engraved caps and a font of fleurons. The letterforms are uniformly balanced and well-considered across all of the weights, making it a highly versatile and colorful text face. A titling face, designed for use at sizes above 36pt, was added to the family in 2002. It shows noticeable variation from the text forms, with a more assertive angularity, higher contrast, and sharply tapered serifs lending it a distinct character of its own.

IN CONTEXT

typography *n.* [ML f. Gk *typos*, impression, cast + *graphia*, writing] Art of printing; style or appearance of printed matter (*the typography was admirable*).

Italic and **bold** weights are conventionally used to indicate differentiation, emphasis, attributions, and quotations.

Typefaces or families With an *extended* range of **weights**, the designer has greater scope in *manipulating* these qualities.

KEY FEATURES

A — Medium contrast
hn — Subtly curved stems
h — Concave serif base, with rounded ends to serifs
b — Spur foot
e — High bar
f — Full-height ascender
W — Crossed
w — Serifed apex
k — Single, slightly stepped junction at stem
Q — Curved tail from center of base
t — Short triangulated ascender

HOEFLER TEXT: SELECTED ALPHABETS

ABCDEFGHIJKLMNOPQRSTUVWXYZ &!?(),:;'
abcdefghijklmnopqrstuvwxyz

The typographer's first duty is to the text itself. An intelligent interpretation of the text will not only ensure readability, but will also reflect its tone, its structure, and its cultural context. The typographer's analysis illuminates the text, like the musician's reading of a score.

Regular

ABCDEFGHIJKLMNOPQRSTUVWXYZ &!?(),:;'
abcdefghijklmnopqrstuvwxyz

The typographer's first duty is to the text itself. An intelligent interpretation of the text will not only ensure readability, but will also reflect its tone, its structure, and its cultural context. The typographer's analysis illuminates the text, like the musician's reading of a score.

Italic

ABCDEFGHIJKLMNOPQRSTUVWXYZ &!?(),:;'
abcdefghijklmnopqrstuvwxyz

The typographer's first duty is to the text itself. An intelligent interpretation of the text will not only ensure readability, but will also reflect its tone, its structure, and its cultural context. The typographer's analysis illuminates the text, like the musician's reading of a score.

Bold

Hoefler Text typeface © The Hoefler Type Foundry, 1991–1994. http://www.typography.com

Adobe Caslon

A digital Caslon face, redrawn by Carol Twombly in 1990

The popularity of William Caslon's faces has led to a wide range of typefaces bearing his name. Adobe Caslon, redrawn by Carol Twombly from Caslon's 1738 specimens, is a sensitive reconstruction that shows the influence of Dutch old-style faces but also some characteristics of the Transitional forms that were to follow. Twombly's type moderates the high contrast that is exaggerated in some other digital Caslons, but retains the exceptional crispness of the letters and the sharpness of the serifs. Adobe Caslon Pro is available in three weights and includes a full range of alternates, ligatures, superiors, small caps, non-lining figures, swashes, and ornaments, drawn from the ornaments of the Caslon foundry.

Caslon's types were widely adopted for use in the US, and were used for the publication of the Declaration of Independence in 1776. Long favored for book work, Caslon remains a text face of unassertive grace, legible in its individual forms and readable in the rhythmic relationships between letters. The colorful italic is distinguished by a pronounced angle and a very distinctive ampersand. The face should normally be used at text sizes. The Caslon Foundry produced an accompanying titling face, which formed the basis for Matthew Carter's Big Caslon.

IN CONTEXT

typography *n.* [ML f. Gk *typos*, impression, cast + *graphia*, writing] Art of printing; style or appearance of printed matter (*the typography was admirable*).

Italic and **bold** weights are conventionally used to indicate differentiation, emphasis, attributions, and quotations.

Typefaces or families With an *extended* range of **weights**, the designer has greater scope in *manipulating* these qualities.

KEY FEATURES

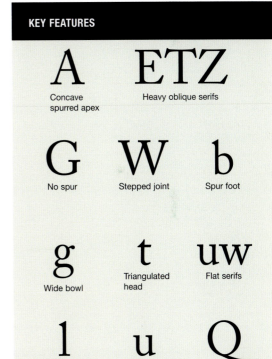

A — Concave spurred apex

ETZ — Heavy oblique serifs

G — No spur

W — Stepped joint

b — Spur foot

g — Wide bowl

t — Triangulated head

uw — Flat serifs

l — Oblique beaked serif

u — Oblique serif base

Q — Swash tail

ADOBE CASLON: SELECTED ALPHABETS

ABCDEFGHIJKLMNOPQRSTUVWXYZ &!?(),.:;'
abcdefghijklmnopqrstuvwxyz

The typographer's first duty is to the text itself. An intelligent interpretation of the text will not only ensure readability, but will also reflect its tone, its structure, and its cultural context. The typographer's analysis illuminates the text, like the musician's reading of a score.

Regular

ABCDEFGHIJKLMNOPQRSTUVWXYZ &!?(),.:;'
abcdefghijklmnopqrstuvwxyz

The typographer's first duty is to the text itself. An intelligent interpretation of the text will not only ensure readability, but will also reflect its tone, its structure, and its cultural context. The typographer's analysis illuminates the text, like the musician's reading of a score.

Italic

ABCDEFGHIJKLMNOPQRSTUVWXYZ &!?(),.:;'
abcdefghijklmnopqrstuvwxyz

The typographer's first duty is to the text itself. An intelligent interpretation of the text will not only ensure readability, but will also reflect its tone, its structure, and its cultural context. The typographer's analysis illuminates the text, like the musician's reading of a score.

Bold

DANTE

ABCDEFGHIJKLMNOPQRSTUVWXYZ &!?(),:;'
abcdefghijklmnopqrstuvwxyz

The typographer's first duty is to the text itself. An intelligent interpretation of the text will not only ensure readability, but will also reflect its tone, its structure, and its cultural context. The typographer's analysis illuminates the text, like the musician's reading of a score.

GIOVANNI MARDERSTEIG, 1954

An elegant and detailed synthesis of the Aldine types, reflecting the influence of Francesco Griffo. Often seen as an alternative to Bembo, Dante is one of the most distinguished 20th-century revivals of the Aldine form. A set of titling capitals is a key feature of the face.

ADOBE GARAMOND

ABCDEFGHIJKLMNOPQRSTUVWXYZ &!?(),:;'
abcdefghijklmnopqrstuvwxyz

The typographer's first duty is to the text itself. An intelligent interpretation of the text will not only ensure readability, but will also reflect its tone, its structure, and its cultural context. The typographer's analysis illuminates the text, like the musician's reading of a score.

ROBERT SLIMBACH, 1989

Moderate contrast, and a more rounded form and evenness of stroke than Linotype or Stempel versions, make Slimbach's one of the most readable Garamonds. It is available with swash italics, some elegant terminal letters, ornaments, and titling capitals.

MINION

ABCDEFGHIJKLMNOPQRSTUVWXYZ &!?(),:;'
abcdefghijklmnopqrstuvwxyz

The typographer's first duty is to the text itself. An intelligent interpretation of the text will not only ensure readability, but will also reflect its tone, its structure, and its cultural context. The typographer's analysis illuminates the text, like the musician's reading of a score.

ROBERT SLIMBACH, 1991

Slightly condensed and with pronounced contrast, this is an efficient text face that combines character and functionality. Redrawn as a multiple master face, it allows for adjustments to width and optical sizing, and includes Greek and Russian fonts.

GRANJON

ABCDEFGHIJKLMNOPQRSTUVWXYZ &!?(),:;'
abcdefghijklmnopqrstuvwxyz

The typographer's first duty is to the text itself. An intelligent interpretation of the text will not only ensure readability, but will also reflect its tone, its structure, and its cultural context. The typographer's analysis illuminates the text, like the musician's reading of a score.

GEORGE JONES,1928

A somewhat lightweight Garamond in its digital form, with medium contrast and restrained serifs. Granjon includes small caps and non-lining numerals.

VAN DIJCK

ABCDEFGHIJKLMNOPQRSTUVWXYZ &!?(),:;'
abcdefghijklmnopqrstuvwxyz

The typographer's first duty is to the text itself. An intelligent interpretation of the text will not only ensure readability, but will also reflect its tone, its structure, and its cultural context. The typographer's analysis illuminates the text, like the musician's reading of a score.

JAN VAN KRIMPEN, 1935

Based upon the typefaces produced for the Dutch publishing house Elzevir in the late 17th century, Van Dijck is a functional text face with a moderate contrast, rather blunt serifs, and high ascenders.

JANSON

ABCDEFGHIJKLMNOPQRSTUVWXYZ &!?(),:;'
abcdefghijklmnopqrstuvwxyz

The typographer's first duty is to the text itself. An intelligent interpretation of the text will not only ensure readability, but will also reflect its tone, its structure, and its cultural context. The typographer's analysis illuminates the text, like the musician's reading of a score.

HERMANN ZAPF, 1954

Based upon the work of Míklos Kis, Janson is an elegant Garalde with a high contrast that is moderated for text use in the 1985 Janson Text, making that a more practical choice for text setting.

CLIFFORD

ABCDEFGHIJKLMNOPQRSTUVWXYZ &!?(),:;'
abcdefghijklmnopqrstuvwxyz

The typographer's first duty is to the text itself. An intelligent interpretation of the text will not only ensure readability, but will also reflect its tone, its structure, and its cultural context. The typographer's analysis illuminates the text, like the musician's reading of a score.

AKIRA KOBAYASHI, 1999

An extended type family that re-creates the weight and feel of foundry types, partially based upon Alexander Wilson's Long Primer type.

ITC FOUNDERS CASLON

ABCDEFGHIJKLMNOPQRSTUVWXYZ &!?(),:;'
abcdefghijklmnopqrstuvwxyz

The typographer's first duty is to the text itself. An intelligent interpretation of the text will not only ensure readability, but will also reflect its tone, its structure, and its cultural context. The typographer's analysis illuminates the text, like the musician's reading of a score.

JUSTIN HOWES, 1998

Available in a range of size-specific versions, Founders Caslon reflects the variations in form between the different sizes of Caslon's letters. A display weight and font of ornaments is also available.

LUCIDA

ABCDEFGHIJKLMNOPQRSTUVWXYZ &!?(),:;'
abcdefghijklmnopqrstuvwxyz

The typographer's first duty is to the text itself. An intelligent interpretation of the text will not only ensure readability, but will also reflect its tone, its structure, and its cultural context. The typographer's analysis illuminates the text, like the musician's reading of a score.

CHARLES BIGELOW AND KRIS HOLMES, 1985

Part of a large type family, with serif, sans, Greek, Cyrillic, Hebrew, and many variants, including versions for low-resolution use. Both serif and sans are excellent robust text faces and highly suitable for use as screen fonts.

MT EHRHARDT

ABCDEFGHIJKLMNOPQRSTUVWXYZ &!?(),:;'
abcdefghijklmnopqrstuvwxyz

The typographer's first duty is to the text itself. An intelligent interpretation of the text will not only ensure readability, but will also reflect its tone, its structure, and its cultural context. The typographer's analysis illuminates the text, like the musician's reading of a score.

MONOTYPE STUDIO, 1937

Based upon the Janson faces designed by Miklós Kis, this has a narrow set and large x-height, making it an extremely effective and widely used book face.

BERLING

ABCDEFGHIJKLMNOPQRSTUVWXYZ &!?(),:;'
abcdefghijklmnopqrstuvwxyz

The typographer's first duty is to the text itself. An intelligent interpretation of the text will not only ensure readability, but will also reflect its tone, its structure, and its cultural context. The typographer's analysis illuminates the text, like the musician's reading of a score.

KARL-ERIK FROSBERG, 1951

A wide set and rather lightweight face, characterized by a crispness of form, with a beaked r and f, and relatively short descenders.

ITC GARAMOND

ABCDEFGHIJKLMNOPQRSTUVWXYZ &!?(),:;'
abcdefghijklmnopqrstuvwxyz

The typographer's first duty is to the text itself. An intelligent interpretation of the text will not only ensure readability, but will also reflect its tone, its structure, and its cultural context. The typographer's analysis illuminates the text, like the musician's reading of a score.

TONY STAN, 1970

Based upon a model not from Garamond but from Jannon, ITC Garamond is a contemporary interpretation rather than a literal reconstruction.

STEMPEL GARAMOND

ABCDEFGHIJKLMNOPQRSTUVWXYZ &!?(),:;'
abcdefghijklmnopqrstuvwxyz

The typographer's first duty is to the text itself. An intelligent interpretation of the text will not only ensure readability, but will also reflect its tone, its structure, and its cultural context. The typographer's analysis illuminates the text, like the musician's reading of a score.

GÜNTER GERHARD LANGE, 1972

The only Garamond in which both italic and roman are based on a genuine Garamond, this is a historically faithful and balanced version of a classic text face.

GOUDY OLD STYLE

ABCDEFGHIJKLMNOPQRSTUVWXYZ &!?(),:;'
abcdefghijklmnopqrstuvwxyz

The typographer's first duty is to the text itself. An intelligent interpretation of the text will not only ensure readability, but will also reflect its tone, its structure, and its cultural context. The typographer's analysis illuminates the text, like the musician's reading of a score.

FREDERIC GOUDY, 1915

A broad, assertive face, anchored by heavy triangular serifs and animated by distinctive features, including the upturned ear of g, fluid lower bar of the E, and diamond dots.

PLANTIN

ABCDEFGHIJKLMNOPQRSTUVWXYZ &!?(),:;'
abcdefghijklmnopqrstuvwxyz

The typographer's first duty is to the text itself. An intelligent interpretation of the text will not only ensure readability, but will also reflect its tone, its structure, and its cultural context. The typographer's analysis illuminates the text, like the musician's reading of a score.

FRANK PIERPOINT, 1913

Based upon the 16th-century roman of Robert Granjon, Plantin is a legible, robust, and heavy type of only moderate contrast. A bold condensed version is also available.

AMERICAN GARAMOND

ABCDEFGHIJKLMNOPQRSTUVWXYZ &!?(),:;'
abcdefghijklmnopqrstuvwxyz

The typographer's first duty is to the text itself. An intelligent interpretation of the text will not only ensure readability, but will also reflect its tone, its structure, and its cultural context. The typographer's analysis illuminates the text, like the musician's reading of a score.

MORRIS FULLER BENTON, 1918

Also known as ATF Garamond and Garamond No.3, American Garamond is a restrained and functional interpretation of the Jannon faces.

LE MONDE LIVRE

ABCDEFGHIJKLMNOPQRSTUVWXYZ &!?(),:;'
abcdefghijklmnopqrstuvwxyz

The typographer's first duty is to the text itself. An intelligent interpretation of the text will not only ensure readability, but will also reflect its tone, its structure, and its cultural context. The typographer's analysis illuminates the text, like the musician's reading of a score.

JEAN-FRANÇOIS PORCHEZ, 1994–99

Part of an extended family of faces, including a sans serif version, Le Monde Livre classic includes an extensive range of ligatures and alternates.

ALDUS

ABCDEFGHIJKLMNOPQRSTUVWXYZ &!?(),:;'
abcdefghijklmnopqrstuvwxyz

The typographer's first duty is to the text itself. An intelligent interpretation of the text will not only ensure readability, but will also reflect its tone, its structure, and its cultural context. The typographer's analysis illuminates the text, like the musician's reading of a score.

HERMANN ZAPF, 1953

A companion face to Palatino, Aldus refers more closely to the Aldine letters of Francesco Griffo. It is narrow in form, crisp and compact, with a somewhat square form evident in the D and o.

REMINGA

ABCDEFGHIJKLMNOPQRSTUVWXYZ &!?(),:;'
abcdefghijklmnopqrstuvwxyz

The typographer's first duty is to the text itself. An intelligent interpretation of the text will not only ensure readability, but will also reflect its tone, its structure, and its cultural context. The typographer's analysis illuminates the text, like the musician's reading of a score.

XAVIER DUPRÉ, 2001

A contemporary digital face with Aldine characteristics and sharply defined serifs, available in three weights with a full set of small caps.

BIG CASLON

ABCDEFGHIJKLMNOPQRSTUVWXYZ

THE TYPOGRAPHER'S FIRST DUTY IS TO THE TEXT ITSELF. AN INTELLIGENT INTERPRETATION OF THE TEXT WILL NOT ONLY ENSURE READABILITY, BUT WILL ALSO REFLECT ITS TONE, ITS STRUCTURE, AND ITS CULTURAL CONTEXT. THE TYPOGRAPHER'S ANALYSIS ILLUMINATES THE TEXT, LIKE THE MUSICIAN'S READING OF A SCORE.

MATTHEW CARTER, 1994

Based upon the vigorous and distinctive display sizes of the original Caslon types, Big Caslon has an extended set of ligatures and can be used with Caslon text faces.

TRANSITIONAL

The term Transitional refers to the transition from the Garalde to the Didone letterform. One of the key influences upon this development was the typeface known as the Romain du Roi, designed in 1692 by Philippe Grandjean (1666–1714) for the Imprimerie Royale.

The Romain du Roi was based on a square grid and demonstrated a highly systematic construction, ensuring consistency in the stroke width and the form of the serif.

Transitional characteristics

Transitionals are distinguished from Garaldes by a number of subtle but significant characteristics. The development toward a vertical stress completes the evolution of specifically typographic forms, transcending the influence of pen lettering. The serifs are well defined but shallower and less triangulated than many of their predecessors. Though in most cases the serifs are bracketed, the bracket curve is often tighter, prefiguring the development of the unbracketed hairline serifs that feature in Pierre-Simon Fournier's letters and were to become a key attribute of the faces of Giambattista Bodoni and Firmin Didot.

Transitionals are also characterized by a more dramatic variation in stroke width—a controversial development that led to charges of impaired legibility and letters too bright to read comfortably. This refinement of form and detailing was itself made feasible by developments in printing technology. John Baskerville was an innovator not only in the development of typographic form itself, but also in the use of hot-pressed papers and improved inks, allowing for higher definition and less ink-spread than ever before, and creating the conditions not only for the heightened color of his own faces, but also for the culmination of the vivid contrasted letterform in the Didones that were to follow.

Transitional to Didone

As they mark the transition from the old style of Garaldes to the modern form of the Didones, different examples of the Transitional

TRANSITIONAL: CHARACTERISTIC FEATURES

Oo
Vertical or near vertical stress

ABC
High contrast

A
Pointed apex

C
Verical serifs

W
Central apex, sometimes serifed

K
Jointed, with leg branching off from arm

gr
Drop ears

J
Drop tail

Q
Extended wave tail, sometimes entering counter

1 Borderlines Film & Art poster
A poster design by Will Hill for a series of arts events explores the forms of Baskerville across a range of sizes and tonal weights.

2 Type foundry sample
Promotional document emphasizing the high contrast and deep bracketed serifs of Monotype Bell.

3 NAICU conference material
The insertion of a modified italic ff ligature contrasts dramatically with the vertical stress of the Transitional roman letters in this design by Robert Rytter & Associates.

4 *Bound Image* excerpt A text on Baskerville designed by Phil Baines, set against a detail of lettering from John Baskerville's own headstone, illustrates the relationship between his types and the inscriptional lettering of his time.

5 Romain du Roi A page of drawings for Philippe Grandjean's innovative type design of 1692.

genre show greater degrees of affinity to the earlier or the later model. Baskerville's types are more easily understood in relation to his contemporary and rival William Caslon, whereas John Bell's Bell, recut by Monotype as Monotype Bell in 1931, clearly anticipates the Didones and might as readily be classified as an early Didone. The emergence of the Didone genre is most clearly signaled in the Transitionals of Fournier, whose letters have an unbracketed serif and many of the defining Didone characteristics. William Martin's letters designed for the printer William Bulmer in 1790, and recut as Monotype Bulmer, similarly prefigure Bodoni in many key aspects. Type historians differ in attributing some of these faces either to the Transitional or the Didone category.

20th-century Transitionals

Twentieth-century examples on the Transitional model have provided a number of durable, robust, and functional types— notably Morris Fuller Benton's Century Schoolbook for ATF, Hermann Zapf's Melior, and the sensitive adaptation of Baskerville's letters, first for mechanical composition as Monotype Baskerville and later for photosettting and digital. American interpretations of the genre include two distinguished typefaces designed by the hugely versatile designer W.A. Dwiggins: Electra and Caledonia. A recent addition to the Transitional genre is Zuzana Licko's Mrs Eaves, named for Baskerville's mistress and later wife, who went on to produce commercially successful typefaces after Baskerville's death.

New Baskerville

Designed by John Quaranta in 1978 and later licensed to ITC

New Baskerville refines the most attractive characteristics of Baskerville's original forms while returning to them some of the defining contrast that was moderated in the smaller sizes of Monotype Baskerville. It has a larger x-height than the Monotype, improving overall legibility and making the face more economical in use.

It is also distinguished by a sensitively extended range of weights, giving a total of four: roman, semi-bold, bold, and heavy. The semi-bold can also be used effectively for text setting. The family includes a small-cap font. The enhanced contrast makes the lighter weight roman a little dazzling to the eye (recalling criticisms made of the typeface when it was first introduced), and the thin strokes can suffer at small sizes under conditions of poor resolution or low-definition printing. It is, however, an exceptionally graceful and effective text face when used in larger text sizes.

IN CONTEXT

typography *n.* [ML f. Gk *typos*, impression, cast + *graphia*, writing] Art of printing; style or appearance of printed matter (*the typography was admirable*).

Italic and **bold** weights are conventionally used to indicate differentiation, emphasis, attributions, and quotations.

Typefaces or families With an *extended* range of **weights**, the designer has greater scope in *manipulating* these qualities.

KEY FEATURES

h — Medium x-height
O — Vertical stress
N — High contrast
Q — Jointed tail

C — Near vertical upper and lower serifs
G — High foot
g — Open bowl tail
f — Pronounced overhang

W — Pointed apex
d — Oblique serif
e — High bar and small counter

rga — Half-curved drop
b — Spur foot
du — Oblique serif at foot

lkh — Oblique serif ascenders
j — Deep descender with pronounced loop

NEW BASKERVILLE: SELECTED ALPHABETS

ABCDEFGHIJKLMNOPQRSTUVWXYZ &!?(),.;'
abcdefghijklmnopqrstuvwxyz

The typographer's first duty is to the text itself. An intelligent interpretation of the text will not only ensure readability, but will also reflect its tone, its structure, and its cultural context. The typographer's analysis illuminates the text, like the musician's reading of a score.

Roman

ABCDEFGHIJKLMNOPQRSTUVWXYZ &!?(),.;'
abcdefghijklmnopqrstuvwxyz

The typographer's first duty is to the text itself. An intelligent interpretation of the text will not only ensure readability, but will also reflect its tone, its structure, and its cultural context. The typographer's analysis illuminates the text, like the musician's reading of a score.

Italic

ABCDEFGHIJKLMNOPQRSTUVWXYZ &!?(),.;'
abcdefghijklmnopqrstuvwxyz

The typographer's first duty is to the text itself. An intelligent interpretation of the text will not only ensure readability, but will also reflect its tone, its structure, and its cultural context. The typographer's analysis illuminates the text, like the musician's reading of a score.

Bold

Century Schoolbook

Designed by Morris Fuller Benton for Monotype in 1924.

Century Schoolbook is widely recognized as a model of legibility. Each of its main characteristics appears governed by practical considerations: it has well defined counters, pronounced bracketed serifs with clearly defined slab ends, a high x-height, and short descenders.

It is widely used in publishing, and in particular, as its title suggests, educational publishing. It is perhaps more notable for the legibility of its individual letters than its inherent readability when used in the setting of extended texts, and requires fairly generous letter spacing if the broad counters are not to become intrusive.

It is a durable typeface, distinguished largely by its considerable practical qualities.

IN CONTEXT

typography *n.* [ML f. Gk *typos*, impression, cast + *graphia*, writing] Art of printing; style or appearance of printed matter (*the typography was admirable*).

Italic and **bold** weights are conventionally used to indicate differentiation, emphasis, attributions, and quotations.

Typefaces or families With an *extended* range of **weights**, the designer has greater scope in *manipulating* these qualities.

KEY FEATURES

E — Short serifed bar

m — Thick, squared serifs and tight brackets

C — High lower finial with no serif

J — Baseline ball terminal

T — Deep oblique serifs

R — Upturned foot

Ww — Serifed apex

Q — Loop and wave tail with secondary counter

c — Ball terminal

e — Angled finial

q — Oblique spur on stem

y — Ball tail

hdl — Slightly angled ascender terminals

CENTURY SCHOOLBOOK: SELECTED ALPHABETS

ABCDEFGHIJKLMNOPQRSTUVWXYZ &!?(),:;'
abcdefghijklmnopqrstuvwxyz

The typographer's first duty is to the text itself. An intelligent interpretation of the text will not only ensure readability, but will also reflect its tone, its structure, and its cultural context. The typographer's analysis illuminates the text, like the musician's reading of a score.

Roman

ABCDEFGHIJKLMNOPQRSTUVWXYZ &!?(),:;'
abcdefghijklmnopqrstuvwxyz

The typographer's first duty is to the text itself. An intelligent interpretation of the text will not only ensure readability, but will also reflect its tone, its structure, and its cultural context. The typographer's analysis illuminates the text, like the musician's reading of a score.

Italic

ABCDEFGHIJKLMNOPQRSTUVWXYZ !?(),:;'
abcdefghijklmnopqrstuvwxyz

The typographer's first duty is to the text itself. An intelligent interpretation of the text will not only ensure readability, but will also reflect its tone, its structure, and its cultural context. The typographer's analysis illuminates the text, like the musician's reading of a score.

Bold

Electra

Designed by the exceptionally versatile William Addison Dwiggins in 1935

Electra is sometimes categorized as a Didone. It is better viewed as a hybrid or synthesis of a number of influences, reflecting the diversity of sources that informed Dwiggins' work, rather than deriving from a single historical model. While it has the high contrast characteristic of the Didone faces, it also has a slightly inclined stress and makes recognizable allusions to the pen-lettered forms found in Dwiggins' hand-rendered designs.

Designed for metal setting, the regular weight appears somewhat light and anemic when printed at text sizes. This may be another case where the faithful digitization of metal letterforms results in a certain loss of impact, diminishing the face's weight when compared to the quality achieved by relief printing.

The bold is more colorful and is still light enough to be practical as a main font for text setting. The light strokes and very open counters require careful attention to letter spacing. Electra is a distinctive face of considerable character and somewhat limited practical use.

IN CONTEXT

typography *n.* [ML f. Gk *typos*, impression, cast + *graphia*, writing] Art of printing; style or appearance of printed matter (*the typography was admirable*).

Italic and **bold** weights are conventionally used to indicate differentiation, emphasis, attributions, and quotations.

Typefaces or families With an *extended* range of **weights**, the designer has greater scope in *manipulating* these qualities.

ELECTRA: SELECTED ALPHABETS

ABCDEFGHIJKLMNOPQRSTUVWXYZ &!?(),:;'
abcdefghijklmnopqrstuvwxyz

The typographer's first duty is to the text itself. An intelligent interpretation of the text will not only ensure readability, but will also reflect its tone, its structure, and its cultural context. The typographer's analysis illuminates the text, like the musician's reading of a score.

Regular

ABCDEFGHIJKLMNOPQRSTUVWXYZ &!?(),:;'
abcdefghijklmnopqrstuvwxyz

The typographer's first duty is to the text itself. An intelligent interpretation of the text will not only ensure readability, but will also reflect its tone, its structure, and its cultural context. The typographer's analysis illuminates the text, like the musician's reading of a score.

Cursive

ABCDEFGHIJKLMNOPQRSTUVWXYZ &!?(),:;'
abcdefghijklmnopqrstuvwxyz

The typographer's first duty is to the text itself. An intelligent interpretation of the text will not only ensure readability, but will also reflect its tone, its structure, and its cultural context. The typographer's analysis illuminates the text, like the musician's reading of a score.

Bold

KEY FEATURES

O Slightly inclined stress

E High contrast

afg Slight calligraphic inflection

e High bar

t Squared finial on ascender

a Low bowl

G Very low bar

h Low x-height

N Tapered, unbracketed serifs

r Shortened outer serifs and ear

T Different angled serifs

Ww Jointed and serifed

Q Flat jointed tail inclined left

g High bowl and linked tail

Jj Tapered tail with minimal curve

Melior

Melior was designed primarily as a newspaper type, and combines the functionality of a practical "workhorse" typeface with a distinctly modern accent. The initial impression of a square form reveals a geometry of complex curves, evocative of sculptural forms, architecture, and product design. These qualities are not allowed to obstruct the readability of the face, which combines individual legibility of characters with an easy and consistent visual rhythm.

Melior is available in three weights. It allows for fairly tight letter spacing and is an excellent text face. Its innovative qualities are very much of their time, and it is most suitable for 20th-century contexts. It is primarily a text face, though the heavier weights may be used for display or subhead purposes.

IN CONTEXT

typography *n.* [ML f. Gk *typos*, impression, cast + *graphia*, writing] Art of printing; style or appearance of printed matter (*the typography was admirable*).

Italic and **bold** weights are conventionally used to indicate differentiation, emphasis, attributions, and quotations.

Typefaces or families With an *extended* range of **weights**, the designer has greater scope in *manipulating* these qualities.

KEY FEATURES

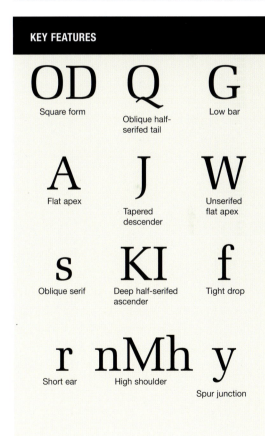

OD — Square form

Q — Oblique half-serifed tail

G — Low bar

A — Flat apex

J — Tapered descender

W — Unserifed flat apex

s — Oblique serif

KI — Deep half-serifed ascender

f — Tight drop

r — Short ear

nMh — High shoulder

y — Spur junction

MELIOR: SELECTED ALPHABETS

ABCDEFGHIJKLMNOPQRSTUVWXYZ &!?(),:;'
abcdefghijklmnopqrstuvwxyz

The typographer's first duty is to the text itself. An intelligent interpretation of the text will not only ensure readability, but will also reflect its tone, its structure, and its cultural context. The typographer's analysis illuminates the text, like the musician's reading of a score.

Regular

ABCDEFGHIJKLMNOPQRSTUVWXYZ &!?(),:;'
abcdefghijklmnopqrstuvwxyz

The typographer's first duty is to the text itself. An intelligent interpretation of the text will not only ensure readability, but will also reflect its tone, its structure, and its cultural context. The typographer's analysis illuminates the text, like the musician's reading of a score.

Italic

ABCDEFGHIJKLMNOPQRSTUVWXYZ &!?(),:;'
abcdefghijklmnopqrstuvwxyz

The typographer's first duty is to the text itself. An intelligent interpretation of the text will not only ensure readability, but will also reflect its tone, its structure, and its cultural context. The typographer's analysis illuminates the text, like the musician's reading of a score.

Bold

BASKERVILLE

ABCDEFGHIJKLMNOPQRSTUVWXYZ &!?(),:;'
abcdefghijklmnopqrstuvwxyz

The typographer's first duty is to the text itself. An intelligent interpretation of the text will not only ensure readability, but will also reflect its tone, its structure, and its cultural context. The typographer's analysis illuminates the text, like the musician's reading of a score.

MATTHEW CARTER AND TIM HOLLOWAY, 1978

Differentiated from the ITC New Baskerville largely by a much heavier bold, Baskerville remains one of the most elegant and functional Transitional faces for book work and other text setting.

BULMER

ABCDEFGHIJKLMNOPQRSTUVWXYZ &!?(),:;'
abcdefghijklmnopqrstuvwxyz

The typographer's first duty is to the text itself. An intelligent interpretation of the text will not only ensure readability, but will also reflect its tone, its structure, and its cultural context. The typographer's analysis illuminates the text, like the musician's reading of a score.

WILLIAM MARTIN, 1790; MORRIS FULLER BENTON, 1928

A development from Baskerville's example, but showing even greater contrast and more emphatic serifs.

TIMES NEW ROMAN

ABCDEFGHIJKLMNOPQRSTUVWXYZ &!?(),:;'
abcdefghijklmnopqrstuvwxyz

The typographer's first duty is to the text itself. An intelligent interpretation of the text will not only ensure readability, but will also reflect its tone, its structure, and its cultural context. The typographer's analysis illuminates the text, like the musician's reading of a score.

STANLEY MORISON AND VICTOR LARDENT, 1932

A modernized form of Pierpoint's Plantin, Times New Roman is a durable, economical text face. Such character as it retained is largely eroded by its familiarity.

ITC CHARTER

ABCDEFGHIJKLMNOPQRSTUVWXYZ &!?(),:;'
abcdefghijklmnopqrstuvwxyz

The typographer's first duty is to the text itself. An intelligent interpretation of the text will not only ensure readability, but will also reflect its tone, its structure, and its cultural context. The typographer's analysis illuminates the text, like the musician's reading of a score.

MATTHEW CARTER, 1993

Heavy, square-ended serifs and low contrast make for a robust face with some Didone features. An attractive small-cap font completes a highly functional face.

MONOTYPE BELL

ABCDEFGHIJKLMNOPQRSTUVWXYZ &!?(),:;'
abcdefghijklmnopqrstuvwxyz

The typographer's first duty is to the text itself. An intelligent interpretation of the text will not only ensure readability, but will also reflect its tone, its structure, and its cultural context. The typographer's analysis illuminates the text, like the musician's reading of a score.

RICHARD AUSTIN, 1931

A high-contrast face, animated by subtle variations in stem width and a curved leg to the R and K, creating a face that possesses color and warmth.

ITC SLIMBACH

ABCDEFGHIJKLMNOPQRSTUVWXYZ &!?(),:;'
abcdefghijklmnopqrstuvwxyz

The typographer's first duty is to the text itself. An intelligent interpretation of the text will not only ensure readability, but will also reflect its tone, its structure, and its cultural context. The typographer's analysis illuminates the text, like the musician's reading of a score.

ROBERT SLIMBACH, 1987

A square form, very high x-height, and triangulated serifs create a text face that is both economical and even in its visual rhythm. It is available in four weights.

FOURNIER

ABCDEFGHIJKLMNOPQRSTUVWXYZ &!?(),:;'
abcdefghijklmnopqrstuvwxyz

The typographer's first duty is to the text itself. An intelligent interpretation of the text will not only ensure readability, but will also reflect its tone, its structure, and its cultural context. The typographer's analysis illuminates the text, like the musician's reading of a score.

MONOTYPE STUDIOS, 1925

A Transitional that closely anticipates the Didot letterforms in its well-defined contrasts and linear serifs.

PERPETUA

ABCDEFGHIJKLMNOPQRSTUVWXYZ &!?(),:;'
abcdefghijklmnopqrstuvwxyz

The typographer's first duty is to the text itself. An intelligent interpretation of the text will not only ensure readability, but will also reflect its tone, its structure, and its cultural context. The typographer's analysis illuminates the text, like the musician's reading of a score.

ERIC GILL, 1925

A face that owes more to a lettercutter's understanding of the Roman letter than to typographic history. The refinement of the delicate serifs and the low x-height limit its functionality as a text face.

MRS EAVES

ABCDEFGHIJKLMNOPQRSTUVWXYZ &!?(),:;'
abcdefghijklmnopqrstuvwxyz

The typographer's first duty is to the text itself. An intelligent interpretation of the text will not only ensure readability, but will also reflect its tone, its structure, and its cultural context. The typographer's analysis illuminates the text, like the musician's reading of a score.

ZUZANA LICKO, 1996

A contemporary interpretation of Baskerville's legacy, Mrs Eaves features an extended set of ligatures.

WARNOCK

ABCDEFGHIJKLMNOPQRSTUVWXYZ &!?(),:;'
abcdefghijklmnopqrstuvwxyz

The typographer's first duty is to the text itself. An intelligent interpretation of the text will not only ensure readability, but will also reflect its tone, its structure, and its cultural context. The typographer's analysis illuminates the text, like the musician's reading of a score.

ROBERT SLIMBACH, 2000

Characterized by triangulated serifs and a lively angularity, Warnock is a Transitional with a suggestion of calligraphic form, particularly in the swash letters that form part of a very extended type family.

JOANNA

ABCDEFGHIJKLMNOPQRSTUVWXYZ &!?(),.:;'
abcdefghijklmnopqrstuvwxyz

The typographer's first duty is to the text itself. An intelligent interpretation of the text will not only ensure readability, but will also reflect its tone, its structure, and its cultural context. The typographer's analysis illuminates the text, like the musician's reading of a score.

ERIC GILL, 1928 AND 1958

A Slab Serif on a Humanist body, Joanna is a highly simplified face with a thin, unbracketed serif, and can be effectively paired with Gill Sans.

DUTCH 811

ABCDEFGHIJKLMNOPQRSTUVWXYZ
&!?(),:;'abcdefghijklmnopqrstuvwxyz

The typographer's first duty is to the text itself. An intelligent interpretation of the text will not only ensure readability, but will also reflect its tone, its structure, and its cultural context. The typographer's analysis illuminates the text, like the musician's reading of a score.

MATTHEW CARTER, 1970

Originally designed as Olympian, Dutch 811 is a sturdy Transitional intended primarily for newspaper work.

CELESTE

ABCDEFGHIJKLMNOPQRSTUVWXYZ &!?(),:;'
abcdefghijklmnopqrstuvwxyz

The typographer's first duty is to the text itself. An intelligent interpretation of the text will not only ensure readability, but will also reflect its tone, its structure, and its cultural context. The typographer's analysis illuminates the text, like the musician's reading of a score.

CHRIS BURKE, 1994

An unbracketed triangular serif and crisp terminals characterize a face of vivid clarity and definition that is equally effective in each of its four weights. The Celeste family includes a small-text version adjusted for small sizes.

CHELTENHAM

ABCDEFGHIJKLMNOPQRSTUVWXYZ &!?(),:;'
abcdefghijklmnopqrstuvwxyz

The typographer's first duty is to the text itself. An intelligent interpretation of the text will not only ensure readability, but will also reflect its tone, its structure, and its cultural context. The typographer's analysis illuminates the text, like the musician's reading of a score.

**BERTRAM GOODHUE, 1896;
MORRIS FULLER BENTON, 1902**

Cheltenham has short, blunt serifs and a low x-height offset by short descenders. The lowercase letters are noticeably more compact than the somewhat broad capitals.

COCHIN

ABCDEFGHIJKLMNOPQRSTUVWXYZ &!?(),:;'
abcdefghijklmnopqrstuvwxyz

The typographer's first duty is to the text itself. An intelligent interpretation of the text will not only ensure readability, but will also reflect its tone, its structure, and its cultural context. The typographer's analysis illuminates the text, like the musician's reading of a score.

**GEORGE PEIGNOT, 1914;
EXTENDED BY MATTHEW CARTER, 1977**

A distinctive floating wave tail to the Q is typical of the lively detailing of a colorful face that has high contrast and a low x-height.

ITC CLEARFACE

ABCDEFGHIJKLMNOPQRSTUVWXYZ &!?(),:;'
abcdefghijklmnopqrstuvwxyz

The typographer's first duty is to the text itself. An intelligent interpretation of the text will not only ensure readability, but will also reflect its tone, its structure, and its cultural context. The typographer's analysis illuminates the text, like the musician's reading of a score.

VICTOR CARUSO, 1978

A slightly condensed Transitional form, with low contrast and deep and narrow triangulated serifs.

POPPL PONTIFEX

ABCDEFGHIJKLMNOPQRSTUVWXYZ &!?(),:;'
abcdefghijklmnopqrstuvwxyz

The typographer's first duty is to the text itself. An intelligent interpretation of the text will not only ensure readability, but will also reflect its tone, its structure, and its cultural context. The typographer's analysis illuminates the text, like the musician's reading of a score.

FRIEDRICH POPPL, 1976

A colorful 20th-century face loosely based upon the Granjon tradition, with a substantial weight and low contrast.

ITC ZAPF INTERNATIONAL

ABCDEFGHIJKLMNOPQRSTUVWXYZ &!?(),:;'
abcdefghijklmnopqrstuvwxyz

The typographer's first duty is to the text itself. An intelligent interpretation of the text will not only ensure readability, but will also reflect its tone, its structure, and its cultural context. The typographer's analysis illuminates the text, like the musician's reading of a score.

HERMANN ZAPF, 1977

Designed as a titling face, the square form is distinctly late 20th century, while the detailing suggests Transitional and Didone influences in its ball terminals and vivid contrasts.

STONE SERIF

ABCDEFGHIJKLMNOPQRSTUVWXYZ &!?(),:;'
abcdefghijklmnopqrstuvwxyz

The typographer's first duty is to the text itself. An intelligent interpretation of the text will not only ensure readability, but will also reflect its tone, its structure, and its cultural context. The typographer's analysis illuminates the text, like the musician's reading of a score.

SUMNER STONE, 1988

The full-serif version of the Stone family, Stone Serif has an attractive balanced weight and generous x-height. It can be paired with both Stone Sans and the half-serifed Stone Informal.

COMENIUS

ABCDEFGHIJKLMNOPQRSTUVWXYZ &!?(),:;'
abcdefghijklmnopqrstuvwxyz

The typographer's first duty is to the text itself. An intelligent interpretation of the text will not only ensure readability, but will also reflect its tone, its structure, and its cultural context. The typographer's analysis illuminates the text, like the musician's reading of a score.

HERMANN ZAPF, 1976

A colorful and elegant 20th-century Transitional with pronounced contrast and rather square form.

MODERN

DIDONE

This category of types, also known as Modern, is based upon the typefaces produced in the late 18th and early 19th centuries in Italy by Giambattista Bodoni (1740–1813) and in France by Firmin Didot (1764–1836).

Didones are characterized by a pronounced contrast in weight between the vertical strokes and the horizontal hairlines, which serves to emphasize the vertical stress of the letters. These qualities allow for extended typeface families, incorporating a wide range of widths and weights, including both extended ultra bolds and condensed faces.

Development of Didones

Advances in print technology and paper manufacture in the late 18th century created the conditions for a radical new genre of typeface design. Harder and less absorbent papers, denser inks, and more accurate presses allowed for increased precision in the printing process, and facilitated the design of typefaces in which both the contrast, or color, and the delicacy of the hairline strokes were far more pronounced than had previously been possible. These typefaces represented a radical shift in typographic form.

While the genre is primarily associated with Bodoni and Didot, the principles of Didone type have been applied to both contemporary typefaces and revivals. Herbert Bayer's Bayer Type was designed in 1931 as an experimental monocase; a more

conventional Didone was released by the Berthold Foundry, under the title Bayer Type, in 1935; and the original monocase was digitized by The Foundry in the 1990s. Jean-François Porchez designed the Ambroise type family, a contemporary interpretation of various typefaces belonging to Didot's late style, issued by the Porchez Typofonderie in 2001. Each typeface is named after members of the three generations of the Didot family.

Important Didones

Bodoni Reinterpretations of Bodoni by different type foundries in both Europe and the US have led to a wide range of variants of Bodoni's original forms. Berthold Bodoni may be the most complete modern synthesis of this process. It incorporates a number of generations of redesigns. While the resulting Berthold Bodoni has become established as the most widely used typeface under this title, its evolution has resulted in a design several times removed from Giambattista Bodoni's original.

Didot The first Didone typeface was cut in 1781 by François Ambroise Didot, whose son Firmin developed and refined the trademark characteristics that have come to be associated with

DIDONE: CHARACTERISTIC FEATURES

A — Pronounced or extreme contrast and pointed apex

Oo — Vertical stress

W — Crossed or jointed

Q — Vertical tail junction

fraj — Circular or elliptical drop

H — Hairline serifs

ET — Bracketed and unbracketed serifs within same font

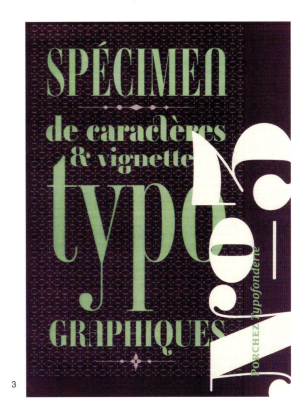
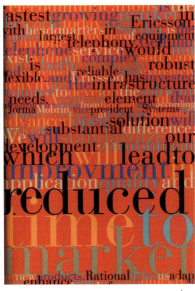

4

5

1 Eight Orafi poster The layering of type on both vertical and horizontal axes reveals the rich vocabulary of forms within the Didone face used in this poster design by Studio di Progettazione Grafica.

2 Bodoni poster Jeffery Keedy's radical deconstruction of one of Giambattista Bodoni's title pages disrupts the symmetrical rationality of Bodoni's original while retaining many of its characterisitic features.

3 Type foundry sample
A promotional specimen book from the Porchez Typofonderie for the Ambroise type family.

4 Brooks/Cahan annual report Minus leading utilizes the robust vertical stresses and variations of stroke width to create graphic texture while retaining legibility.

5 *The Body* book jacket Broad, open counters allow for sensitive integration of text within the image on this design by Lucille Tenazas. Successful horizontal and vertical alignment is achieved with the help of consistent body widths.

the family name, culminating in the Didot of 1800, which has formed the basis of the genre. Well-known Didots include Adrian Frutiger's Linotype Didot and Jonathan Hoefler's HTF Didot.

Walbaum Designed by Justus Erich Walbaum in the early 19th century, Walbaum now exists in two equally authentic versions based upon Walbaum's original matrices; Monotype Walbaum is based upon the smaller text sizes of the original, and is consequently heavier in weight.

Bauer Bodoni

Bauer Bodoni is closer to Bodoni's original than the Berthold and Monotype designs, and the roman form is more subtle in its tonal color. Available in a range of weights and widths, it is a typeface of exceptional elegance that combines an ordered regularity of form with a vivid contrast of stroke widths. It is characterized by a vertical stress, emphasized by the contrasts between vertical and horizontal strokes, and a roundness of form echoed in the drop terminals of the r and f.

Like most Didones, it can be effective in the setting of extended text, provided the printing and paper is of sufficient quality to ensure that the delicate hairlines and high contrasts are retained. All weights and widths of the Bodoni family can be used to dramatic effect as display faces.

IN CONTEXT

typography *n.* [ML f. Gk *typos*, impression, cast + *graphia*, writing] Art of printing; style or appearance of printed matter (*the typography was admirable*).

Italic and **bold** weights are conventionally used to indicate differentiation, emphasis, attributions, and quotations.

Typefaces or families With an *extended* range of **weights**, the designer has greater scope in *manipulating* these qualities.

KEY FEATURES

H High contrast	**O** Vertical stress	**A** Pointed apex
C Vertical serifs	**W** Crossed	**w** Low-jointed strokes and linked serifs
G Low bar	**J** Partial descender	**Q** Vertical junction to tail
g Deep lower-story bowl	**dk** Ascender serifs, horizontal lower stroke, and slight upturn	**fj** Ball terminals
gr Ball ears	**y** Flexed descender	**!** Diamond

BAUER BODONI: SELECTED ALPHABETS

ABCDEFGHIJKLMNOPQRSTUVWXYZ &!?(),.:;'
abcdefghijklmnopqrstuvwxyz

The typographer's first duty is to the text itself. An intelligent interpretation of the text will not only ensure readability, but will also reflect its tone, its structure, and its cultural context. The typographer's analysis illuminates the text, like the musician's reading of a score.

Roman

ABCDEFGHIJKLMNOPQRSTUVWXYZ &!?(),.:;'
abcdefghijklmnopqrstuvwxyz

The typographer's first duty is to the text itself. An intelligent interpretation of the text will not only ensure readability, but will also reflect its tone, its structure, and its cultural context. The typographer's analysis illuminates the text, like the musician's reading of a score.

Italic

ABCDEFGHIJKLMNOPQRSTUVWXYZ &!?(),.:;'
abcdefghijklmnopqrstuvwxyz

The typographer's first duty is to the text itself. An intelligent interpretation of the text will not only ensure readability, but will also reflect its tone, its structure, and its cultural context. The typographer's analysis illuminates the text, like the musician's reading of a score.

Bold

Linotype Didot

Designed by Adrian Frutiger for Linotype in 1991 after the types of Firmin Didot

Less robust than Bodoni, Linotype Didot is an elegant face in which the decorative features of the Didone genre can be seen to best advantage. Linotype Didot has a broad form, very high contrast, and a combination of bracketed and hairline serifs. The high contrast and fine hairlines require high-quality printing and a well-considered choice of paper. These qualities limit its use as a text face, making it more suitable for short passages than extended bodies of continuous text.

Linotype Didot is available in two weights and a distinguished lightweight italic. A headline font has been designed for display use, retaining the refinements of detailing at larger sizes. There is also a font of ornaments.

IN CONTEXT

typography *n.* [ML f. Gk *typos*, impression, cast + *graphia*, writing] Art of printing; style or appearance of printed matter (*the typography was admirable*).

Italic and **bold** weights are conventionally used to indicate differentiation, emphasis, attributions, and quotations.

Typefaces or families With an *extended* range of **weights**, the designer has greater scope in *manipulating* these qualities.

KEY FEATURES

h	O	H
High contrast	Vertical stress	Unbracketed hairline serifs
T	rg	W
Bracketed serifs	Concave drop form to ear	Stepped junction
y	Q	g
Flexed descender	Tapered tail from base	Narrow loop
7	5	4
Curved stroke	Deeply curved bar	Open counter

LINOTYPE DIDOT: SELECTED ALPHABETS

ABCDEFGHIJKLMNOPQRSTUVWXYZ &!?(),.:;'
abcdefghijklmnopqrstuvwxyz

The typographer's first duty is to the text itself. An intelligent interpretation of the text will not only ensure readability, but will also reflect its tone, its structure, and its cultural context. The typographer's analysis illuminates the text, like the musician's reading of a score.

Roman

ABCDEFGHIJKLMNOPQRSTUVWXYZ &!?(),.:;'
abcdefghijklmnopqrstuvwxyz

The typographer's first duty is to the text itself. An intelligent interpretation of the text will not only ensure readability, but will also reflect its tone, its structure, and its cultural context. The typographer's analysis illuminates the text, like the musician's reading of a score.

Italic

ABCDEFGHIJKLMNOPQRSTUVWXYZ &!?(),.:;'
abcdefghijklmnopqrstuvwxyz

The typographer's first duty is to the text itself. An intelligent interpretation of the text will not only ensure readability, but will also reflect its tone, its structure, and its cultural context. The typographer's analysis illuminates the text, like the musician's reading of a score.

Bold

Fairfield

Designed by Rudolf Růžička for linotype setting, 1939; digitized by Alex Kazcun, 1991

Fairfield is a delicate and slightly rectangular face with many similar characteristics to W.A. Dwiggins' Electra. It is a clear and graceful book face, with a distinctive italic font. The italic modified by Alex Kazcun is broad and fluid, with noticeably low junctions and a decorative alternate alphabet of swash capitals.

Kazcun's digital redesign has a more pronounced contrast and additional weights, extending the functionality of the face while retaining its distinctive character.

KEY FEATURES

O — Vertical stress

h — High contrast

g — Sharply angled link and small ear

T — Extended serif on bar ends

dh — Angled heads and tapered serifs

a — Angled foot

Ww — Oblique foot and apex serif

Q — Jointed tail

ANE — Swash italic initials

mn — Very low junctions in italic

FAIRFIELD: SELECTED ALPHABETS

ABCDEFGHIJKLMNOPQRSTUVWXYZ &!?(),.:;'
abcdefghijklmnopqrstuvwxyz

The typographer's first duty is to the text itself. An intelligent interpretation of the text will not only ensure readability, but will also reflect its tone, its structure, and its cultural context. The typographer's analysis illuminates the text, like the musician's reading of a score.

Medium

ABCDEFGHIJKLMNOPQRSTUVWXYZ &!?(),.:;'
abcdefghijklmnopqrstuvwxyz

The typographer's first duty is to the text itself. An intelligent interpretation of the text will not only ensure readability, but will also reflect its tone, its structure, and its cultural context. The typographer's analysis illuminates the text, like the musician's reading of a score.

Medium Italic

ABCDEFGHIJKLMNOPQRSTUVWXYZ &!?(),.:;'
abcdefghijklmnopqrstuvwxyz

The typographer's first duty is to the text itself. An intelligent interpretation of the text will not only ensure readability, but will also reflect its tone, its structure, and its cultural context. The typographer's analysis illuminates the text, like the musician's reading of a score.

Bold

Walbaum

Designed by Justus Erich Walbaum, early 19th century; redesigned by Günter Gerhard Lange, 1970s

Walbaum is a German development of the Didone tradition established by Bodoni and Didot. It was adapted by Monotype as a typesetting face in 1933, and subsequently redesigned by Günter Gerhard Lange for photosetting, using the original Walbaum matrices.

Walbaum Book and Walbaum Standard were issued in 1975–79, and included a newly developed bold and small caps. Because its revival in the 20th century concentrated upon its use as a book face, Walbaum is one of the most practical of the Didones for text setting. The bold weights have small counters that restrict their use at small sizes, but the regular weight gives a broad and even appearance when set as continuous text.

IN CONTEXT

typography *n.* [ML f. Gk *typos*, impression, cast + *graphia*, writing] Art of printing; style or appearance of printed matter (*the typography was admirable*).

Italic and **bold** weights are conventionally used to indicate differentiation, emphasis, attributions, and quotations.

Typefaces or families With an *extended* range of **weights**, the designer has greater scope in *manipulating* these qualities.

KEY FEATURES

H — High contrast

O — Vertical stress

Do — Squared curves

J — Tail rests on baseline

K — Small bar before leg junction

R — Curved leg

A — Pointed apex

Q — Descending tail

Ww — Serifed apex

EFC — Bracketed serifs

A — Unbracketed hairline serif

g — High upper story

b — No foot serif

& — Horizontal serif

2 — Very full loop

3 — Angled serif

WALBAUM: SELECTED ALPHABETS

ABCDEFGHIJKLMNOPQRSTUVWXYZ
&!?(),:;'abcdefghijklmnopqrstuvwxyz

The typographer's first duty is to the text itself. An intelligent interpretation of the text will not only ensure readability, but will also reflect its tone, its structure, and its cultural context. The typographer's analysis illuminates the text, like the musician's reading of a score.

Book Regular

ABCDEFGHIJKLMNOPQRSTUVWXYZ &!?(),:;'
abcdefghijklmnopqrstuvwxyz

The typographer's first duty is to the text itself. An intelligent interpretation of the text will not only ensure readability, but will also reflect its tone, its structure, and its cultural context. The typographer's analysis illuminates the text, like the musician's reading of a score.

Book Italic

ABCDEFGHIJKLMNOPQRSTUVWXYZ
&!?(),:;'abcdefghijklmnopqrstuvwxyz

The typographer's first duty is to the text itself. An intelligent interpretation of the text will not only ensure readability, but will also reflect its tone, its structure, and its cultural context. The typographer's analysis illuminates the text, like the musician's reading of a score.

Book Bold

ACANTHUS

ABCDEFGHIJKLMNOPQRSTUVWXYZ &!?(),:;'
abcdefghijklmnopqrstuvwxyz

The typographer's first duty is to the text itself. An intelligent interpretation of the text will not only ensure readability, but will also reflect its tone, its structure, and its cultural context. The typographer's analysis illuminates the text, like the musician's reading of a score.

AKIRA KOBAYASHI, 1998

A broad and beautifully balanced Didone with two weights, an open display face and a text face for use at smaller sizes, making it highly functional for text and titling.

CALEDONIA

ABCDEFGHIJKLMNOPQRSTUVWXYZ &!?(),:;'
abcdefghijklmnopqrstuvwxyz

The typographer's first duty is to the text itself. An intelligent interpretation of the text will not only ensure readability, but will also reflect its tone, its structure, and its cultural context. The typographer's analysis illuminates the text, like the musician's reading of a score.

WILLIAM ADDISON DWIGGINS, 1931

Less emphatic in its vertical contrasts than the classic Didones, Caledonia has a generous x-height and is an effective if somewhat "bright" book face.

PHOTINA

ABCDEFGHIJKLMNOPQRSTUVWXYZ &!?(),:;'
abcdefghijklmnopqrstuvwxyz

The typographer's first duty is to the text itself. An intelligent interpretation of the text will not only ensure readability, but will also reflect its tone, its structure, and its cultural context. The typographer's analysis illuminates the text, like the musician's reading of a score.

JOSE MENDOZA Y ALMEIDA, 1972

The squared form, complex curves, and variable stresses make this a distinctly 20th-century Didone. It has similar proportions to Univers, with which it can be paired.

KEPLER

ABCDEFGHIJKLMNOPQRSTUVWXYZ &!?(),:;'
abcdefghijklmnopqrstuvwxyz

The typographer's first duty is to the text itself. An intelligent interpretation of the text will not only ensure readability, but will also reflect its tone, its structure, and its cultural context. The typographer's analysis illuminates the text, like the musician's reading of a score.

ROBERT SLIMBACH, 2003

A fluent contemporary Didone, including swashes and ornaments, that is available in six weights. The family includes condensed and extended widths in four optical sizings.

ELLINGTON

ABCDEFGHIJKLMNOPQRSTUVWXYZ &!?(),:;'
abcdefghijklmnopqrstuvwxyz

The typographer's first duty is to the text itself. An intelligent interpretation of the text will not only ensure readability, but will also reflect its tone, its structure, and its cultural context. The typographer's analysis illuminates the text, like the musician's reading of a score.

MICHAEL HARVEY, 1990

A display-based 20th-century face with a squared form, pronounced oblique stroke lowercase, and strong calligraphic characteristics. These are particularly effective in the italic.

HTF DIDOT

ABCDEFGHIJKLMNOPQRSTUVWXYZ &!?(),:;'
abcdefghijklmnopqrstuvwxyz

The typographer's first duty is to the text itself. An intelligent interpretation of the text will not only ensure readability, but will also reflect its tone, its structure, and its cultural context. The typographer's analysis illuminates the text, like the musician's reading of a score.

JONATHAN HOEFLER, 1992

A highly refined and complex Didone, produced in three optical sizings, maximizing the extreme delicacy of the hairlines in display use while retaining form and legibility at text sizes.

BODONI

ABCDEFGHIJKLMNOPQRSTUVWXYZ &!?(),:;'
abcdefghijklmnopqrstuvwxyz

The typographer's first duty is to the text itself. An intelligent interpretation of the text will not only ensure readability, but will also reflect its tone, its structure, and its cultural context. The typographer's analysis illuminates the text, like the musician's reading of a score.

AMORRIS FULLER BENTON, 1914

A robust, durable, and relatively heavy interpretation of Bodoni's letters.

MONOTYPE BODONI

ABCDEFGHIJKLMNOPQRSTUVWXYZ &!?(),:;'
abcdefghijklmnopqrstuvwxyz

The typographer's first duty is to the text itself. An intelligent interpretation of the text will not only ensure readability, but will also reflect its tone, its structure, and its cultural context. The typographer's analysis illuminates the text, like the musician's reading of a score.

MONOTYPE STUDIOS, 1922

A delicate and sharply defined Bodoni, with a very heavy bold weight and a noticeably lightweight italic.

ITC FENICE

ABCDEFGHIJKLMNOPQRSTUVWXYZ &!?(),:;'
abcdefghijklmnopqrstuvwxyz

The typographer's first duty is to the text itself. An intelligent interpretation of the text will not only ensure readability, but will also reflect its tone, its structure, and its cultural context. The typographer's analysis illuminates the text, like the musician's reading of a score.

ALDO NOVARESE, 1979

A highly contrasted face whose condensed form and high x-height allow for economical text setting.

SCOTCH ROMAN

ABCDEFGHIJKLMNOPQRSTUVWXYZ &!?(),:;'
abcdefghijklmnopqrstuvwxyz

The typographer's first duty is to the text itself. An intelligent interpretation of the text will not only ensure readability, but will also reflect its tone, its structure, and its cultural context. The typographer's analysis illuminates the text, like the musician's reading of a score.

A.D. FARMER, 1907

Bracketed triangular serifs provide weight and contrast in the capitals, while the lowercase is more moderated, making the face suitable for text use.

SLAB SERIF

The name Clarendon was first used by Robert Besley of the Fann Street Foundry, London, to market a typeface designed by Benjamin Fox in 1845. It has since become a generic term for bracketed Slab Serif types of the period and contemporary adaptations of this style.

The term Egyptian is used to describe unbracketed Slab Serifs, though a number of bracketed faces have been published under this name. Egyptians normally have a slab serif of equal thickness to the main strokes, whereas the less familiar Italiennes are faces in which the slab serif is heavier than the stroke width. This style was widely used in poster designs at the turn of the 20th century and re-emerged in the work of psychedelic poster artists of the 1960s.

Relief forms

Like the early Grotesques, Slab Serif typefaces developed from large-scale display letters used in both woodblock letterpress printing and architectural lettering. The robust forms and substantial serifs of the Clarendons and Egyptians were perfectly suited to casting as relief forms in metal, and as a result they feature in many Victorian engineering projects as well as appearing in posters, playbills, and other promotional materials of the time. The broad and assertive serif provides an effective compensation for the irregularities of intercharacter space, and this led to their use in a number of monospace fonts.

Monospaced typefaces

The letterforms developed for use in mechanical typewriters up to the 1970s and 1980s are a crude form of Slab Serif, in which the solidity of form and the stability given by the serifs serves to compensate for inconsistencies of intercharacter space. Each of the letters on a mechanical typewriter sits upon a body of uniform width, unlike metal type, in which the width of the body is determined by the width of the letter. This influenced the design of certain letters, notably the exaggerated width

APPLICATIONS

At their best, Slab Serifs are both robust and colorful, with the serifs providing a strong continuity of line. The historic Slab Serifs are generally most effective in the heavier weights. Clarendons, in particular, are useful in text setting, particularly in cases where a greater weight is required than might be provided by more traditional text faces. The substantial serifs and consistent stroke widths retain their form when printed upon rough or absorbent papers or at low digital resolutions. They also survive reversal better than any other serif form, and are excellent for display and semi-display contexts. They were widely used in publishing, packaging, and art/editorial design in the late 1950s and early 1960s.

SLAB SERIF: CHARACTERISTIC FEATURES

H
Low contrast

Oo
Vertical stress

T
Bracketed serifs with squared ends (Clarendons)

ET
Unbracketed serifs (Egyptians)

pg
Short descenders

Q
Tail enters counter

agr
Pronounced drop forms

1

2

3

4

of the serifs in both the capital and lowercase i. The suitability of Slab Serifs as the model for monospace typewriter faces led, in turn, to their use in monospace digital faces, such as Courier— the most widely used default font in current use. Monospacing ensures consistent fit between the letterforms and the grid of pixels on the monitor screen.

Slab Serif influences

Twentieth-century Slab Serif typefaces reflect a variety of influences, and refer to a number of typographic traditions. While some can be seen as derivative of the heavier weights of Didones, the emergence of the Slab Serif owes as much to the early display Grotesques as to the mainstream of the serif tradition, and Slab Serifs continued to reflect historic developments in the sans serif form. Some 20th-century Slab Serifs appear to be serifed forms of sans letters, a reading confirmed in the design of faces such as Erik Spiekermann's Officina, in which the sans and serif versions share a common basic form. The historical basis for this idea is illustrated in Jonathan Hoefler's ingenious Proteus series: a set of four related faces based in the traditions of Victorian display lettering and designed to sit upon the same body, with the variants including a sans serif, a slab serif, and a triangular serif.

The forms of modern Slab Serifs frequently allude to developments in the sans serif letter tradition. Gustav Jeager's Epikur, published by Berthold, has a wide set and a geometric construction reminiscent of Renner's Futura; Memphis, designed by Rudolf Wolf for Stempel, is also predominantly geometric. Rockwell, an unbracketed Slab Serif published by Monotype, suggests a serifed Grotesque. City, designed by Georg Trump, is a sturdy, heavily rectangular Slab Serif, suitable only for display work.

1 *How Downtown Became Empty* **book jacket** An evocative use of a condensed type reflects the traditional association of Slab Serifs with architectural contexts in this cover design by Shane Keaney.
2 Chapter title page from the book *Garcia* Fred Woodward's design makes vivid use of Slab Serif and other letterforms from the decorative traditions of the 19th century.
3 McCoy Tyner Sextet poster This poster design by Niklaus Troxler alternating positive and negative forms shows the robust qualities of bold Slab Serif letters.
4 Fall Out Boy poster Stereotype Design has used dramatically extended letters on both vertical and horizontal axes to create a multidirectional network of Slab Serif forms.

Clarendon

Designed by Hermann Eidenbenz in 1953, based on the display face issued by the Fann Street Foundry in 1845

Clarendon is among the most evocative and colorful of the Victorian faces. The lighter weights are a later development that extends the functionality of the face, being more suitable for text setting than the bold form that is the basis of the genre. Although the broad width of the letters makes it a relatively uneconomical face for setting extended texts, the serifs are exceptionally durable and will retain their form under conditions of poor reproduction, surviving either low screen resolution or unsympathetic conditions of printing. Clarendon will hold its legibility fairly well when used as a screen font in web applications or when printed onto low-quality paper.

It is also effective for architectural and environmental applications, because the strong serif forms can be easily cut out and reproduced in three-dimensional media.

IN CONTEXT

typography n. [ML f. Gk typos, impression, cast + graphia, writing] Art of printing; style or appearance of printed matter (the typography was admirable).

Italic and **bold** weights are conventionally used to indicate differentiation, emphasis, attributions, and quotations.

Typefaces or families With an extended range of **weights**, the designer has greater scope in manipulating these qualities.

CLARENDON: SELECTED ALPHABETS

ABCDEFGHIJKLMNOPQRSTUVWXYZ &!?(),.:;'
abcdefghijklmnopqrstuvwxyz

The typographer's first duty is to the text itself. An intelligent interpretation of the text will not only ensure readability, but will also reflect its tone, its structure, and its cultural context. The typographer's analysis illuminates the text, like the musician's reading of a score.

Regular

ABCDEFGHIJKLMNOPQRSTUVWXYZ &!?(),.:;'
abcdefghijklmnopqrstuvwxyz

The typographer's first duty is to the text itself. An intelligent interpretation of the text will not only ensure readability, but will also reflect its tone, its structure, and its cultural context. The typographer's analysis illuminates the text, like the musician's reading of a score.

Light

ABCDEFGHIJKLMNOPQRSTUVWXYZ &!?(),.:;'abcdefghijklmnopqrstuvwxyz

The typographer's first duty is to the text itself. An intelligent interpretation of the text will not only ensure readability, but will also reflect its tone, its structure, and its cultural context. The typographer's analysis illuminates the text, like the musician's reading of a score.

Bold

KEY FEATURES

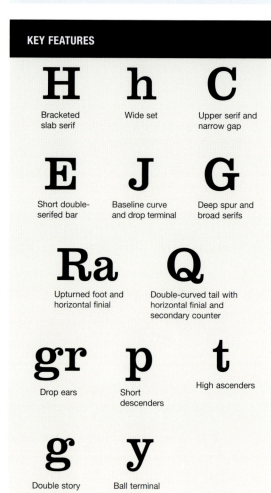

H Bracketed slab serif

h Wide set

C Upper serif and narrow gap

E Short double-serifed bar

J Baseline curve and drop terminal

G Deep spur and broad serifs

Ra Upturned foot and horizontal finial

Q Double-curved tail with horizontal finial and secondary counter

gr Drop ears

p Short descenders

t High ascenders

g Double story

y Ball terminal

Rockwell

Designed by Frank Pierpont and issued by Monotype in 1934

Rockwell is a largely geometric face with a well-defined slab serif. The roman weight is monoline, with a serif of equal thickness to the stroke width, while the bold weight has slight contrast, with some broader vertical strokes. Rockwell has a fairly high x-height and noticeably short descenders. The italic is a somewhat undeveloped oblique form of the roman.

Rockwell is available in four weights. A distinctive bar at the apex of the A and the deep serifs of the T and L serve to reinforce the linear qualities of the typeface, which is robust and particularly effective in establishing strong horizontal emphasis and the setting of small amounts of well-leaded text. Its simplicity, geometric form, and strong horizontal values have also made it an appropriate and effective face for web design and other screen-based applications. It is also an effective display face, with a rugged weight and color that provide scope for the interplay of positive and negative forms.

IN CONTEXT

typography *n.* [ML f. Gk *typos*, impression, cast + *graphia*, writing] Art of printing; style or appearance of printed matter (*the typography was admirable*).

Italic and **bold** weights are conventionally used to indicate differentiation, emphasis, attributions, and quotations.

Typefaces or families With an *extended* range of **weights**, the designer has greater scope in *manipulating* these qualities.

KEY FEATURES

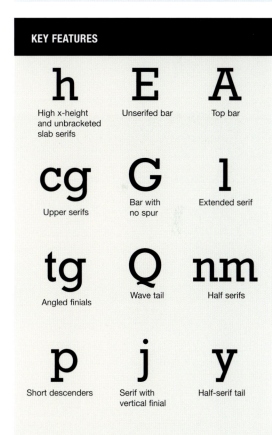

h — High x-height and unbracketed slab serifs
E — Unserifed bar
A — Top bar

cg — Upper serifs
G — Bar with no spur
l — Extended serif

tg — Angled finials
Q — Wave tail
nm — Half serifs

p — Short descenders
j — Serif with vertical finial
y — Half-serif tail

ROCKWELL: SELECTED ALPHABETS

ABCDEFGHIJKLMNOPQRSTUVWXYZ &!?(),.:;'
abcdefghijklmnopqrstuvwxyz

The typographer's first duty is to the text itself. An intelligent interpretation of the text will not only ensure readability, but will also reflect its tone, its structure, and its cultural context. The typographer's analysis illuminates the text, like the musician's reading of a score.

Regular

ABCDEFGHIJKLMNOPQRSTUVWXYZ &!?(),.:;'
abcdefghijklmnopqrstuvwxyz

The typographer's first duty is to the text itself. An intelligent interpretation of the text will not only ensure readability, but will also reflect its tone, its structure, and its cultural context. The typographer's analysis illuminates the text, like the musician's reading of a score.

Italic

ABCDEFGHIJKLMNOPQRSTUVWXYZ &!?(),.:;'
abcdefghijklmnopqrstuvwxyz

The typographer's first duty is to the text itself. An intelligent interpretation of the text will not only ensure readability, but will also reflect its tone, its structure, and its cultural context. The typographer's analysis illuminates the text, like the musician's reading of a score.

Bold

Scala

Designed by Martin Majoor in the late 1980s for the Vredenburg concert hall in Utrecht, Netherlands, and released in 1991

Scala is a text face with an unbracketed slab serif and a linear form that functions well under conditions of low resolution. It is essentially a Slab Serif on a Garalde form, and might be viewed as a more consistent realization of an idea previously attempted in Eric Gill's Joanna.

The regular weight is fairly even in color, with a restrained contrast providing a dramatic comparison to the greater contrasts of the bold weight. Condensed forms and a full expert set of small caps complete a versatile and elegant face.

Scala has a companion sans serif, Scala Sans, a balanced and harmonious monoline Humanist Sans that shares the same underlying skeleton and is available in four weights. There is also has a set of display variants, Scala Jewel.

IN CONTEXT

typography *n.* [ML f. Gk *typos*, impression, cast + *graphia*, writing] Art of printing; style or appearance of printed matter (*the typography was admirable*).

Italic and **bold** weights are conventionally used to indicate differentiation, emphasis, attributions, and quotations.

Typefaces or families With an *extended* range of weights, the designer has greater scope in *manipulating* these qualities.

KEY FEATURES

H Low contrast	N Fine slab serif	h Low x-height
W Crossed	E Narrow	H Wide set
j Tapered tail with spur	Kk Single junction at apex	b6 Open counters
FZ Double serif on top bars	Q Curved tail with serif	a Low bowl
s Oblique serifs	hnm Low junction at shoulders	

SCALA: SELECTED ALPHABETS

ABCDEFGHIJKLMNOPQRSTUVWXYZ &!?(),:;'
abcdefghijklmnopqrstuvwxyz

The typographer's first duty is to the text itself. An intelligent interpretation of the text will not only ensure readability, but will also reflect its tone, its structure, and its cultural context. The typographer's analysis illuminates the text, like the musician's reading of a score.

Regular

ABCDEFGHIJKLMNOPQRSTUVWXYZ &!?(),:;'
abcdefghijklmnopqrstuvwxyz

The typographer's first duty is to the text itself. An intelligent interpretation of the text will not only ensure readability, but will also reflect its tone, its structure, and its cultural context. The typographer's analysis illuminates the text, like the musician's reading of a score.

Italic

ABCDEFGHIJKLMNOPQRSTUVWXYZ &!?(),:;'
abcdefghijklmnopqrstuvwxyz

The typographer's first duty is to the text itself. An intelligent interpretation of the text will not only ensure readability, but will also reflect its tone, its structure, and its cultural context. The typographer's analysis illuminates the text, like the musician's reading of a score.

Bold

Officina

Designed by Erik Spiekermann and Ole Schafer, 1990 and 1998

Officina is a highly functional near-monoline face. A condensed Slab Serif form, it has four weights, and is also available in a sans serif version, Officina Sans. The Officina family was originally designed as a functional office typeface, but its understated utilitarian qualities were adopted for more widespread use, prompting the design of the extended family of weights.

Officina's outwardly rugged structure reveals enlivening subtleties, such as the complex curves of the G and S forms, the half serifs of the m, n, and h, and the stem and descender of the single-story g. It can naturally be paired with the sans serif version, which has identical basic forms at all weights.

IN CONTEXT

typography *n.* [ml f. Gk *typos*, impression, cast + *graphia*, writing] Art of printing; style or appearance of printed matter *(the typography was admirable)*.

Italic and **bold** weights are conventionally used to indicate differentiation, emphasis, attributions, and quotations.

Typefaces or families With an *extended* range of **weights**, the designer has greater scope in *manipulating* these qualities.

KEY FEATURES

E — Monoline

J — Bar terminal

G — Extending bar

EF — Unserifed full-length bar

Rhmn — Half serifs

Z — Inclined serifs

bd — Curved spurs

l — Curved foot

A — Low bar

M — Splayed stems and short central junction

OFFICINA: SELECTED ALPHABETS

ABCDEFGHIJKLMNOPQRSTUVWXYZ &!?(),.:;'
abcdefghijklmnopqrstuvwxyz

The typographer's first duty is to the text itself. An intelligent interpretation of the text will not only ensure readability, but will also reflect its tone, its structure, and its cultural context. The typographer's analysis illuminates the text, like the musician's reading of a score.

Normal

ABCDEFGHIJKLMNOPQRSTUVWXYZ &!?(),.:;'
abcdefghijklmnopqrstuvwxyz

The typographer's first duty is to the text itself. An intelligent interpretation of the text will not only ensure readability, but will also reflect its tone, its structure, and its cultural context. The typographer's analysis illuminates the text, like the musician's reading of a score.

Italic

ABCDEFGHIJKLMNOPQRSTUVWXYZ &!?(),.:;'
abcdefghijklmnopqrstuvwxyz

The typographer's first duty is to the text itself. An intelligent interpretation of the text will not only ensure readability, but will also reflect its tone, its structure, and its cultural context. The typographer's analysis illuminates the text, like the musician's reading of a score.

Bold

EGYPTIENNE F

ABCDEFGHIJKLMNOPQRSTUVWXYZ &!?(),:;'
abcdefghijklmnopqrstuvwxyz

The typographer's first duty is to the text itself. An intelligent interpretation of the text will not only ensure readability, but will also reflect its tone, its structure, and its cultural context. The typographer's analysis illuminates the text, like the musician's reading of a score.

ADRIAN FRUTIGER, 1956

A square, late 20th-century form with a wide serif of slightly less than stem width.

SERIA

ABCDEFGHIJKLMNOPQRSTUVWXYZ &!?(),:;'
abcdefghijklmnopqrstuvwxyz

The typographer's first duty is to the text itself. An intelligent interpretation of the text will not only ensure readability, but will also reflect its tone, its structure, and its cultural context. The typographer's analysis illuminates the text, like the musician's reading of a score.

MARTIN MAJOOR, 2000

A Humanist Slab Serif with distinctive inflection to the counterforms and a slight taper to the serif.

SILICA

ABCDEFGHIJKLMNOPQRSTUVWXYZ &!?(),:;'
abcdefghijklmnopqrstuvwxyz

The typographer's first duty is to the text itself. An intelligent interpretation of the text will not only ensure readability, but will also reflect its tone, its structure, and its cultural context. The typographer's analysis illuminates the text, like the musician's reading of a score.

SUMNER STONE, 1993

A Humanist Slab Serif characterized by angled heads and other subtleties of form unusual in the genre.

SERIFA

ABCDEFGHIJKLMNOPQRSTUVWXYZ &!?(),:;'
abcdefghijklmnopqrstuvwxyz

The typographer's first duty is to the text itself. An intelligent interpretation of the text will not only ensure readability, but will also reflect its tone, its structure, and its cultural context. The typographer's analysis illuminates the text, like the musician's reading of a score.

ADRIAN FRUTIGER, 1967

A broad, slightly squared monoline face that is highly legible across each of its four weights.

BETON

ABCDEFGHIJKLMNOPQRSTUVWXYZ &!?(),:;'
abcdefghijklmnopqrstuvwxyz

The typographer's first duty is to the text itself. An intelligent interpretation of the text will not only ensure readability, but will also reflect its tone, its structure, and its cultural context. The typographer's analysis illuminates the text, like the musician's reading of a score.

HEINRICH JOST, 1931

The short slab serifs match the heavier stroke widths of a somewhat inconsistent face, in which selected strokes are lightened, compromising the overall monoline appearance.

AACHEN

ABCDEFGHIJKLMNOPQRSTUVWXYZ &!?(),:;'abcdefghijklmnopqrstuvwxyz

The typographer's first duty is to the text itself. An intelligent interpretation of the text will not only ensure readability, but will also reflect its tone, its structure, and its cultural context. The typographer's analysis illuminates the text, like the musician's reading of a score.

ALAN MEEKS AND COLIN BRIGNALL, 1969

A very black titling face, in which the weight of the stroke far exceeds the white of the counters, giving a dense and colorful graphic form.

SHERRIF

ABCDEFGHIJKLMNOPQRSTUVWXYZ &!?(),:;' abcdefghijklmnopqrstuvwxyz

The typographer's first duty is to the text itself. An intelligent interpretation of the text will not only ensure readability, but will also reflect its tone, its structure, and its cultural context. The typographer's analysis illuminates the text, like the musician's reading of a score.

PETER VERHUEL, 1996

A robust Slab Serif with complex curves and a vertical stress, suitable for both print and screen use.

MEMPHIS

ABCDEFGHIJKLMNOPQRSTUVWXYZ &!?(),:;' abcdefghijklmnopqrstuvwxyz

The typographer's first duty is to the text itself. An intelligent interpretation of the text will not only ensure readability, but will also reflect its tone, its structure, and its cultural context. The typographer's analysis illuminates the text, like the musician's reading of a score.

RUDOLF WOLF, 1929–36

The apex serif of the A reinforces the strong horizontal emphasis of a geometric Slab Serif form.

ITC AMERICAN TYPEWRITER

ABCDEFGHIJKLMNOPQRSTUVWXYZ &!?(),:;' abcdefghijklmnopqrstuvwxyz

The typographer's first duty is to the text itself. An intelligent interpretation of the text will not only ensure readability, but will also reflect its tone, its structure, and its cultural context. The typographer's analysis illuminates the text, like the musician's reading of a score.

JOEL KADEN AND TONY STAN, 1974

One of the most harmonious Typewriter faces, American Typewriter makes a decorative feature of its rounded serifs and the lightly swollen appearance of its strokes. It is available in three weights and condensed versions.

ITC TACTILE

ABCDEFGHIJKLMNOPQRSTUVWXYZ &!?(),:;' abcdefghijklmnopqrstuvwxyz

The typographer's first duty is to the text itself. An intelligent interpretation of the text will not only ensure readability, but will also reflect its tone, its structure, and its cultural context. The typographer's analysis illuminates the text, like the musician's reading of a score.

JOSEPH STILZLIEN, 2002

A colorful 21st-century Slab Serif with complex curves and a combination of bracketed and unbracketed serifs. It is available in four weights.

HUMANIST SANS

Within the context of sans serif faces, the term Humanist refers to faces based upon a classical or early Humanist model, in which the underlying proportions are derived from the Roman capital letter.

Humanist Sans typefaces function well for the setting of extended text, though they do not as a rule provide for very economical setting because most have a lower x-height than the Grotesques. Heavier weights may be effectively used for smaller quantities of text, and benefit from generous leading. Humanist Sans faces are notable for their compatibility with classic serif types, and can be paired with a number of Humanist, Garalde, and Transitional faces that are based upon similar Roman proportions.

The pattern of reference evident in Humanist Sans faces embodies the historical dialogue between type design and the distinct but related traditions of letter cutting and signwriting, and reflects the influence of the autographic letter upon the industrial type form.

Gill Sans

One of the most lasting and celebrated Humanist Sans faces, Gill Sans, was itself influenced by the alphabet designed by Edward Johnston for the London Underground. Johnston and Gill both came to the design of type from a background in the manual crafts of lettering; Gill as a letter carver, Johnston as a calligrapher. In both cases, the proportions of the classic Roman letter continued to inform the structure of the monoline letters they designed. Johnston's alphabet was not fully developed as a commercial typeface, but its design as a display letter

crucially influenced both Gill Sans and Paul Renner's Futura. Gill Sans was commissioned from Gill by Stanley Morison of the London offices of Monotype.

Though unique as a commercial typeface, Gill Sans is less an innovation than the stabilizing of a form of sans serif in wide use within signwriting from the late 19th century onward—a basic monoline letter that had not previously been expressed in the form of metal type.

Its longevity and continued use serve to confirm its status as a preeminent Humanist Sans, in which the designer's own sensibility is applied in the knowledge of classical form, and refined by the skills of the Monotype drawing office. It should be remembered that Gill Sans was a team effort, the success of

HUMANIST SANS: CHARACTERISTIC FEATURES

AWDR

Classical proportions to capital letters

adr

Minimal contrast, with some adjustments to strokes at junctions

Te

Medium x-height

ABC

Light weight

M

Vertical outer strokes

a

Double story

B

Wide lower bowl

EF

Equal length cross strokes

1

2

3

which depended as much upon the effectiveness with which the Monotype craftsmen articulated Gill's vision into metal as on the design itself. As one might expect of a face derived from conventions of signwriting and letter cutting, it works at scale, but it can also be effective as a text face.

Humanist Sans interpretations

The ideal of the Gill Sans form has been expressed through a variety of distinct and highly personal interpretations, and has taken on a number of national accents. Its closest American equivalent may be W.A. Dwiggins' Metro, which though described as a Gothic, has more affinity with Gill Sans than with the geometric faces upon which it was designed to improve. It is characterized by some variations in the angle of terminals, which serve to animate and enliven a somewhat four-square letter. Frederic Goudy's Goudy Sans is a typically colorful and flamboyant contribution to the genre, with some quasi-medieval gestures and a very effective italic.

Hans Eduard Meier's Syntax is a Humanist Sans that incorporates a rich synthesis of influences into a coherent whole. Meier cites Jan Tschichold's Sabon as an influence, but one can also see references to pen lettering and to Hellenic letterforms in the right-angled terminals. Optima, designed by Hermann Zapf, is a more explicitly calligraphic form, broadly Humanist in proportion, and might equally be classified as a Glyphic in view of the spread of the slightly waisted strokes toward a broadening terminal. Legacy Sans, designed by Ronald Arnholm for ITC, is an unserifed version of Jenson and thus literally a Humanist Sans.

4

New generations

Jeremy Tankard's Bliss is a characteristically English sans serif family, totaling over 160 fonts. It is designed in an extensive range of weights, includes small-cap fonts at each weight. Reflecting the influence of Johnston, Gill, Meier, and Frutiger, it is at once a classic face in the English Humanist tradition and a definitive 21st-century design, making full use of the capabilities of digital type media. Gerard Unger's Praxis might equally be classified as a Neo-Grotesque, but its description as a Humanist Sans face reflects the way in which the term has, in recent years, come to be used more loosely to describe the friendlier qualities of a new generation of Neo-Grotesques.

Gill Sans

Designed by Eric Gill in close collaboration with Stanley Morison and Monotype in 1928

Originally designed as a display face, like the Johnston Underground letters to which it owes a considerable debt of influence, the clarity of Gill Sans subsequently led to its adoption as a text face. Gill Sans is a quintessential Humanist Sans typeface: a monoline form based upon classical proportions. Gill was primarily a lettercutter, who approached the industrial processes of commercial type design with some initial reluctance, and his first face for Monotype reflects his grounding in the proportions of the Roman letter.

While largely monoline, Gill Sans has a compensatory tapering of stroke widths toward the junctions, most noticeable in the lowercase r and the link of the g. The typeface has a distinctive italic font, with a single-story a and notable p. Initially designed in two weights, regular and bold, a range of additional weights and display variants was subsequently developed. Although the regular weight may sometimes be found a little light as a text face, the bold or semi-bold weight can also be effectively used for text setting, giving attractive weight and color on the page.

The classical proportions of the letters mean that Gill Sans is suitable for pairing with Garalde faces and some Transitionals, notably Baskerville.

IN CONTEXT

typography n. [ML f. Gk typos, impression, cast + graphia, writing] Art of printing; style or appearance of printed matter (the typography was admirable).

Italic and **bold** weights are conventionally used to indicate differentiation, emphasis, attributions, and quotations.

Typefaces or families With an extended range of **weights**, the designer has greater scope in **manipulating** these qualities.

GILL SANS: SELECTED ALPHABETS

ABCDEFGHIJKLMNOPQRSTUVWXYZ &!?(),.;'
abcdefghijklmnopqrstuvwxyz

The typographer's first duty is to the text itself. An intelligent interpretation of the text will not only ensure readability, but will also reflect its tone, its structure, and its cultural context. The typographer's analysis illuminates the text, like the musician's reading of a score.

Regular

ABCDEFGHIJKLMNOPQRSTUVWXYZ &!?(),.;'
abcdefghijklmnopqrstuvwxyz

The typographer's first duty is to the text itself. An intelligent interpretation of the text will not only ensure readability, but will also reflect its tone, its structure, and its cultural context. The typographer's analysis illuminates the text, like the musician's reading of a score.

Italic

ABCDEFGHIJKLMNOPQRSTUVWXYZ &!?(),.;'
abcdefghijklmnopqrstuvwxyz

The typographer's first duty is to the text itself. An intelligent interpretation of the text will not only ensure readability, but will also reflect its tone, its structure, and its cultural context. The typographer's analysis illuminates the text, like the musician's reading of a score.

Bold

KEY FEATURES

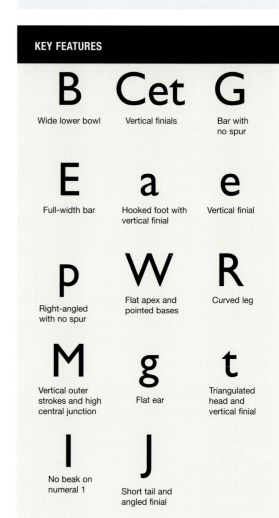

B Wide lower bowl

Cet Vertical finials

G Bar with no spur

E Full-width bar

a Hooked foot with vertical finial

e Vertical finial

P Right-angled with no spur

W Flat apex and pointed bases

R Curved leg

M Vertical outer strokes and high central junction

g Flat ear

t Triangulated head and vertical finial

1 No beak on numeral 1

J Short tail and angled finial

Syntax

Designed by Hans Eduard Meier and issued by Stempel in 1968; digitized by Adobe in 1989; further developed as Linotype Syntax

Syntax is a well-proportioned, clear yet visually lively typeface, with a subtle variation of stroke width and stress, giving a flavor of pen lettering noticeable at the junctions of certain letters. There is a suggestion of Hellenic influences in the distinctive terminals that are its most distinctive characteristic. These end at a right angle to the stroke, giving animation and visual interest.

Syntax has a high x-height and a slightly narrower set than other Humanist Sans faces, such as Gill. The capitals are noticeably shorter than the ascenders. Syntax is a vivid and robust face, suitable for both text and display use, with a range of four weights allowing for considerable differentiation and visual interest. The typeface features an alternate set of x-height numerals. These are set to consistent height, without the ascenders and descenders of old-style numerals.

IN CONTEXT

typography *n.* [ML f. Gk *typos*, impression, cast + *graphia*, writing] Art of printing; style or appearance of printed matter (*the typography was admirable*).

Italic and **bold** weights are conventionally used to indicate differentiation, emphasis, attributions, and quotations.

Typefaces or families With an *extended* range of **weights**, the designer has greater scope in **manipulating** these qualities.

KEY FEATURES

h — High x-height

EB — Short capitals

kvc — Right-angled finials

k — Single junction at stem

t — Horizontal finial ascender

g — Double story, with link and lower bowl aligned left

Ss — Equal curves

M — Splayed outer strokes

R — Curved leg

a — Double story

SYNTAX: SELECTED ALPHABETS

ABCDEFGHIJKLMNOPQRSTUVWXYZ &!?(),:;'
abcdefghijklmnopqrstuvwxyz

The typographer's first duty is to the text itself. An intelligent interpretation of the text will not only ensure readability, but will also reflect its tone, its structure, and its cultural context. The typographer's analysis illuminates the text, like the musician's reading of a score.

Roman

ABCDEFGHIJKLMNOPQRSTUVWXYZ &!?(),:;'
abcdefghijklmnopqrstuvwxyz

The typographer's first duty is to the text itself. An intelligent interpretation of the text will not only ensure readability, but will also reflect its tone, its structure, and its cultural context. The typographer's analysis illuminates the text, like the musician's reading of a score.

Italic

ABCDEFGHIJKLMNOPQRSTUVWXYZ &!?(),:;'
abcdefghijklmnopqrstuvwxyz

The typographer's first duty is to the text itself. An intelligent interpretation of the text will not only ensure readability, but will also reflect its tone, its structure, and its cultural context. The typographer's analysis illuminates the text, like the musician's reading of a score.

Bold

Bliss

Designed by Jeremy Tankard and released in 1996

Based on an intention to "create the first commercial typeface with an English feel since Gill Sans," Jeremy Tankard's Bliss is much more than this, not least in the extent of its variant fonts. The design of Bliss is informed by each of the key landmarks in the development of the Humanist Sans typeface, reflecting the acknowledged influence of Johnston's London Underground letters, Gill's Gill Sans, and Meier's Syntax. Started in 1991, the initial release in 1996 was in four weights.

The influence of Meier is most evident in the right-angled terminals of the lowercase letters. The italic is a judicious mixture of cursive forms with sloped versions of the roman, but is also distinguished from the roman by lower and more flowing junctions.

As a digital Humanist Sans face, Bliss is more effective across a wider range of contexts than any of its distinguished ancestors. It can be used for display and text, and is also effective as an on-screen font, holding its readability under conditions of low resolution. Foreign language versions bring the total number to over 160 fonts.

IN CONTEXT

typography *n.* [ML f. Gk *typos*, impression, cast + *graphia*, writing] Art of printing; style or appearance of printed matter (*the typography was admirable*).

Italic and **bold** weights are conventionally used to indicate differentiation, emphasis, attributions, and quotations.

Typefaces or families With an *extended* range of **weights**, the designer has greater scope in *manipulating* these qualities.

KEY FEATURES

EFTZCStr

Diagonal and straight finials

G — No bar

e — Low bar

A — Pointed, slightly flattened apex and low bar

l — Curved foot

W — High joint

M — Vertical stems

Kk — Single junction at stem

CcSs — Vertical upper finials with right-angled lower finials

BLISS: SELECTED ALPHABETS

ABCDEFGHIJKLMNOPQRSTUVWXYZ &!?(),.;'
abcdefghijklmnopqrstuvwxyz

The typographer's first duty is to the text itself. An intelligent interpretation of the text will not only ensure readability, but will also reflect its tone, its structure, and its cultural context. The typographer's analysis illuminates the text, like the musician's reading of a score.

Medium

ABCDEFGHIJKLMNOPQRSTUVWXYZ &!?(),.;'
abcdefghijklmnopqrstuvwxyz

The typographer's first duty is to the text itself. An intelligent interpretation of the text will not only ensure readability, but will also reflect its tone, its structure, and its cultural context. The typographer's analysis illuminates the text, like the musician's reading of a score.

Italic

ABCDEFGHIJKLMNOPQRSTUVWXYZ &!?(),.;'
abcdefghijklmnopqrstuvwxyz

The typographer's first duty is to the text itself. An intelligent interpretation of the text will not only reflect its tone, its structure, and its cultural context. The typographer's analysis illuminates the text, like the musician's reading of a score.

Bold

Legacy Sans

Designed by Ronald Arnholm and issued by ITC in 1992

The Legacy family comprises both a serif and a sans serif face, both based upon the form and proportions of Jenson's roman. Legacy Sans is therefore explicitly a Humanist Sans. It is characterized by a delicate modulation of stroke width and a fluid diagonal stroke to the S. It is a broad face with well-defined counters, and benefits from fairly loose character spacing. The italic is a highly legible cursive sans, distinct from the alphabet of the serif form, and can be used for text setting.

The correspondence of underlying proportion and x-height make Legacy Serif a natural companion face. Legacy Sans is available in four weights.

IN CONTEXT

typography *n.* [ML f. Gk *typos*, impression, cast + *graphia*, writing] Art of printing; style or appearance of printed matter (*the typography was admirable*).

Italic and **bold** weights are conventionally used to indicate differentiation, emphasis, attributions, and quotations.

Typefaces or families With an *extended* range of **weights**, the designer has greater scope in *manipulating* these qualities.

KEY FEATURES

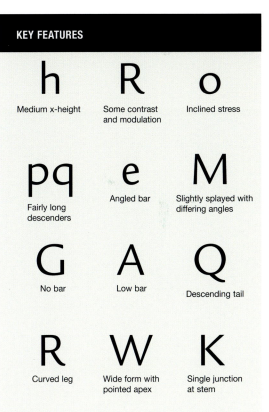

h Medium x-height	**R** Some contrast and modulation	**o** Inclined stress
pq Fairly long descenders	**e** Angled bar	**M** Slightly splayed with differing angles
G No bar	**A** Low bar	**Q** Descending tail
R Curved leg	**W** Wide form with pointed apex	**K** Single junction at stem

LEGACY SANS: SELECTED ALPHABETS

ABCDEFGHIJKLMNOPQRSTUVWXYZ &!?(),:;'
abcdefghijklmnopqrstuvwxyz

The typographer's first duty is to the text itself. An intelligent interpretation of the text will not only ensure readability, but will also reflect its tone, its structure, and its cultural context. The typographer's analysis illuminates the text, like the musician's reading of a score.

Medium

ABCDEFGHIJKLMNOPQRSTUVWXYZ &!?(),:;'
abcdefghijklmnopqrstuvwxyz

The typographer's first duty is to the text itself. An intelligent interpretation of the text will not only ensure readability, but will also reflect its tone, its structure, and its cultural context. The typographer's analysis illuminates the text, like the musician's reading of a score.

Medium Italic

ABCDEFGHIJKLMNOPQRSTUVWXYZ &!?(),:;'
abcdefghijklmnopqrstuvwxyz

The typographer's first duty is to the text itself. An intelligent interpretation of the text will not only ensure readability, but will also reflect its tone, its structure, and its cultural context. The typographer's analysis illuminates the text, like the musician's reading of a score.

Bold

ITC ERAS

ABCDEFGHIJKLMNOPQRSTUVWXYZ &!?(),.:;'
abcdefghijklmnopqrstuvwxyz

The typographer's first duty is to the text itself. An intelligent interpretation of the text will not only ensure readability, but will also reflect its tone, its structure, and its cultural context. The typographer's analysis illuminates the text, like the musician's reading of a score.

**ALBERT BOTON AND
ALBERT HOLLENSTEIN, 1976**

A modernistic late 20th-century Humanist Sans face, animated by asymmetrical curves and open counters.

LUCIDA SANS

ABCDEFGHIJKLMNOPQRSTUVWXYZ &!?(),.:;'
abcdefghijklmnopqrstuvwxyz

The typographer's first duty is to the text itself. An intelligent interpretation of the text will not only ensure readability, but will also reflect its tone, its structure, and its cultural context. The typographer's analysis illuminates the text, like the musician's reading of a score.

**CHARLES BIGELOW AND
KRIS HOLMES, 1985**

The sans serif version from the extensive Lucida family. The companion face Lucida Typewriter Sans is a monospace font, ideal for low-resolution and screen use.

MYRIAD

ABCDEFGHIJKLMNOPQRSTUVWXYZ &!?(),.:;'
abcdefghijklmnopqrstuvwxyz

The typographer's first duty is to the text itself. An intelligent interpretation of the text will not only ensure readability, but will also reflect its tone, its structure, and its cultural context. The typographer's analysis illuminates the text, like the musician's reading of a score.

**CAROL TWOMBLY AND
ROBERT SLIMBACH, 1992**

An extended typeface family, including four widths and four weights, Myriad includes Cyrillic and Russian alphabets, and full sets of ligatures and symbols.

STONE SANS

ABCDEFGHIJKLMNOPQRSTUVWXYZ &!?(),.:;'
abcdefghijklmnopqrstuvwxyz

The typographer's first duty is to the text itself. An intelligent interpretation of the text will not only ensure readability, but will also reflect its tone, its structure, and its cultural context. The typographer's analysis illuminates the text, like the musician's reading of a score.

**SUMNER STONE, JOHN RENNER,
AND BOB ISHI, 1987**

Stone Sans has a high x-height, an elegant modulation of width, and lively right-angled terminals. It has two companion faces, Stone Serif and the half-serifed Stone Informal.

CRONOS

ABCDEFGHIJKLMNOPQRSTUVWXYZ &!?(),.:;'
abcdefghijklmnopqrstuvwxyz

The typographer's first duty is to the text itself. An intelligent interpretation of the text will not only ensure readability, but will also reflect its tone, its structure, and its cultural context. The typographer's analysis illuminates the text, like the musician's reading of a score.

ROBERT SLIMBACH, 1997

Rounded terminals give a friendly manual quality to a face that includes alternates, ligatures, and symbols. Cronos is available in four weights and four optical sizings.

ROTIS

ABCDEFGHIJKLMNOPQRSTUVWXYZ &!?(),:;'
abcdefghijklmnopqrstuvwxyz

The typographer's first duty is to the text itself. An intelligent interpretation of the text will not only ensure readability, but will also reflect its tone, its structure, and its cultural context. The typographer's analysis illuminates the text, like the musician's reading of a score.

OTL AICHER, 1989

A condensed Humanist Sans form, the monoline Rotis Sans is part of an extended family that includes a more modulated semi sans, and both half-serif and serif variants.

ITC JOHNSTON

ABCDEFGHIJKLMNOPQRSTUVWXYZ &!?(),:;'
abcdefghijklmnopqrstuvwxyz

The typographer's first duty is to the text itself. An intelligent interpretation of the text will not only ensure readability, but will also reflect its tone, its structure, and its cultural context. The typographer's analysis illuminates the text, like the musician's reading of a score.

DAVID FAREY, 1999

A sensitive transcription of Johnston's Underground display face into digital form. An italic version was more recently added.

OPTIMA

ABCDEFGHIJKLMNOPQRSTUVWXYZ &!?(),:;'
abcdefghijklmnopqrstuvwxyz

The typographer's first duty is to the text itself. An intelligent interpretation of the text will not only ensure readability, but will also reflect its tone, its structure, and its cultural context. The typographer's analysis illuminates the text, like the musician's reading of a score.

HERMANN ZAPF, 1952

A delicate sans serif, characterized by its tapered stems, Optima alludes to Greek inscriptional forms without appearing archaic.

FOUNDRY SANS

ABCDEFGHIJKLMNOPQRSTUVWXYZ &!?(),:;'
abcdefghijklmnopqrstuvwxyz

The typographer's first duty is to the text itself. An intelligent interpretation of the text will not only ensure readability, but will also reflect its tone, its structure, and its cultural context. The typographer's analysis illuminates the text, like the musician's reading of a score.

DAVID QUAY AND FREDA SACK, 1990

A light and classically proportioned sans serif, with a Hellenic flavor to the s and numerals.

QUADRAAT SANS

ABCDEFGHIJKLMNOPQRSTUVWXYZ &!?(),:;'
abcdefghijklmnopqrstuvwxyz

The typographer's first duty is to the text itself. An intelligent interpretation of the text will not only ensure readability, but will also reflect its tone, its structure, and its cultural context. The typographer's analysis illuminates the text, like the musician's reading of a score.

FRED SMEIJERS, 1998

A classically proportioned face animated by angled terminals and some subtle Glyphic mannerisms, Quadraat is part of an extended family that includes serif and display faces.

GROTESQUE

The early sans serif Grotesque typefaces were developed in the 19th century and, like the Slab Serifs, evolved from display type, signwriting, and architectural lettering. Despite their modern connotations, however, their roots go back to classical times.

DIRECTORY OF TYPEFACES 118

One of the earliest examples of a commercial sans serif typeface was the Two-line Egyptian produced in 1819 by the Caslon Foundry in London. Through the 19th century, the sans serif capital became a feature of the expanding graphic vocabulary of display type. Though the unadorned sans came to denote modernity and a radical abandonment of historical associations, the unserifed form can be traced back to Hellenic sources and Roman Republican lettering, and it is likely that its introduction into the currency of 19th-century type design occurred by way of a revival of Hellenic references in architecture.

Grotesques and Gothics

The display faces upon which the idiom is founded were often only produced as capital fonts, without a lowercase or italic. Though simple and direct in overall form, the early Grotesques are not monoline faces, and the heavier weights, in particular, are characterized by marked variations of stroke width, with pronounced tapering and adjustments at junctions.

Morris Fuller Benton designed two of the most durable sans serif faces of the 20th century in Franklin Gothic and News Gothic. The term Gothic was widely used, particularly in the US, to denote Grotesques or sans serif letters in general. The 1980 ITC version of Franklin Gothic has a colorful variety of weight and width, making it effective both as a display face and for the setting of text. While well suited to formal informational contexts, it reveals great dynamic range when used at scale and applied to more radical, asymmetrical display typography.

Jonathan Hoefler has assembled a comprehensive family of widths and weights, first under the title Champion and later in the more extensive Knockout. Based upon printers' woodletter faces of the 1900s, the variations of weight and width in these faces are not mathematically derived. The letterforms vary quite widely in their form and construction, yet work together because they are historically consistent in coming from a common source and context.

GROTESQUE: CHARACTERISTIC FEATURES

ABC — Variable contrast

adr — Some variation in stroke width at junctions

Aaw — Wide set

AaBbCc — No serif

1 *The Muhammad Ali Reader book jacket* Champion Gothic, a contemporary typeface family based upon late 19th-century wood types, is used to reconstruct the graphic vocabulary of the boxing poster on this book cover by Paul Sahre.

2 New Bag jazz poster The crude forms of a flat-sided condensed Grotesque are minus leaded to create a dense and colorful texture in this design by Niklaus Troxler.

3 Type foundry sample Gotham, a typeface based upon architectural lettering, has a broadly geometric structure. This layered design in a Hoefler Type Foundry catalog demonstrates its extensive range of weights and widths.

4 The Art of the Motor Cycle poster The rugged, no-nonsense forms of Gothic 13 used to dramatic effect in an exhibition poster by Justin Salvas.

5 Art & Cinema poster This design by Olivier Stenhuit uses the linear qualities of the lightest weights of Akzidenz Grotesk to integrate a large amount of information into a coherent whole.

Franklin Gothic

Franklin Gothic remains in widespread use as one of the most durable faces of its kind. Recuts for photosetting and digital release have not diminished its vitality. Victor Caruso added book and medium weights for the version released in 1980, and David Berlow added condensed, compressed, and extra compressed versions in the 1990s. The resulting family offers the designer a colorful range of weights and widths suitable for a variety of requirements from functional text setting to bold and emphatic display work.

The appearance of four-square functionality disguises a range of delicate variations of form and stroke width that maintain the grace of this vivid typeface through the extremes of weight and compression.

IN CONTEXT

typography *n.* [ML f. Gk *typos*, impression, cast + *graphia*, writing] Art of printing; style or appearance of printed matter (*the typography was admirable*).

Italic and **bold** weights are conventionally used to indicate differentiation, emphasis, attributions, and quotations.

Typefaces or families With an *extended* range of **weights**, the designer has greater scope in *manipulating* these qualities.

KEY FEATURES

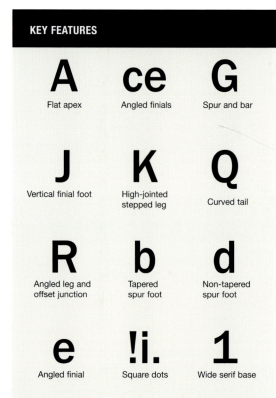

A Flat apex	ce Angled finials	G Spur and bar
J Vertical finial foot	K High-jointed stepped leg	Q Curved tail
R Angled leg and offset junction	b Tapered spur foot	d Non-tapered spur foot
e Angled finial	!i. Square dots	1 Wide serif base

FRANKLIN GOTHIC: SELECTED ALPHABETS

ABCDEFGHIJKLMNOPQRSTUVWXYZ &!?(),:;'
abcdefghijklmnopqrstuvwxyz

The typographer's first duty is to the text itself. An intelligent interpretation of the text will not only ensure readability, but will also reflect its tone, its structure, and its cultural context. The typographer's analysis illuminates the text, like the musician's reading of a score.

Medium

ABCDEFGHIJKLMNOPQRSTUVWXYZ &!?(),:;'
abcdefghijklmnopqrstuvwxyz

The typographer's first duty is to the text itself. An intelligent interpretation of the text will not only ensure readability, but will also reflect its tone, its structure, and its cultural context. The typographer's analysis illuminates the text, like the musician's reading of a score.

Medium italic

ABCDEFGHIJKLMNOPQRSTUVWXYZ &!?(),:;'
abcdefghijklmnopqrstuvwxyz

The typographer's first duty is to the text itself. An intelligent interpretation of the text will not only ensure readability, but will also reflect its tone, its structure, and its cultural context. The typographer's analysis illuminates the text, like the musician's reading of a score.

Demi

Akzidenz Grotesk

This somewhat geometric Grotesque was ideally matched to the principles of the New Typography and was subsequently favored by typographers of the Swiss school. As a key component of modernist graphics, Akzidenz Grotesk strongly influenced the design of Neue Haas Grotesk, which was later retitled Helvetica. Its continued influence is evident both in the development of new Grotesques and in contemporary reappraisals of the Helvetica model.

Akzidenz Grotesk has a rather broad form, similar to the English 19th-century Grotesques, and this establishes a vivid horizontal emphasis, which is particularly valuable in asymmetrical layouts.

While its wide set and low x-height make it a less practical text face than the later Neo-Grotesques, it has considerably greater visual interest and character.

IN CONTEXT

typography n. [ML f. Gk typos, impression, cast + graphia, writing] Art of printing; style or appearance of printed matter (the typography was admirable).

Italic and **bold** weights are conventionally used to indicate differentiation, emphasis, attributions, and quotations.

Typefaces or families With an extended range of **weights**, the designer has greater scope in **manipulating** these qualities.

KEY FEATURES

H — Wide set

h — Medium x-height

Kk — Jointed leg

G — Wide bar and stem

g — Short descenders

scG — Angled finials

e — Low bar

t — Curved foot and symmetrical bar

as — Narrow openings

Q — Angled rectangular tail

E — Shortened central bar

AKZIDENZ GROTESK: SELECTED ALPHABETS

ABCDEFGHIJKLMNOPQRSTUVWXYZ &!?(),:;'
abcdefghijklmnopqrstuvwxyz

The typographer's first duty is to the text itself. An intelligent interpretation of the text will not only ensure readability, but will also reflect its tone, its structure, and its cultural context. The typographer's analysis illuminates the text, like the musician's reading of a score.

Light

ABCDEFGHIJKLMNOPQRSTUVWXYZ &!?(),:;'
abcdefghijklmnopqrstuvwxyz

The typographer's first duty is to the text itself. An intelligent interpretation of the text will not only ensure readability, but will also reflect its tone, its structure, and its cultural context. The typographer's analysis illuminates the text, like the musician's reading of a score.

Roman

**ABCDEFGHIJKLMNOPQRSTUVWXYZ &!?(),:;'
abcdefghijklmnopqrstuvwxyz**

The typographer's first duty is to the text itself. An intelligent interpretation of the text will not only ensure readability, but will also reflect its tone, its structure, and its cultural context. The typographer's analysis illuminates the text, like the musician's reading of a score.

Bold

Knockout

Designed by Jonathan Hoefler in 1994

The Knockout family comprises 32 Grotesques organized by weight into seven series of five fonts, each series containing a range of widths. The forms are drawn from the woodletter types that were the stock-in-trade of jobbing printers from the late 19th century well into the 20th, and were characteristically used in boxing and wrestling posters. An earlier family, Champion, comprises five faces of capitals; Knockout is a further development, including lowercase letters suitable for text setting. Knockout is as much a stylistic anthology as a family, enlivened by marked variations of form and construction between the letters at different weights and widths.

Comparison with another major sans serif family, Adrian Frutiger's Univers, reveals the unique qualities of Hoefler's approach, in which types are grouped by consistency of historical context rather than being designed as strict mathematical derivatives from a common template. The result is a colorful collection of robust faces that can be combined in a wide range of different ways. Like the printer's fonts from which they are derived, they have no italic form.

IN CONTEXT

typography n. [ML f. Gk typos, impression, cast + graphia, writing] Art of printing; style or appearance of printed matter (the typography was admirable).

Italic and bold **weights** are conventionally used to indicate differentiation, emphasis, attributions, and quotations.

Typefaces or families With an extended range of **weights**, the designer has greater scope in **manipulating** these qualities.

KEY FEATURES

Range of weights

Range of widths

Monoline Low bar Vertical strokes

SGCSGC

SGCSGC

SGCSGC

SGCSGC

Variations in form between weights

KNOCKOUT: SELECTED ALPHABETS

ABCDEFGHIJKLMNOPQRSTUVWXYZ &!?(),:;'
abcdefghijklmnopqrstuvwxyz

The typographer's first duty is to the text itself. An intelligent interpretation of the text will not only ensure readability, but will also reflect its tone, its structure, and its cultural context. The typographer's analysis illuminates the text, like the musician's reading of a score.

30 Junior Welterwt

ABCDEFGHIJKLMNOPQRSTUVWXYZ &!?(),:;'
abcdefghijklmnopqrstuvwxyz

The typographer's first duty is to the text itself. An intelligent interpretation of the text will not only ensure readability, but will also reflect its tone, its structure, and its cultural context. The typographer's analysis illuminates the text, like the musician's reading of a score.

51 Middleweight

ABCDEFGHIJKLMNOPQRSTUVWXYZ
&!?(),:;'abcdefghijklmnopqrstuvwxyz

The typographer's first duty is to the text itself. An intelligent interpretation of the text will not only ensure readability, but will also reflect its tone, its structure, and its cultural context. The typographer's analysis illuminates the text, like the musician's reading of a score.

73 Full Heviweight

Knockout typeface © The Hoefler Type Foundry, 1994. http://www.typography.com

News Gothic

Conceived as part of the process of modernizing 19th-century sans serif styles, News Gothic is a classic American Gothic face that has remained in widespread use. A companion to Franklin Gothic, with which it shares many characteristics, its regular form is both lighter in stroke width and more condensed.

The development of Franklin Gothic to include an extended range of weights and widths served to narrow the distinction between the two faces even further. Franklin Gothic was originally a display-weight face to which text-weight variants were added, while News Gothic was originated at a weight more suitable for text setting and has bold forms for display use.

The distinctions between them may be noted in the junction and arc of the n or m. In News Gothic the junctions lead to a straight stroke that then moderates into a curve from its highest point. The same junction in Franklin Gothic leads directly into a curved stroke with a greater moderation of stroke width.

IN CONTEXT

typography *n.* [ML f. Gk *typos*, impression, cast + *graphia*, writing] Art of printing; style or appearance of printed matter (*the typography was admirable*).

Italic and bold **weights** are conventionally used to indicate differentiation, emphasis, attributions, and quotations.

Typefaces or families With an *extended* range of **weights**, the designer has greater scope in *manipulating* these qualities.

KEY FEATURES

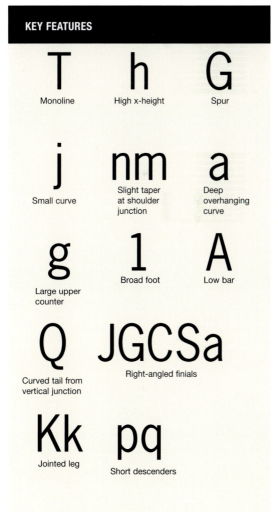

T — Monoline
h — High x-height
G — Spur
j — Small curve
nm — Slight taper at shoulder junction
a — Deep overhanging curve
g — Large upper counter
1 — Broad foot
A — Low bar
Q — Curved tail from vertical junction
JGCSa — Right-angled finials
Kk — Jointed leg
pq — Short descenders

NEWS GOTHIC: SELECTED ALPHABETS

ABCDEFGHIJKLMNOPQRSTUVWXYZ &!?(),:;'
abcdefghijklmnopqrstuvwxyz

The typographer's first duty is to the text itself. An intelligent interpretation of the text will not only ensure readability, but will also reflect its tone, its structure, and its cultural context. The typographer's analysis illuminates the text, like the musician's reading of a score.

Regular

ABCDEFGHIJKLMNOPQRSTUVWXYZ &!?(),:;'
abcdefghijklmnopqrstuvwxyz

The typographer's first duty is to the text itself. An intelligent interpretation of the text will not only ensure readability, but will also reflect its tone, its structure, and its cultural context. The typographer's analysis illuminates the text, like the musician's reading of a score.

Oblique

ABCDEFGHIJKLMNOPQRSTUVWXYZ &!?(),:;'
abcdefghijklmnopqrstuvwxyz

The typographer's first duty is to the text itself. An intelligent interpretation of the text will not only ensure readability, but will also reflect its tone, its structure, and its cultural context. The typographer's analysis illuminates the text, like the musician's reading of a score.

Bold

GOTHIC 821

ABCDEFGHIJKLMNOPQRSTUVWXYZ &!?(),:;'
abcdefghijklmnopqrstuvwxyz

The typographer's first duty is to the text itself. An intelligent interpretation of the text will not only ensure readability, but will also reflect its tone, its structure, and its cultural context. The typographer's analysis illuminates the text, like the musician's reading of a score.

HEINZ HOFFMAN, 1908

A condensed Germanic block letter with rounded corners, suitable for poster design and other display work.

GOTHIC 13

ABCDEFGHIJKLMNOPQRSTUVWXYZ &!?(),:;'
abcdefghijklmnopqrstuvwxyz

The typographer's first duty is to the text itself. An intelligent interpretation of the text will not only ensure readability, but will also reflect its tone, its structure, and its cultural context. The typographer's analysis illuminates the text, like the musician's reading of a score.

LINOTYPE STUDIOS, 1910

A rich and colorful display Grotesque with a condensed form, high x-height, and a nearly monoline stroke width.

TEMPO

ABCDEFGHIJKLMNOPQRSTUVWXYZ &!?(),:;'
abcdefghijklmnopqrstuvwxyz

The typographer's first duty is to the text itself. An intelligent interpretation of the text will not only ensure readability, but will also reflect its tone, its structure, and its cultural context. The typographer's analysis illuminates the text, like the musician's reading of a score.

ROBERT HUNTER MIDDLETON, 1931

A condensed bold Grotesque with right-angled terminals on the a and s, and an exaggerated angle to the oblique italic form.

BUREAU GROTESQUE

ABCDEFGHIJKLMNOPQRSTUVWXYZ &!?(),:;'
abcdefghijklmnopqrstuvwxyz

The typographer's first duty is to the text itself. An intelligent interpretation of the text will not only ensure readability, but will also reflect its tone, its structure, and its cultural context. The typographer's analysis illuminates the text, like the musician's reading of a score.

DAVID BERLOW, 1989–93

A family of 15 fonts that incorporates characteristics of mid-20th-century Grotesques across a numerically coded range of weights and widths.

TRADE GOTHIC

ABCDEFGHIJKLMNOPQRSTUVWXYZ &!?(),:;'
abcdefghijklmnopqrstuvwxyz

The typographer's first duty is to the text itself. An intelligent interpretation of the text will not only ensure readability, but will also reflect its tone, its structure, and its cultural context. The typographer's analysis illuminates the text, like the musician's reading of a score.

JACKSON BURKE, 1948

A typical early 20th-century Grotesque that appears more condensed in the heavier weights. An extended variant is also available.

MONOTYPE GROTESQUE

ABCDEFGHIJKLMNOPQRSTUVWXYZ &!?(),:;'
abcdefghijklmnopqrstuvwxyz

The typographer's first duty is to the text itself. An intelligent interpretation of the text will not only ensure readability, but will also reflect its tone, its structure, and its cultural context. The typographer's analysis illuminates the text, like the musician's reading of a score.

MONOTYPE STUDIOS, 1926

Formerly known as Grotesque 215, this is a mainstay among the Monotype display faces, with a clear broad form and good x-height.

MONOTYPE GROTESQUE BOLD

ABCDEFGHIJKLMNOPQRSTUVWXYZ &!?(),:;'abcdefghijklmnopqrstuvwxyz

The typographer's first duty is to the text itself. An intelligent interpretation of the text will not only ensure readability, but will also reflect its tone, its structure, and its cultural context. The typographer's analysis illuminates the text, like the musician's reading of a score.

MONOTYPE STUDIOS, 1926

The bold companion face to Monotype Grotesque, formerly known as Grotesque 216. It is a rich and vivid display and titling face.

GOTHAM

ABCDEFGHIJKLMNOPQRSTUVWXYZ &!?(),:;'
abcdefghijklmnopqrstuvwxyz

The typographer's first duty is to the text itself. An intelligent interpretation of the text will not only ensure readability, but will also reflect its tone, its structure, and its cultural context. The typographer's analysis illuminates the text, like the musician's reading of a score.

Gotham typeface © The Hoefler Type Foundry, 2000. http://www.typography.com

TOBIAS FRERE-JONES, 2002

Gotham is based upon an American architectural alphabet that forms the basis for a range of weights and width variants.

ABADI

ABCDEFGHIJKLMNOPQRSTUVWXYZ &!?(),:;'
abcdefghijklmnopqrstuvwxyz

The typographer's first duty is to the text itself. An intelligent interpretation of the text will not only ensure readability, but will also reflect its tone, its structure, and its cultural context. The typographer's analysis illuminates the text, like the musician's reading of a score.

CHONG WAH, 1987

A broad and somewhat geometric face, with a low x-height characteristic of early 20th-century Grotesques.

ERBAR

ABCDEFGHIJKLMNOPQRSTUVWXYZ &!?(),:;'
abcdefghijklmnopqrstuvwxyz

The typographer's first duty is to the text itself. An intelligent interpretation of the text will not only ensure readability, but will also reflect its tone, its structure, and its cultural context. The typographer's analysis illuminates the text, like the musician's reading of a score.

JAKOB ERBAR, 1922–30

A highly condensed display face with largely elliptical counter forms. Narrow lowercase letters and some angled finials add visual interest and contribute to a strong vertical emphasis.

NEO-GROTESQUE

The term Neo-Grotesque describes a second generation of Grotesques, designed in the 1950s, that formed a key component of Swiss typography and the international modernist style. Neo-Grotesques appear more mechanical than the earlier Grotesques, with less variation of stroke width, a wider set, and a noticeably higher x-height.

The foundation of the Neo-Grotesque genre is the 18th-century Grotesque typeface Akzidenz Grotesk, produced by the Berthold Foundry in 1896. This typeface was favored by typographers of the Swiss typographic school, and strongly influenced the design of Max Meidinger's Neue Haas Grotesk (later renamed Helvetica).

Important Neo-Grotesques

Helvetica differs from Akzidenz Grotesk primarily in having a much greater x-height and a slightly narrower set, both of which make it a more practical and economic face. Similar characteristics are found in Folio, designed by Konrad Bauer and Walter Baum.

Univers, designed by Adrian Frutiger for Deberny & Peignot, is a Neo-Grotesque systematically designed across an extended family of weights and widths. Avoiding the variations of form that enliven some earlier typeface families, or the peculiar compromises that occur when different weights are developed after the original, all the Univers family derives from the original conception of the typeface and are all mathematical variants of

a common model. The result is impressive in its thoroughness and consistency, if somewhat characterless.

A neutral face

It is a frequent criticism of Neo-Grotesques in general, and Helvetica in particular, that these letters are anonymous or mechanical in their appearance. It is true that they show less character than most other faces. This is both their weakness and their greatest strength. In many ways, they exemplify the ideal of type as a neutral vessel or carrier of meaning; an ideal of transparency summarized in Beatrice Warde's analogy of type as a crystal goblet, providing the minimum of visual interference between the reader and the text. They refer to no particular regional or decorative tradition, though their adoption as a key element of Swiss typographic modernism has meant that they are strongly associated with the design philosophies of their time.

Digital faces

Erik Spiekermann's Meta is available in an extensive range of weights, widths, and alphabets, including Greek and Cyrillic versions. Like many contemporary sans serif faces, it has both

NEO-GROTESQUE: CHARACTERISTIC FEATURES

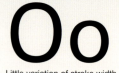

Oo — Little variation of stroke width

on — Slightly condensed form

Te — High x-height

ABC — Minimal contrast

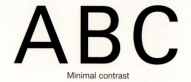

Q — Well-defined counters

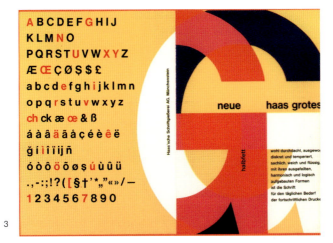

1 *Trust Me* **poster** Jennifer Sterling utilizes the highly legible but visually interesting Meta typeface in her innovative designs for Bhoss's *Trust Me* CD and related literature.

2 Wonder Brands poster
The functional and unpretentious appearance of Helvetica is put to ironic use in a conference poster by Paula Scher, drawing upon the vitality of "low end" advertising.

3 Type foundry sample The Haas Foundry's original specimen book for Neue Haas Grotesk, the earliest incarnation of Helvetica, demonstrates the typeface's geometric precision and the scope it provides for dynamic asymmetrical composition.

4 The Next Wave invitation The familiarity and apparent simplicity of Neo-Grotesques allows for radical use of positive and negative space across a complex format in this design by Kristine Matthews.

5 Theater poster Neo-Grotesque faces retain their legibility and remain highly functional even when layered at varying tonal densities in this design by Büro für Gestaltung.

Humanist and Grotesque characteristics. Arial, adopted as the default font by Microsoft, is a digital derivative of Helvetica. Though widely viewed as inferior in form by many typographers, it benefits from an exceptionally thorough process of hinting (see page 19), ensuring a consistency of form and readability on screen across all sizes, maintaining its legibility under conditions of low resolution.

Helvetica

Designed by Max Meidinger in 1957 and formerly known as Neue Haas Grotesk

Helvetica develops many of the characteristics that had made Akzidenz Grotesk a popular choice in pre-war and post-war modernist graphics. It differs from Akzidenz primarily in having a much greater x-height and a slightly narrower set, both of which make it a more practical and economic face. Widely adopted as the mark of Swiss typographic style, it remains the ideal of a stylistically neutral, "transparent" type, and became one of the most widely used typefaces of the 20th century. As the basis for numerous signage systems and a mainstay of information graphics, it established an identity as the typographic language of factual information. A typeface largely devoid of nuance, it acquired an authoritative voice through familiarity and repetition.

Helvetica has a number of derivatives, notably Geneva and Arial. The original form can be distinguished by the horizontal finials, which have been moderated in many of the later typefaces. It is available from several sources in a large number of weights and other versions, including rounded and outline faces. It is a highly legible face, as much by virtue of its familiarity as the inherent clarity of the letterforms, and functions well for the setting of text and as a deliberately neutral or minimalist choice for display setting.

IN CONTEXT

typography *n.* [ML f. Gk *typos*, impression, cast + *graphia*, writing] Art of printing; style or appearance of printed matter (*the typography was admirable*).

Italic and **bold** weights are conventionally used to indicate differentiation, emphasis, attributions, and quotations.

Typefaces or families With an *extended* range of **weights**, the designer has greater scope in *manipulating* these qualities.

KEY FEATURES

A — Flat apex

C — Narrow opening

Q — Straight angled tail

JSagk — Horizontal finials

G — Spur and wide bar

R — Wide bowl and curved leg

ij. — Square dots

t — Flat finial to ascender

K — Jointed leg

HELVETICA: SELECTED ALPHABETS

ABCDEFGHIJKLMNOPQRSTUVWXYZ &!?(),:;'
abcdefghijklmnopqrstuvwxyz

The typographer's first duty is to the text itself. An intelligent interpretation of the text will not only ensure readability, but will also reflect its tone, its structure, and its cultural context. The typographer's analysis illuminates the text, like the musician's reading of a score.

Roman

ABCDEFGHIJKLMNOPQRSTUVWXYZ &!?(),:;'
abcdefghijklmnopqrstuvwxyz

The typographer's first duty is to the text itself. An intelligent interpretation of the text will not only ensure readability, but will also reflect its tone, its structure, and its cultural context. The typographer's analysis illuminates the text, like the musician's reading of a score.

Italic

ABCDEFGHIJKLMNOPQRSTUVWXYZ &!?(),:;'
abcdefghijklmnopqrstuvwxyz

The typographer's first duty is to the text itself. An intelligent interpretation of the text will not only ensure readability, but will also reflect its tone, its structure, and its cultural context. The typographer's analysis illuminates the text, like the musician's reading of a score.

Bold

Univers

Designed by Adrian Frutiger in 1954–57 and issued by Deberny & Peignot in 1957

Univers represents the first modular type family. Systematically designed across an extended family of weights and widths, it comprises a matrix of options totaling 21 faces, coded by number, including 5 weights, and available in 4 widths: ultra condensed, condensed, regular, and extended.

Univers has been widely viewed as an alternative or competitor to Helvetica. It has a greater variation of stroke width and shows less affinity to the early 20th-century Grotesques, such as Akzidenz Grotesk. It was, as a consequence, less widely adopted into the graphic vocabulary of the Swiss school, but it is, in many ways, a more original and ambitious undertaking than Helvetica and achieves an admirable consistency across its range of weight and width.

Univers is a durable face that can prove particularly useful when a wide range of differentiation is required. The condensed versions can be effectively used as text faces, allowing for setting to narrower columns than would normally be feasible.

IN CONTEXT

typography *n.* [ML f. Gk *typos*, impression, cast + *graphia*, writing] Art of printing; style or appearance of printed matter (*the typography was admirable*).

Italic and **bold** weights are conventionally used to indicate differentiation, emphasis, attributions, and quotations.

Typefaces or families With an *extended* range of **weights**, the designer has greater scope in *manipulating* these qualities.

KEY FEATURES

Oo — Slightly square form

Q — Horizontal tail

Kk — Single junction at stem

Caecj — Horizontal finials

a — Square foot

g — Narrow opening

ypq — Short descenders

t — Angled ascender finial

e — Low bar

G — Bar with no spur

UNIVERS: SELECTED ALPHABETS

ABCDEFGHIJKLMNOPQRSTUVWXYZ &!?(),.:;'
abcdefghijklmnopqrstuvwxyz

The typographer's first duty is to the text itself. An intelligent interpretation of the text will not only ensure readability, but will also reflect its tone, its structure, and its cultural context. The typographer's analysis illuminates the text, like the musician's reading of a score.

55 Regular

ABCDEFGHIJKLMNOPQRSTUVWXYZ &!?(),.:;'
abcdefghijklmnopqrstuvwxyz

The typographer's first duty is to the text itself. An intelligent interpretation of the text will not only ensure readability, but will also reflect its tone, its structure, and its cultural context. The typographer's analysis illuminates the text, like the musician's reading of a score.

55 Oblique

ABCDEFGHIJKLMNOPQRSTUVWXYZ &!?(),.:;'
abcdefghijklmnopqrstuvwxyz

The typographer's first duty is to the text itself. An intelligent interpretation of the text will not only ensure readability, but will also reflect its tone, its structure, and its cultural context. The typographer's analysis illuminates the text, like the musician's reading of a score.

65 Bold

Meta

Developed by Erik Spiekermann in 1985 and released by FontShop in 1991

Representative of a new generation of sans serif faces developed in the 1990s, Meta is sometimes described as a Humanist Sans face. Like Jean-François Porchez's Parisine, Meta was initially designed as an alternative to the widely used Helvetica, and is perhaps best understood by reference to the dominant influence of the Neo-Grotesques of the 1950s. Like other late 20th-century sans serifs, it retains and enhances the functionality of the Swiss school while introducing a distinctive individuality of form. The use of complex curves and right-angled terminals is particularly noticeable in the forms of the c and s, and creates a greater openness in the partially enclosed forms of these letters. A curved foot effectively differentiates the lowercase l.

Meta is available in five weights, with a condensed form available in six. It also includes Greek and Cyrillic fonts, and versions are available to support a wide range of other languages. Meta is a highly legible text face with a distinctly modern character, which reveals additional levels of visual interest and variation when used for display purposes. It is also effective as a screen font.

IN CONTEXT

typography *n.* [ML f. Gk *typos*, impression, cast + *graphia*, writing] Art of printing; style or appearance of printed matter (*the typography was admirable*).

Italic and **bold** weights are conventionally used to indicate differentiation, emphasis, attributions, and quotations.

Typefaces or families With an *extended* range of weights, the designer has greater scope in **MANIPULATING** these qualities.

KEY FEATURES

Open curves | Low bar | Right-angled finials

Curved foot | Slight curve to right-angled finial base | Short bar

Flat apex | Angled stems | Open loop

Spur junction | High single junction at stem | Short arm

Low junction

META: SELECTED ALPHABETS

ABCDEFGHIJKLMNOPQRSTUVWXYZ &!?(),:;'
abcdefghijklmnopqrstuvwxyz

The typographer's first duty is to the text itself. An intelligent interpretation of the text will not only ensure readability, but will also reflect its tone, its structure, and its cultural context. The typographer's analysis illuminates the text, like the musician's reading of a score.

Normal

ABCDEFGHIJKLMNOPQRSTUVWXYZ &!?(),:;'
abcdefghijklmnopqrstuvwxyz

The typographer's first duty is to the text itself. An intelligent interpretation of the text will not only ensure readability, but will also reflect its tone, its structure, and its cultural context. The typographer's analysis illuminates the text, like the musician's reading of a score.

Italic

ABCDEFGHIJKLMNOPQRSTUVWXYZ &!?(),:;'
abcdefghijklmnopqrstuvwxyz

The typographer's first duty is to the text itself. An intelligent interpretation of the text will not only ensure readability, but will also reflect its tone, its structure, and its cultural context. The typographer's analysis illuminates the text, like the musician's reading of a score.

Bold

Bell Centennial

Bell Centennial is a condensed face designed for maximum economy and high legibility at small sizes, originally commissioned for the telephone directories of the Bell Company in the United States. The earlier Linotype face, Bell Gothic, had been used for this purpose since the late 1930s, but it had suffered a decline in print quality in the transition from metal to photosetting. Carter's Bell Centennial marked a significant advance in both legibility and economy of setting, in a type specifically designed to address the problems of small type printed on low-quality paper. In addition, the design is distinguished by the introduction of notched junctions. These counter both the distortion caused by the spread of light at the junctions of photoset letters, and the spread of ink in the printing of type on absorbent papers. They have subsequently been adopted as a stylistic feature by designers using the face at display sizes.

The original face was named for its functions within the directory: Bell Centennial name and number, and Bell Centennial address were followed by a companion face, the slightly wider Bell Centennial subcaption.

IN CONTEXT

typography n. [ML f. Gk typos, impression, cast + graphia, writing] Art of printing; style or appearance of printed matter (the typography was admirable).

Italic and **bold** weights are conventionally used to indicate differentiation, emphasis, attributions, and quotations.

Typefaces or families With an extended range of **weights**, the designer has greater scope in **MANIPULATING** these qualities.

KEY FEATURES

O
Monoline

Sg
Increased space in counterforms

J
Upturned tail resting on baseline

KMN
Notches at junctions

csry
Vertical finials

Q
Diagonal crossing tail

Kk
Jointed leg

R
Straight diagonal leg

G
Right-angled bar

nmh
High junctions from stems

BELL CENTENNIAL: SELECTED ALPHABETS

ABCDEFGHIJKLMNOPQRSTUVWXYZ &!?(),:;'
abcdefghijklmnopqrstuvwxyz

The typographer's first duty is to the text itself. An intelligent interpretation of the text will not only ensure readability, but will also reflect its tone, its structure, and its cultural context. The typographer's analysis illuminates the text, like the musician's reading of a score.

Address

ABCDEFGHIJKLMNOPQRSTUVWXYZ &!?(),:;'
abcdefghijklmnopqrstuvwxyz

The typographer's first duty is to the text itself. An intelligent interpretation of the text will not only ensure readability, but will also reflect its tone, its structure, and its cultural context. The typographer's analysis illuminates the text, like the musician's reading of a score.

Subcaption

ABCDEFGHIJKLMNOPQRSTUVWXYZ &!?(),:;'
abcdefghijklmnopqrstuvwxyz

The typographer's first duty is to the text itself. An intelligent interpretation of the text will not only ensure readability, but will also reflect its tone, its structure, and its cultural context. The typographer's analysis illuminates the text, like the musician's reading of a score.

Name and Number

ANTIQUE OLIVE

ABCDEFGHIJKLMNOPQRSTUVWXYZ &!?(),:;' abcdefghijklmnopqrstuvwxyz

The typographer's first duty is to the text itself. An intelligent interpretation of the text will not only ensure readability, but will also reflect its tone, its structure, and its cultural context. The typographer's analysis illuminates the text, like the musician's reading of a score.

ROGER ESCOFFON, 1966

An extended family of widths and weights, Antique Olive is a refined Neo-Grotesque with many subtleties of stroke width and unusually broad horizontals.

BELL GOTHIC

ABCDEFGHIJKLMNOPQRSTUVWXYZ &!?(),:;' abcdefghijklmnopqrstuvwxyz

The typographer's first duty is to the text itself. An intelligent interpretation of the text will not only ensure readability, but will also reflect its tone, its structure, and its cultural context. The typographer's analysis illuminates the text, like the musician's reading of a score.

C.H. GRIFFITH, 1937

A lightweight condensed Neo-Grotesque, enlivened by angled terminals on several lowercase letters.

FOLIO

ABCDEFGHIJKLMNOPQRSTUVWXYZ &!?0,:;' abcdefghijklmnopqrstuvwxyz

The typographer's first duty is to the text itself. An intelligent interpretation of the text will not only ensure readability, but will also reflect its tone, its structure, and its cultural context. The typographer's analysis illuminates the text, like the musician's reading of a score.

KONRAD BAUER AND WALTER BAUM, 1947

A substantial Neo-Grotesque with some subtle detailing in the graceful a and g forms. A condensed version is also available.

ARIAL

ABCDEFGHIJKLMNOPQRSTUVWXYZ &!?(),:; abcdefghijklmnopqrstuvwxyz

The typographer s first duty is to the text itself. An intelligent interpretation of the text will not only ensure readability, but will also reflect its tone, its structure, and its cultural context. The typographer s analysis illuminates the text, like the musician s reading of a score.

ROBIN NICHOLAS AND PATRICIA SAUNDERS, 1990–92

Developed and adopted as a default font by Microsoft, detailed hinting ensures a consistency of screen appearance for this widely used Helvetica derivative.

LETTER GOTHIC TEXT

ABCDEFGHIJKLMNOPQRSTUVWXYZ &!?(),:;' abcdefghijklmnopqrstuvwxyz

The typographer's first duty is to the text itself. An intelligent interpretation of the text will not only ensure readability, but will also reflect its tone, its structure, and its cultural context. The typographer's analysis illuminates the text, like the musician's reading of a score.

ALBERT PINAGGERA, 1998

A refined text version of the monospace Letter Gothic, characterized by the serifed I and the bar terminals of the I and J.

GOVAN

ABCDEFGHIJKLMNOPQRSTUVWXYZ &!?(),:;'
abcdefghijklmnopqrstuvwxyz

The typographer's first duty is to the text itself. An intelligent interpretation of the text will not only ensure readability, but will also reflect its tone, its structure, and its cultural context. The typographer's analysis illuminates the text, like the musician's reading of a score.

AOLE SCHAFER AND ERIK SPIEKERMAN, 2001

A heavy condensed display Gothic with a distinctive curved foot to the l and a set of lined superscript letters.

ITC CONDUIT

ABCDEFGHIJKLMNOPQRSTUVWXYZ &!?(),.:;'
abcdefghijklmnopqrstuvwxyz

The typographer's first duty is to the text itself. An intelligent interpretation of the text will not only ensure readability, but will also reflect its tone, its structure, and its cultural context. The typographer's analysis illuminates the text, like the musician's reading of a score.

MARK VAN BRONKHORST, 1997 AND 2002

A rectangular condensed face with an elegant small-cap font and some distinctive italic variants.

ITC TABULA

ABCDEFGHIJKLMNOPQRSTUVWXYZ &!?(),.:;'
abcdefghijklmnopqrstuvwxyz

The typographer's first duty is to the text itself. An intelligent interpretation of the text will not only ensure readability, but will also reflect its tone, its structure, and its cultural context. The typographer's analysis illuminates the text, like the musician's reading of a score.

JULIEN JANISZEWSKI, 2002

A square Grotesque available in four weights, with clean lines and good legibility at small sizes.

TAHOMA

ABCDEFGHIJKLMNOPQRSTUVWXYZ &!?(),:;'
abcdefghijklmnopqrstuvwxyz

The typographer's first duty is to the text itself. An intelligent interpretation of the text will not only ensure readability, but will also reflect its tone, its structure, and its cultural context. The typographer's analysis illuminates the text, like the musician's reading of a score.

MATTHEW CARTER, 1995

Designed for Microsoft as a screen font, Tahoma includes Greek and Cyrillic alphabets, and is particularly effective for web use.

VERDANA

ABCDEFGHIJKLMNOPQRSTUVWXYZ &!?(),:;'
abcdefghijklmnopqrstuvwxyz

The typographer's first duty is to the text itself. An intelligent interpretation of the text will not only ensure readability, but will also reflect its tone, its structure, and its cultural context. The typographer's analysis illuminates the text, like the musician's reading of a score.

MATTHEW CARTER, 1996

A development of the range and functionality of Tahoma, Verdana has a broader and more rounded form, and includes an italic.

GEOMETRIC

Geometric typefaces reflect the idea that type can be reduced to simple geometric units and cleansed of all historical associations. They are characteristic of the spirit of modernism that formed the dominant design ideology in Europe from the 1930s through the 1950s.

Like any idiom that is historically specific, the geometric typeface inevitably became a recognizable style in itself. Rather than achieving universal currency and widespread use, it came to symbolize a historic ideal of universality; a notion of modernity that already belongs to the past.

This genre stands in direct contrast to the revivalist craft-based tradition that inspired William Morris's Humanist revivals, and instead asserts the integrity of the machine and the irreducible qualities of geometric form. The assertion of geometric principles reflects a determination to eliminate from type design any symbolic value or reference to past tradition.

The Geometric ideal
Herbert Bayer's typeface Universal, designed in 1925, stands as the embodiment of the Geometric ideal, and its iconic status is reinforced by its use on the facade of the Bauhaus. A monoline, it is composed almost entirely of simple geometric units: straight lines, circles, and arcs. It is the rigorous application of this reductive principle that ironically gives it its character: the contrast between the ill-defined counters of the e and the full circular counters of the b; the truncated finial of the e; the unresolved reference to a hybridized capital form in the g; and the a that appears largely inconsistent with the geometry of the other letters.

Bayer's letters were redrawn for each successive use and were never fully developed as a working face. Universal has influenced many other attempts at geometric type, and has continued to have some limited use, most notably in Paul Rand's logo for the American Broadcast Corporation (using a more consistent and stabilized lowercase a). Universal was redrawn in Fontographer in 1991 by Matthew Carter. ITC Bauhaus has been described as a redrawing of Universal, but is actually a distinctive development in the solutions it finds to the problems of geometric monoline, introducing line breaks to resolve the cumbersome junctions of unadjusted strokes.

APPLICATIONS

Few Geometric sans serifs are entirely satisfactory for long text setting; the replication of a limited number of geometric components reduces the differentiation of letters, while circular counters can create obtrusive "holes," interrupting the smooth reading of a line of text. Geometrics are, above all, the expression of an idea, and as such carry a set of associative values fitting them better for display and semidisplay use.

GEOMETRIC: CHARACTERISTIC FEATURES

OEM
Geometric construction

Oo
Rigorous monoline stroke width

a
Single story

ABC
No contrast

pbdq
Circular counters

Jan Tschichold attempted a similar project with his own Universal of 1926. Recently revived as a digital face by The Foundry, it reflects a sensitivity characteristic of the graphic awareness that Tschichold brought to all of his work. It is a less rigorous expression of Geometric principles than Bayer Universal, and a considerably more attractive typeface.

Other important Geometrics

Futura was designed by Paul Renner and issued by the Bauer Foundry in Frankfurt. Recent research examined the disputed originality of Renner's initial designs, but his major achievement lies less in specific innovations of form than in the skill with which he developed an emerging modernist idiom into a durable, functional typeface. The radical design ideology of the Bauhaus and the principles of the New Typography were sensitively interpreted by Renner to produce a face that has become a 20th-century classic. Futura as we know it today is particularly notable among early 20th-century type families for the fact that it maintains its coherence across an extended range of weights. Though not all of these were originated by Renner, it is a reflection of the integrity of his original letterforms that they provided such a clear foundation for development.

Avant Garde was designed by Herb Lubalin as a display face while Lubalin was art editor for the magazine of the same name. It was originally designed as a titling face and incorporated an ingenious range of capital ligatures to maintain the very tight setting for which it was designed. It is a fully geometric face, with very few of the adjustments to junctions seen in Renner's Futura. The geometric rigor provides for a dramatic set of capital forms and a rather less satisfactory lowercase. Avant Garde proved ideally suited to digitization, since its simplicity of form requires fewer bitmap points, and therefore less memory, than most faces. As a consequence, a severely reduced and unsatisfactory version of Avant Garde is widely available.

Kabel, designed by Rudolf Koch for the Klingspor Foundry in 1927–30, was radically redrawn for ITC in 1986 with a noticeably greater x-height. It is a colorful Geometric with slightly more of a Humanist flavor than Avant Garde. The angled bar of the e makes an unexpected allusion to Humanist letters, or possibly to a Hellenic model.

The square model

The term Geometric should also include those typefaces constructed upon a square model, in which the use of curved strokes has either been minimized or removed completely. These are predominantly display faces, though the proportion of the square informs the design of more comprehensive faces, such as Eurostile. An important historic model can be found in the square letters designed by Theo van Doesberg in 1928, revived in digital form in the 1990s by The Foundry as Architype Aubette.

1

2

3

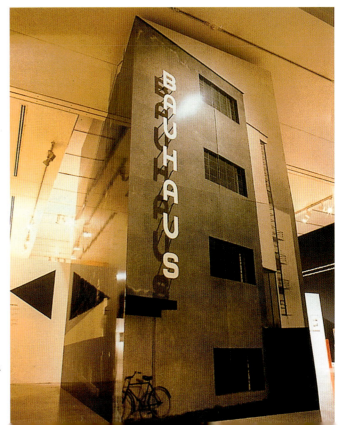

4

1 Type foundry sample This piece from the Bauer Foundry's leaflet advertising the release of Futura in 1927 shows the type's dynamism and versatility.

2 Type foundry sample The cover design of this specimen piece issued by the Klingspor Foundry in 1929 emphasizes the characteristics of Kabel, notably the angled finials and the drastic variation in character width.

3 Ariane's Cup poster 2002 A contemporary square Geometric type contrasts effectively with the curvilinear forms of the sail in this poster for a boat race sponsored by the European Space Agency, designed by Eggers+Diaper.

4 Bauhaus façade reconstruction Exhibition design by John and Orna Designs reconstructing the façade of the Dessau Bauhaus, featuring Herbert Bayer's Universal type, held at London's Design Museum, 2000.

Avant Garde Gothic

Designed by Herb Lubalin, Ed Benguiat, and Tom Carnase in the late 1960s

ITC Avant Garde Gothic was developed from the titling face designed by Lubalin for *Avant Garde* magazine, but it does not include the extended range of capital ligatures and alternates that chararacterized and enlivened Lubalin's original. Avant Garde was originally designed to be set very tight, and numerous variant forms were devised to maintain an even rhythm of letter spacing and to incorporate the overlapping of certain letters into the design.

Subsequent decades saw Avant Garde increasingly adopted for use as a text face. While the rigid geometry of the design is tempered in the junctions of some letters, the lowercase is in many ways less satisfactory than the capitals, revealing many of the shortcomings of Geometric sans serifs when used for text setting. The repetition of geometric forms can impede differentiation between letters, and the circular counters can be visually intrusive.

The typographic expression of an abstract idea that is most fully resolved in its capital letters, Avant Garde Gothic is at its most effective when used as a titling face.

IN CONTEXT

typography *n.* (ML f. Gk *typos*, impression, cast + *graphia*, writing) Art of printing; style or appearance of printed matter (*the typography was admirable*).

Italic and **bold** weights are conventionally used to indicate differentiation, emphasis, attributions, and quotations.

Typefaces or families With an *extended* range of **weights**, the designer has greater scope in *manipulating* these qualities.

AVANT GARDE GOTHIC: SELECTED ALPHABETS

ABCDEFGHIJKLMNOPQRSTUVWXYZ &!?(),:;'
abcdefghijklmnopqrstuvwxyz

The typographer's first duty is to the text itself. An intelligent interpretation of the text will not only ensure readability, but will also reflect its tone, its structure, and its cultural context. The typographer's analysis illuminates the text, like the musician's reading of a score.

Book

ABCDEFGHIJKLMNOPQRSTUVWXYZ &!?(),:;'
abcdefghijklmnopqrstuvwxyz

The typographer's first duty is to the text itself. An intelligent interpretation of the text will not only ensure readability, but will also reflect its tone, its structure, and its cultural context. The typographer's analysis illuminates the text, like the musician's reading of a score.

Book Oblique

ABCDEFGHIJKLMNOPQRSTUVWXYZ &!?(),:;'
abcdefghijklmnopqrstuvwxyz

The typographer's first duty is to the text itself. An intelligent interpretation of the text will not only ensure readability, but will also reflect its tone, its structure, and its cultural context. The typographer's analysis illuminates the text, like the musician's reading of a score.

Bold

KEY FEATURES

Oapq — Circular counters

bd — Minimal tapering at junctions

a — Single story

e — Low bar

Q — Wave tail from inside counter

t — Vertical foot and symmetrical bar

EF — Full-width bars

G — Wide bar

ij — Vertical rectangular dots

R — Open counter

CGSsJ — Horizontal finials

jz — Vertical finials

V — Wide angled

Y — Low junction

w — Low apex

k — Stepped joint, short leg, and low junction at stem

Futura

Designed by Paul Renner in 1924–26 and issued by the Bauer Foundry in 1927

The originality of Renner's initial designs is the subject of dispute, but his major achievement lies less in specific innovations of form than in the skill with which he developed an emerging modernist idiom into a durable, functional typeface. The radical design ideology of the Bauhaus and the principles of the New Typography were sensitively interpreted by Renner to produce a face that has become a 20th-century classic.

It is essentially a geometric modernist typeface, and embodies the emerging typographic principles of the Bauhaus (as seen in Herbert Bayer's Universal type). However, this geometry is tempered by refinements of detail and proportion that make it far more harmonious than many more rigidly geometric faces.

The strokes are monoline but with a compensatory tapering toward junctions, a quality also found in Gill Sans. The proportions of the letters are determined largely by their own geometric characteristics but allude subtly to the classical proportions of Humanist Sans type. Futura is notable among early 20th-century type families for the fact that it maintains its coherence across an extended range of weights. It can be used as a text and a display face.

IN CONTEXT

typography *n.* [ML f. Gk *typos*, impression, cast + *graphia*, writing] Art of printing; style or appearance of printed matter (*the typography was admirable*).

Italic and **bold** weights are conventionally used to indicate differentiation, emphasis, attributions, and quotations.

Typefaces or families With an *extended* range of **weights**, the designer has greater scope in *manipulating* these qualities.

KEY FEATURES

AM	C	E
Pointed apex	Vertical finials and wide opening	High, full-width bar
J	Q	hkd
Angled finial	Straight tail with horizontal finials	High ascenders
i	o	t
Straight vertical descender	Circular	Vertical foot
gky	f	Kk
Horizontal finials	Short loop with angled finial	Single junction at stem

FUTURA: SELECTED ALPHABETS

ABCDEFGHIJKLMNOPQRSTUVWXYZ &!?(),.:;'
abcdefghijklmnopqrstuvwxyz

The typographer's first duty is to the text itself. An intelligent interpretation of the text will not only ensure readability, but will also reflect its tone, its structure, and its cultural context. The typographer's analysis illuminates the text, like the musician's reading of a score.

Regular

ABCDEFGHIJKLMNOPQRSTUVWXYZ &!?(),.:;'
abcdefghijklmnopqrstuvwxyz

The typographer's first duty is to the text itself. An intelligent interpretation of the text will not only ensure readability, but will also reflect its tone, its structure, and its cultural context. The typographer's analysis illuminates the text, like the musician's reading of a score.

Oblique

ABCDEFGHIJKLMNOPQRSTUVWXYZ &!?(),.:;'
abcdefghijklmnopqrstuvwxyz

The typographer's first duty is to the text itself. An intelligent interpretation of the text will not only ensure readability, but will also reflect its tone, its structure, and its cultural context. The typographer's analysis illuminates the text, like the musician's reading of a score.

Bold

Kabel

Designed by Rudolf Koch for the Klingspor Foundry in 1927–30; redrawn by ITC in 1986

Kabel is a somewhat idiosyncratic monoline face with a number of distinctive features. The angled bar of the lowercase e evokes Humanist faces, and the crossed form of the W is seldom found in sans serif type.

Koch's original had a low x-height that was dramatically revised in the ITC version, improving legibility but perhaps compromising the geometric proportions of the original. Kabel is currently available in five weights. Many of the more obtrusive aspects of the original are moderated in the demi and bold weights, which have a more balanced form and are better suited for text use than the lighter weights. The latter tend to emphasize the rigorous geometry of the face and are best reserved for display purposes.

Kabel is a product of its time and evokes a particular early modernist enthusiasm for geometric forms. This serves to define the contexts in which its use would now be appropriate, and its limitations as a face for more general use.

IN CONTEXT

typography n. [ML f. Gk typos, impression, cast + graphia, writing] Art of printing; style or appearance of printed matter (the typography was admirable).

Italic and **bold** weights are conventionally used to indicate differentiation, emphasis, attributions, and quotations.

Typefaces or families With an extended range of **weights**, the designer has greater scope in **manipulating** these qualities.

KABEL: SELECTED ALPHABETS

ABCDEFGHIJKLMNOPQRSTUVWXYZ &!?(),:;'
abcdefghijklmnopqrstuvwxyz

The typographer's first duty is to the text itself. An intelligent interpretation of the text will not only ensure readability, but will also reflect its tone, its structure, and its cultural context. The typographer's analysis illuminates the text, like the musician's reading of a score.

Light

ABCDEFGHIJKLMNOPQRSTUVWXYZ &!?(),:;'
abcdefghijklmnopqrstuvwxyz

The typographer's first duty is to the text itself. An intelligent interpretation of the text will not only ensure readability, but will also reflect its tone, its structure, and its cultural context. The typographer's analysis illuminates the text, like the musician's reading of a score.

Book

ABCDEFGHIJKLMNOPQRSTUVWXYZ &!?(),:;'
abcdefghijklmnopqrstuvwxyz

The typographer's first duty is to the text itself. An intelligent interpretation of the text will not only ensure readability, but will also reflect its tone, its structure, and its cultural context. The typographer's analysis illuminates the text, like the musician's reading of a score.

Black

KEY FEATURES

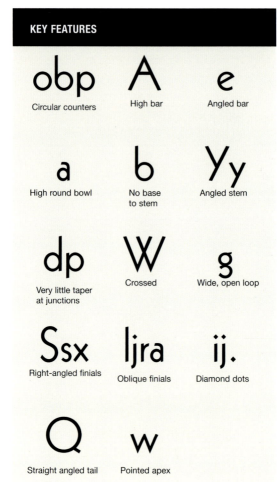

obp — Circular counters

A — High bar

e — Angled bar

a — High round bowl

b — No base to stem

Yy — Angled stem

dp — Very little taper at junctions

W — Crossed

g — Wide, open loop

Ssx — Right-angled finials

ljra — Oblique finials

ij. — Diamond dots

Q — Straight angled tail

w — Pointed apex

Eurostile

Eurostile is a very square monoline face with a high x-height and a distinct 1960s period flavor. Like Novarese's earlier Microgramma, it is based around a fairly rigid and unvarying geometry, and both capital and lowercase letters are fitted to uniform widths. While this lends the typeface an abstract consistency of form, it is a distortion of recognized proportion and hinders legibility.

Primarily a display face, it may be used for the setting of small amounts of continuous text, and although the broad square form is not economical, its high x-height ensures reasonable legibility in the lowercase letters. Its mathematical consistency also makes it a moderately effective face for screen use.

Eurostile is produced in three weights, and condensed and extended versions are available.

IN CONTEXT

typography *n.* [ML f. Gk *typos*, impression, cast + *graphia*, writing] Art of printing; style or appearance of printed matter (*the typography was admirable*).

Italic and **bold** weights are conventionally used to indicate differentiation, emphasis, attributions, and quotations.

Typefaces or families With an *extended* range of **weights**, the designer has greater scope in *manipulating* these qualities.

KEY FEATURES

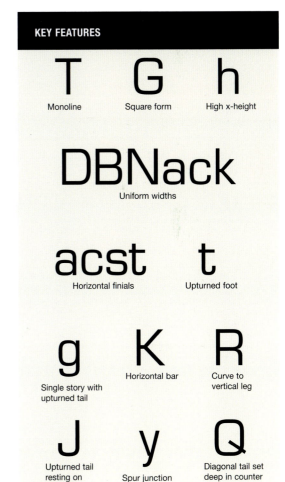

T — Monoline
G — Square form
h — High x-height

DBNack — Uniform widths

acst — Horizontal finials
t — Upturned foot

g — Single story with upturned tail
K — Horizontal bar
R — Curve to vertical leg

J — Upturned tail resting on baseline
y — Spur junction
Q — Diagonal tail set deep in counter

EUROSTILE: SELECTED ALPHABETS

ABCDEFGHIJKLMNOPQRSTUVWXYZ &!?(),:;'
abcdefghijklmnopqrstuvwxyz

The typographer's first duty is to the text itself. An intelligent interpretation of the text will not only ensure readability, but will also reflect its tone, its structure, and its cultural context. The typographer's analysis illuminates the text, like the musician's reading of a score.

Regular

ABCDEFGHIJKLMNOPQRSTUVWXYZ &!?(),:;'
abcdefghijklmnopqrstuvwxyz

The typographer's first duty is to the text itself. An intelligent interpretation of the text will not only ensure readability, but will also reflect its tone, its structure, and its cultural context. The typographer's analysis illuminates the text, like the musician's reading of a score.

Oblique

ABCDEFGHIJKLMNOPQRSTUVWXYZ &!?(),:;'
abcdefghijklmnopqrstuvwxyz

The typographer's first duty is to the text itself. An intelligent interpretation of the text will not only ensure readability, but will also reflect its tone, its structure, and its cultural context. The typographer's analysis illuminates the text, like the musician's reading of a score.

Bold

ITC BAUHAUS

ABCDEFGHIJKLMNOPQRSTUVWXYZ &!?(),:;'
abcdefghijklmnopqrstuvwxyz

The typographer's first duty is to the text itself. An intelligent interpretation of the text will not only ensure readability, but will also reflect its tone, its structure, and its cultural context. The typographer's analysis illuminates the text, like the musician's reading of a score.

ED BENGUIAT AND VICTOR CARUSO, 1975

Very freely adapted from Herbert Bayer's Universal type, ITC Bauhaus is a display face with open counters and a strictly geometric form, based upon circles and straight lines.

ITC SERIF GOTHIC

ABCDEFGHIJKLMNOPQRSTUVWXYZ &!?(),:;'
abcdefghijklmnopqrstuvwxyz

The typographer's first duty is to the text itself. An intelligent interpretation of the text will not only ensure readability, but will also reflect its tone, its structure, and its cultural context. The typographer's analysis illuminates the text, like the musician's reading of a score.

HERB LUBALIN AND ANTONIO DISPAGNA, 1993

A Geometric based around a circular form with a minimal flare serif, suggestive of art deco and Glyphic letters.

BERNHARD GOTHIC

ABCDEFGHIJKLMNOPQRSTUVWXYZ &!?(),:;'
abcdefghijklmnopqrstuvwxyz

The typographer's first duty is to the text itself. An intelligent interpretation of the text will not only ensure readability, but will also reflect its tone, its structure, and its cultural context. The typographer's analysis illuminates the text, like the musician's reading of a score.

LUCIAN BERNHARD, 1930

Low bars, angled finials, and a very low x-height combine in a decorative Geometric most suitable for display purposes.

SUPER GROTESK

ABCDEFGHIJKLMNOPQRSTUVWXYZ &!?(),:;'
abcdefghijklmnopqrstuvwxyz

The typographer's first duty is to the text itself. An intelligent interpretation of the text will not only ensure readability, but will also reflect its tone, its structure, and its cultural context. The typographer's analysis illuminates the text, like the musician's reading of a score.

SVEND SMITAL, 1999

An open, lightweight Geometric with a low x-height, Super Grotesk includes non-lining capitals, and is also available in a condensed version.

SPARTAN

ABCDEFGHIJKLMNOPQRSTUVWXYZ &!?(),:;'abcdefghijklmnopqrstuvwxyz

The typographer's first duty is to the text itself. An intelligent interpretation of the text will not only ensure readability, but will also reflect its tone, its structure, and its cultural context. The typographer's analysis illuminates the text, like the musician's reading of a score.

RICK CUSICK, 1951

Spartan has many of the characteristics of Futura, including the single-story a, but has a flattened apex to the capitals and a less extensive range of weights.

NEUZEIT GROTESK

ABCDEFGHIJKLMNOPQRSTUVWXYZ &!?(),:;'
abcdefghijklmnopqrstuvwxyz

The typographer's first duty is to the text itself. An intelligent interpretation of the text will not only ensure readability, but will also reflect its tone, its structure, and its cultural context. The typographer's analysis illuminates the text, like the musician's reading of a score.

WILHELM PISCHNER, 1928

Similar to Futura and anticipating the design of Avant Garde, Neuzeit is distinguished by a low bar, the bar head terminal of the J, and the geometric leg of the R.

20TH CENTURY

ABCDEFGHIJKLMNOPQRSTUVWXYZ &!?(),:;'
abcdefghijklmnopqrstuvwxyz

The typographer's first duty is to the text itself. An intelligent interpretation of the text will not only ensure readability, but will also reflect its tone, its structure, and its cultural context. The typographer's analysis illuminates the text, like the musician's reading of a score.

SOL HESS, 1954

A derivative of Futura, 20th Century is distinguished by marginally shorter ascenders and a broader M and W.

AVENIR

ABCDEFGHIJKLMNOPQRSTUVWXYZ &!?(),:;'
abcdefghijklmnopqrstuvwxyz

The typographer's first duty is to the text itself. An intelligent interpretation of the text will not only ensure readability, but will also reflect its tone, its structure, and its cultural context. The typographer's analysis illuminates the text, like the musician's reading of a score.

ADRIAN FRUTIGER, 1988

A balanced and restrained Geometric with a Humanist sensitivity in may of its letterfoms, Avenir requires fairly loose letter spacing.

SERPENTINE

ABCDEFGHIJKLMNOPQRSTUVWXYZ &!?(),:;'
abcdefghijklmnopqrstuvwxyz

The typographer's first duty is to the text itself. An intelligent interpretation of the text will not only ensure readability, but will also reflect its tone, its structure, and its cultural context. The typographer's analysis illuminates the text, like the musician's reading of a score.

DICK JENSEN, 1972

A dramatic square face, enlivened by contrasting stroke widths and a slight flare serif, with a dynamic italic form.

POP

ABCDEFGHIJKLMNOPQRSTUVWXYZ &!?(),:;'
abcdefghijklmnopqrstuvwxyz

The typographer's first duty is to the text itself. An intelligent interpretation of the text will not only ensure readability, but will also reflect its tone, its structure, and its cultural context. The typographer's analysis illuminates the text, like the musician's reading of a score.

NEVILLE BRODY, 1992

A condensed display face, designed to a rigid geometric grid, with a colorful balance of positive and negative space.

GLYPHIC

This is a category of carved or inscribed type with its origins in both the history and the contemporary practice of letter cutting, and its main exponents have been equally distinguished in the letter crafts.

Glyphics are primarily a titling form and many have no lowercase. Mantinia and Trajan exist only in capital form. Some of the Germanic Glyphics can be effectively used for limited amounts of text setting, providing a tonal depth similar to that of the heavier Humanist revival faces. Their weight can create more dramatic color in a text page but their application in this context is fairly specialized.

Sometimes known as Flare Serif or Inscriptional, Glyphic is a useful classification for letters in which the stem broadens toward the terminal, and that could be described as having either a vestigial serif or a waisted stem. The category includes those letters based upon classical incised forms, such as Carol Twombly's Trajan, but applies in particular to faces based upon relief letters, in which the surrounding background has been chiseled away.

Germanic Glyphics

A defining example is Albertus, designed by Berthold Wolpe for Monotype. A natural expression of Wolpe's work as a lettering artist, this is typical of the Germanic tradition of Glyphics, also evident in the typefaces of Rudolf Koch, with whom Wolpe studied. The heavier Glyphics allow for a complex interplay between positive and negative forms that has been a characteristic of German and Eastern European display typography.

Though the forms are Roman, the sensitivity to color and the interrelationship of positive and negative space reflects the vivid contrasts of the 20th-century Blackletter, a graphic vocabulary in which both Koch and Wolpe were proficient. Some Glyphic forms allude specifically to Blackletter tradition, whereas many others take their form and proportion from the Roman letter while retaining a Blackletter accent in their contrast and dynamics.

The key characteristics of the form can also be seen in Rudolf Koch's typefaces Neuland and ITC Werkstatte, and in Adrian Frutiger's Rusticana. Rusticana is based upon early Mediterranean inscriptional letters, an influence that is shared by Carol Twombly's Lithos.

Classical inscriptions

Twombly's Trajan is a faithful and sensitive transcription of the Roman letters on the Trajan column, and is widely used in book jacket design; its combination of visual elegance and the gravitas implied by its classical origins have made it a favored choice in the packaging of contemporary literary fiction.

GLYPHIC: CHARACTERISTIC FEATURES

Chiseled form

Sharp terminals or serifs

Waisted stems

Angled finials

Poppl Laudatio, designed by Friedrich Poppl for Berthold 1982, is a Glyphic with a high x-height and generous counters that make it more suitable for the setting of text than most Glyphics. Matthew Carter's Mantinia is based upon the inscriptional lettering on Italian painter Andrea Mantegna's *The Entombment* from the 1470s. It includes an extensive and beautifully considered range of alternates, tall caps, ligatures, and superiors.

1 Type foundry sample Set in Optima in two languages, this typographic poem shows the subtle curves to the waisted strokes. The even visual rhythm is enhanced by the introduction of lowercase letters and an unusual customized ligature.

2 *Preoccupations* book jacket A book cover showing the rich and imposing forms of Albertus, a quintessential Glyphic typeface.

3 Musée des Beaux-Arts poster Mantinia, a typeface based upon inscriptional lettering, has a breadth and solidity that creates a strong horizontal continuity, making it eminently suitable for Philippe Apeloig's poster design, with its complex use of intercharacter space.

TRAJAN

Designed by Carol Twombly in 1989 as a faithful transcription of the 1st-century AD letters on the Trajan column in Rome

Because of its origins, Trajan does not have a minuscule lowercase but has instead a small-cap lowercase, comprising capital forms of a slightly lower height. It has proved an extremely popular titling face, combining classical authority with great refinement of form.

Trajan is available in regular and bold weights, and is suitable for a range of titling functions. It is also suitable for architectural and environmental use, particularly in contexts involving reference to classical concepts or values. If it is to be paired with a text face, this should be based upon similar classical proportions, and care should be taken to complement the delicacy of the strokes and serifs.

IN CONTEXT

TYPOGRAPHY N. [ML F. GK TYPOS, IMPRESSION, CAST AND GRAPHIA, WRITING] ART OF PRINTING; STYLE OR APPEARANCE OF PRINTED MATTER (THE TYPOGRAPHY WAS ADMIRABLE).

ITALIC AND **BOLD** WEIGHTS ARE CONVENTIONALLY USED TO INDICATE DIFFERENTIATION, EMPHASIS, ATTRIBUTIONS, AND QUOTATIONS.

TYPEFACES OR FAMILIES WITH AN EXTENDED RANGE OF WEIGHTS, THE DESIGNER HAS GREATER SCOPE IN **MANIPULATING** THESE QUALITIES.

7PT

TRAJAN: SELECTED ALPHABETS

ABCDEFGHIJKLMNOPQRSTUVWXYZ &!?(),:;'

THE TYPOGRAPHER'S FIRST DUTY IS TO THE TEXT ITSELF. AN INTELLIGENT INTERPRETATION OF THE TEXT WILL NOT ONLY ENSURE READABILITY, BUT WILL ALSO REFLECT ITS TONE, ITS STRUCTURE, AND ITS CULURAL CONTEXT. THE TYPOGRAPHER'S ANALYSIS ILLUMINATES THE TEXT, LIKE THE MUSICIAN'S READING OF A SCORE.

Regular

ABCDEFGHIJKLMNOPQRSTUVWXYZ &!?(),:;'

THE TYPOGRAPHER'S FIRST DUTY IS TO THE TEXT ITSELF. AN INTELLIGENT INTERPRETATION OF THE TEXT WILL NOT ONLY ENSURE READABILITY, BUT WILL ALSO REFLECT ITS TONE, ITS STRUCTURE, AND ITS CULURAL CONTEXT. THE TYPOGRAPHER'S ANALYSIS ILLUMINATES THE TEXT, LIKE THE MUSICIAN'S READING OF A SCORE.

Bold

KEY FEATURES

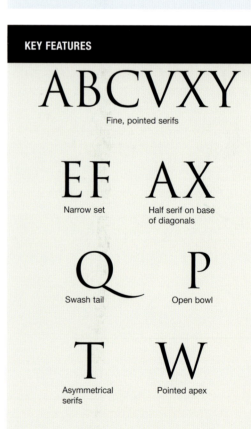

ABCVXY
Fine, pointed serifs

EF
Narrow set

AX
Half serif on base of diagonals

Q
Swash tail

P
Open bowl

T
Asymmetrical serifs

W
Pointed apex

Albertus

Albertus is the typographic expression of a lettercutter's sensibility, and reflects Wolpe's awareness of both carved relief letters and calligraphic form. The Glyphic flare or vestigial serif animates the imposing Humanist letterforms, while the inclined stress and calligraphic inflection introduce subtle modulations of width into the curved strokes.

Although Albertus has a serviceable lowercase that can be used for the setting of limited amounts of text, it is primarily a display face and is frequently used for its capitals alone. These offer a colorful interaction between positive and negative space, characteristic of a designer whose frame of reference encompassed both Roman and Blackletter traditions.

Albertus is available in two weights: light and regular. It has a distinctive and noticeably condensed italic form, which is exceptionally lively and can be more effective than the lowercase roman for the setting of continuous text.

IN CONTEXT

typography *n.* [ML f. Gk *typos*, impression, cast + *graphia*, writing] Art of printing; style or appearance of printed matter *(the typography was admirable).*

Italic and **bold** weights are conventionally used to indicate differentiation, emphasis, attributions, and quotations.

Typefaces or families With an *extended* range of weights, the designer has greater scope in **manipulating** these qualities.

KEY FEATURES

I — Broadening stroke or flare serif

rb — Pronounced taper at junctions

NM — Overhanging diagonals

PR — Narrow bowls

U — Stem

&T — Distinctive x-height ampersand

JJJ — Bar head on bold and italic

ALBERTUS: SELECTED ALPHABETS

ABCDEFGHIJKLMNOPQRSTUVWXYZ &!?(),.;'
abcdefghijklmnopqrstuvwxyz

The typographer's first duty is to the text itself. An intelligent interpretation of the text will not only ensure readability, but will also reflect its tone, its structure, and its cultural context. The typographer's analysis illuminates the text, like the musician's reading of a score.

Light

ABCDEFGHIJKLMNOPQRSTUVWXYZ &!?(),.;'
abcdefghijklmnopqrstuvwxyz

The typographer's first duty is to the text itself. An intelligent interpretation of the text will not only ensure readability, but will also reflect its tone, its structure, and its cultural context. The typographer's analysis illuminates the text, like the musician's reading of a score.

Italic

ABCDEFGHIJKLMNOPQRSTUVWXYZ &!?(),.;'
abcdefghijklmnopqrstuvwxyz

The typographer's first duty is to the text itself. An intelligent interpretation of the text will not only ensure readability, but will also reflect its tone, its structure, and its cultural context. The typographer's analysis illuminates the text, like the musician's reading of a score.

Regular

LITHOS

Lithos has a strongly Hellenic flavor and makes colorful use of many of the characteristics of the early Mediterranean letter. It is animated by its right-angled terminals, the tensile curves of the c and d, and stems that are inclined just off the vertical. It has five weights, ranging from a very fine linear lightweight to a graphically rich black.

True to its sources, Lithos does not have a minuscule lowercase, but has instead a small-cap case comprising capital forms of a slightly lower height. It features a full set of accented characters and a Greek font, featuring a number of alternates.

Lithos is a culturally specific display face that embodies references that are appropriate to a particular range of contexts, since its historical and cultural associations require sensitive treatment.

IN CONTEXT

TYPOGRAPHY N. [ML F. GK TYPOS, IMPRESSION, CAST AND GRAPHIA, WRITING] ART OF PRINTING; STYLE OR APPEARANCE OF PRINTED MATTER (THE TYPOGRAPHY WAS ADMIRABLE).

ITALIC AND **BOLD** WEIGHTS ARE CONVENTIONALLY USED TO INDICATE DIFFERENTIATION, EMPHASIS, ATTRIBUTIONS, AND QUOTATIONS.

TYPEFACES OR FAMILIES WITH AN EXTENDED RANGE OF **WEIGHTS**, THE DESIGNER HAS GREATER SCOPE IN **MANIPULATING** THESE QUALITIES.

7PT

KEY FEATURES

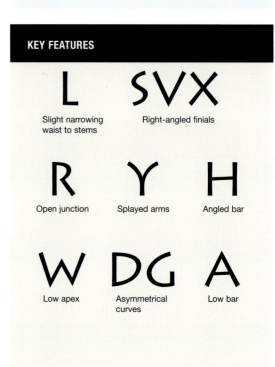

L — Slight narrowing waist to stems

SVX — Right-angled finials

R — Open junction

Y — Splayed arms

H — Angled bar

W — Low apex

DG — Asymmetrical curves

A — Low bar

LITHOS: SELECTED ALPHABETS

ABCDEFGHIJKLMNOPQRSTUVWXYZ &!?(),:;'

THE TYPOGRAPHER'S FIRST DUTY IS TO THE TEXT ITSELF. AN INTELLIGENT INTERPRETATION OF THE TEXT WILL NOT ONLY ENSURE READABILITY, BUT WILL ALSO REFLECT ITS TONE, ITS STRUCTURE, AND ITS CULTURAL CONTEXT. THE TYPOGRAPHER'S ANALYSIS ILLUMINATES THE TEXT, LIKE THE MUSICIAN'S READING OF A SCORE.

Extra Light

ABCDEFGHIJKLMNOPQRSTUVWXYZ &!?(),:;'

THE TYPOGRAPHER'S FIRST DUTY IS TO THE TEXT ITSELF. AN INTELLIGENT INTERPRETATION OF THE TEXT WILL NOT ONLY ENSURE READABILITY, BUT WILL ALSO REFLECT ITS TONE, ITS STRUCTURE, AND ITS CULTURAL CONTEXT. THE TYPOGRAPHER'S ANALYSIS ILLUMINATES THE TEXT, LIKE THE MUSICIAN'S READING OF A SCORE.

Regular

ABCDEFGHIJKLMNOPQRSTUVWXYZ &!?(),:;'

THE TYPOGRAPHER'S FIRST DUTY IS TO THE TEXT ITSELF. AN INTELLIGENT INTERPRETATION OF THE TEXT WILL NOT ONLY ENSURE READABILITY, BUT WILL ALSO REFLECT ITS TONE, ITS STRUCTURE, AND ITS CULTURAL CONTEXT. THE TYPOGRAPHER'S ANALYSIS ILLUMINATES THE TEXT, LIKE THE MUSICIAN'S READING OF A SCORE.

Bold

NEULAND

Designed by Rudolf Koch for the Klingspor Foundry in 1923

Neuland is a bold and vivid face with suggestions of both Fraktur and Mediterranean forms. Koch cut the punches for this face freehand, without preliminary drawings, and some of the spontaneity of this achievement is retained in the digital version, although the variations between letters of different sizes of punch was standardized to a single set of masters.

Koch worked extensively in the Blackletter tradition, and an intuitive awareness of the graphic contrasts of Blackletter colors his display faces. Variations in the angle of finials and the base strokes of letters animate a heavy form in which the relationships of positive and negative space are dramatic but highly readable. It is a unique set of forms, produced in a single weight with no lowercase.

IN CONTEXT

TYPOGRAPHY N. [ML F. GK TYPOS, IMPRESSION, CAST + GRAPHIA, WRITING] ART OF PRINTING; STYLE OR APPEARANCE OF PRINTED MATTER (THE TYPOGRAPHY WAS ADMIRABLE).

ITALIC AND BOLD WEIGHTS ARE CONVENTIONALLY USED TO INDICATE DIFFERENTIATION, EMPHASIS, ATTRIBUTIONS, AND QUOTATIONS.

TYPEFACES OR FAMILIES WITH AN EXTENDED RANGE OF WEIGHTS, THE DESIGNER HAS GREATER SCOPE IN MANIPULATING THESE QUALITIES.

7PT

NEULAND: SELECTED ALPHABETS

ABCDEFGHIJKLMNOPQRSTUVWXYZ &!?O,:;'

THE TYPOGRAPHER'S FIRST DUTY IS TO THE TEXT ITSELF. AN INTELLIGENT INTERPRETATION OF THE TEXT WILL NOT ONLY ENSURE READABILITY, BUT WILL ALSO REFLECT ITS TONE, ITS STRUCTURE, AND ITS CULTURAL CONTEXT. THE TYPOGRAPHER'S ANALYSIS ILLUMINATES THE TEXT, LIKE THE MUSICIAN'S READING OF A SCORE.

Regular

KEY FEATURES

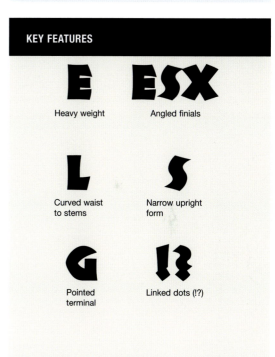

E
Heavy weight

ESX
Angled finials

L
Curved waist to stems

S
Narrow upright form

G
Pointed terminal

!?
Linked dots (!?)

COPPERPLATE GOTHIC

ABCDEFGHIJKLMNOPQRSTUVWXYZ &!?(),:;'
ABCDEFGHIJKLMNOPQRSTUVWXYZ

THE TYPOGRAPHER'S FIRST DUTY IS TO THE TEXT ITSELF. AN INTELLIGENT INTERPRETATION OF THE TEXT WILL NOT ONLY ENSURE READABILITY, BUT WILL ALSO REFLECT ITS TONE, ITS STRUCTURE, AND ITS CULTURAL CONTEXT. THE TYPOGRAPHER'S ANALYSIS ILLUMINATES THE TEXT, LIKE THE MUSICIAN'S READING OF A SCORE.

FREDERIC GOUDY, 1905

Misleadingly titled, this is a Gothic with a Glyphic accent in its very subtle flare serifs. It has no lowercase, and is available in a range of numbered weights and widths.

MEZZ

ABCDEFGHIJKLMNOPQRSTUVWXYZ &!?(),:;'
abcdefghijklmnopqrstuvwxyz

The typographer's first duty is to the text itself. An intelligent interpretation of the text will not only ensure readability, but will also reflect its tone, its structure, and its cultural context. The typographer's analysis illuminates the text, like the musician's reading of a score.

MICHAEL HARVEY, 1994

An oblique face that balances the directness of the hand-rendered letters with a great consistency of color and proportion. It is available in five weights.

FRIZ QUADRATA

ABCDEFGHIJKLMNOPQRSTUVWXYZ &!?(),:;'
abcdefghijklmnopqrstuvwxyz

The typographer's first duty is to the text itself. An intelligent interpretation of the text will not only ensure readability, but will also reflect its tone, its structure, and its cultural context. The typographer's analysis illuminates the text, like the musician's reading of a score.

ERNEST FRIZ, VICTOR CARUSO, AND THIERRY PUYFOULHOUX, 1992

A broad Humanist Glyphic, lightened by open counters and angled terminals.

RUSTICANA

ABCDEFGHIJKLMNOPQRSTUVWXYZ&!?(),:;'

THE TYPOGRAPHER'S FIRST DUTY IS TO THE TEXT ITSELF. AN INTELLIGENT INTERPRETATION OF THE TEXT WILL NOT ONLY ENSURE READABILITY, BUT WILL ALSO REFLECT ITS TONE, ITS STRUCTURE, AND ITS CULTURAL CONTEXT. THE TYPOGRAPHER'S ANALYSIS ILLUMINATES THE TEXT, LIKE THE MUSICIAN'S READING OF A SCORE.

ADRIAN FRUTIGER, 1993

Based upon Roman inscriptional lettering, the waisted stems and right-angled finials are typical of Mediterranean vernacular lettering. There is no lowercase, but it has two companion faces, Herculaneum and Pompeijana.

AUGUSTEA OPEN

ABCDEFGHIJKLMNOPQRSTUVWXYZ &!?(),:;'

THE TYPOGRAPHER'S FIRST DUTY IS TO THE TEXT ITSELF. AN INTELLIGENT INTERPRETATION OF THE TEXT WILL NOT ONLY ENSURE READABILITY, BUT WILL ALSO REFLECT ITS TONE, ITS STRUCTURE, AND ITS CULTURAL CONTEXT. THE TYPOGRAPHER'S ANALYSIS ILLUMINATES THE TEXT, LIKE THE MUSICIAN'S READING OF A SCORE.

ALDO NOVARESE AND ALESSANDRO BUTTI, 1951

Based upon the formal inscriptional letters of imperial Rome, Augustea Open has two weights of line, suggesting the three-dimensionality of an incised form. It has no lowercase.

CRAFT

ABCDEFGHIJKLMNOPQRSTUVWXYZ &!?(),:;'
abcdefghijklmnopqrstuvwxyz

The typographer's first duty is to the text itself. An intelligent interpretation of the text will not only ensure readability, but will also reflect its tone, its structure, and its cultural context. The typographer's analysis illuminates the text, like the musician's reading of a score.

PETER BILAK, 1994

Craft alludes to the cutting of relief letters by retaining the fragments of the surface surrounding some crude but vigorous angular letters. It is available in both positive and reversed versions.

ITC WERKSTATTE

ABCDEFGHIJKLMNOPQRSTUVWXYZ
&!?(),:;'abcdefghijklmnopqrstuvwxyz

The typographer's first duty is to the text itself. An intelligent interpretation of the text will not only ensure readability, but will also reflect its tone, its structure, and its cultural context. The typographer's analysis illuminates the text, like the musician's reading of a score.

SATWINDER SEHMI AND COLIN BRIGNALL, 1999

A lively angular face that alludes both to Blackletter and 20th-century German Glyphics. An engraved inline version is also available.

SOPHIA

ABCDEFGHIJKLMNOPQRSTUVWXYZ &!?(),:;'
ACEEFGHIKLM←→RTTFXZ

THE TYPOGRAPHER'S FIRST DUTY IS TO THE TEXT ITSELF. AN INTELLIGENT INTERPRETATION OF THE TEXT WILL NOT ONLY ENSURE READABILITY, BUT WILL ALSO REFLECT ITS TONE, ITS STRUCTURE, AND ITS CULTURAL CONTEXT. THE TYPOGRAPHER'S ANALYSIS ILLUMINATES THE TEXT, LIKE THE MUSICIAN'S READING OF A SCORE.

MATTHEW CARTER, 1993

Suggested by hybrid alphabets from 6th-century Constantinople, Sophia features a set of joining characters that link with others to form ligatures.

POMPEIA

ABCDEFGHIJKLMNOPQRSTUVWXYZ &!?(),:;'
abcdefghijklmnopqrstuvwxyz

The typographer's first duty is to the text itself. An intelligent interpretation of the text will not only ensure readability, but will also reflect its tone, its structure, and its cultural context. The typographer's analysis illuminates the text, like the musician's reading of a score.

VICTOR DI CASTRO, 1997

Not to be confused with Frutiger's Pompeijana, this is a vivid and robust inline face with a decorative character.

BERLINSANS

ABCDEFGHIJKLMNOPQRSTUVWXYZ &!?(),:;'
abcdefghijklmnopqrstuvwxyz

The typographer's first duty is to the text itself. An intelligent interpretation of the text will not only ensure readability, but will also reflect its tone, its structure, and its cultural context. The typographer's analysis illuminates the text, like the musician's reading of a score.

DAVID BERLOW, 1992

A family of faces ranging from a block weight to a near-monoline light face. The main weight has a subtly waisted stem and distinctive Y and W forms.

SCRIPT, ITALIC, AND CHANCERY

The design of typefaces specifically based upon the handwritten letter dates back to the very origins of type, but soon forms a parallel history that has recently been revitalized by the capabilities of digital type.

While the mainstream of typographic history is characterized by a move away from calligraphic forms toward letters specifically informed by the technologies of the printed letter, a simultaneous tradition has maintained the influence of the written hand upon the design of Script typefaces. These range from highly formal and disciplined letters, based in many cases upon the historical example of noted writing masters, to animated, gestural faces from the 20th century, encompassing a range of highly personal approaches to the arts of pen and brush lettering.

Humanizing Script faces

It must be said that many Script typefaces lack the vitality and spontaneity of calligraphy, since the design of a typeface involves stabilizing and standardizing letterforms that remain fluid and responsive when applied by the calligrapher. All but the most rigidly formal of written letters will be animated by subtle variations in form, according to the letters that precede or follow them, particularly in the case of fully linked Scripts. Typographic standardization of Script characters may compromise the vitality of the letters and their relationships.

Digital typeface design, however, allows the designer to compensate for this by offering extended ranges of variant letters, ligatures, swashes, and alternates. Whereas economic considerations would have made it impractical to cast so many letters in metal, a digital font can comfortably accommodate enough variation to humanize and animate Script type. A preeminent example of this capability can be found in Hermann Zapf's Zapfino, in which four different alphabets, coupled with an extensive range of ligatures, alternates, and terminal letters, allow the designer to replicate much of the scope for variation enjoyed by the calligrapher.

Italic faces

While it is now an established convention that any text face should have a matched italic or italic version, the Renaissance origins of italic are as wholly distinct typefaces, designed for the setting of continuous text. This tradition continues in the form of freestanding Italic and Chancery faces. Delphin, designed by Georg Trump, is characteristic of the Renaissance italic in having an upright roman capital, substantially lower than the ascenders

SCRIPT, ITALIC, AND CHANCERY: CHARACTERISTIC FEATURES

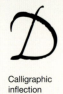

Calligraphic inflection

Angled forms

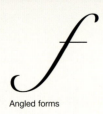

High ascenders

Deep descenders

Low x-height

Contrasting stroke widths

Single story

*Throughout the process, the Adobe Originals team
assisted with aesthetic commentary and technical advice,
and provided inspiration during the difficult moments.
Ex Ponto represents the process of combining my
calligraphic and typographic experience. I found the
transcription of handwriting into a digital typeface to
be very challenging. My focus was to preserve the spon-
taneity and individuality of handwriting while creat-
ing a graphically balanced and captivating design.*

Veljović's writing studies for the typeface, including his notes. From many handwritten pages, he chose letterforms for further development into type characters.

151 CATEGORY 11: SCRIPT, ITALIC, AND CHANCERY

1 Type foundry sample This
sample advertising Mercurius
demonstrates its effectiveness
in two-color printing.

2 Preliminary writing studies
Studies for Jovica Veljovic's
Ex Ponto, showing the development
of the letters selected to make the
definitive face.

3 Type foundry sample The cover
from the specimen booklet for
Zapf Chancery.

4 *The Telling Line* book jacket
The title shows the dramatic
characteristics of Georg Trump's
Delphin in the contrast between
the low roman capitals and
the assertive ascenders
of the lowercase italic forms.

5 Page from *Manuale Tipografico*
This page from Giambattista
Bodoni's typography manual shows
an upright Script face that was to
inform a number of 20th-century
derivatives, notably Morris Fuller
Benton's Linoscript.

of the explicitly script-based italics. These capitals have a wide set
and may also be used to set whole words. Mercurius and Matura
are contemporary Italic faces, designed by the Hungarian letter
artist Imre Reiner.

Chancery

The Chancery hand originated as a formal mode of writing
during the Renaissance and exists today as a form of unlinked
script-based italic. The most widely known example is Hermann
Zapf's Zapf Chancery. Robert Slimbach's Poetica is an extensive
Chancery typeface with a range of ornaments, swashes,
alternates, ligatures, and variant forms.

Snell Roundhand

Designed by Matthew Carter in 1966; currently available from Bitstream and Adobe

Snell Roundhand is a linked Script face that brilliantly translates the example of the 17th-century writing master Charles Snell into typographic form. Initially drawn for photosetting on the Linofilm system, it was later digitized by Carter.

Snell's work was characterized by a concern for restraint and regularity of form, which is why it is not diminished by translation into type. Individually formal, the letters are vibrant and animated when linked. Snell Roundhand has two weights. The letters have well-defined counters and fairly clear differentiation, with the result that it is a comparatively legible Script face that can be used in the setting of limited amounts of continuous text.

As a linked Script face, Snell Roundhand should be set at default letter spacing, since any modification will break or compress the complex linking strokes that join the letters to one another.

IN CONTEXT

typography n. [MLf. Gk typos, impression, cast + graphia, writing] Art of printing; style or appearance of printed matter (the typography was admirable).

Italic and **bold** weights are conventionally used to indicate differentiation, emphasis, attributions, and quotations.

Typefaces or families With an extended range of weights, the designer has greater scope in manipulating these qualities.

9pt

KEY FEATURES

High contrast

Pronounced angle

Ascending stem

Ball terminals

Swash heads

No bar

Tapered tails

Open bowl

Open apex

Stylized form (Q)

SNELL ROUNDHAND: SELECTED ALPHABETS

ABCDEFGHIJKLMNOP2RSTUVWXYZ
&!?(),.:;'abcdefghijklmnopqrstuvwxyz

The typographer's first duty is to the text itself. An intelligent interpretation of the text will not only ensure readability, but will also reflect its tone, its structure, and its cultural context. The typographer's analysis illuminates the text, like the musician's reading of a score.

8pt Regular

ABCDEFGHIJKLMNOP2RSTUVWXYZ
&!?(),.:;'abcdefghijklmnopqrstuvwxyz

The typographer's first duty is to the text itself. An intelligent interpretation of the text will not only ensure readability, but will also reflect its tone, its structure, and its cultural context. The typographer's analysis illuminates the text, like the musician's reading of a score.

8pt Bold

ABCDEFGHIJKLMNOP2RSTUVWXYZ
&!?(),.:;'abcdefghijklmnopqrstuvwxyz

The typographer's first duty is to the text itself. An intelligent interpretation of the text will not only ensure readability, but will also reflect its tone, its structure, and its cultural context. The typographer's analysis illuminates the text, like the musician's reading of a score.

8pt Black

Ex Ponto

Designed by Jovika Veljovic and issued by Adobe in 1995

A face based upon the designer's own calligraphic forms, Ex Ponto reflects exceptionally detailed use of digital technology in reproducing the qualities of a pen nib upon paper. Its rough edges occur along one side of the stroke, creating an alternating rough and smooth outer contour like the "feathering" created by the texture of paper. This quality is retained and articulated digitally through the selective editing of large numbers of points. An extended range of alternates, ligatures, and terminal letters, and a set of titling italics further enhance the typeface's scope for calligraphic variation.

Ex Ponto is exceptional among calligraphic Script faces in the effectiveness of its design across a range of weights. It was designed as a single-axis multiple master face, allowing the user to determine the weight precisely along a sliding scale. It is also available in three predetermined weights (light, regular, and bold) that retain their integrity of form and calligraphic color whether used separately or in combination.

IN CONTEXT

typography n. [M.L. f. Gk typos, impression, cast + graphia, writing] Art of printing; style or appearance of printed matter (the typography was admirable).

Italic and **bold** weights are conventionally used to indicate differentiation, emphasis, attributions, and quotations.

Typefaces or families With an extended range of weights, the designer has greater scope in manipulating these qualities.

11pt

EX PONTO: SELECTED ALPHABETS

ABCDEFGHIJKLMNOPQRSTUVWXYZ &!?(),.;'
abcdefghijklmnopqrstuvwxyz

The typographer's first duty is to the text itself. An intelligent interpretation of the text will not only ensure readability, but will also reflect its tone, its structure, and its cultural context. The typographer's analysis illuminates the text, like the musician's reading of a score.

9pt 290 Regular

ABCDEFGHIJKLMNOPQRSTUVWXYZ &!?(),.;'
abcdefghijklmnopqrstuvwxyz

The typographer's first duty is to the text itself. An intelligent interpretation of the text will not only ensure readability, but will also reflect its tone, its structure, and its cultural context. The typographer's analysis illuminates the text, like the musician's reading of a score.

9pt 175 Light

ABCDEFGHIJKLMNOPQRSTUVWXYZ &!?(),.;'
abcdefghijklmnopqrstuvwxyz

The typographer's first duty is to the text itself. An intelligent interpretation of the text will not only ensure readability, but will also reflect its tone, its structure, and its cultural context. The typographer's analysis illuminates the text, like the musician's reading of a score.

9pt 450 Bold

KEY FEATURES

kh
High ascenders

gj
Deep descenders

YG
Descenders on some caps

AJK
Bar at head

g
Full loop

hn
Low junction to shoulder

Tg
Distressed lower edge

Q
Crossed tail

Zapfino

Designed by Hermann Zapf in the 1990s and published in 1999

Zapfino is perhaps the most vivid example of the potential of digital media for offering extended calligraphic capability. Based upon forms begun in the 1940s (the complexity of which would have made commercial production impractical at the time), it was resumed by Zapf in the 1990s. It comprises four alternate alphabets and a wide range of alternates, terminal and initial letters, and ligatures. This provides a vast range of permutations, giving the designer a level of creative intervention and flexibility closer to the calligrapher's craft than had previously been possible.

Zapfino is primarily a display face, though the more restrained standard alphabet can be used for setting short sections of continuous text. The more extravagant flourishes would normally only be used in titling.

A limited version, comprising only the standard alphabet, is provided with Apple OSX system software.

IN CONTEXT

typography n. [ML f. Gk typos, impression, cast + graphia, writing] Art of printing; style or appearance of printed matter (the typography was admirable).

Italic and bold weights are conventionally used to indicate differentiation, emphasis, attributions, and quotations.

Typefaces or families With an extended range of weights, the designer has greater scope in manipulating these qualities.

12pt

KEY FEATURES

A — Calligraphic contrasts

dk — Very high ascenders

a — Single story

pg — Very deep descenders

Q — Waved tail

R — Leg below baseline

JK — Bar head

Z — Horizontal below baseline

w — Curvilinear

e — High counter

ZAPFINO: SELECTED ALPHABETS

ABCDEFGHIJKLMNOPQRSTUVWXYZ @!?(),:;'
abcdefghijklmnopqrstuvwxyz

The typographer's first duty is to the text itself. An intelligent interpretation of the text will not only ensure readability, but will also reflect its tone, its structure, and its cultural context. The typographer's analysis illuminates the text, like the musician's reading of a score.

11pt One

ABCDEFGHIJKLMNOPQRSTUVWXYZ &!?(),:;'
abcdefghijklmnopqrstuvwxyz

The typographer's first duty is to the text itself. An intelligent interpretation of the text will not only ensure readability, but will also reflect its tone, its structure, and its cultural context. The typographer's analysis illuminates the text, like the musician's reading of a score.

11pt Two

ABCDEFGHIJKLMNOPQRSTUVWXYZ
&?o-d,:;'abcdefghijklmnopqrstuvwxyz

The typographer's first duty is to the text itself. An intelligent interpretation of the text will not only ensure readability, but will also reflect its tone, its structure, and its cultural context. The typographer's analysis illuminates the text, like the musician's reading of a score.

11pt Four

Poetica

Designed by Robert Slimbach in 1992

Poetica vividly demonstrates the scope of digital type systems for invigorating the tradition of the Script typeface and extending the creative scope such faces offer the user. The core of this extended family comprises four fonts, all based upon a consistent italic letter but with varying extents of swash. In addition, the face includes fonts of ligatures, terminal letters, plain and swash small caps, ornaments, and one font dedicated solely to ampersands.

Based upon free-standing Chancery italic alphabets, the face allows for flamboyant or restrained use. The basic italic form is highly legible and consistent, well suited to setting extended text, while the additional fonts enhance the functionality of the face and allow for a wide variety of bravura flourishes.

IN CONTEXT

TYPOGRAPHY n. [ML f. Gk TYPOS, impression, cast + GRAPHIA, writing] Art of printing; style or appearance of printed matter (THE TYPOGRAPHY WAS ADMIRABLE).

ITALIC and BOLD weights are conventionally used to indicate differentiation, emphasis, attributions, and quotations.

TYPEFACES OR FAMILIES With an EXTENDED range of WEIGHTS, the designer has greater scope in MANIPULATING these qualities.

10pt

KEY FEATURES

h Triangular serifs

hn Low junction to shoulder

a Single story

PRD Continuous curve into serif

hpn Narrow form

POETICA: SELECTED ALPHABETS

ABCDEFGHIJKLMNOPQRSTUVWXYZ &!?(),:;'
abcdefghijklmnopqrstuvwxyz

The typographer's first duty is to the text itself. An intelligent interpretation of the text will not only ensure readability, but will also reflect its tone, its structure, and its cultural context. The typographer's analysis illuminates the text, like the musician's reading of a score.

8pt Chancery I

ABCDEFGHIJKLMNOPQRSTUVWXYZ
ABCDEFGHIJKLMNOPQRSTUVWXYZ

THE TYPOGRAPHER'S FIRST DUTY IS TO THE TEXT ITSELF. AN INTELLIGENT INTERPRETATION OF THE TEXT WILL NOT ONLY ENSURE READABILITY, BUT WILL ALSO REFLECT ITS TONE, ITS STRUCTURE, AND ITS CULTURAL CONTEXT. THE TYPOGRAPHER'S ANALYSIS ILLUMINATES THE TEXT, LIKE THE MUSICIAN'S READING OF A SCORE.

8pt Supp Swash Caps II

ABCDEFGHIJKLMNOPQRSTUVWXYZ &!?(),:;'
abcdefghijklmnopqrstuvwxyz

The typographer's first duty is to the text itself. An intelligent interpretation of the text will not only ensure readability, but will also reflect its tone, its structure, and its cultural context. The typographer's analysis illuminates the text, like the musician's reading of a score.

8pt Chancery III

Zapf Chancery

One of the most widely available and familiar Chancery faces, Hermann Zapf's Zapf Chancery is an effective adaptation of the formal pen letter into typographic form. It is based on Italian chancery handwriting.

Designed for photosetting in 1979, it has as its "roman" a slightly inclined italic form with a slope of some four degrees and roman caps, while the italic font has swash caps and a more pronounced slope. Echoing a characteristic of early Italic faces, the capital height is much lower than the ascenders. The descenders are all equally deep, the p and q emphasized by a bar terminal, and the g with a descender similar to that of the y and f. The italic has a two-story g and a descending leg to the k.

Both the roman and italic have a somewhat eccentric x, introducing a note of ambiguity into a face which, though deft and scholarly in the mediation of script into standardized type, lacks the animation of handwritten form.

IN CONTEXT

typography n. [ML f. Gk typos, impression, cast + graphia, writing] Art of printing; style or appearance of printed matter (the typography was admirable).

Italic and bold weights are conventionally used to indicate differentiation, emphasis, attributions, and quotations.

Typefaces or families With an extended range of weights, the designer has greater scope in manipulating these qualities.

KEY FEATURES

fbdh — Curved ascenders

pqy — Deep descenders

Q — Tail stroke just enters counter

Z — Long lower stroke

A — Half-serif foot

pq — Bar foot

Y — Splayed arms

ZAPF CHANCERY: SELECTED ALPHABETS

ABCDEFGHIJKLMNOPQRSTUVWXYZ &!?(),:;'
abcdefghijklmnopqrstuvwxyz

The typographer's first duty is to the text itself. An intelligent interpretation of the text will not only ensure readability, but will also reflect its tone, its structure, and its cultural context. The typographer's analysis illuminates the text, like the musician's reading of a score.

8pt Regular

Linoscript

Designed by Morris Fuller Benton in 1905

Linoscript is a display Script face modeled upon an upright French script and reminiscent of the Script faces designed by Giambattista Bodoni in its high contrast and vertical form. It has variable stresses, which in some characters come close to the vertical stress of a Didone, and it could be effectively paired with a Didone text face. It has a very low x-height and a linked form that creates an unusually open spacing between letters.

Its application is necessarily fairly limited, but the richness of the curved forms of the capitals and the exaggerated contrasts of the x-height make it an arresting and visually rich face in the appropriate context.

IN CONTEXT

typography n. [ml f. Gk typos, impression, cast + graphia, writing] Art of printing; style or appearance of printed matter (the typography was admirable).

Italic and bold weights are conventionally used to indicate differentiation, emphasis, attributions, and quotations.

Typefaces or families With an extended range of weights, the designer has greater scope in manipulating these qualities.

12pt

LINOSCRIPT: SELECTED ALPHABETS

ABCDEFGHIJKLMNOPQRSTUVWXYZ &!?(),.;'

abcdefghijklmnopqrstuvwxyz

The typographer's first duty is to the text itself. An intelligent interpretation of the text will not only ensure readability, but will also reflect its tone, its structure, and its cultural context. The typographer's analysis illuminates the text, like the musician's reading of a score.

12pt Regular

KEY FEATURES

b	h	t
High contrast	Low x-height	High bar

A	G	Y
Single-story capital	Raised body and exaggerated tail	Curved tail

E	vw	Z
Single stroke with no bar	Ascending terminals	Bar

BICKHAM SCRIPT

ABCDEFGHIJKLMNOPQRSTUVWXYZ &!?().:;'
abcdefghijklmnopqrstuvwxyz

The typographer's first duty is to the text itself. An intelligent interpretation of the text will not only ensure readability, but will also reflect its tone, its structure, and its cultural context. The typographer's analysis illuminates the text, like the musician's reading of a score.

12pt text

RICHARD LIPTON, 2000

A fluid traditional copperplate Script, the typeface is enhanced by an extensive range of alternates, endings, ligatures, and ornaments.

MERCURIUS

ABCDEFGHIJKLMNOPQRSTUVWXYZ
&!?(),.:;'abcdefghijklmnopqrstuvwxyz

The typographer's first duty is to the text itself. An intelligent interpretation of the text will not only ensure readability, but will also reflect its tone, its structure, and its cultural context. The typographer's analysis illuminates the text, like the musician's reading of a score.

IMRE RIENER, 1957

A colorful, hand-rendered face with vivid variations in stroke width and an animated lowercase.

DELPHIN

ABCDEFGHIJKLMNOPQRSTUVWXYZ &!?(),.:;'
abcdefghijklmnopqrstuvwxyz

The typographer's first duty is to the text itself. An intelligent interpretation of the text will not only ensure readability, but will also reflect its tone, its structure, and its cultural context. The typographer's analysis illuminates the text, like the musician's reading of a score.

GEORG TRUMP, 1955

Delphin echoes the early Renaissance Italics in combining a cursive lowercase form with a Roman capital shorter than the ascenders. A variety of strokes and angles enlivens an evocative face.

SHELLEY SCRIPT

ABCDEFGHIJKLMNOPQRSTUVWXYZ &!?().:;'
abcdefghijklmnopqrstuvwxyz

The typographer's first duty is to the text itself. An intelligent interpretation of the text will not only ensure readability, but will also reflect its tone, its structure, and its cultural context. The typographer's analysis illuminates the text, like the musician's reading of a score.

11pt text

MATTHEW CARTER, 1972

A revival of the hand of an 18th-century writing master, Shelley Script is available in three degrees of flourish: Andante (shown here), Allegro, and Volante.

NUPTIAL SCRIPT

ABCDEFGHIJKLMNOPQRSTUVWXYZ &!?(),.:;'
abcdefghijklmnopqrstuvwxyz

The typographer's first duty is to the text itself. An intelligent interpretation of the text will not only ensure readability, but will also reflect its tone, its structure, and its cultural context. The typographer's analysis illuminates the text, like the musician's reading of a score.

EDWIN W. SHAAR, 1952

A disconnected script with angular tapered strokes alternating with looped flourishes in an eccentric hybrid of 17th-century Scripts and contemporary cursives.

KAUFMANN

ABCDEFGHIJKLMNOP2RSTUVWXY3 &!?(),.:;'
abcdefghijklmnopqrstuvwxyz

The typographer's first duty is to the text itself. An intelligent interpretation of the text will not only ensure readability, but will also reflect its tone, its structure, and its cultural context. The typographer's analysis illuminates the text, like the musician's reading of a score.

MAX R. KAUFMANN, 1936

A simple linear monoline script, Kaufmann is a characteristically American, informal, connected typeface available in two weights.

CATANEO

ABCDEFGHIJKLMNOPQRSTUVWXYZ Ə!?(),.:;'
abcdefghijklmnopqrstuvwxyz

The typographer's first duty is to the text itself. An intelligent interpretation of the text will not only ensure readability, but will also reflect its tone, its structure, and its cultural context. The typographer's analysis illuminates the text, like the musician's reading of a score.

RICHARD LIPTON AND JACQUELINE SAKWA, 1993

An elegant Chancery cursive inspired by the 16th-century Italian writer Bennardino Cataneo. It includes many swash characters and expert sets in three weights.

AMAZONE

ABCDEFGHIJKLMNOPQRSTUVWX
YZ &!?(),.:;'abcdefghijklmnopqrstuvwxyz

The typographer's first duty is to the text itself. An intelligent interpretation of the text will not only ensure readability, but will also reflect its tone, its structure, and its cultural context. The typographer's analysis illuminates the text, like the musician's reading of a score.

LEONARD D. SMIT, 1958

A flamboyant connected Script with a wide range of ligatures. The extravagant looped forms are loosely based on a 19th-century copperplate model.

CAFLISCH SCRIPT

ABCDEFGHIJKLMNOPQRSTUVWXYZ &!?(),.:;'
abcdefghijklmnopqrstuvwxyz

The typographer's first duty is to the text itself. An intelligent interpretation of the text will not only ensure readability, but will also reflect its tone, its structure, and its cultural context. The typographer's analysis illuminates the text, like the musician's reading of a score.

ROBERT SLIMBACH, 1993

Based on the handwriting of the renowned graphic designer Max Caflisch, it is notable for the lack of contrast in its stroke width, making it a more restrained contemporary Script.

SANVITO

ABCDEFGHIJKLMNOPQRSTUVWXYZ &!?(),.:;'
abcdefghijklmnopqrstuvwxyz

The typographer's first duty is to the text itself. An intelligent interpretation of the text will not only ensure readability, but will also reflect its tone, its structure, and its cultural context. The typographer's analysis illuminates the text, like the musician's reading of a score.

ROBERT SLIMBACH, 1993

Named after a principal scribe of the Italian Renaissance, this is more a calligraphy-based typeface than a full Script. Its letterforms stand alone rather than being calligraphically linked.

CATEGORY 12

DECORATED/ ORNAMENTAL

Both these terms are widely used to describe the profusion of colorful display faces that emerged to meet the needs of a developing consumer culture in the wake of the Industrial Revolution.

As a general but not universal rule, a Decorated face is based upon a recognizable face within which decorative characteristics have been added, whereas in an Ornamental face, the form of the letter itself is determined by some decorative or figurative intention. The Ornamental form may thus be composed of foliage, rustic woodwork, the human form, or abstract elements. The majority of Ornamental faces from the 19th century are capital only, and necessarily designed for use at larger sizes.

Decorated and Ornamental typefaces absorb different stylistic idioms into the form of the letter, frequently reflecting developments in architecture and the graphic arts. Victorian designers and architects drew upon a range of ornamental vocabularies from other cultures and historical periods, appropriating medieval, Egyptian, classical, and gothic references, and producing decorative typefaces in each idiom.

The fashionable typeface

It has long been maintained that such faces represent a typographic dark age, a chaos of disparate and attention-seeking faces, prompting a reaction of typographic reform that begins with the Humanist revivals of William Morris and is later embodied in the work of Stanley Morison for the Monotype corporation. The Victorian display faces have been associated with a decline in quality printing, and a supposed degeneracy in aesthetic standards. This somewhat humorless view ignores both the imaginative bravado of Victorian display type, and its fitness for purpose in an emerging consumer society. These forms mark the development of advertising, brand identity, and promotion, and constitute a spirited response to the need for greater differentiation of products, services, and entertainments.

The extravagant flowering of forms established a category of display type design that continued through the 20th century and up to the present: the ephemeral typeface. Each phase of design history has seen commercial demand for typefaces that capture some quality of contemporaneity—some essence of the spirit of the time. The success with which this is achieved is in turn reflected in the way that once fashionable typefaces become unfashionable period pieces, reflecting the enthusiasms of a past era. This rejection, in turn, prepares them for later reappraisal, as seen in the revival of Victorian display type in the 1960s.

DECORATED/ORNAMENTAL: CHARACTERISTIC FEATURES

Added ornaments

Internal decoration

Inlines or outlines

Display typography is as volatile as fashion, and as subject to unexpected revivals and eccentric experiments. Like fashion collections, some typefaces are not designed for widespread use but as expressions of the speculative or the fantastic, while others reflect classic values and demonstrate a durability that transcends the season's trends. Neither is better; they are simply appropriate to different contexts.

1 Decorated initials A variety of outline and inline detail added to Blackletter and medieval forms.

2 Pictorial letters XYZ Decorated letters from Louis John Pouchee use the broad strokes of an ultra bold Didone or fat face as a surface for detailed pictorial imagery.

3 Equipment alphabet Alphabet design by Mervyn Kurlansky of Pentagram, in which design and office equipment is used to mimic the shape of letterforms. The scale of the different objects has been carefully modified to give a visual cohesion to the flow of the alphabet.

4 Alvin Ailey Dance Theater logo Designers Chermayeff and Geismar use the human figure performing dance moves to create a lively logotype for a dance theater.

SCALA JEWEL

A member of Martin Majoor's otherwise fairly formal Scala family, with its serif and sans serif versions, this typeface revisits the Victorian tradition of the decorated letter. Scala Jewel is a decorated form of the serifed Scala, with four colorful variants: crystal, diamond, pearl, and saphyre.

These letters naturally lend themselves to pairing with Scala or Scala Sans, but their classic proportions mean that they are compatible with many traditional text faces.

IN CONTEXT

TYPOGRAPHY N. [ML F. GK TYPOS, IMPRESSION, CAST · GRAPHIA, WRITING] ART OF PRINTING; STYLE OR APPEARANCE OF PRINTED MATTER (THE TYPOGRAPHY WAS ADMIRABLE).

ITALIC AND BOLD WEIGHTS ARE CONVENTIONALLY USED TO INDICATE DIFFERENTIATION, EMPHASIS, ATTRIBUTIONS, AND QUOTATIONS.

TYPEFACES OR FAMILIES WITH AN EXTENDED RANGE OF WEIGHTS, THE DESIGNER HAS GREATER SCOPE IN MANIPULATING THESE QUALITIES.

KEY FEATURES

HX — Fine slab serif

TFC — Vertical serifs

O — Vertical stress

P — Open counter

W — Crossed and linked apex

G — Low bar

MQ — Decorative features at mid-height

Q — Upturned tail

SCALA JEWEL: SELECTED ALPHABETS

ABCDEFGHIJKLMNOPQRSTUVWXYZ &!?(),:;'

THE TYPOGRAPHER'S FIRST DUTY IS TO THE TEXT ITSELF. AN INTELLIGENT INTERPRETATION OF THE TEXT WILL NOT ONLY ENSURE READABILITY, BUT WILL ALSO REFLECT ITS TONE, ITS STRUCTURE, AND ITS CULTURAL CONTEXT. THE TYPOGRAPHER'S ANALYSIS ILLUMINATES THE TEXT, LIKE THE MUSICIAN'S READING OF A SCORE.

Crystal

ABCDEFGHIJKLMNOPQRSTUVWXYZ &!?(),:;'

THE TYPOGRAPHER'S FIRST DUTY IS TO THE TEXT ITSELF. AN INTELLIGENT INTERPRETATION OF THE TEXT WILL NOT ONLY ENSURE READABILITY, BUT WILL ALSO REFLECT ITS TONE, ITS STRUCTURE, AND ITS CULTURAL CONTEXT. THE TYPOGRAPHER'S ANALYSIS ILLUMINATES THE TEXT, LIKE THE MUSICIAN'S READING OF A SCORE.

Diamond

ABCDEFGHIJKLMNOPQRSTUVWXYZ &!?(),:;'

THE TYPOGRAPHER'S FIRST DUTY IS TO THE TEXT ITSELF. AN INTELLIGENT INTERPRETATION OF THE TEXT WILL NOT ONLY ENSURE READABILITY, BUT WILL ALSO REFLECT ITS TONE, ITS STRUCTURE, AND ITS CULTURAL CONTEXT. THE TYPOGRAPHER'S ANALYSIS ILLUMINATES THE TEXT, LIKE THE MUSICIAN'S READING OF A SCORE.

Pearl

MOONGLOW

Designed by Michael Harvey and marketed by Adobe in 2000

Moonglow is an all-capital outline display face in three widths and three weights. The increases in weight are accompanied by subtle reduction in the weight of the enclosed white space, making the bold weight more of a solid form with a decorative inline, while the lighter weight is an explicitly outline face. The balanced proportions of the letters reveal a highly sensitive and intuitive design, in which subtle non-mathematical curves retain a handcrafted quality and give each letter a distinct character.

The typeface includes some alternate letters, including a Greek e, a crossbar j, a stemmed u, and a crossbar A.

IN CONTEXT

TYPOGRAPHY N. [ML F. GK TYPOS, IMPRESSION, CAST + GRAPHIA, WRITING] ART OF PRINTING; STYLE OR APPEARANCE OF PRINTED MATTER (THE TYPOGRAPHY WAS ADMIRABLE).

ITALIC AND **BOLD** WEIGHTS ARE CONVENTIONALLY USED TO INDICATE DIFFERENTIATION, EMPHASIS, ATTRIBUTIONS, AND QUOTATIONS.

TYPEFACES OR FAMILIES WITH AN EXTENDED RANGE OF WEIGHTS, THE DESIGNER HAS GREATER SCOPE IN MANIPULATING THESE QUALITIES.

7PT

MOONGLOW: SELECTED ALPHABETS

ABCDEFGHIJKLMNOPQRSTUVWXYZ &!?0,;'

THE TYPOGRAPHER'S FIRST DUTY IS TO THE TEXT ITSELF. AN INTELLIGENT INTERPRETATION OF THE TEXT WILL NOT ONLY ENSURE READABILITY, BUT WILL ALSO REFLECT ITS TONE, ITS STRUCTURE, AND ITS CULTURAL CONTEXT. THE TYPOGRAPHER'S ANALYSIS ILLUMINATES THE TEXT, LIKE THE MUSICIAN'S READING OF A SCORE.

Light

ABCDEFGHIJKLMNOPQRSTUVWXYZ &!?(),;'

THE TYPOGRAPHER'S FIRST DUTY IS TO THE TEXT ITSELF. AN INTELLIGENT INTERPRETATION OF THE TEXT WILL NOT ONLY ENSURE READABILITY, BUT WILL ALSO REFLECT ITS TONE, ITS STRUCTURE, AND ITS CULTURAL CONTEXT. THE TYPOGRAPHER'S ANALYSIS ILLUMINATES THE TEXT, LIKE THE MUSICIAN'S READING OF A SCORE.

Regular

ABCDEFGHIJKLMNOPQRSTUVWXYZ &!?(),;'

THE TYPOGRAPHER'S FIRST DUTY IS TO THE TEXT ITSELF. AN INTELLIGENT INTERPRETATION OF THE TEXT WILL NOT ONLY ENSURE READABILITY, BUT WILL ALSO REFLECT ITS TONE, ITS STRUCTURE, AND ITS CULTURAL CONTEXT. THE TYPOGRAPHER'S ANALYSIS ILLUMINATES THE TEXT, LIKE THE MUSICIAN'S READING OF A SCORE.

Bold

KEY FEATURES

F — White inline
I — Waisted stem

RK — Angled finials
P — Open bowl

T — Parallel finials
J — Descending tail

PEPPERWOOD

Designed by Kim Buker Chansler, Carol Twombly, and Carl Crossgrove for Adobe in 1994

Pepperwood draws upon late 19th-century woodletter faces and the poster traditions associated with the American West. The letters are radically condensed and outlined, with decorative points at top and base, and a jewel form at the center. This reflects the influence of ornamental Celtic letters from the 19th century.

In an ingenious application of current technology to a historic idiom, the inner and outer forms are created as separate fonts, allowing for either to be used separately or for the two to be overlaid and independently colored.

If Pepperwood is to be paired with a text face, this should be both historically consistent and robust. A Clarendon or similar Slab Serif would bring appropriate weight and color to match the dramatic qualities of the display face.

IN CONTEXT

TYPOGRAPHY &. [n: F. GK ΤΥΠΟΣ, IMPRESSION, CAST AND ΓΡΑΦΙΑ, WRITING) ART OF PRINTING; STYLE OR APPEARANCE OF PRINTED MATTER (THE TYPOGRAPHY WAS ADMIRABLE).

ΡΟΜΑΝ AND **BOLD** WEIGHTS ARE CONVENTIONALLY USED TO INDICATE DIFFERENTIATION, EMPHASIS, ATTRIBUTIONS, AND QUOTATIONS.

TYPEFACES OR FAMILIES WITH AN EXTENDED RANGE OF **WEIGHTS**, THE DESIGNER HAS GREATER SCOPE IN SUBTLY CREATING THESE QUALITIES.

11PT

KEY FEATURES

Condensed form

Fine outline with triangular detailing

Square jewel at midpoint

Heavy horizontal strokes

Recessed verticals

PEPPERWOOD: SELECTED ALPHABETS

ABCDEFGHIJKLMNOPQRSTUVWXYZ &!?(),.;'

THE TYPOGRAPHER'S FIRST DUTY IS TO THE TEXT ITSELF. AN INTELLIGENT INTERPRETATION OF THE TEXT WILL NOT ONLY ENSURE READABILITY, BUT WILL ALSO REFLECT ITS TONE, ITS STRUCTURE, AND ITS CULTURAL CONTEXT. THE TYPOGRAPHER'S ANALYSIS ILLUMINATES THE TEXT, LIKE THE MUSICIAN'S READING OF A SCORE.

24pt & 12pt Regular

ABCDEFGHIJKLMNOPQRSTUVWXYZ &!?(),.;'

THE TYPOGRAPHER'S FIRST DUTY IS TO THE TEXT ITSELF. AN INTELLIGENT INTERPRETATION OF THE TEXT WILL NOT ONLY ENSURE READABILITY, BUT WILL ALSO REFLECT ITS TONE, ITS STRUCTURE, AND ITS CULTURAL CONTEXT. THE TYPOGRAPHER'S ANALYSIS ILLUMINATES THE TEXT, LIKE THE MUSICIAN'S READING OF A SCORE.

24pt & 12pt Outline

ABCDEFGHIJKLMNOPQRSTUVWXYZ &!?(),.;'

THE TYPOGRAPHER'S FIRST DUTY IS TO THE TEXT ITSELF. AN INTELLIGENT INTERPRETATION OF THE TEXT WILL NOT ONLY ENSURE READABILITY, BUT WILL ALSO REFLECT ITS TONE, ITS STRUCTURE, AND ITS CONTEXT. THE TYPOGRAPHER'S ANALYSIS ILLUMINATES THE TEXT, LIKE THE MUSICIAN'S READING OF A SCORE.

24pt & 12pt Fill

Zaragoza

Designed by Phil Grimshaw in 1995 for ITC

Zaragoza is a Decorated cursive face of considerable color and vitality. It combines an animated and fluid scriptal quality with an inline form reminiscent of 19th-century Decorated fat face letters. There is a high contrast between the hairline horizontals and the broad strokes, which are enlivened by horizontal "fletching," the term given to a featherlike repeat pattern of fine triangular strokes.

The letters are characterized by visual variety and detailing, such as the floating tail of the Q and the ball terminals of the tail and ear forms. The pronounced angle of italicization creates a considerable sense of forward momentum.

The face is available in a single weight and includes a small number of ligatures and alternates.

IN CONTEXT

typography n. [M.E. f. Gk typos, impression, cast and graphia, writing] Art of printing; style or appearance of printed matter (the typography was admirable).

Italic and bold weights are conventionally used to indicate differentiation, emphasis, attributions, and quotations.

Typefaces or families With an extended range of weights, the designer has greater scope in manipulating these qualities.

ZARAGOZA: SELECTED ALPHABETS

ABCDEFGHIJKLMNOPQRSTUVW
XYZ &!?(),.;'
abcdefghijklmnopqrstuvwxyz

The typographer's first duty is to the text itself. An intelligent interpretation of the text will not only ensure readability, but will also reflect its tone, its structure, and its cultural context. The typographer's analysis illuminates the text, like the musician's reading of a score.

8pt Plain

KEY FEATURES

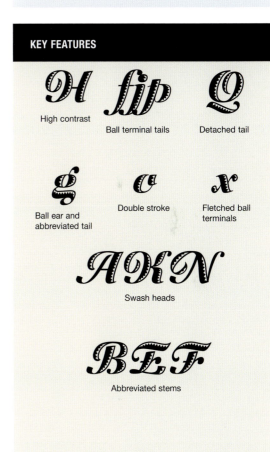

High contrast

Ball terminal tails

Detached tail

Ball ear and abbreviated tail

Double stroke

Fletched ball terminals

Swash heads

Abbreviated stems

CASTELLAR

ABCDEFGHIJKLMNOPQRSTUVWXYZ &!?(),:;'

THE TYPOGRAPHER'S FIRST DUTY IS TO THE TEXT ITSELF. AN INTELLIGENT INTERPRETATION OF THE TEXT WILL NOT ONLY ENSURE READABILITY, BUT WILL ALSO REFLECT ITS TONE, ITS STRUCTURE, AND ITS CULTURAL CONTEXT. THE TYPOGRAPHER'S ANALYSIS ILLUMINATES THE TEXT, LIKE THE MUSICIAN'S READING OF A SCORE.

JOHN PETERS, 1957

An inline capital face with two widths of line, the darker stroke on the left of the stem suggesting an incised form.

SAPHIR

ABCDEFGHIJKLMNOPQRSTUVWXYZ &!?(),:;'

THE TYPOGRAPHER'S FIRST DUTY IS TO THE TEXT ITSELF. AN INTELLIGENT INTERPRETATION OF THE TEXT WILL NOT ONLY ENSURE READABILITY, BUT WILL ALSO REFLECT ITS TONE, ITS STRUCTURE, AND ITS CULTURAL CONTEXT. THE TYPOGRAPHER'S ANALYSIS ILLUMINATES THE TEXT, LIKE THE MUSICIAN'S READING OF A SCORE.

HERMANN ZAPF, 1953

A bold Didone, or fat face, with floral details reversed out of the body, evocative of Victorian display lettering.

ZEBRAWOOD

ABCDEFGHIJKLMNOPQRSTUVWXYZ &!?(),:;'

THE TYPOGRAPHER'S FIRST DUTY IS TO THE TEXT ITSELF. AN INTELLIGENT INTERPRETATION OF THE TEXT WILL NOT ONLY ENSURE READABILITY, BUT WILL ALSO REFLECT ITS TONE, ITS STRUCTURE, AND ITS CULTURAL CONTEXT. THE TYPOGRAPHER'S ANALYSIS ILLUMINATES THE TEXT, LIKE THE MUSICIAN'S READING OF A SCORE.

KIM BUKER CHANSLER, 1994

A dimensionalized outline face with a graduated coloring, suggesting the vernacular of fairground display lettering and Victorian ephemera. A separate overlay font allows for filling with a second color.

ARNOLD BOECKLIN

ABCDEFGHIJKLMNOPQRSTUVWXYZ &!?(),:;'
abcdefghijklmnopqrstuvwxyz

The typographer's first duty is to the text itself. An intelligent interpretation of the text will not only ensure readability, but will also reflect its tone, its structure, and its cultural context. The typographer's analysis illuminates the text, like the musician's reading of a score.

ARNOLD BOECKLIN, 1904

A typeface constructed from organic attenuated forms, heavier toward the base, characteristic of art nouveau design.

SASSAFRAS

ABCDEFGHIJKLMNOPQRSTUVWXYZ &!?(),:;'
abcdefghijklmnopqrstuvwxyz

The typographer's first duty is to the text itself. An intelligent interpretation of the text will not only ensure readability, but will also reflect its tone, its structure, and its cultural context. The typographer's analysis illuminates the text, like the musician's reading of a score.

ARTHUR BAKER, 1995

A display face based upon a double calligraphic stroke, tapering toward the base of each letter. The underlying proportions are Humanist. Sassafras includes an italic and several alternate letters.

11pt text

CABARGA CURSIVA

ABCDEFGHIJKLMNOPQRSTUVWXYZ &!?(),:;'
abcdefghijklmnopqrstuvwxyz

The typographer's first duty is to the text itself. An intelligent interpretation of the text will not only ensure readability, but will also reflect its tone, its structure, and its cultural context. The typographer's analysis illuminates the text, like the musician's reading of a score.

DEMETRIO AND LESLIE CABARGA, 1982

A linked cursive, combining sharp geometric angularity with more fluid strokes and a colorful inlining.

JAZZ

ABCDEFGHIJKLMNOPQRSTUVWXYZ &!?(),:;'
abcdefghijklmnopqrstuvwxyz

The typographer's first duty is to the text itself. An intelligent interpretation of the text will not only ensure readability, but will also reflect its tone, its structure, and its cultural context. The typographer's analysis illuminates the text, like the musician's reading of a score.

ALAN MEEKS, 1992

A geometric, late art deco form "fletched" with fine horizontal lines.

MILANO

ABCDEFGHIJKLMNOPQRSTUVWX
YZ &!?(),:;'abcdefghijklmnopqrstuvwxyz

The typographer's first duty is to the text itself. An intelligent interpretation of the text will not only ensure readability, but will also reflect its tone, its structure, and its cultural context. The typographer's analysis illuminates the text, like the musician's reading of a score.

DAVID QUAY, 1985

A dimensionalized outline cursive with a repetitive curlicue on every capital.

BODONI CLASSIC SHADOW

ABCDEFGHIJKLMNOPQRSTUVW
XYZ

THE TYPOGRAPHERS FIRST DUTY IS TO THE TEXT ITSELF. AN INTELLIGENT INTERPRETATION OF THE TEXT WILL NOT ONLY ENSURE READABILITY BUT WILL ALSO REFLECT ITS TONE AND ITS CULTURAL CONTEXT.

GERT WEISCHER, 2004

A range of floral and decorated initials on a Didone form, Classic Shadow is part of the Bodoni Classic family, but reflects the late 19th-century proliferation of floriated forms.

FLASH

ABCDEFGHIJKLMNOPQRSTUVWXYZ !?,:;

THE TYPOGRAPHERS FIRST DUTY IS TO THE TEXT ITSELF. AN INTELLIGENT INTERPRETATION OF THE TEXT WILL NOT ONLY ENSURE READABILITY, BUT WILL ALSO REFLECT ITS TONE, ITS STRUCTURE, AND ITS CULTURAL CONTEXT. THE TYPOGRAPHERS ANALYSIS ILLUMINATES THE TEXT, LIKE THE MUSICIANS READING OF A SCORE.

ENRICH CROUS-VIDAL, 1953

A bold inclined letter with negative incised markings and the suggestion of a dimensional shadow, Flash is part of a family of faces designed as a typographic description of Latin cultures, and includes a font of ornaments.

BLACKLETTER

Although the use of Blackletter for text setting was quickly superseded by the early Humanist faces across most of Europe, it continued and developed in more specialized applications up to the present day.

As with any typeface that has specific associations with a period or culture, some knowledge of this context is necessary if one is to make effective use of these vivid and evocative forms. Study of historic and contemporary examples will reveal a mixing of different Blackletter idioms, and their use in combination with serifed roman letters. Consideration should be given to the weight and color of Blackletter when combining with other types, as roman type will need to be visually robust if it is not to be overpowered by the tonal density and angularity of a Schwabacher or Textura.

Blackletter has a distinct and particular history in Germany, where its significance as an expression of national identity politicized its continued use through the first half of the 20th century. In the rest of Europe, Blackletter evolved largely as a display idiom, particularly adapted for use in religious contexts or as a consciously archaic form intended to evoke a sense of the past.

Blackletter families

Blackletter contains four major families: Textura, Rotunda, Bastarda (or Schwabacher), and Fraktur. Textura is the Blackletter used in the Gutenberg Bible: a close-set, vertical form. It is a characteristic of early Blackletter that the weight of the stroke width generally exceeds the white space of both counters and intercharacter spacing. It was followed, though not superseded, by the Rotunda form cut by printers in Switzerland and Italy. After 1480, the Schwabacher types, based upon local Bastarda traditions, appeared in Bohemia, Germany, and Switzerland.

Fraktur developed from imperial Chancery hands during the reign of Maximilian I. Its name refers to the broken curves that characterize this form of Blackletter. Both Schwabacher and

Fraktur came into common use between 1493 and 1522, when the new High German language was becoming established. Whereas the early Textura forms reflected a widespread manuscript tradition, Schwabacher letters, in particular, came to be seen as the visual embodiment of German national identity, and as the visual form of the German language. They are also the typographic voice of Protestantism, as the form used for Martin Luther's German bible of 1522.

These forms remained in wide use across a sphere of Germanic cultural influence encompassing Austria, Bohemia, Poland, and Switzerland, and were a significant element in typographic development in the Netherlands. The complex history of Blackletter reinforced and formalized a range of distinctive regional differences, notably between the English "Old English" and the German Fraktur. Both idioms have been revisited and refined by leading type designers over the last three centuries.

Development of Blackletter

The history of Blackletter has included some attempts to streamline its forms and incorporate aspects of Roman lettering toward a

BLACKLETTER: CHARACTERISTIC FEATURES

High contrast

kuon

Narrow lowercase

ova

Angled stress

Broad stroke widths

more rational modern hybrid. Johann Friedrich Unger attempted a synthesis of Blackletter with Roman type in collaboration with Firmin Didot. His Unger Fraktur, designed in 1793, revived by Bierbaum and currently published by Berthold, reflects some aspects of the Didone form within the Blackletter tradition.

Outside of the German-speaking world, the somewhat characterless Old English and its American equivalent Cloister Black have enjoyed widespread if rather indiscriminate use as signifiers of antiquity up to the present day. The early 20th century saw a revival of interest in 17th- and 18th-century Fraktur and Schwabacher faces in Germany, and was a period in which both the rediscovery of classic Blackletter types and the organic forms of the Jugendstil influenced the design of many new faces. The adoption of Blackletter as the graphic expression of Nazi militarism was abruptly reversed by edict in 1941, but continued to color public perceptions of the Blackletter tradition.

Modern interpretations

Relatively few Blackletter faces have been adapted from metal to digital, and the majority of examples available today are original, sometimes radical reinterpretations of the Blackletter form. The interrupted development of Blackletter created the conditions for some imaginative reappraisals of a tradition that had been interrupted by the events of World War II and a typographic vocabulary that had to some extent fallen into disrepute.

Fette Fraktur is an assertive typeface of unknown provenance that has been adapted from metal casting for Linotype to digital by Adobe. Duc de Berry is an elegant Bastarda in the French style, designed by Gottfried Pott and issued by Linotype. More recently, Jonathan Barnbrook's Bastard family reconsiders the Blackletter tradition from the radical perspectives of digital typeface design. Entirely geometric, it is an imaginative reflection upon the genre, designed across a range of ironically titled weights and widths.

Zuzana Licko's Totally Gothic is the result of an experimental enquiry into Blackletter. A bitmapped Textura, autotraced in Fontographer, produced a set of letters that evoke their Blackletter sources while retaining none of the calligraphic origins of the form, but substituting instead a sequence of curved lines that are explicitly digital.

Many examples of individually lettered graphics allude loosely to Blackletter traditions, notably in the work of lettering designers such as Margo Chase. The form has a great richness of color and weight that lends itself well to packaging and expressive lettering. German packaging and promotional graphics make richly flavored use of a range of Blackletter forms, and Blackletter faces continue to be used for the mastheads of newspapers across Europe.

1

2

3

1–3 German currency notes
Regional currency notes from Germany issued between World Wars I and II, showing a variety of Blackletter forms.
4 Excerpt from Gutenberg bible
The close-set, vertical form of the Textura Blackletter can be seen in the first movable types used in Johann Gutenberg's bible of 1455.

4

Clairvaux

Designed by Hubert Maring and issued by Linotype in 1990

Clairvaux is a Bastarda that embodies noticeable references to Carolingian minuscule, and may consequently be more legible to non-German readers than many other Blackletter faces. The reference to Carolingian minuscule is particularly evident in the lowercase a.

The title refers to the Cistercian abbey of Clairvaux, and the calligraphic qualities of the face reflect the manuscript tradition in a face that might equally be defined as a Script. Its simplicity of form is in marked contrast to the more dramatic Blackletter faces, and it would be feasible for setting limited amounts of running text.

IN CONTEXT

typography n. [ᴍᴇ f. Gk typos, impression, cast + graphia, writing] Art of printing; style or appearance of printed matter (the typography was admirable).

Italic and bold weights are conventionally used to indicate differentiation, emphasis, attributions, and quotations.

Typefaces or families With an extended range of weights, the designer has greater scope in manipulating these qualities.

KEY FEATURES

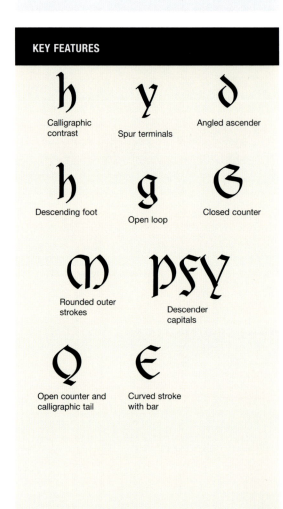

h — Calligraphic contrast

y — Spur terminals

d — Angled ascender

h — Descending foot

g — Open loop

G — Closed counter

M — Rounded outer strokes

PFY — Descender capitals

Q — Open counter and calligraphic tail

E — Curved stroke with bar

CLAIRVAUX: SELECTED ALPHABETS

ABCDEFGHIJKLMNOPQRSTUVWXYZ &!?(),:;'
abcdefghijklmnopqrstuvwxyz

The typographer's first duty is to the text itself. An intelligent interpretation of the text will not only ensure readability, but will also reflect its tone, its structure, and its cultural context. The typographer's analysis illuminates the text, like the musician's reading of a score.

8pt Regular

ABCDEFGHIJKLMNOPQRSTUVWXYZ &!?(),:;'
abcdefghijklmnopqrstuvwxyz

The typographer's first duty is to the text itself. An intelligent interpretation of the text will not only ensure readability, but will also reflect its tone, its structure, and its cultural context. The typographer's analysis illuminates the text, like the musician's reading of a score.

8pt Dfr

Fette Fraktur

Designed by Johann Christian Bauer and issued by the Bauer Foundry in 1850; digital form by Adobe

Fette Fraktur is a highly colored, dramatic Fraktur with a vivid contrast of angled and curved strokes. Several historic Blackletter forms and ligatures are included in addition to the standard alphabet, while the numerals show the affinities between this phase of Blackletter and the late Didone or fat-face display types in their wide set and pronounced variation of stroke width.

Although there are few instances in which they would be suitable for setting text of any length, Blackletter types continue to enjoy widespread use as a decorative form, and the weight and color of Fette Fraktur make it an appropriate choice for display use.

IN CONTEXT

typography n. [ME f. Gk typos, impression, cast + graphia, writing] Art of printing; style or appearance of printed matter (the typography was admirable).

Italic and bold weights are conventionally used to indicate differentiation, emphasis, attributions, and quotations.

Typefaces or families With an extended range of weights, the designer has greater scope in manipulating these qualities.

10pt

FETTE FRAKTUR: SELECTED ALPHABETS

ABCDEFGHIJKLMNOPQRSTUVWXYZ &!?0,.;'
abcdefghijklmnopqrstuvwxyz

The typographer's first duty is to the text itself. An intelligent interpretation of the text will not only ensure readability, but will also reflect its tone, its structure, and its cultural context. The typographer's analysis illuminates the text, like the musician's reading of a score.

8pt Regular

KEY FEATURES

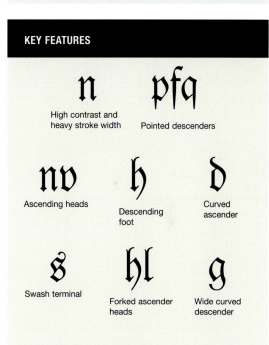

High contrast and heavy stroke width

Pointed descenders

Ascending heads

Descending foot

Curved ascender

Swash terminal

Forked ascender heads

Wide curved descender

𝔚𝔦𝔩𝔥𝔢𝔩𝔪 𝔎𝔩𝔦𝔫𝔤𝔰𝔭𝔬𝔯 𝔖𝔠𝔥𝔯𝔦𝔣𝔱

Designed by Rudolf Koch in 1926; available from Adobe as Wilhelm Klingspor Gotisch

An ornamental Textura, Wilhelm Klingspor Schrift is a vivid, animated face. The weight of the capital letters is enlivened by a decorative second stroke, and the angular verticality of the face is relieved by the subtle curves of the d and z, and the hairline spurs that accent the diagonals. The face incorporates the regular vertical intervals that characterize the Textura, alongside elements of differentiation and visual interest, to create a face that is rhythmically consistent but colorful.

The repetition of condensed vertical forms limits the legibility of the face, which is primarily suitable for display or titling functions.

IN CONTEXT

typography n. [ME f. Gk typos, impression, cast + graphia, writing] Art of printing; style or appearance of printed matter (the typography was admirable).

Italic and bold weights are conventionally used to indicate differentiation, emphasis, attributions, and quotations.

Typefaces or families With an extended range of weights, the designer has greater scope in manipulating these qualities.

WILHELM KLINGSPOR SCHRIFT: SELECTED ALPHABETS

𝔄𝔅ℭ𝔇𝔈𝔉𝔊ℌℑ𝔍𝔎𝔏𝔐𝔑𝔒𝔓𝔔ℜ𝔖𝔗𝔘𝔙𝔚𝔛𝔜ℨ &!?(),:;'
abcdefghijklmnopqrstuvwxyz

The typographer's first duty is to the text itself. An intelligent interpretation of the text will not only ensure readability, but will also reflect its tone, its structure, and its cultural context. The typographer's analysis illuminates the text, like the musician's reading of a score.

8pt Regular

𝔄𝔅ℭ𝔇𝔈𝔉𝔊ℌℑ𝔍𝔎𝔏𝔐𝔑𝔒𝔓𝔔ℜ𝔖𝔗𝔘𝔙𝔚𝔛𝔜ℨ &!?(),:;'
abcdefghijklmnopqrstuvwxyz

The typographer's first duty is to the text itself. An intelligent interpretation of the text will not only ensure readability, but will also reflect its tone, its structure, and its cultural context. The typographer's analysis illuminates the text, like the musician's reading of a score.

8pt Dfr

KEY FEATURES

Hairline second stroke on capitals

Descender capitals

𝔛

Bar

anh

Narrow Textura lowercase

bhk

Splayed terminal head

Descending foot

f

Straight descender

ȝ

Looped tail

Duc de Berry

Designed by Gottfried Pott and issued by Linotype in 1991

Duc de Berry is a Bastarda reflecting French Blackletter traditions. The o is characteristic of the more open and curvaceous Bastarda form, and the face is alive with detail and color. The capitals are embellished with hairline strokes ending in rectangular terminals, and the vertical emphasis of the lowercase is moderated by concave strokes on the m and n, and the dramatic ascender of the d.

Less dense than many Blackletter faces, it shows a greater Romanesque influence, and as a result, it is reasonably legible for limited amounts of text setting. It includes a small number of historic Blackletter forms and ligatures, and is designed in a single weight.

IN CONTEXT

typography n. [ML f. Gk typos, impression, cast + graphia, writing] Art of printing; style or appearance of printed matter (the typography was admirable).

Italic and bold weights are conventionally used to indicate differentiation, emphasis, attributions, and quotations.

Typefaces or families with an extended range of weights, the designer has greater scope in manipulating these qualities.

DUC DE BERRY: SELECTED ALPHABETS

ABCDEFGHIJKLMNOPQRSTUVWXYZ o!?(),.:'
abcdefghijklmnopqrstuvwxyz

The typographer's first duty is to the text itself. An intelligent interpretation of the text will not only ensure readability, but will also reflect its tone, its structure, and its cultural context. The typographer's analysis illuminates the text, like the musician's reading of a score.

8pt Regular

ABCDEFGHIJKLMNOPQRSTUVWXYZ o!?(),.:'
abcdefghijklmnopqrstuvwxyz

The typographer's first duty is to the text itself. An intelligent interpretation of the text will not only ensure readability, but will also reflect its tone, its structure, and its cultural context. The typographer's analysis illuminates the text, like the musician's reading of a score.

8pt Dfr

KEY FEATURES

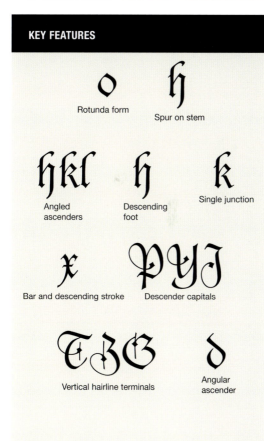

Rotunda form

Spur on stem

Angled ascenders

Descending foot

Single junction

Bar and descending stroke

Descender capitals

Vertical hairline terminals

Angular ascender

NOTRE DAME

ABCDEFGHIJKLMNOPQRSTUVWXYZ &!?(),.;'
abcdefghijklmnopqrstuvwxyz

The typographer's first duty is to the text itself. An intelligent interpretation of the text will not only ensure readability, but will also reflect its tone, its structure, and its cultural context. The typographer's analysis illuminates the text, like the musician's reading of a score.

KARLGEORG HOEFER, 1993

A formalized and regular Textura, with a double hairline in the capitals, Notre Dame includes historic forms and ornaments.

WITTENBERGER FRAKTUR

ABCDEFGHIJKLMNOPQRSTUVWXYZ &!? (),.;'
abcdefghijklmnopqrstuvwxyz

The typographer's first duty is to the text itself. An intelligent interpretation of the text will not only ensure readability, but will also reflect its tone, its structure, and its cultural context. The typographer's analysis illuminates the text, like the musician's reading of a score.

MONOTYPE STUDIO, 1906

A broad, open Fraktur, in which the fluid capitals contrast with the strong verticals of the lowercase. Wittenberger is available in two weights.

BASTARD

ABCDEFGHIJKLMNOPQRSTUVWXYZ &!?(),.;'
abcdefghijklmnopqrstuvwxyz

The typographer's first duty is to the text itself. An intelligent interpretation of the text will not only ensure readability, but will also reflect its tone, its structure, and its cultural context. The typographer's analysis illuminates the text, like the musician's reading of a score.

JON BARNBROOK, 1990

A digital typeface, re-creating Blackletter from largely geometric components across a range of weights and widths.

BROKENSCRIPT

ABCDEFGHIJKLMNOPQRSTUVWXYZ et!?(),.;'
abcdefghijklmnopqrstuvwxyz

The typographer's first duty is to the text itself. An intelligent interpretation of the text will not only ensure readability, but will also reflect its tone, its structure, and its cultural context. The typographer's analysis illuminates the text, like the musician's reading of a score.

JUST VAN ROSSUM, 1990

An undecorated Textura, angular and digitally stylized, Brokenscript is also available in a "rough" version with irregular edges. It is visually rich and surprisingly legible when set as text.

JOHANNES G

ABCDEFGHIJKLMNOPQRSTUVWXYZ · !?(),.;'
abcdefghijklmnopqrstuvwxyz

The typographer's first duty is to the text itself. An intelligent interpretation of the text will not only ensure readability, but will also reflect its tone, its structure, and its cultural context. The typographer's analysis illuminates the text, like the musician's reading of a score.

MANFRED KLEIN, 1991

A rich digital Textura, reminiscent of the earliest printed types, Johannes G is a contemporary homage to Gutenberg.

KOBERGER

ABCDEFGHIJKLMNOPQRSTUVWXYZ &!?(),:;'
abcdefghijklmnopqrstuvwxyz

The typographer's first duty is to the text itself. An intelligent interpretation of the text will not only ensure readability, but will also reflect its tone, its structure, and its cultural context. The typographer's analysis illuminates the text, like the musician's reading of a score.

MANFRED KLEIN, 1991

An irregular and visually lively Bastarda of limited legibility but considerable visual interest and diversity of form.

OLD ENGLISH

ABCDEFGHIJKLMNOPQRSTUVWXYZ &!?(),:;'
abcdefghijklmnopqrstuvwxyz

The typographer's first duty is to the text itself. An intelligent interpretation of the text will not only ensure readability, but will also reflect its tone, its structure, and its cultural context. The typographer's analysis illuminates the text, like the musician's reading of a score.

MONOTYPE, 1990

One of the most visible examples of a continuing English Blackletter tradition, Old English lacks the character or fluency of most German Textura faces.

GOUDY TEXT

ABCDEFGHIJKLMNOPQRSTUVWXYZ
&!?(),:;'abcdefghijklmnopqrstuvwxyz

The typographer's first duty is to the text itself. An intelligent interpretation of the text will not only ensure readability, but will also reflect its tone, its structure, and its cultural context. The typographer's analysis illuminates the text, like the musician's reading of a score.

FREDERIC GOUDY, 1928

An American interpretation of Blackletter, in which the designer's decorative sensibility informs the capitals, while the lowercase is smooth, narrow, and fairly legible.

LINOTEXT

ABCDEFGHIJKLMNOPQRSTUVWXYZ
&!?(),:;'abcdefghijklmnopqrstuvwxyz

The typographer's first duty is to the text itself. An intelligent interpretation of the text will not only ensure readability, but will also reflect its tone, its structure, and its cultural context. The typographer's analysis illuminates the text, like the musician's reading of a score.

MORRIS FULLER BENTON, 1901

A somewhat formalized and static Textura, characteristic of Blackletter faces designed outside the German tradition.

TOTALLY GOTHIC

ABCDEFGHIJKLMNOPQRSTUVWXYZ &!?(),:;'
abcdefghijklmnopqrstuvwxyz

The typographer's first duty is to the text itself. An intelligent interpretation of the text will not only ensure readability, but will also reflect its tone, its structure, and its cultural context. The typographer's analysis illuminates the text, like the musician's reading of a score.

ZUZANA LICKO, 1990

A typeface created by digital tracing of Blackletter forms, Totally Gothic retains a Blackletter flavor while originating a unique graphic vocabulary.

BEYOND CLASSIFICATION

Inevitably there are some types that resist classification, either because they include insufficient identifying characteristics or because they incorporate characteristics of more than one category.

APPLICATIONS

Many typefaces resist classification because they have been designed to question typographic convention and provoke comment and debate. Their function is therefore largely limited to display applications where a spirit of contemporanaeity and indeed provocation may be appropriate. Few are suited to text setting, in which familiarity of form is an important aspect of overall readability.

An increasing number of typefaces resist categorization. Some contemporary digital typefaces are designed to test the very limits of the term typeface in challenging accepted conventions of character recognition and legibility.

Multiple options

Even the fundamental classification of faces as either serif or sans serif is called into question by a typeface such as Lance Hidy's Penumbra, which utilizes multiple master technology to offer a sliding scale of options within the face, ranging from sans to full serif. The emergence of the experimental typeface, and of type design as a medium of creative inquiry, has produced a diversity of faces that may have limited application but serve to stimulate debate and challenge prevailing orthodoxies.

Hybridized faces

The 1990s saw a number of hybridized faces, such as Max Kisman's Fudoni and Jonathan Barnbrook's Prototype, in which elements of two or more typefaces are combined. Both of these make use of revered canonical classic faces: Fudoni being a composite of Futura and Bodoni, and Prototype incorporating elements of five traditional faces. They stand as a provocative demonstration of the potential of digital media to subvert preconceptions about typographic identity.

Resisting classification

It might be argued that the present conditions of digital type design make historical typographic classifications irrelevant. Digitally designed faces may be defined by using the terminology of metal type, but explicitly contemporary typeface designs may draw freely upon a range of ideas and references, both from within type history and outside it. They may draw their inspiration from digital media rather than print, may make a virtue of impermanence and unpredictability, and may make deliberately playful or ironic allusions to the orthodoxies that they contradict. Since the advent of digital media, the design of type has developed as a field of radical experimentation, a medium of creative play and an expression of conceptual enquiry.

BEYOND CLASSIFICATION: CHARACTERISTIC FEATURES

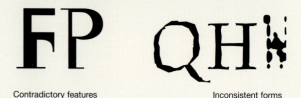

Contradictory features

Inconsistent forms

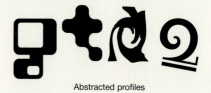

Abstracted profiles

Hybridized features

1

2

3

4

5

1 Type foundry sample Charles Wilkin's Superchunk is an explicitly manual face, animated by extreme irregularity and variation of form, giving the appearance of hand lettering rather than a typeface.

2 Ethnic Heritage Ensemble jazz poster Niklaus Troxler has created beadwork-style lettering to reflect an African-American band's fusion of African drum rhythms with American improvisational music.

3 Noteworthy masthead Paone Design Associate's newsletter masthead for the Philadelphia Youth Orchestra combines the musical notation font Sonata with hand-drawn letterforms.

4 Tourism poster Template Gothic, an experimental face based upon found lettering, has proved to be a durable titling face. Its sense of contemporanaeity and directness is ideal for this poster by Büro für Gestaltung for a travel agency specializing in adventure vacations.

5 Eskelin and Bennink jazz poster Niklaus Troxler pushes legibility to the limit in a reflection of the band's improvisational musical style.

PENUMBRA

Designed by Lance Hidy for Adobe in 1994

Penumbra resists one of the most basic elements of categorization, because it is a single typeface capable of both serif and sans serif forms. Designed as a multiple master face on a structure that is broadly classical or Humanist, Penumbra allows the user to determine the extent of serif on a sliding scale, from a full serif to a sans. It is also available as four distinct fonts, defined as sans, flare, half serif, and serif.

IN CONTEXT

TYPOGRAPHY N. [ML F. GK TYPOS, IMPRESSION, CAST PLUS GRAPHIA, WRITING] ART OF PRINTING; STYLE OR APPEARANCE OF PRINTED MATTER (THE TYPOGRAPHY WAS ADMIRABLE).

ITALIC AND **BOLD** WEIGHTS ARE CONVENTIONALLY USED TO INDICATE DIFFERENTIATION, EMPHASIS, ATTRIBUTIONS, AND QUOTATIONS.

TYPEFACES OR FAMILIES WITH AN EXTENDED RANGE OF **WEIGHTS**, THE DESIGNER HAS GREATER SCOPE IN **MANIPULATING** THESE QUALITIES.

KEY FEATURES

Geometric Low bar Single junction at stem

Narrow bowl Low junction

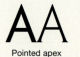 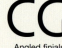 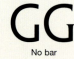
Pointed apex Angled finials No bar

PENUMBRA: SELECTED ALPHABETS

ABCDEFGHIJKLMNOPQRSTUVWXYZ &!?(),:;'

THE TYPOGRAPHER'S FIRST DUTY IS TO THE TEXT ITSELF. AN INTELLIGENT INTERPRETATION OF THE TEXT WILL NOT ONLY ENSURE READABILITY, BUT WILL ALSO REFLECT ITS TONE, ITS STRUCTURE, AND ITS CULTURAL CONTEXT. THE TYPOGRAPHER'S ANALYSIS ILLUMINATES THE TEXT, LIKE THE MUSICIAN'S READING OF A SCORE.

220 Light 150 Flare

ABCDEFGHIJKLMNOPQRSTUVWXYZ &!?(),:;'

THE TYPOGRAPHER'S FIRST DUTY IS TO THE TEXT ITSELF. AN INTELLIGENT INTERPRETATION OF THE TEXT WILL NOT ONLY ENSURE READABILITY, BUT WILL ALSO REFLECT ITS TONE, ITS STRUCTURE, AND ITS CULTURAL CONTEXT. THE TYPOGRAPHER'S ANALYSIS ILLUMINATES THE TEXT, LIKE THE MUSICIAN'S READING OF A SCORE.

365 Regular 1000 Serif

ABCDEFGHIJKLMNOPQRSTUVWXYZ &!?(),:;'

THE TYPOGRAPHER'S FIRST DUTY IS TO THE TEXT ITSELF. AN INTELLIGENT INTERPRETATION OF THE TEXT WILL NOT ONLY ENSURE READABILITY, BUT WILL ALSO REFLECT ITS TONE, ITS STRUCTURE, AND ITS CULTURAL CONTEXT. THE TYPOGRAPHER'S ANALYSIS ILLUMINATES THE TEXT, LIKE THE MUSICIAN'S READING OF A SCORE.

725 Bold 150 Flare

Template Gothic

Designed by Barry Deck in the 1990s and distributed by Émigré

Template Gothic was originally based upon a piece of stencil lettering found in a United States laundromat. As such, it embodies a move toward specificity and referentiality in typeface design; a celebration of the peculiarities of circumstance surrounding a typeface's origins and sources. This can be read as a reversal of the modernist ideal of an international typography, freed from localized values or associations.

Whereas many typefaces in this genre have been more significant as statements of intent than as faces for long-term use, Template Gothic has proved effective for display and the setting of limited amounts of text.

179

IN CONTEXT

typography n. [ML f. Gk **typos**, impression, cast + **graphia**, writing] Art of printing; style or appearance of printed matter (**the typography was admirable**).

Italic and bold weights are conventionally used to indicate differentiation, emphasis, attributions, and quotations.

Typefaces or families With an **extended** range of **weights**, the designer has greater scope in **manipulating** these qualities.

KEY FEATURES

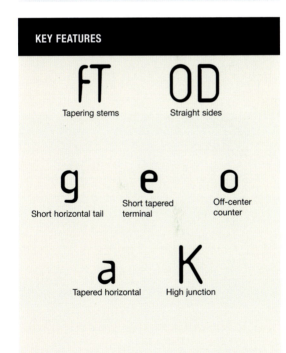

FT — Tapering stems
OD — Straight sides
g — Short horizontal tail
e — Short tapered terminal
o — Off-center counter
a — Tapered horizontal
K — High junction

TEMPLATE GOTHIC: SELECTED ALPHABETS

ABCDEFGHIJKLMNOPQRSTUVWXYZ &!?(),:;'
abcdefghijklmnopqrstuvwxyz

The typographer's first duty is to the text itself. An intelligent interpretation of the text will not only ensure readability, but will also reflect its tone, its structure, and its cultural context. The typographer's analysis illuminates the text, like the musician's reading of a score.

Regular

ABCDEFGHIJKLMNOPQRSTUVWXYZ &!?(),:;'
abcdefghijklmnopqrstuvwxyz

The typographer's first duty is to the text itself. An intelligent interpretation of the text will not only ensure readability, but will also reflect its tone, its structure, and its cultural context. The typographer's analysis illuminates the text, like the musician's reading of a score.

Bold

Fudoni

Designed Max Kisman in 1991 and distributed by FontShop International

Fudoni is a quintessentially unclassifiable typeface, being based upon an explicit and deliberate contradiction of typographic norms. It is composed of elements of two classic typefaces, Futura and Bodoni. To combine a 20th-century monoline sans and an 18th- century Didone might seem no more than a perverse joke, but the resulting face is colorful, irreverent, and witty.

Although, like many experimental types from this period, its application is limited, it functions well as a display face, ideally suited to expressing nonconformity and disregard for convention.

Fudoni exists in three versions: Fudoni One, Two, and Three. While these can be read as a range of weights, they also incorporate variations of form, combining elements of the two faces in different ways in each version.

IN CONTEXT

typography n. [ML f. Gk **typos**, impression, cast + **graphia**, writing] Art of printing; style or appearance of printed matter (**the typography was admirable**).

Italic and **bold** weights are conventionally used to indicate differentiation, emphasis, attributions, and quotations.

Typefaces or families With an extended range of **weights**, the designer has greater scope in manipulating these qualities.

KEY FEATURES

TTT
Variable serifs

eee
Irregular stroke weights

ggg
High bowl

mmm
Irregular shoulders

aaa
Small counter

kk
Heavy leg

FUDONI: SELECTED ALPHABETS

ABCDEFGHIJKLMNOPQRSTUVWXYZ &!?(),.:;'
abcdefghijklmnopqrstuvwxyz

The typographer's first duty is to the text itself. An intelligent interpretation of the text will not only ensure readability, but will also reflect its tone, its structure, and its cultural context. The typographer's analysis illuminates the text, like the musician's reading of a score.

One

ABCDEFGHIJKLMNOPQRSTUVWXYZ &!?(),.:;'
abcdefghijklmnopqrstuvwxyz

The typographer's first duty is to the text itself. An intelligent interpretation of the text will not only ensure readability, but will also reflect its tone, its structure, and its cultural context. The typographer's analysis illuminates the text, like the musician's reading of a score.

Two

ABCDEFGHIJKLMNOPQRSTUVWXYZ &!?(),.:;'
abcdefghijklmnopqrstuvwxyz

The typographer's first duty is to the text itself. An intelligent interpretation of the text will not only ensure readability, but will also reflect its tone, its structure, and its cultural context. The typographer's analysis illuminates the text, like the musician's reading of a score.

Three

Matrix

Zuzana Licko may have been the first designer to comprehend fully the problems of digital typeface design, and to integrate this understanding into the design of explicitly digital faces.

While they allude to various typographic categories, their central characteristic is the recognition of the pixel grid as a basic component of the design process (rather than an obstruction to the smooth contour of a letter). As a consequence, these faces retain their form, consistency, and legibility under conditions of very low resolution, while showing greater detail at higher resolutions. Instead of being designed for optimum conditions, they aim to produce a satisfactory form at each level.

In addition to representing a key point in the evolution of digital type design, Matrix remains highly functional as a screen font.

IN CONTEXT

typography *n.* [ML f. Gk *typos*, impression, cast + *graphia*, writing] Art of printing; style or appearance of printed matter (*the typography was admirable*).

Italic and **bold** weights are conventionally used to indicate differentiation, emphasis, attributions, and quotations.

Typefaces or families With an **extended** range of **weights**, the designer has greater scope in *manipulating* these qualities.

KEY FEATURES

M	O	h
Medium contrast	Vertical stress	High x-height

H	itl
Triangular serifs	Triangular heads

arz	y
Vertical terminals	Serifed tail

b	cvk
Spur foot	Ball terminal italics

MATRIX: SELECTED ALPHABETS

ABCDEFGHIJKLMNOPQRSTUVWXYZ &!?(),.:;'
abcdefghijklmnopqrstuvwxyz

The typographer's first duty is to the text itself. An intelligent interpretation of the text will not only ensure readability, but will also reflect its tone, its structure, and its cultural context. The typographer's analysis illuminates the text, like the musician's reading of a score.

Regular

ABCDEFGHIJKLMNOPQRSTUVWXYZ &!?(),.:;'
abcdefghijklmnopqrstuvwxyz

The typographer's first duty is to the text itself. An intelligent interpretation of the text will not only ensure readability, but will also reflect its tone, its structure, and its cultural context. The typographer's analysis illuminates the text, like the musician's reading of a score.

Script

ABCDEFGHIJKLMNOPQRSTUVWXYZ &!?(),.:;'
abcdefghijklmnopqrstuvwxyz

The typographer's first duty is to the text itself. An intelligent interpretation of the text will not only ensure readability, but will also reflect its tone, its structure, and its cultural context. The typographer's analysis illuminates the text, like the musician's reading of a score.

Bold

FETISH NO. 338

ABCDEFGHIJKLMNOPQRSTUVWXYZ &!?{},:;'

THE TYPOGRAPHER'S FIRST DUTY IS TO THE TEXT ITSELF. AN INTELLIGENT INTERPRETATION OF THE TEXT WILL NOT ONLY ENSURE READABILITY, BUT WILL ALSO REFLECT ITS TONE, ITS STRUCTURE, AND ITS CULTURAL CONTEXT. THE TYPOGRAPHER'S ANALYSIS ILLUMINATES THE TEXT, LIKE THE MUSICIAN'S READING OF A SCORE.

FETISH TYPEFACE © THE HOEFLER TYPE FOUNDRY, 1994. HTTP://WWW.TYPOGRAPHY.COM

JONATHAN HOEFLER, 1995

Sometimes described as a Blackletter, Fetish is an eclectic assemblage of details and characteristics, more evocative of a generalized sense of past time than a specific history.

BEOWOLF

ABCDEFGHIJKLMNOPQRSTUVWXYZ &!?(),:;'
abcdefghijklmnopqrstuvwxyz

The typographer's first duty is to the text itself. An intelligent interpretation of the text will not only ensure readability, but will also reflect its tone, its structure, and its cultural context. The typographer's analysis illuminates the text, like the musician's reading of a score.

ERIK VAN BLOCKLAND AND JUST VAN ROSSUM, 1990

A typeface designed to generate unpredictable variants in the irregularities of outline, described as "type you can't trust." The companion Beosans was designed in 1992.

LOCALIZER

ABCDEFGHIJKLMNOPQRSTUVWXYZ &!?(),:;'
abcdefghijklmnopqrstuvwxyz

The typographer's first duty is to the text itself. An intelligent interpretation of the text will not only ensure readability, but will also reflect its tone, its structure, and its cultural context. The typographer's analysis illuminates the text, like the musician's reading of a score.

CRITZLER, 1996

A face based upon the geometric form and rounded contours of early computer typefaces, Localizer is animated by the use of two main stroke widths, creating unexpected counterforms and letters that sit above the baseline.

ANGST

ABCDEFGHIJKLMNOPQRSTUVWXYZ &!?(),:;'
abcdefghijklmnopqrstuvwxyz

The typographer's first duty is to the text itself. An intelligent interpretation of the text will not only ensure readability, but will also reflect its tone, its structure, and its cultural context. The typographer's analysis illuminates the text, like the musician's reading of a score.

JURGEN HEUBER, 1997

A deliberately irregular typeface that fractures into a secondary drawn line, Angst combines a range of character widths to dramatic effect.

MULINEX

ABCDEFGHIJKLMNOPQRSTUVWXYZ &!?(),:;'
abcdefghijklmnopqrstuvwxyz

The typographer's first duty is to the text itself. An intelligent interpretation of the text will not only ensure readability, but will also reflect its tone, its structure, and its cultural context. The typographer's analysis illuminates the text, like the musician's reading of a score.

ALLESSIO LEONARDI, 1994

A once functional sans serif letterform invaded by a decorative curlicue.

ATLANTA

ABCDEFGHIJKLMNOPQRSTUVWXYZ &!?(),:;'

ABCDEFGHIJKLMNOPQRSTUVWXYZ

THE TYPOGRAPHER'S FIRST DUTY IS TO THE TEXT ITSELF. AN INTELLIGENT INTERPRETATION OF THE TEXT WILL NOT ONLY ENSURE READABILITY, BUT WILL ALSO REFLECT ITS TONE, ITS STRUCTURE, AND ITS CULTURAL CONTEXT. THE TYPOGRAPHER'S ANALYSIS ILLUMINATES THE TEXT, LIKE THE MUSICIAN'S READING OF A SCORE.

PETER BILAK, 1995

Reproducing a crude dot matrix as printed on low-quality paper, Atlanta is a condensed capital face available in three weights.

DOG

ABCDEFGHIJKLMNOPQRSTUVWXYZ &!?(),:;'

abcdefghijklmnopqrstuvwxyz

The typographer's first duty is to the text itself. An intelligent interpretation of the text will not only ensure readability, but will also reflect its tone, its structure, and its cultural context. The typographer's analysis illuminates the text, like the musician's reading of a score.

PAUL SYCH, 1991

A decorative, angular face with deliberate bitmap steps and a highly condensed form.

SCRATCHED OUT

ABCDEFGHIJKLMNOPQRSTUVWXYZ &!?[],:;'

abcdefghijklmnopqrstuvwxyz

The typographer's first duty is to the text itself. An intelligent interpretation of the text will not only ensure readability, but will also reflect its tone, its structure, and its cultural context. The typographer's analysis illuminates the text, like the musician's reading of a score.

PIERRE DI SCUILLO, 1995

A deliberately crude bitmap form, in which each letter has been graphically "canceled," testing the reader's expectations of legibility.

FUSAKA

ABCDEFGHIJKLMNOPQRSTUVWXYZ &!?[],:;'

THE TYPOGRAPHER'S FIRST DUTY IS TO THE TEXT ITSELF. AN INTELLIGENT INTERPRETATION OF THE TEXT WILL NOT ONLY ENSURE READABILITY, BUT WILL ALSO REFLECT ITS TONE, ITS STRUCTURE, AND ITS CULTURAL CONTEXT. THE TYPOGRAPHER'S ANALYSIS ILLUMINATES THE TEXT, LIKE THE MUSICIAN'S READING OF A SCORE.

MICHAEL WANT, 1996

A Western alphabet constructed of strokes suggesting Japanese kanji and other ideogram forms.

MOONBASE ALPHA

ABCDEFGHIJKLMNOPQRSTUVWXYZ +!?{},:;'

abcdefghijklmnopqrstuvwxyz

The typographer's first duty is to the text itself. An intelligent interpretation of the text will not only ensure readability, but will also reflect its tone, its structure, and its cultural context. The typographer's analysis illuminates the text, like the musician's reading of a score.

CORNELL WINDLIN, 1991

A rounded digital form, in which a graceful fluidity emerges from the distortion of the bitmap grid.

BUILDING A TYPEFACE COLLECTION

The range of typefaces available to the user is vast and potentially bewildering. More type is available, at less cost, to more users, than ever before. A good starting point is to build up a working library that includes key examples from each of the main categories identified in the directory.

Free fonts

Given the cost of some fonts, one might be surprised to note how many are available without charge. When evaluating independently produced free fonts and shareware, it can generally be assumed that you get what you pay for. The quality of detail in kerning and optical mastering that one would expect of a professional-quality text face represents a major investment of the designer's time and is seldom available without cost.

There are, however, a number of display faces and more speculative experimental designs that designers or foundries make available without charge as a promotional device. These may form an interesting adjunct to your main library, but it would be unwise to try to base a working font collection around them.

A number of typefaces come "bundled" with computer operating systems and other software. The range and quality of these has increased and improved in recent years, and many of the fonts provided with recent operating systems, design software, and type management software will enhance your collection. Some of these fonts are "loss leaders" that provide a partial, but still perfectly usable, version of a more extended typeface family.

What to include

There are sound arguments for limiting the number of text faces you use regularly. Greater familiarity with a small number of typefaces can be expected to lead to a deeper awareness of their finer details than will result from continuous sampling and experimentation. Similarly, a carefully chosen selection of well-designed typefaces will serve you far better than a huge library of inferior fonts.

Fonts cost far less when bought in collections (or indeed entire libraries) than when bought singly, so it may be best to look at the output of the major established foundries first (see contacts opposite). You are likely to find it more economical to buy a foundry collection than to purchase separately a large number of individual faces that you have selected.

Each of the major foundries offers a representative spread of typefaces in each of the major categories, including their versions of classic types. Some foundries give different names to their digital redesigns of historic typefaces. In many cases, foundries compile economical selections of widely used fonts. While these collections may not include special features, such as expert sets or multiple master fonts, they often represent excellent value for money and can form the core of your working library or collection, which you may then augment with additional, more specialized faces as the necessity or opportunity arises.

Copyright

The use of any typeface involves acceptance of the manufacturer's terms and conditions, which normally limit the number of individual sites for which the font is licensed. To copy a font that has been licensed to another user, or to allow another user to copy a font licensed to you, is a breach of copyright. This is not only a matter of law but also of professional ethics: type designers rely upon the revenue from the licensing of their fonts, and it is this revenue that enables them to continue in their work. Scrupulous observance of copyright is not only a legal necessity for the professional, but also a reflection of our professional obligation to support the continued development of type design.

It should not be assumed that the terms under which a typeface has been licensed will support unlimited use. Faces licensed for educational use may not be used for commercial projects, and use of a typeface for mass publishing may require a new and substantially more expensive licensing agreement.

CONTACTS & BIBLIOGRAPHY

ADOBE SYSTEMS INCORPORATED
345 Park Avenue, San Jose, CA 95110-2704, United States
T +1/408/536 6000 F +1/408/537 6000
www.adobe.com/type
Addresses in other countries around the world can be found at:
http://store.adobe.com/aboutadobe/contact.html

BERTHOLD DIRECT CORP.
47 West Polk Street #100–175, Chicago, IL 60605, United States
F +1/866/743 0502
bertholdinfo@bertholdtypes.com www.bertholdtypes.com

BITSTREAM INC.
Athenaeum House, 215 First Street, 17th Floor, Cambridge,
MA 02142, United States
T +1/617/497 6222 F +1/617/868 0784
www.bitstream.com

CARTER & CONE TYPE INC.
30321 Point Marina Drive, Canyon Lake, CA 92587, United States
T +1/951/244 5965 F +1/951/244 0946
info@carterandcone.com www.carterandcone.com

ÉMIGRÉ INC.
1700 Shattuck Avenue #307, Berkeley, CA 94709, United States
T +1/530/756 2900 F +1/530/756 1300
info@emigre.com www.emigre.com

FONTSHOP INTERNATIONAL (FONTFONT)
60 Tehama Street, San Francisco, CA 94105, United States
T +1/415/512 2093 F +1/415/512 2097
info@fontshop.com www.fontshop.com

FUNDACIÓN TIPOGRÁFICA BAUER
Calle Selva de Mar 50, E-08019 Barcelona, Spain
T +34 93 308 45 45 F +34 93 308 21 14
bauer@ftbauer.com www.neufville.com

HOEFLER & FRERE-JONES, INC. (HOEFLER TYPE FOUNDRY)
611 Broadway, Room 608, New York, NY 10012-2608, United States
T +1/212/777 6640 F +1/212/777 6684
info@typography.com www.typography.com

ITC (INTERNATIONAL TYPEFACE CORPORATION)
200 Ballardvale Street, Wilmington, MA 01887-1069, United States
T +1/978/284 5961
info@itcfonts.com www.itcfonts.com

LINOTYPE LIBRARY
Du-Pont-Strasse 1, D-61352 Bad Homburg, Germany
T +49/61/72 48 44 18 F +49/61/72 48 44 29
info@linotype.com www.linotype.com

MONOTYPE IMAGING INC.
For North America, South America, Australia, and New Zealand:
200 Ballardvale Street, Wilmington, MA 01887, United States
T +1/978/284 7200 F +1/978/657 8568
www.monotypeimaging.com
Fonts can be purchased at www.fonts.com
For Europe, Pacific Rim, and rest of the world:
Unit 2, Perrywood Business Park, Salfords, Redhill, Surrey
RH1 5DZ, England
T +44/1737/765 959 F +44/1737/769 243
tec.europe@monotypeimaging.com

PORCHEZ TYPOFONDERIE
14 Rue Paul Bert, 92240 Malakoff, France
T +33/1/46 54 26 92 F +33/1/46 54 04 64
jfporchez@hol.fr www.typofonderie.com

P22 TYPE FOUNDRY (INCLUDES LANSTON TYPE COMPANY)
PO Box 770, Buffalo, NY 14213, United States
T +1/716/885/4490 F +1/716/885/4482
www.p22.com

JEREMY TANKARD TYPOGRAPHY LTD
The Old Fire Station, 39 Church Lane, Lincoln, Lincolnshire
LN2 1QJ, England
T +44/1522/805 654 F +44/1522/805 628
info@typography.net www.typography.net

GERARD UNGER
Parklaan 29A, 1405 GN Bussum, The Netherlands
T +31/35/693 66 21 F +31/35/693 91 21
ungerard@planet.nl www.gerardunder.com

(URW)++ DESIGN & DEVELOPMENT
Poppenbütteler Bogen 29A, D-22399 Hamburg, Germany
T +49/40/60 60 50 F +49/40/60 60 51 11
info@urwpp.de www.urwpp.de

SELECT BIBLIOGRAPHY

Phil Baines and Andrew Haslam, *Type and Typography*, Laurence King

Robert Bringhurst, *The Elements of Typographic Style*, Hartley and Marks

Sebastian Carter, *Twentieth Century Type Designers*, Lund Humphries

Manfred Klein, Yvonne Schwermer Scheddin, and Erik Spiekermann, *Type and Typographers*, Architecture Design and Technology Press

Bob Gordon, *Making Digital Type Look Good*, Thames and Hudson

David Jury, *About Face: Reviving the Rules of Typography*, Rotovision

Fred Smeijers, *Counterpunch*, Hyphen

James Craig, *Basic Typography: A Design Manual*, Watson Guptill

Peter Bain and Paul Shaw(eds), *Blackletter: Type and Cultural Identity*, Princeton Architectural Press

Ruari McLean, *The Thames and Hudson Manual of Typography*, Thames and Hudson

David Earls, *Designing Typefaces*, Rotovision

Alexander Branczyk and Jutta Nachtwey, *Emotional Digital*, Thames and Hudson

GLOSSARY

Aldine Types derived from the types used by Aldus Manutius from punches by Francesco Griffo at the end of the 15th century.

Alignment The arrangement of lines of continuous text to a fixed margin or axis: flush (ranged), justified, or centered.

Ampersand Glyph used in place of the word "and," derived from contraction of the French *et*.

Application A computer program that performs a specific function, such as layout, image manipulation, and font design.

Arabic numerals The figures 0 through 9, as distinct from Roman numerals.

Ascender The part of the lowercase letter that rises above the x-height.

Assymetrical type Type arranged to multiple margins or alignments, producing an irregular composition on the page.

Baseline The notional horizontal line upon which the base of the letters is positioned.

Bezier A form of curve established by computer-determined control points, used in defining outlines in digital type.

Binary code The basis for digital data, made up of two distinct characters: 0 and 1.

Bit A contraction of "binary" and "digit"; the primary unit of digital information.

Bitmap The image on the monitor in which each pixel is mapped to a specific bit in the computer memory.

Black A term used to denote an extra bold weight of type.

Blackletter Germanic script based upon manuscript forms; variants include Textura, Rotunda, Bastarda, and Fraktur.

Bleed Any part of a design that extends beyond the cropped edge of the page.

Body Originally the metal block on which the print surface of the type letter was positioned, the body has come to denote the overall area within which each digital letter or glyph is contained.

Body size The size of type, expressed using the point system.

Body type Type of a size suitable for the setting of continuous text, normally between 6 and 14 points.

Bold The heavier weight variant of a regular typeface; also demi bold, ultra bold.

Borders Solid, multiple, or broken lines used to separate, enclose, or underline type. Borders may be composed of repeat typographic glyphs or specified as continuous linear forms.

Bracketing The curve from the letter stem or main stroke to the serif. Serifs that join at a sharp angle are described as unbracketed.

Calligraphic type Type based upon hand-rendered script letterforms.

Caps A common abbreviation of capital or uppercase letters.

Case The tray or drawer containing metal type that gave the name to upper and lowercase letters.

Casting Typesetting by the mechanical casting of lines of type or individual letters from molten metal. See also hand casting.

Centered Lines of type set with equal ragged margins left and right, to a central axis.

Chapter head Title and/or number set on the opening page of a chapter.

Chase Rectangular metal frame into which hand-set type and illustrations are locked for printing.

Cicero A European unit of measurement roughly equivalent to the pica.

Composition A traditional term for the arrangement and assembly of type for print.

Condensed Narrow type, normally a reduced variant of a regular width.

Copy The original raw text to be typeset.

Counter The enclosed spaces within letters, such as the bowls of b, p, and o.

Crosshead A heading that crosses more than one column of text.

Cursive Sloped type, normally based upon handwriting but not linked.

Dagger/double dagger Additional footnote reference marks, used in a similar manner to asterisks.

Descender The descending stroke, tail, or loop of a lowercase letter that falls below the baseline.

Didot A historic European system of point measurement.

Display type Type designed for use at larger sizes for titling and headlining. Display types may not contain all the glyphs or font variants found in a text face.

Drop-cap An initial display letter of larger size than the text into which it is set.

Egyptian Originally a term used to denote the antique qualities of sans serif, the term Egyptian was later adopted to denote an unbracketed slab serif.

Ellipsis Three dots used to indicate an omission.

Em A square measure of a width equal to the body height of the type, also described as an em-quad in metal setting.

Em-dash A dash of one em in width.

Em-space Intercharacter space of one em in width.

En A measure of width equal to half the body height of the type.

En-dash A dash of one en in width.

En-space Intercharacter space of one en in width.

Extended Wide type, normally a wider variant of a regular width. Also described as expanded.

Face The print surface of metal type, and the style of that form: the typeface.

Family A group of related typefaces, sometimes including condensed and extended versions, titling sizes, and additional alphabets.

Film setting Photosetting onto photographic film or paper for reproduction.

Flush The alignment of type to a single straight margin, also known as ranged.

Folios The name traditionally given to page numbers.

Font/fount A full set of characters of one particular typeface in one style.

Foot The base of the letterform, which normally sits upon the baseline.

Foundry type Metal type cast for hand setting and repeated use.

Fraktur Broken script; a form of Blackletter.

Galley A metal tray in which metal type was held prior to locking in chases for printing.

Galley proofs Type set from metal or photosetting, produced for checking prior to final assembly.

Glyph Term used to describe each graphic form within a digital font, including letters, punctuation, ligatures, and diacritics.

Gothic A term variously used to describe Blackletter types in Europe and sans serifs in the US.

Grid The arrangement of common vertical and horizontal rules that govern the positioning of type and illustrations on the page.

Grotesque Term used in Britain for the description of early sans serif typefaces. See also Gothic.

Hairline A term for a fine line, referring both to the finest available weight of rule and the fine serifs of Didone types.

Hand casting The casting by hand of individual letters of type from matrices.

H&J A common abbreviation for hyphenation and justification: the adjustment and specification of hyphenation and word spacing for justified type.

Hanging indent Style in which the first line of a paragraph is set outside the margin used for the remainder of the copy. Also called an exdent.

Hot metal The mechanical casting of type from molten metal.

Humanist Early types, also known as Venetian, in which the roman letterform replaces the Textura.

Humanist Sans Sans serif types based upon classical proportions.

Hung initial Display initial letter set outside the margin used for the remainder of the copy.

Imposition The arrangement of multiple pages for commercial printing from large plates.

Incunabula A term used for examples of early printing, particularly books from the 15th century.

Indent The practice of indicating the beginning of a new paragraph by insetting the first word, frequently by an em-space.

Initial Opening letter of a chapter or paragraph, sometimes set in a larger contrasting face for decoration or emphasis.

Italic Sloping letters, originally typefaces based upon Renaissance handwritten forms, later paired with roman fonts.

Justification The adjustment of word space to create regular left and right margins in running text.

Kern The part of a metal letter that overhangs the body, typically the loop of the f.

Kerning The adjustment of space between individual characters.

Kern pairs In-built adjustment to the spacing of problematic letter pairs, incorporated in the design of the font.

Latin Letterforms derived from Roman sources.

Latin script The Western European alphabet.

Leading The space between lines of type, specified as the measurement in points from one baseline to the next.

Letterpress Relief printing from metal or wood types; the principal method of printing from the 15th to the mid-20th century.

Letter spacing The amount of space between letters in a text, adjusted unilaterally rather than individually.

Ligature A compound form combining two letters to overcome visual problems of overhanging letters, such as occur in the letter pairs fi and fl.

Linotype A mechanical composition system designed to cast whole lines, or slugs, of metal type.

Lithography Printing process using chemical separation to create inked areas on a metal plate or stone. See also offset lithography.

Lowercase The small letters derived from minuscule written forms, as distinct from the capital uppercase letters.

Majuscule The handwritten or calligraphic basis for uppercase letters.

Margin The negative space between the type and the page edge. The term margin is also used to describe the line that defines the outer edge of the type area.

Matrix The mold from which metal type was cast, created by the impression made from a steel punch. Also used to describe photographic negative images of type used in photosetting.

Measure The length of a line or column of type.

Minuscule The handwritten or calligraphic basis for lowercase letters.

Modern Term used to describe the Didone faces of the late 18th century.

Monotype Mechanical composition system designed to cast each letter as a separate unit or sort.

Non-lining figures Also known as old-style figures, non-lining figures correspond to the lowercase letters and have ascenders and descenders, rather than being aligned to the height of the capitals.

Oblique Characters slanted to the right. The term oblique is sometimes used to distinguish sloped letters from true cursive or italic forms.

Offset lithography Commercial printing from a photosensitized lithographic plate. The printed areas are created by a process of chemical separation and transferred (offset) to a printing roller.

OpenType A new font format based upon the Unicode standard and allowing for dramatically increased glyph sets.

Outline face Typeface with only outline printing.

Pagination The numbering of pages in consecutive order.

Paragraph mark The use of a typographic element or symbol to indicate the beginning of a new paragraph.

Photosetting The setting of type by mechanically exposing photographic paper or film to a light projected through a sequence of letterforms.

Pica Also known as a pica em: a horizontal measure of 12 points.

Pixel An abbreviation of "picture element," used to describe a single square of the computer screen.

Point Unit of typographic measurement used to define the size of type and leading. One point equals 1/72 of an inch.

PostScript A page description language developed by Adobe in 1983.

Printer font The digital font containing the information that determines the form of the printed letter.

Punch The original forms from which the casting matrices were struck. Originally cut in steel by hand, punches were created mechanically from the late 19th century.

Ragged Term used to describe the irregular margin created by unjustified or flush type.

Ranged See flush.

Recto The right-hand page of a page spread. Page 1 and subsequent odd-numbered folios always fall on the recto page.

Resolution The accuracy of visual definition, determined by the number of pixels on either monitor or output device.

Reversed copy Type set to print out wrong-reading.

Reversed type Type set to read in white or a lighter color out of a printed surround.

Roman Upright letterform as distinct from italic, or the regular weight as distinct from the bold. Also used to describe the serif letter.

Romanesque Based upon the roman form of the Humanist bookhand, as distinct from the Textura forms of Blackletter.

Roman numerals Numerals set using the Roman system based on the use of I, V, L, X, C.

Rules Printed lines used to decorate or differentiate areas of type and image. Rules may be single, double, or broken.

Running head Repeated title and chapter heading occurring on each page of a book.

Running text Text set as a continuous sequence of words.

Sans serif Type without serifs; also variously described as Grotesque or Gothic.

Screen font The digital font that determines the display of type on the screen. Screen fonts are paired with printer fonts that contain more detailed information.

Script The term script is used to describe different alphabets such as Latin, Cyrillic, Greek, or Hebrew, particularly where these are contained within a single type family.

Script typefaces Script types are based upon handwritten letterforms that may be either formal or informal. The term script usually denotes linked letters rather than unlinked cursive letters.

Serif The broadening or triangular forms at the terminals of letters, derived from Roman inscriptional lettering.

Set width The width of the body of the letter.

Side bearing The space at either side of the letter, on the body of metal types or in the specification of digital fonts.

Slab serif Broad serifs with a squared end, either unbracketed or bracketed.

Slugs Solid lines of type cast by the Linotype mechanical composition system.

Small caps The use of a smaller size of capital forms in place of lowercase. Properly size-adjusted small capitals are a feature of expert set fonts.

Sorts Originally the term for individual pieces of cast type; sorts was later used to describe special characters outside the standard alphabet, such as symbols and dingbats.

Swash Decorative letters with long flourishes, tails, and ascenders. Usually produced as a variant or alternate font.

Text The main body of continuous copy on the page, as distinct from titling and headings.

Text typeface Typeface suitable for setting continuous text at sizes from 6 to 14 points.

Textura A form of Blackletter characterized by condensed lowercase letters and angular form.

Tiff Tagged image file: a method of storing images as bitmaps.

Tracking A term used to describe general letter spacing of a text or sentence (as distinct from individual kerning adjustments).

Transitional A category of type marking the transition from the Old Style or Garalde forms to the Modern or Didone.

TrueType A page description language introduced for use on the Macintosh computer.

Typeface A specific design of type available in a range of sizes. A text typeface customarily includes a number of fonts, including bold, italic, and bold italic.

U&lc An abbreviation of upper and lowercase.

Unicode An international character set proposed in 1997 to contain all the world's languages. The computer code system forms the basis for OpenType.

Unit A variable measurement of width based upon the division of the em into equal increments to describe the widths of letters, side bearings, and word spacing. Current professional systems use increments of a thousand units to the em.

Unit value The width of individual characters expressed in units.

Unjustified type Type in which the word spacing has not been adjusted to produce even margins. See also flush.

Uppercase The capital letter forms in a font.

Venetian See Humanist.

Verso The left-hand page, facing the recto. Page 2 and subsequent even-numbered folios always fall on the verso page.

Vox classification System for classifying typefaces devised in 1954 by Maximillien Vox.

Weight The density and stroke width of the letters within a typeface. Typefaces customarily include a bold weight and may include additional light, black, or ultra bold fonts.

Widow An unacceptably short line at the end of a column or paragraph.

Word spacing The space between words, ideally equivalent to the width of a lowercase i.

Wrong-reading Type reading in reverse mirror image, as found on punches, metal type, or negatives.

X-height The height of lowercase letters within a typeface, specifically the height of the lowercase x.

INDEX

Page numbers in *italic* refer
to illustrations/captions

CREDITS

Quarto would like to thank and acknowledge the following for supplying photographs and illustrations reproduced in this book. All other illustrations are the copyright of Quarto Publishing plc. While every effort has been made to credit contributors, Quarto would like to apologize should there have been any omissions or errors—and would be pleased to make the appropriate correction for future editions of the book.

Key a above; b below; c center; l left; r right

10al St. Bride Printing Library, London; 11ar The Bridgeman Art Library/Universitaats Bibliothek, Gottingen; 11br The Board of Trinity College, Dublin; 12al Nicholas Jenson; 12br St. Bride Printing Library, London; 13al & ar St. Bride Printing Library, London; 14 & 15 (except *The Times*) St. Bride Printing Library, London; 15 *The Times* masthead, The Times Newspapers; 17al St. Bride Printing Library, London; 17ac Jan Tschichold; 17ar Penguin Books; 17bl Doyle Dane Bernbach Ltd; 17br Intégral Concept; 18l Studio Dubar; 18c Neville Brody; 19al Emigré; 19ar April Greiman Inc; 24l Adrian Frutiger; 32 type foundry samples from Adobe Systems, FontShop International (FontFont), Linotype Library, Monotype Imaging, PampaType Digital Foundry, P22 Type Foundry, and Jeremy Tankard Typography; 41 Einar Gylfason; 43bl Will Hill; 50 Juliana Theory at The House of Blues 18 x 24 limited edition silk screen poster by Stereotype Design, designer Mike Joyce, client Louder Than Bombs; 51 The Blakes, New Tattoo, 18 x 24 limited edition silk screen poster by Stereotype Design, designer Mike Joyce, client Readymade Records; 54bl Günter Rambow; 54ar Büro für Gestaltung; 55al Be Heard self-promotional booklet by Robert Rytter & Associates, creative director Robert Rytter, art director Helen Armstrong, copyrighters David Treadwell and Sean Krause; 55bl Vote poster by Doyle Partners, creative director and designer Stephen Doyle, client AIGA; 55br work from the Higher National Diploma Course, London College of Printing; 56l Google Inc., www.google.com; 56c&r Piscatello Design Center, client Bernhardt Design; 57a KearneyRocholl; 57b

website by Paone Design Associates, designer Gregory Paone, programmer Juan Sansinenea, client Trevor Dixon Photography; 58l Blair Robinson/De La Warr Pavilion, Bexhill; 58r detail of Keele University lettering by Richard Kindersley; 59al & br text works for East Lane, Bawdsey, Suffolk by letterer Bettina Furnee and poets Tony Mitton and Simon Frazer; 59c Jean Francois Porchez/ Typofonderie, Malaoff, France; 59cr & br Poulin + Morris for the Polshek Partnership's renovation of the New York Public Library for the Performing Arts at the Lincoln Center, New York; 62 Monotype; 65al book jacket from *Mason & Dixon* by Thomas Pynchon, published by Random House, 1998; 65ar & cr Be Heard self-promotional booklet by Robert Rytter & Associates, creative director Robert Rytter, art director Helen Armstrong, copyrighters David Treadwell and Sean Krause; 65br William Morris, Kelmscott Press; 73al Jeremy Tankard; 73ar Shinnoske Sugisaki; 72bc Jean Francois Porchez/ Typofonderie, Malaoff, France; 85al Will Hill; 85ar Monotype; 85cr NAICU conference material by Robert Rytter & Associates, creative director Robert Rytter, art director Helen Armstrong; 85bc Phil Baines; 85br Philippe Grandjean; 95al Studio di Progettazione Grafica; 95ac Jeffery Keedy; 95ar Jean Francois Porchez/ Typofonderie, Malaoff, France; 95bc Brooks/Cahan annual report; 95br Lucille Tenazas; 103al Shane Keaney; 103ac Fred Woodward; 103ar Niklaus Troxler for Willisau Jazz Festival, Switzerland; 103bc Fall Out Boy limited edition silk screen poster by Stereotype Design, designer Mike Joyce, client Fueled By Ramen Records; 111al *Frieze* design by Tom Gidley, typeface design by Gerard

Unger, Holland; 111ac Büro für Gestaltung; 111ar Phrenic New Ballet poster by Paone Design Associates, designers Agnes Sekreta and Gregory Paone, photographer Tobin Rothlein; 111br work from the Higher National Diploma Course, London College of Printing; 119al *The Muhammad Ali Reader* designed by Paul Sahre, orignally published by Rob Weisbach Books; 119ac Niklaus Troxler for Willisau Jazz Festival, Switzerland; 119ar Hoefler Type Foundry; 119bl Justin Salvas; 119br Oliver Stenhuit/ www.designbysign.com; 127al Jennifer Stirling of Stirling Design; 127ac Paul Scher/Pentagram; 127ar Haas Foundry; 127bl Kristine Matthews; 127br Büro für Gestaltung; 135al Bauer Foundry; 135cl Klingspor Foundry; 135ar Ariane's Cup poster 2002 by Birgit Eggers and Mark Diaper of Eggers+Diaper, Berlin; 135br exhibit by John and Orna Designs at the Design Museum, London, 2000; 143al Herman Zapf/Stempel Foundry; 143bl *Preoccupations: Selected Prose 1968–1978* by Seamus Heany, published by Faber, 1980; 143bc & r Apeloig Studio; 151ar *The Telling Lie* by Douglas Martin, published by Julia McRae Books, London, 1989; 151bl brochure design by James Young, type design by Jovica Veljocic; 151br Giambattista Bodoni, 1818; 161c equipment alphabet by Mervyn Kurlansky, Pentagram; 161br Chermayeff and Geismar for Alvin Ailey Dance Theater, New York; 177al Charles Wilkin; 177ar & br Niklaus Troxler for Willisau Jazz Festival, Switzerland; 177cl Noteworthy masthead by Paone Design Associates, designer Gregory Paone, client Philadelphia Youth Orchestra; 177bl Büro für Gestaltung.

Hoefler Text typeface designed by Jonathan Hoefler, Copyright © 1991–1994 The Hoefler Type Foundry, Inc. Requiem designed by Jonathan Hoefler, Copyright © 1991–1994 The Hoefler Type Foundry, Inc. Hoefler Titling designed by Jonathan Hoefler, Copyright © 1994 The Hoefler Type Foundry, Inc. Fetish typeface designed by Jonathan Hoefler, Copyright © 1994 The Hoefler Type Foundry, Inc. Knockout typeface designed by Jonathan Hoefler, Copyright © 1994 The Hoefler Type Foundry, Inc. Gotham typeface designed by Jonathan Hoefler, Copyright © 2000 The Hoefler Type Foundry, Inc. For more information, visit us online at www.typography.com or call (212) 777-6640.

FontShop International, Bergmannstrasse 102, D-10961 Berlin, Germany, is the publisher of FF Acanthus Open Regular, FF Acanthus Text Regular, FF Angst, FF Atlanta, FF Beowolf, FF Bodoni Classic Shadow, FF Brokenscript, FF Celeste 1, FF Clifford, FF Craft, FF Dog, FF Fudoni, FF Govan, FF JohannesG, FF Koberger, FF Localizer Sans, FF Moonbase Alpha, FF Mulinex, FF Pop, FF Quadraat Sans, FF Reminga Regular, FF Scala Bold, FF Scala Italic, FF Scala Jewel, FF Scala Regular, FF Scratched Out, FF Seria, FF Sheriff, FF Super Grotesk.

APELOIG STUDIO
Apeloig.philippe@wanadoo.fr

BÜRO FÜR GESTALTUNG
mail@bfg-online.de
www.bfg-online.de

DOYLE PARTNERS
info@doylepartners.com
www.doylepartners.com

EGGERS+DIAPER
be@eggers-diaper.com
www.eggers-diaper.com

EINAR GYLFASON
einar@oid.is
www.oid.is

JOHN AND ORNA DESIGNS
mail@johnandornadesigns.co.uk
www.johnandornadesigns.co.uk

SHANE KEANEY
shanekea@shanekeaney.com

KEARNEYROCHOLL
info@kearneyrocholl.de
www.rocholl-projects.de

PAONE DESIGN ASSOCIATES
paonedesign@aol.com
www.paonedesign.com

PISCATELLO DESIGN CENTER
info@piscatello.com
www.piscatello.com

POULIN + MORRIS
richard@poulinmorris.com
www.poulinmorris.com

GÜNTER RAMBOW
gunterrambow@web.de

ROBERT RYTTER & ASSOCIATES
rrytter@rytter.com
www.rytter.com

STEREOTYPE DESIGN
mike@stereotype-design.com
www.stereotype-design.com

STUDIO DI PROGETTAZIONE GRAFICA
soberholzer@swissonline.ch

SHINNOSKE SUGISAKI
info@shinn.co.jp
www.shinn.co.jp

NIKLAUS TROXLER
troxler@troxlerart.ch
www.troxlerart.ch
www.jazzwillisau.ch